# Sacred

## AND

# Legendary Art.

## VOL. II.

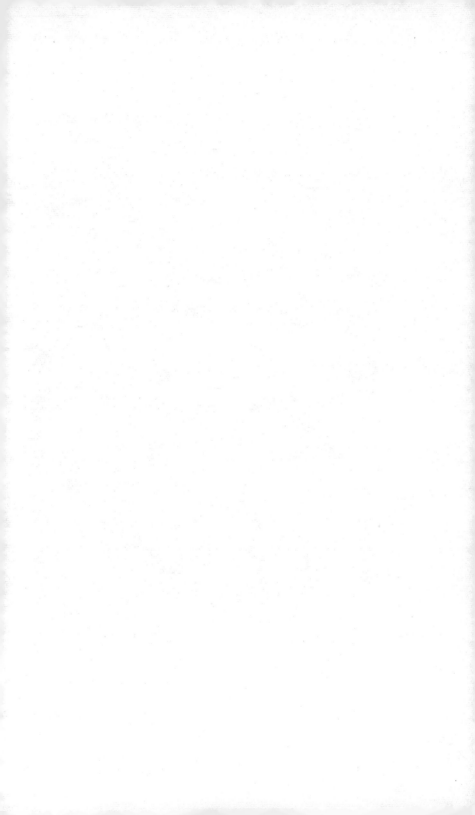

*The Five Virgin Martyrs.*

A J Scott

# 𝕾𝖆𝖈𝖗𝖊𝖉

AND

# 𝕷𝖊𝖌𝖊𝖓𝖉𝖆𝖗𝖞 𝕬𝖗𝖙.

## BY MRS. JAMESON.

### VOLUME II.

CONTAINING

LEGENDS OF THE ANGELS AND ARCHANGELS, THE EVANGELISTS,

THE APOSTLES, THE DOCTORS OF THE CHURCH,

AND ST. MARY MAGDALENE,

AS REPRESENTED IN THE FINE ARTS.

NEW EDITION.

AMS PRESS
NEW YORK

Reprinted from the edition of 1896, New York
First AMS EDITION published 1970
Manufactured in the United States of America

International Standard Book Number:
Complete set: 0-404-03551-5
Volume 2: 0-404-03553-1

Library of Congress Card Catalog Number: 71-124594

AMS PRESS, INC.
NEW YORK, N.Y. 10003

# CONTENTS

OF

# THE SECOND VOLUME.

———◆———

### THE PATRON SAINTS OF CHRISTENDOM.

THOSE SAINTS WHO HAD NOT A SCRIPTURAL OR APOSTOLIC SANCTION,
YET WERE INVESTED BY THE POPULAR AND UNIVERSAL FAITH
WITH A PARAMOUNT AUTHORITY.

# THE VIRGIN PATRONESSES.

# THE EARLY MARTYRS.

## THE GREEK MARTYRS.

## THE LATIN MARTYRS.

### The Four Great Virgins of the Latin Church :

## THE ROMAN MARTYRS.

# LIST OF ILLUSTRATIONS

IN

## THE SECOND VOLUME.

———◆———

### 𝔚𝔬𝔬𝔡𝔠𝔲𝔱𝔰.

---

\* For these two beautiful figures, specimens of *intarsia* (*i.e.*, inlaid wood) from the choir of the church of St. John, Malta, I am indebted to Mrs Austin.

# Etchings.

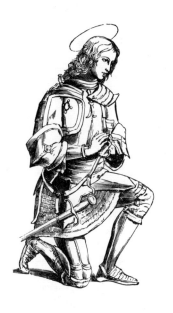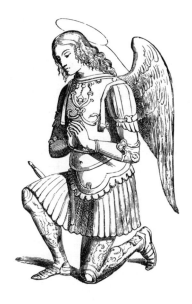

99  St. George of England  (Perugino)  St. Michael of France

## The Patron Saints of Christendom.

BEFORE entering on the general subject of the early martyrs, I shall place together here the great Patron Saints of Eastern and Western Christendom. All saints are, in one sense, patron saints, either as protectors of some particular nation, province, or city; or of some particular avocation, trade, or condition of life; but there is a wide distinction to be drawn between the merely national and local saints, and those universally accepted and revered. St. Denis, for instance, is not much honoured out of France; nor St. Januarius, the Lazzarone saint, out of Naples; but St. George, the patron of England, was at once the GREAT SAINT of the Greek Church, and the patron of the chivalry of Europe; and triumphed wherever triumphed the cross, from the Euphrates to the Pillars of Hercules.

Those patron saints who had not, like St. Peter of Rome, St. Mark of Venice, St. James of Spain, St. Mary Magdalene, a scriptural and apostolic sanction, yet were invested by the popular and universal faith with a paramount dignity and authority, form a class apart. They are—St. George, St. Sebastian, St. Christopher, St. Cosmo, and St. Damian, St. Roch, and St. Nicholas. The virgin patronesses, to whom was rendered a like universal worship, are St. Catherine, St. Barbara, St. Margaret, and St. Ursula.

I place them here together, because I have observed that, in studying the legendary subjects of Art, they must be kept constantly in mind. In every sacred edifice of Europe which still retains its mediæval and primal character, whatever might be its destination, whether church, chapel, convent, *scuola*, or hospital,—in every work of art in which sacred personages are grouped together, without any direct reference to the scenes or events of Scripture, one or other of these renowned patrons is sure to be found ; and it becomes of the utmost importance that their characters, persons, and attributes should be well discriminated. Those who were martyrs do not figure principally in that character. They each represent some phase of the beneficent power, or some particular aspect of the character, of Christ, that divine and universal model to which we all aspire; but so little is really known of these glorified beings, their persons, their attributes,— the actions recorded of them are so mixed up with fable, and in some instances so completely fantastic and ideal,—that they may be fairly regarded as having succeeded to the honours and attributes of the tutelary divinities of the pagan mythology. It is really a most interesting speculation to observe how completely the prevalent state of society in the middle ages modified the popular notions of these impersonations of divine power. Every one knows by heart those exquisite lines in which Wordsworth has traced the rise and influence of the beautiful myths of ancient Greece :—

In that fair clime the lonely herdsman, stretch'd
On the soft grass through half a summer's day,
With music lull'd his indolent repose :
And, in some fit of weariness, if he,
When his own breath was silent, chanced to hear
A distant strain, far sweeter than the sounds
Which his poor skill could make, his Fancy fetch'd,

Even from the blazing chariot of the sun,
A beardless youth, who touched a golden lute,
And fill'd the illumined groves with ravishment.
The nightly hunter, lifting up his eyes
Towards the crescent moon, with grateful heart
Call'd on the lovely wanderer who bestow'd
That timely light to share his joyous sport:
And hence a blooming goddess and her nymphs.

Thus the mythology of the ancient Greeks was the deification of the aspects and harmonies of nature, while the mythology of Christianity was shaped by the aspirations of humanity;—it was the apotheosis of the moral sentiments, coloured by the passions and the sufferings of the time. So in an age of barbarity and violence did St. George, the redresser of wrongs with spear and shield, become the model of knighthood. So when disease and pestilence ravaged whole provinces, the power to avert the plague was invoked in St. Sebastian; and the power to heal, ever a godlike attribute, reverenced in St. Cosmo and St. Damian. So at a time when human life was held cheap, and beset by casualties, when the intercourse between men and nations was interrupted by wide forests, by unaccustomed roads, by floods and swamps, and all perils of sea and land, did St. Christopher represent to the pious the immediate presence of divine aid in difficulty and danger. So also were the virgin patronesses to all intents and purposes *goddesses* in fact, though saints in name. The noble sufferance, the unblemished chastity, the enthusiastic faith of a St. Catherine or a St. Ursula, did not lose by a mingling of the antique grace, where a due reverence inspired the conception of the artist:—Venus and Diana, and Pallas and Lucina, it should seem, could only gain by being invested with the loftier, purer attributes of Christianity. Still there was a diversity in the spirit which rendered the blending of these characters, however accepted in the abstract, not always happy in the representation;—a consideration which will meet us under many aspects as we proceed.

There are fourteen saints, who, in Germany, are especially distinguished as NOTH-HELFER (Helpers-in-need); but as this distinction does not pervade German art especially, and is not received in the rest of Europe, I have thought it unnecessary to do more than mention it.

I will now take these poetical and semideified personages in order; giving the precedence, as is most fit, to our own illustrious patron, the Champion of England and hero of the ' Faerie Queen,' St. George.

## St. George of Cappadocia.

*Lat.* Sanctus Georgius.   *Ital.* San Giorgio.   *Fr.* St. Georges, le très-loyal Chevalier de la Chrétienneté.   *Ger.* Der Heilige Georgius, or, more popularly, Jorg or Georg.   Patron of England, of Germany, of Venice.   Patron saint of soldiers and of armourers.   April 23. A.D. 303.

The legend of St. George came to us from the East; where, under various forms, as Apollo and the Python, as Bellerophon and the Chimera, as Perseus and the Sea-monster, we see perpetually recurring the mythic allegory by which was figured the conquest achieved by beneficent power over the tyranny of wickedness, and which reappears in Christian Art in the legends of St. Michael and half a hundred other saints.    At an early period we find this time-consecrated myth transplanted into Christendom, and assuming, by degrees, a peculiar colouring in conformity with the spirit of a martial and religious age, until the classical demi-god appears before us, transformed into that doughty slayer of the dragon and redresser of woman's wrongs, St. George—

> Yclad in mighty arms and silver shield,
> As one for knightly jousts and fierce encounters fit.

Spenser, however, makes his ' patron of true holinesse' rather unwilling to renounce his *knighthood* for his *sainthood* :—

> But deeds of arms must I at last be fain
> To leave, and lady's love so dearly bought ?

The legend of St. George, as it was accepted by the people and artists of the middle ages, runs thus :—He was a native of Cappadocia, living in the time of the Emperor Diocletian, born of noble Christian parents, and a tribune in the army.    It is related that in travelling to join his legion he came to a certain city in Libya called Selene.[1]    The

---

[1] By some authors the scene is laid at Berytus (Bayreuth) in Syria.

inhabitants of this city were in great trouble and consternation in consequence of the ravages of a monstrous dragon, which issued from a neighbouring lake or marsh, and devoured the flocks and herds of the people, who had taken refuge within the walls: and to prevent him from approaching the city, the air of which was poisoned by his pestiferous breath, they offered him daily two sheep; and when the sheep were exhausted, they were forced to sacrifice to him two of their children daily, to save the rest. The children were taken by lot (all under the age of fifteen); and the whole city was filled with mourning, with the lamentations of bereaved parents and the cries of the innocent victims.

Now the king of this city had one daughter, exceedingly fair, and her name was Cleodolinda. And after some time, when many people had perished, the lot fell upon her, and the monarch, in his despair, offered all his gold and treasures, and even the half of his kingdom, to redeem her; but the people murmured, saying, ' Is this just, O King! that thou, by thine own edict, hast made us desolate, and, behold, now thou wouldst withhold thine own child? '—and they waxed more and more wroth, and they threatened to burn him in his palace unless the princess was delivered up. Then the king submitted, and asked only a delay of eight days to bewail her fate, which was granted; and at the end of eight days, the princess, being clothed in her royal robes, was led forth as a victim for sacrifice; and she fell at her father's feet and asked his blessing, saying that she was ready to die for her people: and then, amid tears and lamentations, she was put forth, and the gates shut against her. Slowly she walked towards the dwelling of the dragon, the path being drearily strewn with the bones of former victims, and she wept as she went on her way. Now, at this time, St. George was passing by, mounted on his good steed; and, being moved to see so beautiful a virgin in tears, he paused to ask her why she wept, and she told him. And he said, ' Fear not, for I will deliver you!' and she replied, ' O noble youth! tarry not here, lest thou perish with me! but fly, I beseech thee!' But St. George would not; and he said, ' God forbid that I should fly! I will lift my hand against this loathly thing, and will deliver thee through the power of Jesus Christ!' At that moment the monster was seen emerging from his lair, and half-

crawling, half-flying towards them.  Then the virgin princess trembled
exceedingly, and cried out, 'Fly, I beseech thee, brave knight, and
leave me here to die!'  But he answered not; only making the sign
of the cross and calling on the name of the Redeemer, he spurred
towards the dragon, and, after a terrible and prolonged combat,
he pinned him to the earth with his lance.   Then he desired the prin-
cess to bring her girdle; and he bound the dragon fast, and gave the
girdle to her hand, and the subdued monster crawled after them like
a dog.   In this guise they approached the city.   The people being
greatly terrified, St. George called out to them, saying,—'Fear
nothing; only believe in the God through whose might I have
conquered this adversary, and be baptized, and I will destroy him
before your eyes.'   So the king and his people believed, and were
baptized,—twenty thousand people in one day.   Then St. George
slew the dragon and cut off his head; and the king bestowed great
rewards and treasures on the victorious knight; but he distributed
all to the poor, and kept nothing, and went on his way, and came
to Palestine.   At that time the edict of the Emperor Diocletian
against the Christians was published, and it was affixed to the
gates of the temples, and in the public markets; and men read it
with terror, and hid their faces; but St. George, when he saw it, was
filled with indignation, the spirit of courage from on high came upon
him, and he tore it down, and trampled it under his feet.   Whereupon
he was seized, and carried before Dacian the proconsul, and condemned
to suffer during eight days the most cruel tortures.   First they bound
him on a wooden cross and tore his body with sharp iron nails, and
then they scorched and burned him with torches, and rubbed salt
into his smarting wounds.   And when Dacian saw that St. George
was not to be vanquished by torments, he called to his aid a certain
enchanter, who, after invoking his demons, mingled strong poison
with a cup of wine and presented it to the saint.   He, having made
the sign of the cross and recommended himself to God, drank it off
without injury:—(an expressive allegory, signifying the power of
Christian truth to expel and defeat evil).   When the magician saw
this miracle, he fell at the feet of the saint, and declared himself a
Christian.   Immediately the wicked judge caused the enchanter to be
beheaded; and St. George was bound upon a wheel full of sharp blades;

but the wheel was broken by two angels who descended from heaven. Thereupon they flung him into a cauldron of boiling lead : and when they believed that they had subdued him by the force of torments, they brought him to the temple to assist at the sacrifice, and the people ran in crowds to behold his humiliation, and the priests mocked him. But St. George knelt down and prayed, and thunder and lightning from heaven fell upon the temple, and destroyed it and the idols ; and the priests and many people were crushed beneath the ruins, as at the prayer of the son of Manoah in ancient times. Then Dacian, seized with rage and terror, commanded that the Christian knight should be beheaded. He bent his neck to the sword of the executioner, and received bravely and thankfully the stroke of death.

St. George is particularly honoured by the Greeks, who place him as captain at the head of the noble army of martyrs, with the title of THE GREAT MARTYR. The reverence paid to him in the East is of such antiquity, that one of the first churches erected by Constantine, after his profession of Christianity (consequently within twenty years after the supposed death of the saint), was in honour of St. George. In the West, however, his apocryphal legend was not accepted, and was, in fact, repudiated from the offices of the Church by Pope Gelasius in 494, when he reformed the calendar. It was then decided that St. George should be placed in the category of those saints ' whose names are justly reverenced among men, but whose actions are known only to God.' After this period we do not hear much of him till the first crusade, when the assistance he is said to have vouchsafed to Godfrey of Boulogne made his name as a military saint famous throughout Europe. The particular veneration paid to him in England dates from the time of Richard I., who, in the wars of Palestine, placed himself and his army under the especial protection of St. George. In 1222 his feast was ordered to be kept as a holiday throughout England ; and the institution of the Order of the Garter, in 1330, seems to have completed his inauguration as our patron saint.[1]

[1] There is ample proof that St. George was popular in this country even in the Anglo-Saxon times ; but, previous to the Normans, Edward the Confessor was patron saint of England. There are 162 churches in England dedicated in honour of St. George. (See Parker's Calendar of the Anglican Church, p. 65.)

The devotional representations of St. George, which are of very frequent occurrence, may be divided into two classes.   1.  Those in which he is standing as patron saint, alone, or grouped with other saints in the Madonna pictures.   2.  Those in which he vanquishes the dragon.

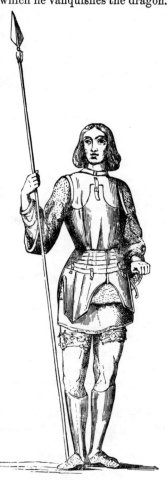

1.  In the single figures, St. George is usually represented young, or in the prime of life.   In the Greek and Italian pictures he is generally beardless, but bearded in the German pictures.   His air and expression should be serenely triumphant : he ought to wear a complete suit of armour, being the same specified by St. Paul (Ephes. vi.),—'The breast-plate of righteousness, the shield of faith, the helmet of salvation, and the sword of the Spirit, which is the word of God.' Sometimes he wears the classical armour of a Roman soldier, sometimes he is armed as a knight of romance. In one hand he bears the palm, in the other a lance ; from which, occasionally, floats a banner with a red cross. The lance is often broken, because in his legend it is said, that, 'his lance being broken, he slew the dragon with his sword.'   The slain dragon lies at his feet.   This is the usual manner of representation, but it is occasionally varied ; for instance, when he stands before us as the patron saint of England and of the Order of the Garter, he has the garter buckled round his knee, and the star of the order embroidered on his mantle.   When he

103   St. George   (Venetian).

figures as patron saint of Venice, he stands leaning on his sword, the lance and banner in his hand, and the dragon usually omitted.

Such representations in the early Italian pictures are often of exquisite beauty, combining the attitude and bearing of the victorious warrior with the mild, devout expression of the martyr saint. For example, in a picture by Cima da Conegliano,[1] he stands to the right of the throne of the Madonna, one hand grasping the lance, the other resting on the pommel of his sword, and in his youthful features an expression divinely candid and serene: there is no dragon. Again, in the famous Madonna del Trono by Fra Bartolomeo,[2] St. George stands by the throne in a full suit of steel plate armour, with an air which Vasari has truly described as '*fiera, pronta, vivace;*' and yet, on his clear open brow, an expression becoming the Christian saint: he bears the standard furled.

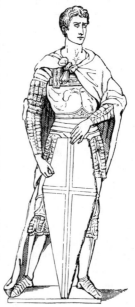

I believe the beautiful little Venetian picture once in the collection of Mr. Rogers (and then called Gaston de Foix) to be a study for a St. George, either by Giorgione or Bonifacio ; and those to whom the Venetian altar-pieces are familiar can have no doubt as to the subject intended.[3]

In a picture by Tintoretto,[4] St. George, as patron of Venice, is seated on the steps of the throne of the Madonna, like a celestial guard ; while the Venetian signoria are approaching to worship.

St. George, standing in armour, points upwards with one hand, and in the other holds an inscription, ' *Quid bono retribuā Dño.*' In a picture by Giolfino, in the S. Anastasia, Verona.

Among the most celebrated single figures of St. George must be mentioned the fine

101    St. George    (Donatello).

---

[1] Acad. Venice.                    [2] Fl. Gal.
[3] It is now in our National Gallery, and ought to go by its right name.
[4] Venice, SS. Gio. e Paolo.

statue by Donatello on the exterior of the Or San Michele at Florence: he is in complete armour, without sword or lance, bareheaded, and leaning on his shield, which displays the cross.   The noble, tranquil, serious dignity of this figure admirably expresses the Christian warrior : it is so exactly the conception of Spenser that it immediately suggests his lines—

> Upon his shield the bloodie cross was scored,
> For sovereign help, which in his need he had.
> Right faithful, true he was, in deed and word ;
> But of his cheere did seem too solemn sad ;
> Yet nothing did he dread, but ever was ydrad.

As a signal example of a wholly different feeling and treatment, may be mentioned the St. George in Correggio's ' Madonna di San Giorgio:'[1] here his habit is that of a Roman soldier; his attitude bold and martial; and, turning to the spectator with a look of radiant triumph, he sets his foot on the head of the vanquished dragon.

2. In the subject called familiarly *St. George and the Dragon*, we must be careful to distinguish between the *emblem* and the *action*. Where we have merely the figure of St. George in the act of vanquishing the dragon,—as in the insignia of the Order of the Garter, on coins, in the carvings of old Gothic churches, in ancient stained glass, &c.—the representation is strictly devotional and allegorical, signifying the victory of faith or holiness over all the powers of evil.   But where St. George is seen as combatant, and the issue of the combat yet undecided ; where accessaries are introduced, as the walls of the city in the background, crowded with anxious spectators ; or where the princess, praying with folded hands for her deliverer, is a conspicuous and important personage,—then the representation becomes dramatic and historical; it is clearly a scene, an incident.   In the former instance, the treatment should be simple, ideal, sculptural; in the latter, picturesque, dramatic, fanciful.

There are two little pictures by Raphael which may be cited as signal examples of the two styles of treatment.   The first, which is in

[1] Dresden Gal.

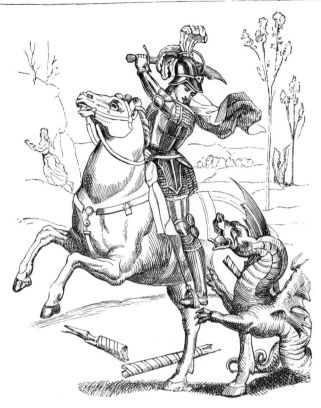

102          St. George  (Raphael.  Louvre).

the Louvre, a serenely elegant and purely allegorical conception, repre-
sents St. George as the Christian warrior, combating with spiritual
arms, and assured of conquest; for thus he sits upon his milk-white
steed, and with such a tranquil and even careless scorn prepares to
strike off the head of the writhing monster beneath. (102) Very dif-
ferent, as a conception, is the second picture, in which St. George
figures as the champion of England; here he is rushing on the dragon
as one who must conquer or die, and transfixes the monster with his
lance; the rescued princess is seen in the background.   This picture

was painted as a present from the Duke of Urbino to Henry VII.; and
St. George has the garter and motto round his knee.   It is now at
St. Petersburg.

When the princess is introduced in the devotional representations,
she is clearly an allegorical personage, representing truth or innocence,
—the Una of Spenser.   I can recollect but one instance in which she
has the lamb; in this example, however, the treatment is anything but
devotional.   It is an exquisite little print, by Lucas van Leyden, which
appears to represent the meeting of St. George and the princess before
the conquest of the dragon: she has been weeping, and is drying her
eyes with the back of her hand, while St. George comforts her, as we
may see, with gallant assurances of deliverance; his squire in the back-
ground holds his horse.   Some other examples of this early treatment
by the German painters are very curious: whether historical or alle-
gorical, they conceived it wholly in a romantic and chivalrous spirit.
We have the casque and floating plume, the twisted mail, the spurs,
the long hair, the banner, the attendant squire.   Albert Dürer has
given us four prints of St. George: in one of them he is standing with
the red-cross banner and has his hair confined in a kind of net cap,
such as the knights of the fifteenth century wore under the helmet; his
plumed casque and the vanquished dragon lie at his feet; he has rather
a long beard, and all the air of a veteran knight.   Sometimes St. George
is seen on horseback, bareheaded, with his helmet at his saddle-bow,
while the rescued princess walks beside him, leading the wounded
dragon bound in her girdle.   In Tintoretto's picture in our National
Gallery, the conquest of the dragon is treated quite in the dramatic
and historical style: here the combat takes place in the background;
and the princess, who is in front, seems to wish, yet dread, to look
round.

In the spirited sketch by Tintoretto, at Hampton Court, St. George
has bound the monster, and the princess Cleodolinda holds one end of
the girdle.   The same incident, but more dramatic and picturesque in
treatment, we find in the Queen's Gallery, painted by Rubens for our
Charles I.   In this picture the saintly legend is exhibited as a scene in
a melodrama, and made the vehicle for significant and not inappropriate
flattery.   The action passes in a rich landscape, representing in the
background a distant view of the Thames, and Windsor Castle as it

then stood. Near the centre is St. George, with his right foot on the neck of the vanquished dragon, presenting to the daughter of the King of Selene—the fair princess Cleodolinda—the end of the girdle which she had given him to bind the monster: the saint and the princess are portraits of Charles I. and Henrietta-Maria. Nearer to the spectator, on the left, is a group of four females, bewailing the ravages of the beast, exhibited in the dead bodies lying near them, and from the sight of which two infants recoil with horror. Behind, the squire of the saintly knight is seen mounted and armed cap-à-pie, and bearing his banner with the red cross; a page holds his horse: beyond them is seen a group of persons on a high bank, and others mounted on trees, who survey the scene; and on the other side, three females, who are embracing each other, and, as the French catalogue has it, 'témoignent par leur attitude une frayeur mêlée de joie.' Two angels from above descend with the palm and the laurel to crown the conqueror. The picture, like the St. George of Raphael, already mentioned, has to an Englishman a sort of national interest, being painted for one of our kings, in honour of our tutelar saint. After the death of Charles I. it was sold out of England, passed into the Orleans Gallery, was brought back to England in 1798, and subsequently purchased by George IV.

There is a beautiful modern bas-relief by Schwanthaler, in which St. George, with his foot on the dragon, is presenting the end of the girdle to the rescued princess.

It appears to me an unpardonable mistake in point of sentiment when the princess is fleeing in terror, as in one of L. Caracci's finest pictures, where she appears in the foreground, and immediately commands attention.[1] Richardson praises the figure, and with justice: he says, 'the lady, that flies in a fright, has the most noble and *gentile* attitude imaginable. She is dressed all in white, she runs away, her back is towards you, but her head, turning over her shoulder, shows a profile exquisitely beautiful, and with a fine expression.' Fine expression of what?—of fear? It shocks our better judgment. The noble princess of the legend, who was ready to die for her people, and who entreated St. George to leave her rather than expose his life, was not likely to

[1] In the cloisters of the San Michele-in-Bosco, at Bologna, now nearly defaced; but the frescoes, once celebrated, are well known through engravings.

fly when he was combating for her sake; she puts up prayers for her
deliverer, and abides the issue.   So Spenser's Una, the Cleodolinda
of the legend :—

> With folded hands, and knees full lowly bent,
> All night did watch, ne once adowne would lay
> Her dainty limbs in her sad drearyment ;
> But praying, still did wake, and waking did lament.

And thus the ancient painters, with a true and elevated feeling, uni-
formly represent her.

Richardson, in his praise of this picture by Ludovico, which he calls
a 'miraculous picture,' seems to have forgotten the principle he has
himself laid down, with excellent taste, though the expression be
somewhat homely.   'If the workmanship be never so exquisite, if the
pencil or chisel be in the utmost degree fine; and the idea of the
persons or things represented is low, or disagreeable; the work may be
excellent, but the picture or sculpture is in the main contemptible,
or of little worth.   Whereas, on the other hand, let the ideas we
receive be great and noble, 'tis comparatively of no importance
whether the work is rough or delicate.'

The devotional figures of the armed St. George, with his foot on
the dragon, resemble in sentiment and significance the figures of
St. Michael: where they are represented together, the wings or the
balance distinguish the archangel; the palm, the martyr.   There are
other military saints who have also the dragon, from whom it is less
easy to distinguish St. George.   St. Theodore of Heraclea and St.
Longinus have both this attribute.   The reader will find in the
legends of these saints the points which distinguish them.

It must be observed, that the dragon in the myth of St. George
never has the human or satanic lineaments, as in the legend of St.
Michael; nor do I know of any instance in which the usual dragon-
type, such as we see it in all the effigies of the conquering St. George,
has been departed from: the gigantic crocodile head; the brazen scales,
that, when he moved, were as 'the clashing of an armour bright;' the
enormous wings, 'like unto sails in which the hollow wind is gathered
full;' the voluminous tail, terminating in a sting; and the iron teeth

and claws; compose the 'dreadful beast,'—which is a beast, and nothing more.

Pictures from the life of St. George as a series occur very seldom. I believe that the reason may be found in the rejection of his legend from the office of the Church of Rome as early as the sixth century, he being placed by Pope Gelasius in the number of those saints 'whose names and whose virtues were rightly adored by men, but whose actions were known only to God.' This has not prevented his legend from being one of the most popular in those European story-books where he figures as one of the Seven Champions of Christendom.

There is a series of early frescoes in the chapel of San Giorgio at Padua, painted, as it is supposed, by the school of Giotto, principally by Jacopo Avanzi and Altichieri. They are arranged in the following order :—

1. The combat with the dragon; the city is seen in the background, with the walls crowded with spectators.

2. The baptism of the king, the queen, the princess, and all the court. The scene is the interior of the church, which, according to the legend, was built by the command of St. George, after the conquest of the dragon : the king is kneeling at the font, holding his crown in his hand; St. George is pouring water upon his head from a vase : the saint is not here in armour, but wears a white tunic, with the pointed shoes and spurs of a cavalier of the fourteenth century. The queen and princess kneel behind the king.

The four frescoes in the lower range represent the martyrdom of the saint. 1. St. George, habited in a long loose mantle, drinks off the poison presented by the Magician, who looks on with surprise. 2. St. George stretched on the wheel, which is destroyed by angels. 3. The fall of the temple of Apollo at the prayer of St. George, who is kneeling in front. 4. St. George is beheaded outside the city : the executioner stands beside him with his sword raised ; the saint kneels with his hands joined, and with a mild, resigned expression. In all these compositions St. George is represented bearded, as a man in the prime of life, and not as a youth.

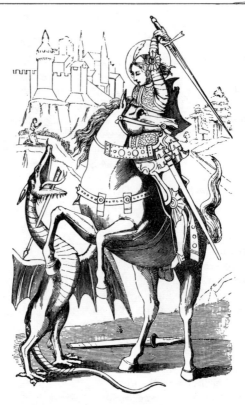

103          St. George   (Carlo Crivelli).

The history of St. George as patron of Venice, as victor, not as martyr, has been painted by Vittore Carpaccio in three beautiful pictures.—1. The combat with the dragon.   2. He is received by the king and people in triumph.   3. The conversion and baptism of the king and his court: the most conspicuous figure is that of the princess, who, with her long golden hair flowing over her shoulders, her hands joined, and with a most lovely expression, kneels to receive baptism from her pious and chivalrous deliverer.[1]

[1] Venice.   Church of St. Giorgio de' Schiavoni.

Of the martyrdom of St. George, as a separate subject, there are several fine examples, but I do not know any of very early date. The leading idea is in all the same : he kneels, and an executioner prepares to strike off his head with a sword. In the Church of San Giorgio, at Verona, I saw over the high altar this subject by Paul Veronese, treated in his usual gorgeous style : St. George, stripped to the waist, kneels to receive the blow ; a monk stands at his side (we are left to wonder how he got there) ; the Virgin in glory, with St. Peter and St. Paul, and a host of angels, appear in the opening heavens above.[1] The composition by Rubens, painted for the chapel of St. George de Lière, near Antwerp, is very fine and full of character. In the composition of Vandyck, he is represented as sacrificed to an idol. The drawing is, I think, in the collection of Sir Robert Peel.

St. George and the dragon, and his martyrdom, are the usual subjects in the many churches dedicated to this saint.

His church at Rome, at the foot of the Palatine, called, from its situation, San Giorgio-in-Velabro, was built by Leo II. in 682. In a casket under the altar is preserved, as a precious relic, a fragment of his banner ; and on the vault of the apsis is an ancient painting, the copy of a more ancient mosaic, which once existed there. In the centre stands the Redeemer between the Virgin and St. Peter; on one side, St. George on horseback, with his palm as martyr, and his standard as the ' Red-Cross Knight;' on the other side, St. Sebastian standing, bearded, and with one long arrow. From the time that these two saints were united in the popular fancy as martyrs and warriors, they are most frequently found in companionship, particularly in the Italian works of art. In the French pictures and Gothic sculpture, St. George does not often appear, and then usually in companionship with St. Maurice or St. Victor, who are likewise military saints. In the German pictures he is often accompanied by St. Florian.

---

[1] In the same church is a series of pictures from the martyrdom of the tutelar saint, *copiosissimi di figure delle più varie, delle più spiritose, delle più terribili ne' carnefici che mai vedessi.* Lanzi, iii. p. 110.

## St. Sebastian.

*Lat.* Sanctus Sebastianus. *Ital.* San Sebastiano ; or San Bastiano. *Fr.* St. Sébastien.
Patron saint against plague and pestilence.   January 20. A.D. 288.

THE story of St. Sebastian is of great beauty and great antiquity; it
has also the rare merit of being better authenticated in the leading
incidents, and less mixed up with incredible and fictitious matter,
than most of the antique legends.

He was a native of Narbonne, in Gaul, the son of noble parents, who
had held high offices in the empire.   He was himself at an early age
promoted to the command of a company in the Prætorian Guards, so
that he was always near the person of the emperor, and held in especial
favour.   At this time he was secretly a Christian, but his faith only
rendered him more loyal to his masters ; more faithful in all his engage-
ments; more mild, more charitable; while his favour with his prince,
and his popularity with the troops, enabled him to protect those who
were persecuted for Christ's sake, and to convert many to the truth.

Among his friends were two young men of noble family, soldiers
like himself; their names were Marcus and Marcellinus.   Being
convicted of being Christians, they were condemned to the torture,
which they endured with unshaken firmness, and were afterwards
led forth to death; but their aged father and mother threw them-
selves in the way, and their wives and children gathered around
them, beseeching them with tears and supplications to recant, and
save themselves, even for the sake of those who loved and could not
survive them.   The two young heroes, who had endured tortures
without shrinking, began to relent and to tremble; but at this criti-
cal moment St. Sebastian, neglecting his own safety, rushed forward,
and, by his exhortations, encouraged them rather to die than to re-
nounce their Redeemer; and such was the power of his eloquence,
that not only were his friends strengthened and confirmed in
their faith, but all those who were present were converted : the family
of the condemned, the guards, and even the judge himself, yield-
ing to the irresistible force of his arguments, were secretly baptized.
Marcus and Marcellinus were for this time saved ; but in a few months

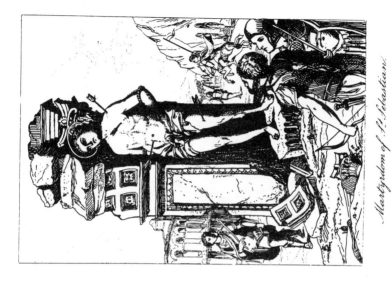

Martyrdom of S. Sebastian.

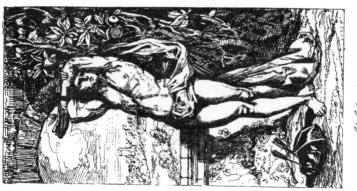

S. Sebastian.

afterwards they were denounced with the whole Christian community, and put to death; they died together, singing with a loud voice, 'Behold, how goodly and gracious a thing it is, brothers, to dwell together in amity;' and the other converts were put to cruel deaths. At length it came to the turn of Sebastian.

But previously the emperor, who loved him, sent for him and remonstrated with him, saying, 'Have I not always honoured thee above the rest of my officers? Why hast thou disobeyed my commands, and insulted my gods?' To which Sebastian replied, with equal meekness and courage, 'O Cæsar, I have ever prayed, in the name of Jesus Christ, for thy prosperity, and have been true to thy service; but as for the gods whom thou wouldst have me worship, they are devils, or, at best, idols of wood and stone.'

Then Diocletian ordered that he should be bound to a stake and shot to death with arrows; and that it should be inscribed on the stake and published to the troops that he suffered for being a Christian, and not for any other fault. And Sebastian having been pierced with many arrows, the archers left him for dead; but in the middle of the night, Irene, the widow of one of his martyred friends, came with her attendants to take his body away, that she might bury it honourably; and it was found that none of the arrows had pierced him in a vital part, and that he yet breathed. So they carried him to her house, and his wounds were dressed; and the pious widow tended him night and day, until he had wholly recovered.

When his Christian friends came around him, they counselled him to fly from Rome, knowing that if he were once discovered there would be no mercy shown to him. But Sebastian felt that this was not a time to hide himself, but to stand forth boldly and openly for the faith he professed; and he went to the palace and stood before the gate, on the steps which he knew the emperor must descend on his way to the Capitol; and he raised his voice, pleading for those who were condemned to suffer, and reproaching the emperor with his intolerance and cruelty; and the emperor, looking on him with amazement, said, 'Art thou not Sebastian?' And he replied, 'I am Sebastian, whom God hath delivered from thy hand, that I might testify to the faith of Jesus Christ and plead for his servants.' Then Diocletian in his fury commanded that they should seize

Sebastian and carry him to the Circus, and beat him to death with clubs; and, that his body might be for ever hidden from his friends, it was thrown into the Cloaca Maxima. But these precautions were in vain, for a Christian lady, named Lucina, found means to recover the body of the saint, and interred it secretly in the catacombs, at the feet of St. Peter and St. Paul.

It is probably from the association of the arrows with his form and story, that St. Sebastian has been regarded from the first ages of Christianity as the protecting saint against plague and pestilence. Arrows have been from all antiquity the emblem of pestilence; Apollo was the deity who inflicted plague, therefore was invoked with prayer and sacrifice against it: and to the honours of Apollo, in this particular character, St. Sebastian has succeeded. It is in this character that numerous churches have been dedicated to him; for according to the legendary traditions there is scarcely a city of Europe that has not been saved by the intercession of St. Sebastian.

His church at Rome, built over that part of the catacombs called the cemetery of Calixtus, is one of the seven Basilicas, and stands about two miles from the city on the Via Appia, outside the gate of San Sebastiano. All traces of the ancient church have disappeared, having been rebuilt in 1611. Under the high altar, is the recumbent statue of the saint. The almost colossal form lies dead, the head resting on his helmet and armour. It is evidently modelled from nature, and is, perhaps, the finest thing ever designed by Bernini : the execution was entrusted to his pupil. There is a fine cast in the Crystal Palace.

The most interesting, though certainly not the most beautiful, effigy of St. Sebastian existing at Rome is a very ancient mosaic, preserved in the church of San Pietro-in-Vincoli, and supposed to have been executed in 683. Nothing can be more unlike the modern conception of the aspect and character of this favourite saint. It represents him as a bearded warrior, in the Roman habit, wearing the cuirass, and over it the long garment or toga; in his hand what seems to be the crown of martyrdom. On a marble tablet, on one side of the effigy, is the following inscription in Latin; I give the translation from Mr. Percy's ' Rome and Romanism : '—

'To St. Sebastian, Martyr, dispeller of the pestilence. In the year of salvation 680, a pernicious and severe pestilence invaded the city of Rome. It was of three months' duration, July, August, and September. Such was the multitude of the dead, that, on the same bier, parents and children, husbands and wives, with brothers and sisters, were borne out to burial places, which, everywhere filled with bodies, hardly sufficed. In addition to this, nocturnal miracles alarmed them ; for two angels, one good and the other evil, went through the city; and this last bearing a rod in his hand, as many times as he struck the doors so many mortals fell in those houses. The disease spread for a length of time, until it was announced to a holy man that there would be an end of the calamity, if, in the church of S. Peter ad Vincula, an altar should be consecrated to Sebastian the Martyr; which thing being done immediately, the pestilence, as if driven back by hand, was commanded to cease.'

This was just a hundred years after the famous plague of the time of Gregory the Great. From this time, the end of the seventh century, St. Sebastian has been accepted as the universal patron against the plague.

He is especially popular as a subject of Art all down the Eastern coast of Italy, in consequence of the prevalence of plague in those districts; sometimes he is represented with his robe outspread, and protecting the people beneath from showers of arrows ; sometimes as interceding at the feet of the Virgin, who at his entreaty commands the destroying angel to sheathe his sword.

The more modern devotional figures of St. Sebastian rarely exhibit him in any other character than that of the martyr: even as patron saint the leading idea is still the same, for the arrows by which he is tranfixed symbolise also the shafts of the pestilence ; and they are the attribute not merely of the suffering and death of the martyr, but of the power of the saint. He is a beautiful Apollo-like figure, in the bloom of youth, undraped, bound to a tree or a column, and pierced by one or several arrows. He is looking up to heaven with an expression of enthusiastic faith or mild resignation, while an angel descends from above with the crown and palm. The variations are merely those of attitude and detail; sometimes his armour is seen lying at his feet; sometimes he is not pierced by the arrows, only bound, and the arrows are lying at the foot of the tree. In the old pictures the background is frequently a court or hall of the imperial palace ; in all the modern pictures the background is landscape—the garden on the Palatine Hill, where, according to tradition, the scene took place. Sometimes soldiers or archers are seen in the distance. Though generally young, he is not

*always* so. Albert Dürer and the Germans give him a respectable beard. Domenichino has also represented him as a man about thirty, copying in this the ancient mosaic in San Pietro-in-Vincoli.

In the pictures of the throned Madonna, St. Sebastian is frequently introduced, standing on one side, arrow-pierced, with his hands bound behind him, and looking up to heaven. In some later pictures we see him kneeling, and presenting to the Virgin the arrows with which he is pierced; or he is in armour, and merely holds an arrow in his hand.

In general the most ancient pictures and prints of this subject are not agreeable, from the stiff and defective drawing; and in the modern schools, when it became a favourite vehicle for the exhibition of elegant forms and fine anatomical modelling, it was too obviously a display of *art*. We must seek, therefore, for the most beautiful St. Sebastians in those works which date between the two extremes; and accordingly we find them in the pictures of Perugino, Francia, Luini, and the old Venetian painters. I could not point to a more charming example of this treatment than the Francia in our National Gallery, nor to a more perfect specimen of the *savoir-faire* school than the Guido in the Dulwich Gallery. The St. Sebastian, as is well known, was Guido's favourite subject; he painted at least seven. Another instance of this kind of ostentatious sentiment in style is the Carlo Dolce in the Corsini Palace at Florence.

The display of beautiful form, permitted and even consecrated by devotion, is so rare in Christian representations, that we cannot wonder at the avidity with which this subject was seized on, as soon as the first difficulties of art were overcome, nor at the multiplicity of examples we find in the later schools, particularly the Venetian and Bolognese. It would take pages to enumerate even a few of these; but I must direct attention to some examples of very beautiful or very peculiar treatment.

1. B. Luini. A beautiful figure bound to a tree, from amid the boughs of which an angel looks down upon him. The expression of the head is not that of enthusiastic faith, but of mild devout resignation.[1]

2. Beltraffio. Bound to a tree, he is wounded, but not transfixed, by the arrows. He is looking down,—not up, as is usual; with long curling hair, and a charming expression of benignity and gentleness.[2]

---

[1] Certosa, Pavia.

[2] The portrait, I believe, of Salaino, himself a painter, whom Vasari styles ' *vaghissimo di*

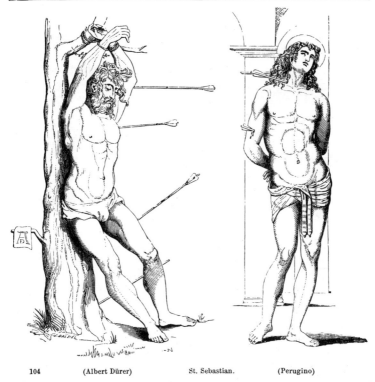

104　　　(Albert Dürer)　　　St. Sebastian.　　　(Perugino)

3. Perugino.　The saint, in red drapery, holds in one hand the palm, in the other three arrows.[1]—Another, in which he is standing undraped, except that around his loins there is an embroidered scarf; his hands are bound behind him; he is transfixed by three arrows, and looking up with the usual enthusiastic expression; his long hair floating in curls upon his shoulders.[2]—Another, in which he kneels before the Virgin; in red drapery, transfixed by a single arrow.[3]

4. Matteo di Siena.　He stands on one side of the Madonna, covered

*grazia e di bellezza,*' and whose beautiful face and curling hair (*capelli ricci e inanellati*) continually appear in the pictures of Lionardo and his school.—(Louvre.)

[1] Perugia, San Pietro.　　　[2] Florence Gal.　　　[3] Perugia, St. Agostino.

with wounds, but not transfixed by arrows.  In one hand a single arrow and a palm, in the other a martyr's crown.  The head extremely fine.[1]

5. A. Mantegna.  He is bound to a pillar near a ruined triumphal arch.[2]  The *ruined* arch and the ruined temples, sometimes strewed round St. Sebastian, may signify the destruction of the heathen powers; otherwise, and in the historical representations, it is an anachronism:—the Palatine was still in all its glory when Sebastian suffered.

6. Giorgione.  He is standing, bound to an orange tree, with his arms bound above his head; the dark eyes raised towards heaven.  His helmet and armour lie at his feet; his military mantle of green, embroidered with gold, is thrown round him.  This picture, with the deep blue sky and the deep green foliage, struck me as one of the most solemn effects ever produced by feeling and colour.  He is neither wounded nor transpierced.[3]

7. Titian.  Bound to a tree; head declined, and the long hair falling partly over the face; very fine and pathetic.[4]  It is the same figure which appears in the celebrated altar-piece dedicated by Averoldo in the church of SS. Nazaro and Celso at Brescia.

8. Razzi.  He is bound to a tree, pierced by three arrows, looking up to heaven with an expression perfectly divine.  This picture was formerly used as a standard, and carried in procession when the city was afflicted by pestilence:—to my feeling it is the most beautiful example of the subject I have seen.[5]

9. Liberale da Verona.  Here also he is bound to the stem of an orange tree; pierced with several arrows.[6]

10. Baroccio.  He is here fully draped, and holds two arrows in each hand, presenting them to the Virgin.

11. Hernando Yanez.  The saint standing with a lily near him; the lily is unusual.[7]

There are a great many fine examples in the Bologna and Flemish schools, in which I have found almost invariably the usual *motif*, combined in general with great beauty of execution.

---

[1] Acad. Siena.                         [2] Vienna Gal.

[3] On seeing this fine picture nearer in 1855, I am convinced that it is not by Giorgione, or has been mercilessly *cleaned.*—(Milan, Brera.)

[4] Lichtenstein Gal. Vienna.     [5] Fl. Acad.     [6] Berlin Gal.     [7] Louvre.  Sp. Gal.

12. Martin Schoen. In a rare print; St. Sebastian, suspended against the trunk of a tree, is transfixed by six arrows. The figure is illdrawn and emaciated; but the expression in the head, declined and sickening into death, very pathetic and beautiful. It is seldom that he is represented as dying or fainting.

13. Some old representations of St. Sebastian, from the German and Spanish schools, are very curious. There was a small picture, by Villegas, in the collection of Louis-Philippe, in which St. Sebastian wears the rich costume of the sixteenth century,—an embroidered vest, a hat and feather; an arrow in his breast; in one hand a bow, and in the other a crucifix. I have seen also a German drawing, in which St. Sebastian is dressed like a German cavalier, wearing a cap, a doublet, and an embroidered cloak; one hand on his sword, the other resting on his shield (which bears croslets and arrowheads as the device); and pierced by three arrows, one of which has passed through his cheek : the expression of the youthful, almost boyish, face very beautiful. (105)

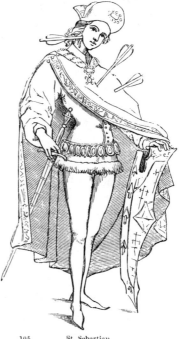

105    St. Sebastian.

14. He wears a full suit of black armour, over which is thrown a red mantle. In one hand he holds two arrows, in the other a cross.[1]

15. In a picture by Raffaelino del Garbo,[2] St. Sebastian wears a blue vest, elegantly embroidered with gold, black hose, and a crimson mantle.

St. Sebastian has afforded an admirable subject for Christian sculpture.

---

[1] In the Hotel de Cluny, Paris.

[2] Berlin Gal. 98.

1. By Matteo Civitale, there is a statue in white marble, in which he is bound to the trunk of a tree, pierced with several arrows. This statue, in spite of sundry faults of design, struck me by the beauty of the attitude and the beauty of expression. It is celebrated as being the first undraped statue of a male adult figure that had been produced since the revival of Art. The arrows are of metal, gilt.[1]

2. The statue by Puget in the church of Carignano at Genoa is also celebrated. It is colossal, and represents him transfixed, with his armour at his feet; there is a good deal of expression, but a total want of simplicity.

3. The statue in his church at Rome has been already mentioned.

St. Sebastian is everywhere popular,[2] but more particularly in those countries and districts which were most exposed to the plague. For instance, all down the east coast of Italy, from Venice to Bari, St. Sebastian is constantly met with. In the more ancient pictures his usual pendant is either St. George or St. Nicholas; in the more modern pictures St. Roch: very often the healing saints St. Cosmo and St. Damian. Wherever these are grouped together, or round the Virgin and Child, the picture has been dedicated against the plague.

Some of these votive pictures have a very pathetic significance, when we consider them as commemorating the terrible visitations of pestilence which occasionally desolated the south of Europe. I will give one or two examples.

1. The Madonna di Misericordia[3] is seen in the midst with her robes outspread, beneath which are gathered the afflicted votaries. Above, the *Padre Eterno* looks down from heaven. On the left of the Virgin St. Sebastian, his hands bound and his whole body stuck full of arrows, looks up with a pleading expression. The votaries present to him a

[1] About 1470. Duomo, Lucca.

[2] In England his effigies are not uncommon, and there are two churches dedicated to his honour, that of Gonerby in Lincolnshire, and Woodbastwich in Norfolk. (See Parker's ' Calendar of the Anglican Church,' p. 284.) He has, however, been banished from the English Calendar, in which many saints more apocryphal and less deserving still keep their place.

[3] See Legends of the Madonna, p. 32.

prayer or petition, which he is supposed to repeat to the Virgin, through whom it reaches the Supreme Being, at whose command St. Michael, the Angel of Judgment, utters the word FIAT, and sheathes his sword.[1]

2. The following example is also very expressive. St. Sebastian, in a rich military costume of blue, embroidered with gold, stands as patron: his large cloak, spread open and sustained by angels, intercepts and shelters his votaries from the plague-arrows, which fall thickly on its folds as they are shot from above.[2]

Scenes from the life of St. Sebastian are confined to a few subjects, which have been frequently treated.

Paul Veronese's 'St. Sebastian exhorting and encouraging Marcus and Marcellinus, as they are led to death,' in the church of S. Sebastiano at Venice, appeared to me, when I saw it last, one of the finest *dramatic* pictures I had ever beheld, and preferable to every other work of the master. Here St. Sebastian stands on the summit of a flight of steps; his fine martial figure, in complete armour, is relieved against the blue sky; he waves a banner in his hand, and his whole air and expression are full of inspired faith and enthusiasm; Marcus and Marcellinus stand by his side as if irresolute, surrounded by their weeping friends. It struck me as a magnificent scene played before me—with such a glow of light and life and movement and colour shed over it—such a triumphant enthusiasm in the martyrs—such variety of passionate energy and supplication and sympathy in the groups of relatives and spectators, that I felt as if in a theatre, looking at a well-played scene in a religious melodrama, and inclined to clap my hands and cry 'Bravo!'

In curious contrast with this splendid composition, I remember a little old picture, in which St. Sebastian is calmly exhorting his friends to die, their mother alone kneeling in supplication; very stiff and dry, but the heads full of simple expression.[3]

---

[1] This curious votive fresco is in a small chapel at Perugia.

[2] This votive fresco was painted by Benozzo Gozzoli in the church of S. Agostino at San Gemignano, and commemorates the disastrous plague of 1464.

[3] N. Semitecolo, A.D. 1367. Padua.

Of the scene in which St. Sebastian confronts the emperor on the steps of his palace, and pleads for the persecuted Christians, I have never seen any picture; yet painting could hardly desire a finer subject.

The Martyrdom of St. Sebastian (for that is the name given to the scene in which he is shot with arrows) should be distinguished from those devotional figures which represent the saint as *martyr*, but not the act of martyrdom. His martyrdom, as an historical scene, is a subject of frequent occurrence, and in every variety of treatment, from three or four figures to thirty or forty. When the scene is supposed to be the garden on the Palatine Hill, he is bound to a tree (in one instance, as I remember, to an orange tree); if the scene be the hall or court, he is bound to a pillar; and the inscription, ' *Sebastianus Christianus*,' is sometimes affixed.

1. The scene is a garden on the Palatine Hill. St. Sebastian is bound on high amid the branches of a tree. Eight soldiers are shooting at him with cross-bows. Above, the sky opens in glory, and two angels hold over his head the crown of martyrdom. Admirable for the picturesque and dramatic treatment.[1]

2. Pollajuolo. The masterpiece of the painter. He is bound high up to the stump of a tree; six executioners with cross-bows, and other figures in strained and difficult attitudes. St. Sebastian is the portrait of Ludovico Capponi.[2]

3. Pinturicchio. He is bound to a broken pillar; another broken column is near him. There are six executioners with bows and arrows, and a man with a kind of mitre on his head is commanding the execution. In the background the Coliseum.[3]

4. In contrast with this representation I will mention that of Vandyck, one of his finest pictures. St. Sebastian is bound to a tree, but not yet pierced : he appears to be preparing for his fate ; with eyes raised to heaven, he seems to pray for strength to endure. The youthful undraped figure is placed in full light; admirable for the faultless drawing and the noble expression. There are several soldiers ; and a centurion, mounted on a white horse, appears to direct the execution.[4]

[1] Fl. Gal.  Painter unknown.    [2] Florence.  Capella dei Pucci.
[3] Vatican.    [4] Munich Gal.

5. Palma. Two executioners bind St. Sebastian to a tree; soldiers are seen approaching with their bows and arrows; a cherub hovers above with the crown and the palm.[1]

6. G. da Santa Croce. St. Sebastian is bound to a pillar, and prepares for death. The emperor on his throne and a number of spectators.[2]

7. The only celebrated St. Sebastian of the Spanish school which I can refer to, is a martyrdom by Sebastian Muñoz, who appears to have painted his patron saint with equal love and power.[3]

8. But the most celebrated example of all is the large picture by Domenichino, in the church of S. Maria degli Angeli at Rome. Here the event is a grand dramatic scene, in which the attention is divided between the sufferings and resignation of the martyr, the ferocity of the executioners, and the various emotions of the spectators; there are about thirty-five figures, and the locality is a garden or land-scape. The mosaic is in St. Peter's.

It is a great mistake, bespeaking the ignorance or careless-ness of the painter, when in the representations of the martyred St. Sebastian an arrow is through his head (as in a composition by Tintoretto, and another by Albert Dürer), for such a wound must have been instantly mortal, and his recovery is always related as having taken place through natural and not through miraculous agency.

St. Sebastian recalled to life after his martyrdom, is a beautiful subject. It is treated in two different ways: sometimes he is droop-ing in apparent death, one arm yet bound to the tree, while pitying angels draw the arrows from his wounds. It has been thus repre-sented by Procaccino; by Vandyck in a beautiful picture now at St. Petersburg; and when conceived in a true religious spirit must be considered as strictly devotional: but I have seen some examples which rather suggested the idea of an Adonis bewept by Cupids, as in a picture by Alessandro Veronese.[4] The ministering angels in this and similar scenes ought never to be infant angels.

[1] Eng. by Sadeler.    [2] A.D. 1520. Berlin Gal.

[3] It is now in the Madrid Gallery. Mr. Stirling mentions it with admiration, but does not describe the picture. There are few good representations of St. Sebastian in Spanish art, perhaps because the rigid ecclesiastical supervision forbade the undraped figure.

[4] Louvre, No. 851.

Another manner of treating this subject is more dramatic than
ideal: St. Sebastian lies on the ground at the foot of a tree, insen-
sible from his wounds; Irene and her maid minister to him; one un-
binds him from the tree, the other extracts the arrows: sometimes
Irene is attended by a physician.   The subject has been thus treated
by Correggio, by Padovanino, and others; but I have never seen
any example which satisfied me either in sentiment or execution.

In the legend of St. Sebastian I find no account of his being tor-
tured previous to his last martyrdom; but I have seen a large Italian
print[1] in which he is bound on the rack—his armour lies near him;
a Pagan priest is seen exhorting him to renounce his faith; and
there are numerous other figures, dogs, &c., introduced.[2]

The death of St. Sebastian, his second martyrdom, was painted
by P. Veronese in his church.   Unfortunately for this picture, it
hangs opposite to the incomparable Marcus and Marcellinus already
described, to which it is much inferior; it therefore receives little
attention, and less than justice.

St. Sebastian is the favoured saint of the Italian women, and
more particularly of the Roman women.   His youth, courage, and
beauty of person, the interest of his story, in which the charity of
women plays such an important part, and the attractive character
of the representation, have led to this preference.   Instances are
recorded of the figure of St. Sebastian producing the same effect on
an excitable southern fancy that the statue of the Apollo produced on
the 'Girl of Provence'—a devotion ending in passion, madness,
and death.

From the fourteenth century the pendant of St. Sebastian in
devotional pictures is generally St. Roch, of whom we are now to
speak.

---

[1] By Caraglio.   Described in Bartsch, *Peintre Graveur*, xix. 282.   See also in the same
work, xx. p. 201.

[2] I conceive it to be an example of ignorance in the artist, if, indeed, it be intended for
a St. Sebastian.

## St. Roch.

*Lat.* Sanctus Rochus. *Ital.* San Rocco. *Fr.* St. Roch, or Roque. Patron saint of those who languish in prison ; of the sick in hospitals; and particularly of those who are stricken by the plague. August 16, A.D. 1327.

THE legend of St. Roch is comparatively modern; the main facts, happily, are not incredible, and tolerably authentic; and in the decorative incidents there is even more of the pathetic than the wonderful. It appealed strongly to the sympathies of the people; it gave them a new patron and intercessor against that scourge of the middle ages, the plague; and as it became extensively known and popular just at the time of the revival of Art, it has followed that the effigy of this beneficent saint is one of those most frequently met with throughout the whole of Western Christendom : in Greek Art it is unknown.

' St. Roch was born at Montpelier, in Languedoc, the son of noble parents.[1] His father's name was John; he came into the world with a small red cross marked upon his breast; and his mother Libera, regarding him, therefore, as one consecrated even from his birth to a life of sanctity, watched over his education with peculiar care. The boy himself, as he grew up, was impressed with the same idea, and in all things acted as one called to the service of God; but with him this enthusiasm did not take the usual form—that of religious vows, or of an existence spent in cloistered solitude;—his desire was to imitate the active virtues of the Redeemer, while treading humbly in his footsteps in regard to the purity and austerity of his life.

' The death of his father and mother, before he was twenty, placed him in possession of vast riches in money and land : he began by following literally the counsel of our Saviour to the young man who asked, " What shall I do to be saved ? " He sold all that the law enabled him to dispose of, and distributed the proceeds to the poor and to the hospitals. Then, leaving the administration of his lands to his father's brother, he put on the dress of a pilgrim, and journeyed on foot

---

[1] Some authors place the date of his birth in 1280, others in 1295.

towards Rome.   When he arrived at Aquapendente, the plague was
raging in the town and the neighbourhood, and the sick and the
dying encumbered the streets.   St. Roch went to the hospital, and
offered to assist in tending the inmates; he was accepted; and such
was the efficacy of his treatment, and his tender sympathy, that, as
it was commonly said, a blessing more than human waited on his
ministry ; and the sick were healed merely by his prayers, or merely
by the sign of the cross, as he stood over them : and when the plague
ceased shortly afterwards, they, in the enthusiasm of their gratitude,
imputed it solely to the intercession of this benign being, who, with
his youth, his gentleness, and his fearless devotion, appeared to them
little less than an angel.'

That St. Roch himself, struck by the success of his ministry,
should have believed that a peculiar blessing rested on his efforts, is
not surprising, when we consider the prevalent belief in miracles and
miraculous influences throughout the thirteenth century.   Hearing
that the plague was desolating the province of Romagna, he hastened
thither, and, in the cities of Cesena and Rimini, devoted himself to
the service of the sick.   Thence he went to Rome, where a fearful
pestilence had broken out, and spent three years in the same chari-
table ministry, always devoting himself to those who were most
miserable and apparently abandoned by all other help.   His inces-
sant prayer to God was, that he might be found worthy to die as a
martyr in the exercise of the duties he had voluntarily taken on
himself; but for a long time his prayer was not heard; it seemed
as if an unseen power shielded his life in the midst of the perils to
which he was daily and hourly exposed.

' Thus some years passed away.   He travelled from city to city :
wherever he heard that there was pestilence and misery prevailing,
there was he found; and everywhere a blessing waited on his presence.
At length he came to the city of Piacenza, where an epidemic of a
frightful and unknown kind had broken out amongst the people : he
presented himself, as usual, to assist in the hospital; but here it
pleased God to put him even to that trial for which he had so often
prayed—to subject him to the same suffering and affliction which he
had so often alleviated, and make him in his turn dependent on the
charity of others for aid and for sympathy.

'One night, being in the hospital, he sank down on the ground, overpowered by fatigue and want of sleep: on awaking, he found himself plague-stricken; a fever burned in every limb, and a horrible ulcer had broken out in his left thigh. The pain was so insupportable that it obliged him to shriek aloud: fearing to disturb the inmates of the hospital, he crawled into the street; but here the officers of the city would not allow him to remain, lest he should spread infection round. He yielded meekly; and, supported only by his pilgrim's staff, dragged himself to a wood or wilderness outside the gates of Piacenza, and there laid himself down, as he thought, to die.

'But God did not forsake him; far from all human help, all human sympathy, he was watched over and cared for. He had a little dog, which in all his pilgrimage had faithfully attended him; this dog every day went to the city, and came back at evening with a loaf of bread in his mouth, though where he obtained it none could tell. Moreover, as the legend relates, an angel from heaven came and dressed his wound, and comforted him, and ministered to him in his solitude, until he was healed; but others, less believing, say it was a man of that country whose name was Gothard, who on this occasion acted the part of a good angel towards him. However this may be, St. Roch, rejoicing that he had been found worthy to suffer in the cause of charity, which is truly the cause of Christ our Redeemer, went on his way as soon as he had strength to travel, and bent his steps towards his own home and country; and being arrived at a little village near Montpelier, which was in fact his own, and the people his hereditary vassals, he was so changed by long suffering, so wasted and haggard, that they did not know him. The whole country being at that time full of suspicion and danger, because of hostilities and insurrections, he was arrested as a spy, and carried before the judge of Montpelier; the judge, who was no other than his own uncle, looked upon him without knowing him, and ordered him to be carried to the public prison. St. Roch, believing that such an affliction could only be laid upon him by the hand of God, with the intent to try him further, held his peace, and instead of revealing himself, yielded meekly to the unjust sentence, and was shut up in a dungeon. Here, having no one to plead for him, and being resolved to leave his cause in the hands of God, and to endure patiently all

that was inflicted, he languished for five years. At the end of that time, as the jailer entered his cell one morning, to bring the usual pittance of bread and water, he was astonished and dazzled by a bright supernatural light, which filled the dungeon; he found the poor prisoner dead, and by his side a writing which revealed his name, and containing, moreover, these words :—" All those who are stricken by the plague, and who pray for aid through the merits and intercession of Roch, the servant of God, shall be healed." When this writing was carried to his uncle the judge, he was seized with grief and remorse, and wept exceedingly, and caused his nephew to be buried honourably, amid the tears and prayers of the whole city.'

The death of St. Roch is usually placed in the year 1327, when he was in his thirty-second year. The people of Montpelier and the neighbourhood regarded his memory with the utmost devotion; but for nearly a hundred years afterwards we do not hear of St. Roch as an object of general veneration in Christendom. In the year 1414, when a council of the Church was held at Constance (the same which condemned Huss), the plague broke out in the city, and the prelates were about to separate and to fly from the danger. Then a young German monk, who had travelled in France, reminded them that there was a saint of that country, through whose merits many had been redeemed from the plague. The council, following his advice, ordered the effigy of St. Roch to be carried in procession through the streets, accompanied by prayers and litanies; and immediately the plague ceased. Such is the tradition to which St. Roch owes his universal fame as a patron saint. In the year 1485 the Venetians, who from their commerce with the Levant were continually exposed to the visitation of the plague, resolved to possess themselves of the relics of St. Roch. A kind of holy alliance was formed to commit this pious robbery. The conspirators sailed to Montpelier under pretence of performing a pilgrimage, and carried off the body of the saint, with which they returned to Venice, and were received by the doge, the senate, and the clergy, and all the people, with inexpressible joy.[1] The magnificent church of St. Roch

1 Baillet, Vie de St. Roch. The Venetian account is slightly varied : In 1485, 'un monaco Camaldolese fu tanto felice da poter rapire il corpo di S. Rocco, ch' era con somma gelosia custodito in Ugheria, Castello nel Milanese, e portarlo a Venezia.' —*Origine delle Feste Veneziane di Giustina Renier Michiel.*

was built to receive the precious relics of the saint, by a community already formed under his auspices for the purpose of tending the sick and poor, and particularly those who were stricken by infectious disorders, in which many of the chief nobility were proud to enrol themselves. Such was the origin of the famous *Scuola di San Rocca* at Venice, on the decoration of which Tintoretto and his scholars lavished their utmost skill.

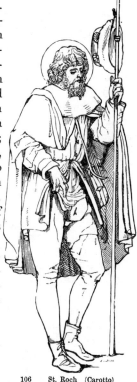

106    St. Roch   (Carotto)

In devotional pictures the figure of St. Roch is easily distinguished. He is represented as a man in the prime of life, with a small beard, delicate and somewhat emaciated features, and a refined and compassionate expression. Those pictures which represent him as a robust coarse-featured man must be considered as mistaken in point of character. He is habited as a pilgrim, with the cockle-shell in his hat; the wallet at his side; in one hand the staff, while with the other he lifts his robe to show the plague-spot, or points to it. In general he is accompanied by his dog. This figure by Carotto will give an idea of the usual manner of treatment in dress and deportment (106).

1. One of the happiest and truest representations of St. Roch I ever saw, consistently with the idea we form of his character, is a figure in an old Florentine picture, I think by Gerino da Pistoia; St. Roch is here a thin pale young man, with light hair and small beard, and mild delicate features.[1]

2. St. Roch intercedes for Cardinal Alessandro d'Este (in a picture by Parmigiano). The cardinal kneels, with joined hands, and St. Roch, bending over him, with a benevolent air, lays his hand on his fur

[1] Florence Gal.

robe.   The dog is in the background.    This appears to have been a
votive picture, on the occasion of the cardinal being struck with ill-
ness, and healed at the intercession of St. Roch.   Such votive figures
of St. Roch are frequently met with in the chapels and churches de-
dicated to him, and more particularly in the hospitals, convents, and
other institutions of the Order of Charity.

3. St. Roch, very richly dressed, stands in the usual attitude, point-
ing to the plague-spot; a small but very fine picture by Garofalo in
the Belvedere Gallery at Vienna.

4. St. Roch with the Angel : a beautiful picture by Annibal Caracci,
in the Fitzwilliam Museum, Cambridge.

5. The great altar-piece painted by Rubens for the church at Alost
is strictly a devotional picture, though treated in the most dramatic
manner.   The upper part of the picture represents the interior of a
prison, illuminated by a supernatural light.   St. Roch, kneeling,
not as a suppliant, but with an expression of the most animated
gratitude, looks up in the face of Christ, and receives from him his
mission as patron saint against the plague.   An angel holds a tablet,
on which is inscribed ' Eris in peste patronus,' in allusion to the
writing found within his cell after his death.   The dog is near him.
In the lower part of the picture a group of the sick and the afflict-
ed (painted with all that power of expression which belonged to
Rubens) invoke the intercession of the charitable saint.   This pic-
ture has been erroneously described as St. Roch supplicating for those
smitten by the plague; the *motif* is altogether different.   Rubens
painted it in eight days for the confraternity of St. Roch; he de-
manded for his work 800 florins, which the agents for the charitable
brotherhood told down without making the slightest objection to the
price.   The painter, delighted with their generosity, presented to them
three smaller pictures to be placed beneath the altar-piece: in the
centre the crucifix: on one side St. Roch healed by the angel; on
the other the saint dying in prison.

The separate pictures of his life are confined to few subjects; the
most frequent of which are—his charity, and his ministration to the
sick.

1. Annibal Caracci.   St. Roch distributes his goods to the poor
before he sets out on his pilgrimage to Rome.   One of his most cele-

brated pictures, full of beautiful and pathetic expression. It was painted for a benevolent canon of Reggio, who presented it to the charitable brotherhood of St. Roch in his native city. Such pictures, whatever their merit as works of art, seem to me to lose much when transported from their original destination to the walls of a gallery.

2. Procaccino. St. Roch ministering to the sick. The patients are seen in beds in the background ; some are brought by their friends and laid at the feet of the saint.

3. Finer is a picture by Bassano, of which the intense and natural expression rivets the attention and melts the heart. Here the Virgin, a very majestic figure, stands alone in the sky above, interceding for the sufferers below. It is the finest and one of the largest pictures by Bassano I have ever seen.[1] Pictures of this subject are often met with; but perhaps the finest of all, at least the most effective, is that of Tintoretto ;—the variety of expression in the sufferers and spectators is wonderfully dramatic.[2]

(We must distinguish this scene in the life of St. Roch from a similar subject in the life of St. Charles Borromeo. St. Roch wears the habit of a pilgrim; St. Charles that of a bishop or cardinal.)

4. St. Roch in the desert is healed by an angel ; the dog is seen approaching with a loaf of bread in his mouth. The mild pathetic resignation and gratitude of the good saint, and the picturesque accompaniments, render this a very striking subject. The picture by Tintoretto is the finest example.

5. Guido. St. Roch in prison ; his dog at his side ; an angel from above comforts him. (At Modena. The same subject by Tintoretto at Venice.)

6. St. Roch dying in prison. He is extended on some straw, and his hands are folded in prayer. Sometimes he is alone ; but sometimes a jailer or attendant, entering the prison, looks at him with astonishment.

The statues of St. Roch exhibit him in the usual attitude, which, it must be confessed, is hardly fitted for sculpture ; yet some of these figures are very beautiful in sentiment, and make us forget the merely physical infliction in the sublime self-devotion.

---

[1] Milan, Brera, No. 53.    [2] Venice, Scuola di San Rocco.

The history of this saint, in a series of subjects, is often found in the churches and chapels dedicated to him : we have generally the following scenes :—1. He distributes his goods to the poor, called ' The Charity of St. Roch ' (*L' Elemosina di San Rocco*). 2. He ministers to the sick : the scene is generally a hospital. 3. St. Roch in the desert. He is prostrated by sickness, and points to an ulcer in his thigh. An angel and his dog are near him. 4. St. Roch standing before the Pope. 5. St. Roch in prison, visited by an angel. 6. His death.

In the upper hall of the Scuola di San Rocco, at Venice, where the brotherhood used to assemble, the tribune at the end is wainscoted by panels of oak, oh which the whole history of the saint is carved in relief in twenty subjects.[1]

Those works of art in which St. Sebastian and St. Roch figure in companionship as joint protectors against the plague are innumerable. The two beautiful figures by Francia, engraved by Marc' Antonio, are examples of simplicity and benign graceful feeling. The contrast between the enthusiastic martyr and the compassionate pilgrim ought always to be strongly marked, not merely in the attitude and habiliments, but in the whole character and expression.

There are two saints who are easily confounded with St. Roch—St. Omobuono and St. Alexis. The reader will do well to turn to their respective legends, where I have particularised the points of difference.

With St. Sebastian and St. Roch, we often find in significant companionship the medical brothers, St. Cosmo and St. Damian. The first two saints as patrons of the sick ; the last two as patrons of those who heal the sick.[2]

---

[1] They were executed about the middle of the last century by Giovanni Marchiori and his pupils ; the workmanship beautiful, but the designs in the mannered taste of the time.

[2] See Introduction, p. 22.

## St. Cosmo and St. Damian.

*Lat.* SS. Cosmus et Damianus. *Ital.* SS. Cosimo e Damiano, gli santi medici Arabi. *Fr.* SS. Côme et Damien. Patron saints of medicine and the medical profession. Patrons also of the Medici family ; and as such they figure on the coins of Florence. (Sept. 27, A.D. 301.)

' Cosmo and Damian were two brothers, Arabians by birth, but they dwelt in Ægæ, a city of Cilicia.[1] Their father having died while they were yet children, their pious mother, Theodora, brought them up with all diligence, and in the practice of every Christian virtue. Their charity was so great, that not only they lived in the greatest abstinence, distributing their goods to the infirm and poor, but they studied medicine and surgery, that they might be able to prescribe for the sick, and relieve the sufferings of the wounded and infirm ; and the blessing of God being on all their endeavours, they became the most learned and the most perfect physicians that the world had ever seen. They ministered to all who applied to them, whether rich or poor. Even to suffering animals they did not deny their aid, and they constantly refused all payment or recompense, exercising their art only for charity and for the love of God; and thus they spent their days. At length those wicked emperors, Diocletian and Maximian, came to the throne, in whose time so many saints perished. Among them were the physicians, Cosmo and Damian, who, professing themselves Christians, were seized by Lycias the proconsul of Arabia, and cast into prison. And first they were thrown into the sea, but an angel saved them ; and then into the fire, but the fire refused to consume them ; and then they were bound on two crosses and stoned, but of the stones flung at them, none reached them, but fell on those who threw them and many were killed. So the proconsul, believing that they were enchanters, commanded that they should be beheaded, which was done.'

This Oriental legend, which is of great antiquity, was transplanted into Western Europe in the first ages of Christianity. The Emperor Justinian, having been recovered, as he supposed, from a dangerous

[1] It is worth while to remark here, that in this city of Ægæ there was a temple of Æsculapius, famous for the miraculous cures wrought by the god, and destroyed by Constantine.

illness, by the intercession of these saints, erected a superb church in their honour. Among the Greeks they succeeded to the worship and attributes of Æsculapius; and, from their disinterested refusal of all pay or reward, they are distinguished by the honourable title of *Anargyres*, which signifies moneyless, or *without fees*.

One of the most interesting of the old Roman churches is that erected to the honour of these saints by Pope Felix IV. in 526. It stands in the Forum, near the temple of Antoninus and Faustina, on the site of the temple of Remus: the Greek mosaics in the apsis exhibit probably the most ancient representations of St. Cosmo and St. Damian which exist. In the centre is the figure of Christ holding a roll (i.e., the Gospel) in his hand, a majestic figure; on one side St. Peter presents St. Cosmo, on the other St. Paul presents St. Damian, to the Saviour. They are exactly alike, in loose white draperies, and holding crowns of offering in their hands; colossal, ghastly, rigid, and solemn, after the manner of the old mosaics, and of course wholly ideal. Nearly contemporary are the mosaics in the ancient church of San Michele at Ravenna, where the archangels Michael and Gabriel stand on each side of the Redeemer, and beyond them SS. Cosmo and Damian.

The representations of these benevolent brothers in later times are equally ideal, but more characteristic as personages.

In devotional pictures they are always represented together, attired in the habit of physicians, a loose dark red robe, trimmed with fur, and generally red caps. It is thus Chaucer describes the dress of a physician in his time—'In scarlet gown, furred well.'

They hold a little box of ointment in one hand, and a lancet or some surgical instrument in the other: sometimes it is a pestle and mortar. They occur frequently in the old Florentine pictures, particularly in those painted in the fifteenth century, in the time of Cosmo de' Medici. In several beautiful Madonna pictures in the Gallery of the Uffizii, and in the churches of Florence, they are grouped with other saints, from whom they are distinguished by their medical costume, and a certain expression of grave attention, rather than devotion, which gives them often the look of portraits.

The illustration is a sketch from a picture by Bicci di Lorenzo, in the Florence Gallery. They stand together, in red gowns and caps,

107    St. Cosmo and St. Damian    (Bicci di Lorenzo. A.D. 1418).

and red hose. This picture remained in the Duomo from the date
of its execution, 1418, till 1844, and is curious as having been
painted in the time of Giovanni de' Medici, the founder of the
greatness of the family.

It is as the patron saints of the Medici family that their statues,
designed by M. Angelo, stand on each side of the Madonna in the
Medici Chapel at Florence, where they are so overpowered by the
stupendous grandeur of the other statues, that few visitors look
at them, and fewer comprehend why they are there. They have no
attributes; and it must be allowed that, whatever be their artistic
merit, they are quite devoid of individual propriety of character.

VOL. II.                                                        G

These saints are very interesting when they occur in votive pictures, as significant of thanksgiving for restoration to health; they are generally presenting a votary to Christ or the Madonna. Where they are kneeling or standing in company with St. Sebastian and St. Roch, the picture commemorates some visitation of the plague or other epidemic disorder, as in 1. A most beautiful picture in the Academy of Siena: clothed in loose robes, they kneel in front before the Madonna; St. George and St. Sebastian on each side.[1] 2. And another, more beautiful, by Ghirlandajo, where St. John the Baptist, as patron of Florence, stands on one side, and Cosmo and Damian on the other. 3. Another, by Titian, in the Salute at Venice, where SS. Cosmo and Damian, with St. Roch and St. Sebastian, stand before the throne of St. Mark—commemorative of the great plague in 1512.[2] 4. And another, by Tintoretto; SS. Cosmo and Damian, in magnificent robes of crimson velvet with ermine capes, kneeling; one holds a palm, the other a pestle and mortar; they look up to the Madonna, who appears in a glory above with St. George, St. Mark, and St. Catherine, the patrons of Venice.[3]

5. SS. Cosmo and Damian kneeling in front before the throne of the Madonna. Standing by the throne, St. Mary Magdalene, St. Catherine, St. John B., and St. Francis.[4]

These are apparently votive pictures, expressing public or national gratitude; but others should seem to be the expression of private feeling. For example: SS. Cosmo and Damian are seated at a table, and consulting over a book; they wear loose robes, and red caps turned up with fur; the heads, which are very fine, have the air of portraits: a sick man, approaching from behind, reverently takes off his cap.[5]

While devotional pictures of these helpful and beneficent saints are extremely common, and varied in treatment, subjects from their life and history are very rare; they are most frequently met with in the

---

[1] Matteo di Siena, A.D. 1470.

[2] See the plate opposite page 22, vol. i. St. Mark, as patron of Venice, sits enthroned above, holding his Gospel; below, on the right, stand St. Roch and St. Sebastian as protectors, and on the left St. Cosmo and St. Damian, the medical saints, as healers. I have merely given the expressive group. No copy or description can do justice to the glow of life and colour in the picture.

[3] Venice Acad.　　　　[4] Fl. Acad.　　　　[5] Rome. Corsini Pal.

Florentine school of the fifteenth century, among the works of Angelico, Pesellino, and Ghirlandajo.

1. Old Italian.  SS. Cosmo and Damian, visiting the sick, minister to Christ in the disguise of a pilgrim ; a beautiful allegory, or rather a literal interpretation of the text, ' Inasmuch as ye have done it unto the least of these my brethren, ye have done it unto me.'  A quaint little picture, but very expressive.[1]

2. Pesellino.  The two brothers minister to a sick man.[2]

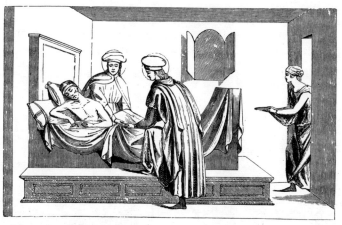

108            SS. Cosmo and Damian minister to the sick    (Pesellino. A.D. 1450).

They are sometimes surgeons as well as apothecaries, cutting off and replacing legs and arms ; and sometimes they are letting blood.

3. It is related that a certain man, who was afflicted with a cancer in his leg, went to perform his devotions in the church of St. Cosmo and St. Damian at Rome, and he prayed most earnestly that these beneficent saints would be pleased to aid him.  When he had prayed, a deep sleep fell upon him.  Then he beheld St. Cosmo and St. Damian, who stood beside him ; and one carried a box of oint-ment, the other a sharp knife.  And one said, ' What shall we do to replace this diseased leg when we have cut it off ? ' and the other replied, ' There is a Moor who has been buried just now in San

[1] Vatican.                    [2] Louvre.

Pietro in Vincole ; let us take his leg for the purpose.' Then they brought the leg of the dead man, and with it they replaced the leg of the sick man ; anointing it with celestial ointment, so that he remained whole.   When he awoke he almost doubted whether it could be himself ; but his neighbours, seeing that he was healed, looked into the tomb of the Moor, and found that there had been an exchange of legs: and thus the truth of this great miracle was proved to all beholders.[1]

Of this story I have seen some grotesque representations.   For example :—The sick man is lying on a bed, and St. Cosmo and St. Damian are busy affixing a black leg ; at a little distance on the ground lies the dead Moor, with a white leg lying beside him.[2]

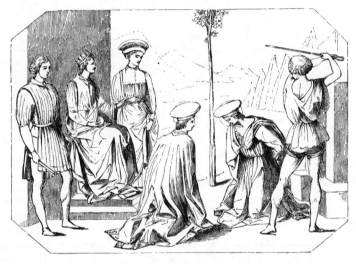

169       The Martyrdom of SS. Cosmo and Damian      (Pesellino).

4. In the scene of their martyrdom by Pesellino—a beautiful little picture—they are beheaded.   They wear the red tunics and red caps usual in Florentine representations.[3]

About the year 1439, Cosmo de' Medici commissioned Fra Angelico

---

[1] Legenda Aurea.            [2] Fl. Gal.            [3] Fl. Acad.

to paint the altar-piece which he presented to the Church of San Marco at Florence. Underneath the group of the Virgin and Child, Angelico represented the legendary history of the patron saints of the Medici family in nine beautiful little miniatures; at Munich are three pictures which I suppose to belong to this series, which formed the predella of the altar-piece. 1. St. Cosmo and St. Damian, with their brethren, are bound and thrown into the sea, but saved by angels. On the right the unjust judge, Lysias, is healed by the prayer of the martyrs. 2. St. Cosmo and St. Damian are nailed to two crosses, and their three brethren below are shot to death with stones and arrows. 3. The third picture, which formed the centre, is a Pietà, very poetically treated.[1] Sometimes in the scene of their martyrdom three other personages, their kinsmen, suffer with them. In other respects the legend as given above is, in all the examples I have seen, very exactly adhered to. These saints do not appear in the later schools. As, perhaps, a solitary instance, may be mentioned a picture by Salvator Rosa, where St. Cosmo and St. Damian on a pile of faggots are exposed to the flames, which refuse to consume them. I know the composition only from the engraving by Pierre Simon.

## St. Christopher.

*Lat.* St. Christophorus.    *Ital.* San Cristofero, or Cristofano.
*Fr.* St. Christophe, or St. Christofle.    *Ger.* Der Heilige Christoph.    (July 25, A.D. 364.)

Among the religious parables of the middle ages, there is not one more fanciful and more obvious in its application than the story of St. Christopher. But, although poetical and significant as a parable, it becomes as a mere legend prosaic and puerile : it is necessary to keep the latent meaning in view while we read the story, and when we look upon the extremely picturesque representations of the Canaanitish giant ; for, otherwise, the peculiar superstition which has rendered him so popular and so important as a subject of art will lose all its interest.

Christopher was of the land of Canaan, and the name by which he was there known was Offero. He was a man of colossal stature, and

---

[1] Munich. Pinnakothek. Cabinet, xxi.

of a terrible aspect, and, being proud of his vast bulk and strength,
he was resolved that he would serve no other than the greatest and
the most powerful monarch that existed.   So he travelled far and
wide to seek this greatest of kings; and at length he came to the
court of a certain monarch who was said to exceed in power and
riches all the kings of the earth, and he offered to serve him.   And
the king, seeing his great height and strength,—for, surely, since
the giant of Gath there had been none like to him,—entertained
him with joy.

Now it happened one day, as Christopher stood by the king in his
court, there came a minstrel who sang before the king, and, in his
story there was frequent mention of the devil, and every time the
king heard the name of the evil spirit he crossed himself.   Chris-
topher inquired the reason of this gesture, but the king did not
answer.   Then said Christopher, 'If thou tellest me not, I leave
thee!'   So the king told him: 'I make that sign to preserve me
from the power of Satan, for I fear lest he overcome me and slay
me.'   Then said Christopher, 'If thou fearest Satan, then thou art
not the most powerful prince in the world; thou hast deceived me.
I will go seek this Satan, and him will I serve; for he is mightier
than thou art.'   So he departed, and he travelled far and wide; and
as he crossed a desert plain, he beheld a great crowd of armed men,
and at their head marched a terrible and frightful being, with the
air of a conqueror: and he stopped Christopher on his path, saying,
'Man, where goest thou?'   And Christopher answered, 'I go to
seek Satan, because he is the greatest prince in the world, and him
would I serve.'   Then the other replied, 'I am he: seek no farther.'
Then Christopher bowed down before him, and entered his service;
and they travelled on together.

Now, when they had journeyed a long, long way, they came to a place
where four roads met, and there was a cross by the way-side.   When
the Evil One saw the cross he was seized with fear, and trembled
violently; and he turned back, and made a great circuit to avoid it.
When Christopher saw this he was astonished, and inquired, 'Why
hast thou done so?' and the devil answered not.   Then said Christo-
pher, 'If thou tellest me not, I leave thee.'   So, being thus con-
strained, the fiend replied, 'Upon that cross died Jesus Christ; and

when I behold it I must tremble and fly, for I fear him.' Then Christopher was more and more astonished; and he said, 'How, then! this Jesus, whom thou fearest, must be more potent than thou art! I will go seek him, and him will I serve!' So he left the devil, and travelled far and wide, seeking Christ; and, having sought him for many days, he came to the cell of a holy hermit, and desired of him that he would show him Christ. Then the hermit began to instruct him diligently, and said, 'This king, whom thou seekest, is, indeed, the great king of heaven and earth; but if thou wouldest serve him, he will impose many and hard duties on thee. Thou must fast often.' And Christopher said, 'I will not fast; for, surely, if I were to fast my strength would leave me.' 'And thou must pray!' added the hermit. Said Christopher, 'I know nothing of prayers, and I will not be bound to such a service.' Then said the hermit, 'Knowest thou a certain river, stony and wide and deep, and often swelled by the rains, and wherein many people perish who attempt to pass over?' And he answered, 'I know it.' Then said the hermit, 'Since thou wilt neither fast nor pray, go to that river, and use thy strength to aid and to save those who struggle with the stream, and those who are about to perish. It may be that this good work shall prove acceptable to Jesus Christ, whom thou desirest to serve; and that he may manifest himself to thee!' To which Christopher replied, joyfully, 'This can I do. It is a service that pleaseth me well!' So he went as the hermit had directed, and he dwelt by the side of the river; and, having rooted up a palm-tree from the forest,—so strong he was and tall,—he used it for a staff to support and guide his steps, and he aided those who were about to sink, and the weak he carried on his shoulders across the stream; and by day and by night he was always ready for his task, and failed not, and was never wearied of helping those who needed help.

So the thing that he did pleased our Lord, who looked down upon him out of heaven, and said within himself, 'Behold this strong man, who knoweth not yet the way to worship me, yet hath found the way to serve me!'

Now, when Christopher had spent many days in this toil, it came to pass one night, as he rested himself in a hut he had built of boughs, he

heard a voice which called to him from the shore: it was the plaintive
voice of a child, and it seemed to say, 'Christopher, come forth and
carry me over!' And he rose forthwith and looked out, but saw
nothing; then he lay down again; but the voice called to him, in the
same words, a second and a third time; and the third time he sought
round about with a lantern; and at length he beheld a little child
sitting on the bank, who entreated him, saying, 'Christopher, carry
me over this night.' And Christopher lifted the child on his strong
shoulders, and took his staff and entered the stream. And the
waters rose higher and higher, and the waves roared, and the winds
blew; and the infant on his shoulders became heavier and still
heavier, till it seemed to him that he must sink under the exces-
sive weight, and he began to fear; but nevertheless, taking courage,
and staying his tottering steps with his palm-staff, he at length
reached the opposite bank; and when he had laid the child down,
safely and gently, he looked upon him with astonishment, and he said,
'Who art thou, child, that hath placed me in such extreme peril?
Had I carried the whole world on my shoulders, the burthen had
not been heavier!' And the child replied, 'Wonder not, Christopher,
for thou hast not only borne the world, but him who made the world,
upon thy shoulders. Me wouldst thou serve in this thy work of char-
ity; and, behold, I have accepted thy service: and in testimony that I
have accepted thy service and thee, plant thy staff in the ground,
and it shall put forth leaves and fruit.' Christopher did so, and the
dry staff flourished as a palm-tree in the season, and was covered
with clusters of dates,—but the miraculous child had vanished.

Then Christopher fell on his face, and confessed and worshipped
Christ.

Leaving that place, he came to Samos, a city of Lycia, where he
found many Christians, who were tortured and persecuted; and he
encouraged them and cheered them. One of the heathens struck him
on the face; but Christopher only looked at him steadfastly, saying,
'If I were not a Christian, I would be avenged of that blow.' The
king of the country sent soldiers to seize him, and he permitted them
to bind him and lead him before their master. The king, when he saw
him, was so terrified by his gigantic stature, that he swooned on his
throne. When he had recovered, he said, 'Who art thou?' and he

answered, 'Formerly I was called Offero, the bearer; but now my name is Christopher, for I have borne Christ.' Then the king, whose name was Dagnus, ordered him to be carried to prison, and sent two women to allure him to sin, knowing that if he could be seduced to sin, he would soon be enticed to idolatry. But Christopher stood firm; and the women, being terrified and awed, fell down and worshipped Christ, and were both put to death. And the tyrant, finding it impossible to subdue or to tempt the saint, commanded him to be scourged and tortured, and then beheaded. And, as they led him to death, he knelt down and prayed that those who looked upon him, trusting in God the Redeemer, should not suffer from tempest, earthquake, or fire.

Thus did Christopher display the greatness of his charity, and the meekness of his spirit; thus he sealed his faith with martyrdom; and it was believed that, in consequence of his prayer, those who beheld the figure of St. Christopher were exempt during that day from all perils of earthquake, fire, and flood. The mere sight of his image, that type of strength, was deemed sufficient to inspire with courage those who had to struggle with the evils and casualties of life, and to reinvigorate those who were exhausted by the labours of husbandry. The following is one of the many inscriptions inculcating this belief, and which usually accompanied his effigy,—

> Christophori Sancti speciem quicumque tuetur
> Illo namque die nullo languore tenetur.

Which may be rendered, 'Whoever shall behold the image of St. Christopher, on that day shall not faint or fail.'

Hence it became a custom to place his image in conspicuous places, to paint it of colossal size on the walls of churches and houses, where it is sometimes seen occupying the whole height of the building, and is visible from a great distance, being considered as a good omen for all those who look upon it. A mountain in Granada, which is first seen by ships arriving from the African coast, is called San Christobal, in allusion to this poetical superstition.

At Florence, on the façade of the ancient church of San Miniato-tra-le-Torri, Pollajuolo painted a gigantic figure of St. Christopher,

about twenty feet in height, which served during many years as a model of form to the artists of his school; Michael Angelo, when young, copied it several times : it exists no longer.    A St. Christopher, thirty-two feet high, was painted at Seville, by Matteo Perez de Alesio (A.D. 1584): and all who have travelled in France, Germany, Italy, particularly through the south of Germany and the Venetian States, will remember the colossal figures of St. Christopher, on the exterior, or some conspicuous part of the interior, of the churches, town halls, and other sacred or public buildings.    These effigies were sometimes painted in vivid colours, often renewed, in order to render them more distinctly visible.    On the walls of old English churches, figures of St. Christopher were very common. Many of these, which had been covered with whitewash, have been recently uncovered.[1]

Since the very sight of St. Christopher is supposed to bring an accession of strength, fortitude, and confidence in the Divine aid, it is fortunate that there can be no mistake about it, and that it is so peculiar as to be instantly recognised.    He stands above the ankles in water ; his proportions are those of a Hercules : according to the Greek formula he should be beardless, and some of the Italian pictures so represent him, or with very little beard ; but the Germans give him a strong black beard and a quantity of black bushy hair, the better to express the idea of physical strength and manliness.    The infant Christ is seated on his shoulders, and bears in his hand the globe as Sovereign and Creator of the world ; more rarely it is a cross, as Redeemer ; but the former, considering the significance of the subject, is the more proper emblem.    In general he is looking up to the divine Infant, but sometimes also he is looking down and making his way painfully and anxiously through the rising waters ; he seems bending under the miraculous burthen, and supports his tottering steps with a staff, which is often an entire palm-tree with the leaves and branches.    In the background is a hermit, bearing a lamp or torch, to light him on his way.

Such is the religious representation.    It is evident that at all times the Roman Church, while honouring the name of the martyr, accepted the legend as an allegory merely ; and the flood, through which he is

---

[1] There are four churches still remaining dedicated in his name in England. (See Parker's 'Calendar of the Anglican Church,' p 205.)

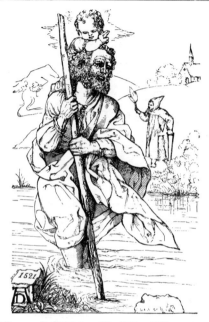

110          St. Christopher   (Albert Dürer, 1521).

wading, is, by some, interpreted to signify the Red Sea, that is, the
waters of baptism; by others, the waters of affliction (a common
oriental and scriptural metaphor): he carries Christ, and, with him,
' the burthen and the weight of all this unintelligible world : '—the
hermit of religious consolation lights him on his way. The allegory, in
whatever sense we interpret it, is surely very beautiful : to my fancy
there is something quite pathetic in these old pictures of St. Chris-
topher, where the great simple-hearted, good-natured giant, tottering
under his incomprehensible burthen, looks up with a face of wonder
at the glorious Child, who smiles encouragement, and gives his bene-
diction from above.

In later times, the artists desecrated this fine subject by employing it
as a mere *tour de force*, a display of manly and muscular form, for which
the Farnese Hercules, or, if that were not at hand, any vulgar porter

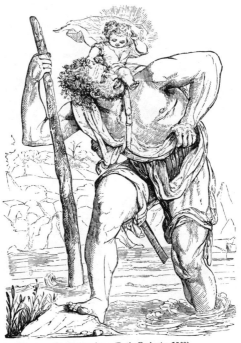

111        St. Christopher   (Paolo Farinato, 1560).

or gondolier, served as a model.    Thus the religious sentiment was
obscured or lost, and the whole representation became coarse and
commonplace, when not absolutely grotesque and ridiculous.

In the figure by Titian in the Ducal Palace at Venice, the attitude
and character of the saint are precisely those of a gondolier,—only
that the palm tree has been substituted for the oar.

In the picture by Farinato, a small spirited sketch now at Alton
Towers, the figure is that of a Hercules, but the expression in the head
of the child extremely fine (111).

When St. Christopher is introduced standing near the Madonna, or
grouped with other saints, the water is omitted, but he is never without
his palm-staff.   Where the artist has varied the action or accessories,
the figure ceases to be strictly devotional, and becomes fanciful and

112  St. Christopher (From the ancient woodcut).

dramatic. This, however, is so seldom the case, that I know of very few examples.

1. The earliest woodcut which exists, and of which it is possible to fix the date, is a rude figure of St. Christopher, of German design and execution, represented in the usual manner, except that there is a watermill and a miller in the foreground. It is inscribed—

Cristofori faciem die quacunque tueris
Illa nempe die morte mala non morieris.

Literally, 'On whatever day thou shalt behold the face of St. Christopher, surely on that day thou shalt not die an evil death.' It was evidently intended to circulate among the labouring poor, as an emblem of strength and consolation, and quite as intelligible then, as Bunyan's 'Christian in the Slough of Despond' would be now.[1]

2. H. Hemling. St. Christopher, bearing Christ, is wading through a deep river, the water rising to his knees. The hermit lights him as usual, but in the background the first beams of the sun are just seen illuminating the dark waste of waters; a circumstance beautifully imagined, and which adds to the significance of the allegory.[2]

3. Elzheimer. St. Christopher as usual wading through the stream; precipitous rocks, and the hermit in the distance : the effect is night with a full moon.[3]

The following examples must be considered as exceptional.

4. Engraving,—Lucas v. Leyden. St. Christopher seated on the ground ; on the other side of the river, Christ beckons to him for aid.

5. Engraving,—Old German. St. Christopher seated on the bank of a river; the Infant Christ is in the act of descending on his shoulders.

6. Engraving,—F. Amato. St. Christopher offers his services to the Infant Christ, who is seated on the ground.

7. I have seen an old coarse engraving, in which St. Christopher is represented on horseback,—the whim, I suppose, of an ignorant or capricious artist.

8. Engraving. St. Christopher wades through the waters, bearing Christ, who has one foot on a large globe, and, instead of the hand extended in benediction, he is impatiently urging the saint with a drawn sword, which he brandishes over his head. Full of spirit, but a most capricious and irreligious version of the subject.

9. In Van Eyck's wonderful altar-piece, at Ghent, the pilgrims, who

---

[1] I have given a reduced facsimile in the 'Memoirs of Early Italian Painters,' which, through the kindness of Mr C. Knight, I am able to repeat here. Only two impressions of the original are known to exist,—one in the Paris collection, and one in the library of Earl Spencer, at Althorp. In the 'Athenæum' for October 4, 1845, there is an account of an earlier woodcut, dated 1418, and discovered in the library at Malines, in 1844.

[2] Boisserée Gal.                                        [3] Windsor.

approach to worship the Lamb of God, are led by the giant Christopher, who strides on before the rest, grasping his palm-tree; his voluminous crimson mantle sweeps the ground, and a heathenish turban decks his head. This is one of the few instances where he is without his divine burthen: the poetry and significance of the allusion will be understood at once.

10. M. Didron tells us, that in the Greek churches he found St. Christopher often represented with the head of a dog or wolf, like an Egyptian divinity; he adds, that he had never been able to obtain a satisfactory explanation of this peculiarity. These figures, which are ancient, have in some instances been blurred over and half effaced by the scruples of modern piety.[1]

The history of St. Christopher, as painted in the chapels dedicated to him, for instance by Mantegna in the ' Eremitani,' at Padua, is comprised in three subjects: his passage across the river; the conversion of the heathen at Samos; and his martyrdom; the other circumstances of his legend being repudiated by the Church: some of them (for instance, the meeting with the arch-fiend and his host of demons) would furnish most picturesque subjects, but rather in the *genre* than in the historical style.

I have seen only three pictures of his martyrdom separately treated.

1. The scene is an open court, surrounded with rich architecture; the body of the giant-saint lies on the ground; here he is about twelve or fourteen feet in stature, and the severed head, beardless and with flowing hair, lies near it; soldiers and executioners are about to bear away the body; one lifts up the huge leg with both his hands; many others look on with astonishment. Most picturesque as a scene, but with no attempt at religious feeling or character.

2. Tintoretto. St. Christopher kneels, and the executioner prepares

---

[1] Vasari relates an amusing anecdote of a patron who insisted on his painting a figure of St. Christopher six palms in height, within a space which measured only four palms, and desired that he would represent the Madonna with the Child on her knees, and by her side St. Christopher with another Christ on his shoulders. Vasari, to reconcile difficulties, painted the saint kneeling, with one foot in the water, while the Virgin, bending from the clouds, placed her divine Infant on his shoulders.— *Vasari*, ii. 833. (Fl. edit., 1838.)

to strike off his head; no other figure, except an angel descending: here St. Christopher is not represented as of gigantic proportions.[1]

3. Lionello Spada. In this picture the conception is wholly reversed: the giant kneels with his hands bound, and looking up with a mild resignation, which contrasts with his vast strength and size; the executioner, who has raised himself on a step to reach him, prepares to strike off his head, while an angel descends from above with the martyr's crown. In colour, expression, and simple powerful feeling, perhaps Spada's masterpiece; such, at least, is the opinion of Dr. Waagen.[2]

## St. Nicholas of Myra.

*Lat.* Sanctus Nicholaus. *Ital.* San Niccolò, or Nicola di Bari. *Ger.* Der Heilige Nicolaus, or Niklas. Patron saint of children, and especially schoolboys; of poor maidens, of sailors, of travellers and merchants. Protector against thieves, and losses by robbery or violence. Chief Patron saint of Russia. Patron of Bari, of Venice, of Freiberg, and of numerous other towns and cities, particularly of sea-ports and towns engaged in commerce. (Dec. 6, A.D. 326.)

I PLACE St. Nicholas here because, although he wears the paraphernalia of bishop, it is as the powerful and beneficent patron saint, seldom as the churchman, that he appears before us; and of all patron saints he is, perhaps, the most universally popular and interesting. While knighthood had its St. George, serfhood had its St. Nicholas. He was emphatically the saint of the people; the *bourgeois* saint invoked by the peaceable citizen, by the labourer who toiled for his daily bread, by the merchant who traded from shore to shore, by the mariner struggling with the stormy ocean. He was the protector of the weak against the strong, of the poor against the rich, of the captive, the prisoner, the slave; he was the guardian of young marriageable maidens, of schoolboys, and especially of the orphan poor. In Russia, Greece, and throughout all Catholic Europe, children are still taught to reverence St. Nicholas, and to consider themselves as placed under his peculiar care : if they are good, docile, and attentive to their studies, St. Nicholas, on the eve of his festival, will graciously fill their cap or their

---

[1] Venice, S. Maria dell' Orto.     [2] Louvre, No. 408.

stocking with dainties; while he has, as certainly, a rod in pickle for the idle and unruly.

Effigies of this most benign bishop, with his splendid embroidered robes, all glittering with gold and jewels, his mitre, his crosier, and his three balls, or his three attendant children, meet us at every turn, and can never be regarded but with some kindly association of feeling. No saint in the calendar has so many churches, chapels, and altars dedicated to him. In England I suppose there is hardly a town without one church at least bearing his name.

It would be in vain to attempt to establish this popular predilection and wide-spread fame on anything like historical evidence. All that can be certainly known of him, is, that a bishop of this name, venerable for his piety and benevolence, was honoured in the East as early as the sixth century; that in the Greek Church he takes rank immediately after the great Fathers; that the Emperor Justinian dedicated to him a church in Constantinople about the year 560; and that since the tenth century he has been known and reverenced in the West, and became one of the greatest patron saints of Italy and the northern nations about the beginning of the twelfth century. There is no end to the stories and legends in which he appears as a chief actor. In this case, as in others, I must confine myself to such as have been treated in Art; and it will be necessary, however quaint and absurd some of these may be, to go into them in detail—otherwise the numerous representations of his life, acts, and miracles will lose half their interest, and more than half their significance.

Nicholas was born at Panthera, a city of the province of Lycia, in Asia Minor. His parents were Christians, and of illustrious birth, and, after they had been married for many years, a son was granted them, in recompense of the prayers, and tears, and alms that they offered up continually. This extraordinary child, on the first day he was born, stood up in his bath with his hands joined in thanksgiving that it had pleased God to bring him into the world. He no sooner knew what it was to feed than he knew what it was to fast, and every Wednesday and Friday he would only take the breast once. As he grew up he was distinguished among all other children

for his gravity and his attention to his studies. His parents, seeing him full of these holy dispositions, thought that they could not do better than dedicate him to the service of God; and accordingly they did so.

When Nicholas was ordained priest, although he had been before remarkable for his sobriety and humility, he became more modest in countenance, more grave in speech, more rigorous in self-denial, than ever. When he was still a youth his father and mother died of the plague, and he remained sole heir of their vast riches: but he looked upon himself as merely the steward of God's mercies, giving largely to all who needed.

Now in that city there dwelt a certain nobleman who had three daughters, and, from being rich, he became poor,—so poor, that there remained no means of obtaining food for his daughters but by sacrificing them to an infamous life; and oftentimes it came into his mind to tell them so, but shame and sorrow held him dumb. Meantime the maidens wept continually, not knowing what to do, and not having bread to eat: and their father became more and more desperate.

When Nicholas heard of this, he thought it a shame that such a thing should happen in a Christian land; therefore one night, when the maidens were asleep, and their father alone sat watching and weeping, he took a handful of gold, and, tying it up in a handkerchief, he repaired to the dwelling of the poor man. He considered how he might bestow it without making himself known, and, while he stood irresolute, the moon coming from behind a cloud showed him a window open; so he threw it in, and it fell at the feet of the father, who, when he found it, returned thanks, and with it he portioned his eldest daughter. A second time Nicholas provided a similar sum, and again he threw it in by night; and with it the nobleman married his second daughter. But he greatly desired to know who it was that came to his aid; therefore he determined to watch, and when the good saint came for the third time, and prepared to throw in the third portion, he was discovered, for the nobleman seized him by the skirt of his robe, and flung himself at his feet, saying, 'O Nicholas! servant of God! why seek to hide thyself?' and he kissed his feet and his hands. But Nicholas made him promise that he would tell no man. And many other charitable works did Nicholas perform in his native city.

113          The Charity of St. Nicholas (Angelico da Fiesole)

And after some years he undertook a voyage to the Holy Land, and he embarked on board a ship; and there came on a terrible storm, so that the ship was nigh to perish. The sailors fell at his feet, and besought him to save them; and he rebuked the storm,

which ceased immediately.    It happened in the same voyage that
one of the sailors fell overboard and was drowned; but by the prayers
of St. Nicholas he was restored to life.

On returning from Palestine St. Nicholas repaired to the city of
Myra, where he lived for some time unknown and in great humility.
And the bishop of that city died.    And it was revealed to the clergy
that the first man who entered the church on the following morning
was the man chosen by God to succeed as bishop.    Nicholas, who
was accustomed to rise up very early in the morning to pray, ap-
peared before the doors of the church at sunrise; so they laid hold
of him, and led him into the church, and consecrated him bishop.
Having attained this dignity, he showed himself worthy of it by the
practice of every saintly virtue, but more especially by a charity
which knew no bounds.    Sometime afterwards the city and the
province were desolated by a dreadful famine, and Nicholas was told
that certain ships laden with wheat had arrived in the port of Myra.
He went, therefore, and required of the captains of these vessels
that they should give him out of each a hundred hogsheads of wheat
for the relief of his people; but they answered, ' We dare not do
this thing, for the wheat was measured at Alexandria, and we must
deliver it into the granary of the emperor.'    And St. Nicholas said,
' Do as I have ordered you, for it shall come to pass, by the grace of
God, that, when ye discharge your cargo, there shall be found no
diminution.'    So the men believed him, and when they arrived in
Constantinople they found exactly the same quantity that they had
received at Alexandria.    In the meantime St. Nicholas distributed
the corn to the people according to their wants : and it was miracu-
lously multiplied in his hands, so that they had not only enough to
eat, but sufficient to sow their lands for the following year.

It was during this famine that St. Nicholas performed one of his
most stupendous miracles.    As he was travelling through his diocese to
visit and comfort his people, he lodged in the house of a certain host
who was a son of Satan.    This man, in the scarcity of provisions, was
accustomed to steal little children, whom he murdered, and served up
their limbs as meat to his guests.    On the arrival of the bishop and his
retinue, he had the audacity to serve up the dismembered limbs of
these unhappy children before the man of God, who had no sooner cast

his eyes on them than he was aware of the fraud. He reproached the host with his abominable crime, and going to the tub where their remains were salted down, he made over them the sign of the cross, and they rose up whole and well. The people who witnessed this great wonder were struck with astonishment (as, indeed, they might well be), and the three children, who were the sons of a poor widow, were restored to their weeping mother.

Some time after these events, the Emperor Constantine sent certain tribunes of his army to put down a rebellion in Phrygia. They arrived at the city of Myra, and the bishop, in order to save his people from their exactions and their violence, invited them to his table, and entertained them honourably. As they were sitting down to the feast it was told to St. Nicholas that the prefect of the city had condemned three innocent men to death, and that they were about to be executed, and that all the city was in commotion because of this wickedness.

When St. Nicholas heard this, he rose hastily, and, followed by his guests, ran to the place of execution. And he found the three men with their eyes bound, kneeling there, and the executioner stood with his sword already bared; but when St. Nicholas arrived, he seized the sword and took it out of his hands, and caused the men to be unbound. No one dared to resist him, and even the prefect humbled himself before him, and entreated forgiveness, which the saint granted not without difficulty. The tribunes looking on meanwhile were filled with wonder and admiration. When they had received the blessing of the good bishop they continued their voyage to Phrygia.

Now it happened, during their absence from Constantinople, that their enemies had turned the mind of the emperor against them, and filled him with suspicion. On their return they were accused of treason, and thrown into a dungeon, whence they were to be led to death on the following day. In their extremity they remembered St. Nicholas, and cried to him to save them: they did not cry in vain, for God heard them out of heaven, and St. Nicholas, in the distant land where he dwelt, also heard their supplication. And that same night he appeared to Constantine in a dream, and commanded him on his peril to release these men, threatening him with the anger of Heaven if he disobeyed. Constantine immediately pardoned the men,

and the next morning he sent them to Myra to thank St. Nicholas, and to present to him a copy of the Gospels, written in letters of gold, and bound in a cover enriched with pearls and precious stones. The fame of this great miracle spread far and wide; and since that time all those who are in any way afflicted or distressed, and who stand in great peril of their lives, invoke this glorious saint, and find succour at his hands. And thus it happened to certain mariners in the Ægean Sea, who, in the midst of a frightful tempest, in which they were like to founder, called upon Christ to deliver them through the intercession of the blessed St. Nicholas, who thereupon appeared to them and said, ' Lo, here I am, my sons ! put your trust in God, whose servant I am, and ye shall be saved." And immediately the sea became calm, and he conducted the vessel into a safe harbour. Wherefore those who peril their lives on the great deep do also invoke St. Nicholas ; and all harbours of refuge, and many chapels and altars on the sea coast, are dedicated to him.

Many other great and good actions did St. Nicholas perform; but at length he died, yielding up his soul to God with great joy and thankfulness, on the sixth day of December in the year of our Lord 326, and he was buried in a magnificent church which was in the city of Myra.

It is related that St. Nicholas was summoned to the Council of Nice in the year 325, and that, in his zeal, he smote Arius on the face; but there are many who do not believe this, seeing that the name of Nicholas of Myra does not appear among the bishops cited on that occasion.

The miracles which St. Nicholas performed after his death were not less wonderful than those which he had performed during his lifetime, and for hundreds of years pilgrims from all parts of the East resorted to his tomb. In the year 807, Achmet, who commanded the fleet of Haroun Alraschid, attacked the sanctuary, intending to demolish it; but he was deceived by the vigilance of the monks, and, putting to sea again, he was destroyed with his whole fleet, as a punishment for this great sacrilege. After this event the body of St. Nicholas rested in his tomb for the space of 280 years ; various attempts were made to carry it off, many cities and churches aspiring to the possession of so great a treasure. At length, in 1084, certain merchants of Bari, a city

on the coast of Italy opposite to Ragusa, resolved to accomplish this great enterprise. In their trading voyages to the coast of Syria, they had heard of the miracles of St. Nicholas, and, in their pious enthusiasm, resolved to enrich their country with the possession of these wonder-working relics. They landed at Myra, where they found the country desolated by the Saracens, the church in ruins, and the tomb guarded only by three monks. They had no difficulty in taking away the holy remains, which were received in the city of Bari with every demonstration of joy; and a magnificent church was built over them, which was dedicated by Pope Urban II. From this period the veneration for St. Nicholas extended over the West of Europe. It is proper to add, that the Venetians affirm that they have the true body of St. Nicholas, carried off from Myra by Venetian merchants in the year 1100. The pretensions, however, of the city of Bari are those generally acknowledged, and thence the saint has obtained the name, by which he is best known, of *St. Nicholas de Bari.*[1]

Devotional figures of St. Nicholas exhibit him as standing in the habit of a bishop. In the Greek pictures he is dressed as a Greek bishop, without the mitre, bearing the cross instead of the crosier, and on his cope embroidered the three Persons of the Trinity:[2] but in Western Art his episcopal habit is that of the Western Church; he wears the mitre, the cope, in general gorgeously ornamented, the jewelled gloves, and the crosier. He has sometimes a short grey beard; sometimes he is beardless, in allusion to his youth when elected bishop. His proper attribute, the three balls, may be variously interpreted; but in general they are understood to signify the three purses of gold, which he threw into the poor man's window. Some say they represent three loaves of bread, and allude to his feeding the poor during the famine; and others, again, interpret them into a general allusion to the Trinity. The first is, however, the most popular interpretation. These balls are sometimes placed

[1] As patron of seamen, St. Nicholas is especially popular in sea-port towns. About 376 churches in England are dedicated in his honour.

[2] Figures and heads of St. Nicholas are especially frequent in the Greek devotional pictures, as he is the greatest, or, at least, the most popular, saint of the Greek Church.

114        St. Nicholas        (Botticelli.   Capitol, Rome)

upon his book, as in the illustration; sometimes at his feet; and
sometimes in his lap, as in a miniature engraved in Dibdin's
'Decameron,' where he is throned, and gives his benediction as patron.
I have also seen them converted into an ornament for his crosier, when
they could not conveniently be placed elsewhere, as in a picture by
Bartolo Senese.   Occasionally, instead of the three balls, there are three
purses full of gold, which express more distinctly the allusion to his
famous act of charity, as in a statue in his church at Foligno.[1]   An-

[1] In this instance the three purses are laid on his book.   In a picture by Angelico at
Perugia, the three purses lie at his feet.   I saw an etching from this picture in the posses-
sion of the Chevalier Bunsen.

other, and also a very frequent attribute, alludes to the miracle of the three children. They are represented in a tub or a vase, looking up to him with joined hands.

115    St. Nicholas (From a miniature in the 'Heures d'Anne de Bretagne,' 1500).

I presume this story of the children to have been, in its primitive form, one of those religious allegories which express the conversion of sinners or unbelievers. I am the more inclined to this opinion, because I have seen pictures in which the wicked host is a manifest demon with hoofs and claws; and the tub, which contains the three children, has the form of a baptismal font.

As patron of seamen, St. Nicholas has often an anchor at his side, or a ship is seen in the background, as in a picture by Paul Veronese.

In consequence of his popularity as Patron and Protector, St. Nicholas frequently appears as an attendant on the enthroned Madonna and Child.[1] The most beautiful example I can refer to is Raphael's ' Madonna *dei Ansidei* ' at Blenheim, where the benign and pensive dignity of St. Nicholas, holding the gospel open in his hand, rivals in characteristic expression the refined loveliness of the Virgin and her Son. We may imagine him reading aloud from his book some divine precept of charity, as, ' *Love your enemies; do good to them that hate you:* ' it seems reflected in his face.[2]

I think it unnecessary to particularise further the devotional pictures in which St. Nicholas figures alone (or, which is much more frequent, grouped with other saints), because he is in general easily discriminated, —the three balls, on his book or at his feet, being the most frequent attribute, and one which belongs to no other saint. As patron saint of children, a child is sometimes kissing his hand or the hem of his garment. I recollect, in a picture by Bonvicino, at Brescia, an application of the religious character of this saint to portraiture and common life, which appears to me highly beautiful and poetical. St. Nicholas is presenting to the Virgin two orphans, while she looks down upon them from her throne with a benign air, pointing them out to the notice of the Infant Saviour, who is seated in her lap. The two boys, orphans of the noble family of Roncaglia, are richly dressed; one holds the mitre of the good bishop; the other, the three balls.

---

[1] See ' Legends of the Madonna,' p. 98.

[2] Of this celebrated picture, an engraving of wonderful beauty has lately been published by Louis Gruner. In the expression of the heads, the softness of the modelling in the flesh, and in the power and elegance of the drawing and execution, he has in this fine print equalled the greatest masters in his art.

Separate scenes from his life do not often occur; in general we have two, three, or more together. The favourite subject, in a detached form, is that which is properly styled ' The Charity of St. Nicholas.' The leading idea does not vary. In one part of the composition the three maidens are represented as asleep; their father watching near them. Nicholas is seen outside in the act of throwing a purse (or, in some cases, a ball of gold) in at the window: he is young, and in a secular dress. There is an engraving, after a composition by Parmigiano, which can hardly be excelled for delicacy and grace: the figures and attitudes of the daughters are most elegant. In a series of the actions of St. Nicholas, whether it consists of many or few subjects, this beautiful incident is never omitted. As a Greek series we have generally two or three or more of the following subjects. Sometimes the selection of scenes is from his life; sometimes from the miracles performed after his death, or after his translation from the coast of Syria to the coast of Italy; or both are combined.

1. His infant piety. The scene is the interior of a room, where his mother is seen in bed; in the foreground, attendants are busied round the new-born saint, who, with a glory round his head, stands upright in his bath, his hands joined in prayer, and his eyes raised to heaven.

2. He stands, as a boy of about twelve years old, listening to the words of a preacher, who points him out to his congregation as the future saint.

3. His charity to the three poor girls: they are seen through a door, asleep in an inner chamber; the father sits in front; outside the house, the saint stands on tiptoe, and is throwing the purse in at the window (113).

(In a small picture which I have seen, but cannot recollect the painter, two of the maidens are reposing, but the third is taking off her father's boot; he sits as one overpowered with sorrow and fatigue: the saint is outside looking in at the window. This is an unusual version; and seems to express, not the act of charity, but the previous moment, and the filial attention of the daughters to their poor father.)

4. The consecration of St. Nicholas as bishop of Myra. We have this subject, by Paul Veronese, in our National Gallery.

5. The Famine at Myra.   A sea-port with ships in the distance ;
in front a number of sacks of corn, and men employed in measuring
it out, or carrying it away ; St. Nicholas in his episcopal robes stands
by, as directing the whole.

6. The Storm at Sea.    Seamen on board a sinking vessel ; St.
Nicholas appears as a vision above ; in one hand he holds a lighted
taper, with the other he appears to direct the course of the vessel.

(In a Greek series of the life of St. Nicholas, the subject which
follows here is the Council of Nice.   A number of bishops are seated
in a semicircle ; Constantine, with crown and sceptre, presides ; in
front Nicholas is in the act of giving Arius the memorable box on
the ear.    This incident I do not remember to have seen in Western
Art.)

7. Three men are seen bound, with guards, &c., and an executioner
raises his sword to strike.   St. Nicholas (he is sometimes hovering
in the air) stays the hand of the executioner.

8. The miracle of the three boys restored to life, when treated as
an incident, and not a devotional representation, is given in a variety
of ways : the mangled limbs are spread on a table, or underneath a
board ; the wicked host is on his knees ; or he is endeavouring to
escape ; or the three boys, already made whole, are in an attitude of
adoration before their benefactor (115).

9. The death of St. Nicholas, and angels bear his soul to heaven.

10. When the series is complete, the translation of the body and
its reception at Bari are included.

The miracles, or rather the parables, which follow are to be found
in the chapel of St. Nicholas at Assisi, on the windows of the cathe-
drals at Chartres and Bourges, and in the ancient Gothic sculpture.
As they were evidently fabricated after the translation of his relics,
they are not likely to occur in genuine Byzantine Art.

1. A certain Jew of Calabria, hearing of the great miracles per-
formed by St. Nicholas, stole his image out of a church, and placed
it in his house.   When he went out, he left under the care of the saint
all his goods and treasures, threatening him (like an irreverent pagan
as he was) that if he did not keep good watch he would chastise him.
On a certain day, the Jew went out, and robbers came and carried

off all his treasures. When the Jew returned, he reproached St. Nicholas, and beat the sacred image and hacked it cruelly. The same night St. Nicholas appeared to the robbers, all bleeding and mutilated, and commanded them immediately to restore what they had taken. They, being terrified by the vision, repaired to the Jew, and gave up everything. And the Jew, being astonished at this miracle, was baptized, and became a true Christian.

This story is represented on one of the windows of the Cathedral at Chartres, and here St. Nicholas figures as the guardian of property.

2. A certain man, who was very desirous of having an heir to his estate, vowed that if his prayer were granted, the first time he took his son to church he would offer a cup of gold on the altar of St. Nicholas. A son was granted, and the father ordered the cup of gold to be prepared; but when it was finished, it was so wonderfully beautiful, that he resolved to keep the cup for himself, and caused another of less value to be made for the saint. After some time the man went on a journey to accomplish his vow; and being on the way, he ordered his little son to bring him water in the golden cup he had appropriated, but, in doing so, the child fell into the water and was drowned. Then the unhappy father lamented himself, and wept and repented of his great sin; and, repairing to the church of St. Nicholas, he offered up the silver cup: but it fell from the altar; and a second and a third time it fell; and while they all looked on astonished, behold! the drowned boy appeared before them, and stood on the steps of the altar bearing the golden cup in his hand. He related how the good St. Nicholas had preserved him alive, and brought him there. The father, full of gratitude, offered up both the cups, and returned home with his son in joy and thanksgiving.

Of this story there are many versions in prose and rhyme, and I have frequently seen it in sculpture, painting, and in the old stained glass; it is on one of the windows of the Cathedral of Bourges: in a bas-relief engraved in Cicognara's work,[1] the child, with the golden cup in his hand, is falling into the sea.

3. A rich merchant, who dwelt on the borders of a heathen country, but was himself a Christian, and a devout worshipper of St. Nicholas,

[1] 'Storia della Scultura moderna.'

had an only son; and it happened that the youth was taken captive by the heathens, and, being sold as a slave, he served the king of that country as cupbearer. One day, as he filled the cup at table, he remembered suddenly that it was the feast of St. Nicholas, and he wept. The king said, 'Why weepest thou, that thy tears fall and mingle in my cup?' And the boy told him, saying, 'This is the day when my parents and my kindred are met together in great joy to honour our good St. Nicholas; and I, alas! am far from them!' Then the king, most like a pagan blasphemer, answered, 'Great as is thy St. Nicholas, he cannot save thee from my hand!' No sooner had he spoken the words, than a whirlwind shook the palace, and St. Nicholas, appearing in the midst, caught up the youth by the hair, and placed him, still holding the royal cup in his hand, suddenly before his family, at the very moment when his father had distributed the banquet to the poor, and was beseeching their prayers in behalf of his captive son.

Of this story also there are innumerable versions; and as a boy with a cup in his hand figures in both stories, it is necessary to distinguish the circumstances and accessories: sometimes it is a daughter, not a son, who is delivered from captivity. In a fresco by Giottino at Assisi, the family are seated at table, and the captive, conducted by St. Nicholas, appears before them: the mother stretches out her arms, the father clasps his hands in thanksgiving, and a little dog recognises the restored captive.

I have observed that St. Nicholas of Bari and St. Julian of Rimini are often found in the same group, as joint protectors of the eastern coast of Italy and all the commercial cities bordering the shore of the Adriatic, from Venice to Tarento. There is a conspicuous example in the Louvre, in a beautiful picture by Lorenzo di Credi (No. 177). Another, an exquisite little Coronation of the Virgin, was in the collection of Mr Rogers.[1]

I must now take leave of the good St. Nicholas. So widely diffused and of such long standing is his fame, that a collection of his effigies

---

[1] See 'Legends of the Madonna,' p. 24.

and the subjects from his legend would comprise a history of art, of morals, of manners, of costume, for the last thousand years.   I have said enough to lead the fancy of the reader in this direction: other and brighter forms beckon us forwards.

# The Virgin Patronesses.

### St. Catherine.   St. Barbara.   St. Margaret.   St. Ursula.

WE owe to these beautiful and glorious impersonations of feminine intellect, heroism, purity, fortitude, and faith, some of the most excelling works of art which have been handed down to us.   Other female martyrs were merely women glorified in heaven, for virtues exercised on earth; but *these* were absolutely, in all but the name, Divinities.   With regard to the others, even the most apocryphal among them, we can still recognise some indications, however vague, however disguised, that they had been at one time or another substantial beings; but with regard to *these*, all such traces of an individual existence seem to have been completely merged in the abstract ideas they represented.   The worship of the others was confined to certain localities, certain occasions; but *these* were invoked everywhere, and at all seasons; they were *powers* differing indeed from the sensuous divinities of ancient Greece, inasmuch as the moral attributes were infinitely higher and purer, but representing them in their superhuman might and majesty; and though the Church assumed that theirs was a delegated power, it was never so considered by the people.   They were styled intercessors; but when a man addressed his prayers to St. Catherine to obtain a boon, it was with the full conviction that she had power to grant it.

I am not now speaking of the faith of the enlightened and reflecting Roman Catholics on such subjects, but of the feelings which existed and still exist, among the lower classes in Catholic

countries, particularly Italy, respecting these poetical beings of whom I am now to speak,

Their wholly ideal character, the tacit setting aside of all human testimony with reference to their real or unreal existence, instead of weakening their influence, invested them with a divine glory, and kept alive the enthusiasm inspired by the dignified and graceful forms in which they stand embodied before us. I know that there are excellent and conscientious persons who for this very reason look upon the pictures and effigies of St. Catherine and St. Barbara with an especial dislike, a terror in which there is a sort of fascination. I wish that what I am about to write may quiet their minds on the subject of these 'mythic fancies:' they will see how impossible it is that these allegories (which by simplicity and ignorance were long accepted as facts) should ever hereafter be received but as one form of poetry; and that under this aspect they cannot die, and ought not.

If those who consider works of art would be content to regard them thus,—not merely as pretty pictures, nor yet as repudiated idols, but as lovely allegories to which the world listened in its dreamy childhood, and which, like the ballad or the fairy tale which kept the sleep from our eyes and our breath suspended in infancy, have still a charm for our latest years;—if they would not be afraid of attaching a meaning to them, but consider what we may be permitted, unreproved, to seek and to find in them, both in sense and sentiment,—how many pleasures and associations would be revealed in every picture, in every group or figure, which is now passed over either with indifference or repugnance! Can they believe there is danger that any rational being should fall back into a second childhood of credulity? Let them now judge. I begin with that *Gloriosissima Vergine*, St. Catherine.

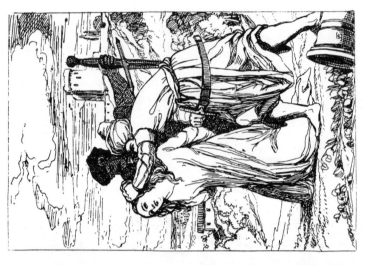

*Martyrdom of S. Barbara.*

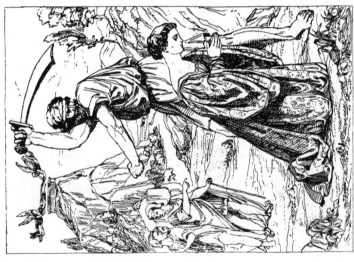

*Martyrdom of S. Catherine.*

116          The Burial of St. Catherine      (Luini).

## St. Catherine of Alexandria, Virgin and Martyr.

*Gr.* Aikaterina, *from* καθαρός, pure, undefiled.   *Lat.* Santa Catharina.   *Ital.* Santa Catarina dei Studienti.   Santa Catarina delle Ruote (or *of the wheels, to distinguish her from five other saints of the same name).*   *Fr.* Madame Saincte Catherine.   *Spa.* Santa Catalina. *Ger.* Die Heilige Katharina von Alexandrien.   Patroness of education, philosophy, science; of students, philosophers, and theologians.   Patroness of schools and colleges.   As patroness of eloquence she was invoked in all diseases of the tongue.   Perhaps from her royal dignity, a favourite patron saint of princesses and ladies of noble birth.   Patroness of Venice.   (Nov. 25, A.D. 307.)

The legend of St. Catherine is not of high antiquity: even among the Greeks, it cannot be traced farther back than the eighth century; and in the East it appears to have originated with the monks of Mount Sinai.   In a literary form, we find it first in the Greek Menology of the Emperor Basil in the ninth century.   The crusaders of the eleventh century brought it from the East; and in gratitude for the aid and protection which this '*Invittissima Eroina*' was supposed to have extended to the Christian warriors in the Holy Land, her Greek name, her romantic, captivating legend, and her worship as one of the most potent of saints, spread with such extraordinary rapidity over the whole of Western Christendom, that in the twelfth century it was all but universal.   About the fifteenth century, some reasonable doubts having been cast, not only on the authenticity of her legend, but on her very existence, vain attempts

VOL. II.                                                                                   L

were made to banish her from the calendar ; her festival, after being one of the most solemn in the Church, was, by several prelates of France and Germany, suppressed altogether, and by others left free from all religious obligations : but in Art, and in the popular veneration, St. Catherine kept her ground.  Even in the English reformed calendar she retains her place; even in London, churches and parishes and institutions, once placed under her protection, still retain her name.[1]

Of all the female saints, next to Mary Magdalene, St. Catherine is the most popular: venerated by the men as the divine patroness of learning; and by the women regarded as the type of female intellect and eloquence, as well as of courageous piety and chastity. She is the inspirer of wisdom and good counsel in time of need,— the Minerva of the heathens, softened and refined by the attributes of the Christian martyr.  The scenes taken from her life and 'acts' are so diversified, and of such perpetual recurrence, that I shall give the legend here with all its details of circumstances, only omitting the long speeches, and passing over without further remark that brave defiance of all historical probabilities which sets criticism at nought.

Constantius Chlorus, the father of Constantine the Great, had a first wife before he married the Empress Helena.  She died in giving birth to a son, whose name was Costis, and whom his father married to the only daughter and heiress of the King of Egypt, a virtuous princess, whose name was Sabinella; with her he lived and reigned in great prosperity and happiness for several years, but after the law of the Pagans, for they were, unhappily, idolaters.

Like all mothers who bring forth saints, Queen Sabinella, had a prophetic dream, in which was prefigured the glory of her first-born.  In due time she gave birth to a daughter, who was named Catherine.  At the moment she came into the world, a glory of light was seen to play around her head.  From her earliest infancy she was the wonder of all who beheld her, for grace of mind and person.  'She drank so plenteously from the well of wisdom,' that at the age of fifteen there was none comparable to her in the learning and philosophy of the Gentiles.

---

[1] There are fifty-one churches in England dedicated in her name.

She could have 'talked of stars and firmaments and firedrakes,' of 'sines and co-sines and fixed ratios,'—she could have answered all those hard things which the Queen of Sheba propounded to King Solomon. The works of Plato were her favourite study; and the teaching of Socrates had prepared her to receive a higher and a purer doctrine.

The king her father, who loved her, ordained to wait upon her seven of the wisest masters that could be gotten together; but Catherine, divinely endowed, so far excelled them all, that they who came to teach her became her disciples. Moreover, he ordained for her a tower in his palace, with divers chambers furnished with all kinds of mathematical instruments, in which she might study at pleasure.

When Catherine was about fourteen, her father, King Costis, died, and left her heiress of his kingdom. But when she was queen, Catherine showed the same contempt for all worldly care and royal splendour that she had hitherto exhibited, for she shut herself up in her palace, and devoted herself to the study of philosophy.

'Therefore,' says the old English legend, 'when the people saw this, they were discontented. And the nobles of that country came to their lady and queen, and desired her to call a parliament. And the estates being met, they besought her, as she was so much given to study and learning, that she would be pleased to take a husband who should assist her in the government of the country, and lead them forth to war.

'When she heard this, she was much abashed and troubled. And she said, "What manner of man is this that I must marry?" "Madam," said the speaker, "you are our most sovereign lady and queen, and it is well known to all that ye possess four notable gifts; the first is, that ye be come of the most noble blood in the whole world; the second, that ye be a great inheritor, and the greatest that liveth of women to our knowledge; the third, that ye, in science, cunning, and wisdom, surpass all others; and the fourth, that in bodily shape and beauty there is none like you: wherefore we beseech ye, Lady, that these good gifts, in which the great God hath endowed you beyond all creatures else, may move you to take a lord to your husband, to the end that ye may have an heir, to the comfort and joy of your people."

' " Then," answered the young Queen Catherine, with a grave countenance, " if God and nature have wrought so great virtues in us, we are so much the more bound to love him, and to please him, and to think humbly of all his great gifts; therefore, my lords and lieges, give heed to my words. He that shall be my husband and the lord of mine heart shall also possess four notable gifts, and be so endowed that all creatures shall have need of him, and he shall have need of none. He shall be of so noble blood that all men shall worship him, and so great that I shall never think that I have made him king; so rich, that he shall pass all others in riches; so full of beauty, that the angels of God shall desire to behold him; and so benign, that he can gladly forgive all offences done unto him. And if ye find me such an one, I will take him for my husband and the lord of my heart."

' With this she cast down her eyes meekly, and held her still. And all her lords and princes and councillors looked upon each other and knew not what to reply ; for they said, " Such a one as she hath devised there never was none, and never shall be ; " and they saw there was no remedy in the matter. Her mother, Sabinella, also intreated her saying, " Alas, my daughter, where shall ye find such a husband?" and Catherine answered, " If I do not find him, he shall find me, for other will I none; "—and she had a great conflict and battle to keep her virginity.

' Now there was a certain holy hermit who dwelt in a desert about two days' journey from the city of Alexandria; to him the Virgin Mary appeared out of heaven, and sent him with a message of comfort to the young Queen Catherine, to tell her that the husband whom she had desired was her son, who was greater than any monarch of this world, being himself the King of Glory, and the Lord of all power and might. Catherine desired to behold her future bridegroom. The hermit therefore gave her a picture representing the Virgin Mary and her divine Son ; and when Catherine beheld the heavenly face of the Redeemer of the world, her heart was filled with love of his beauty and innocence : she forgot her books, her spheres, and her philosophers; — Plato and Socrates became to her tedious as a twice-told tale. She placed the picture in her study, and that night as she slept upon her bed she had a dream.

' In her dream she journeyed by the side of the old hermit, who

conducted her towards a sanctuary on the top of a high mountain : and when they reached the portal, there came out to meet them a glorious company of angels clothed in white, and wearing chaplets of white lilies on their heads ; and Catherine, being dazzled, fell on her face, and an angel said to her, "Stand up, our dear sister Catherine, and be right welcome." Then they led her to an inner court, where stood a second company of angels clothed in purple, and wearing chaplets of red roses on their heads ; and Catherine fell down before them, but they said, " Stand up, our dear sister Catherine, for thee hath the King of Glory delighted to honour." Then Catherine, with a trembling joy, stood up and followed them. They led her on to an inner chamber in which was a royal queen standing in her state, whose beauty and majesty might no heart think, nor pen of man describe, and around her a glorious company of angels, saints, and martyrs : they, taking Catherine by the hand, presented her to the queen, saying, " Our most gracious sovereign Lady, Empress of Heaven, and Mother of the King of Blessedness, be pleased that we here present to you our dear sister, whose name is written in the book of life, beseeching you of your benign grace to receive her as your daughter and handmaiden."

' Our Blessed Lady, full of all grace and goodness, bid her welcome, and, taking her by the hand, led her to our Lord, saying to him, " Most sovereign honour, joy, and glory be to you, King of Blessedness, my Lord and my Son ! Lo ! I have brought into your blessed presence your servant and maid Catherine, which for your love hath renounced all earthly things !" But the Lord turned away his head, and refused her saying, " She is not fair nor beautiful enough for me." The maiden, hearing these words, awoke in a passion of grief, and wept till it was morning.

' Then she called to her the hermit, and fell at his feet, and declared her vision, saying, " What shall I do to become worthy of my celestial bridegroom?" The hermit, seeing she was still in the darkness of heathenism, instructed her fully in the Christian faith : then he baptized her, and, with her, her mother, Sabinella.

' That night, as Catherine slept upon her bed, the Blessed Virgin appeared to her again, accompanied by her divine Son, and with them a noble company of saints and angels. And Mary again presented

Catherine to the Lord of Glory, saying, " Lo! she hath been baptized, and I myself have been her godmother!" Then the Lord smiled upon her, and held out his hand and plighted his troth to her, putting a ring on her finger. When Catherine awoke, remembering her dream, she looked and saw the ring upon her finger; and henceforth regarding herself as the betrothed of Christ, she despised the world, and all the pomp of earthly sovereignty, thinking only of the day which should reunite her with her celestial and espoused Lord. Thus she dwelt in her palace in Alexandria, until the good queen Sabinella died, and she was left alone.'

At this time the tyrant Maximin, who is called by the Greeks Maxentius, greatly persecuted the Church, and, being come to Alexandria, he gathered all the Christians together, and commanded them, on pain of severest torments, to worship the heathen gods. St. Catherine, hearing in the recesses of her palace the cries of the people, sallied forth and confronted the tyrant on the steps of the temple, pleading for her fellow-Christians, and demonstrating ' *avec force syllogismes* ' the truth of the Christian and the falsehood of the Pagan religion. And when she had argued for a long time after the manner of the philosophers, quoting Plato and Socrates, and the books of the Sibyls, she looked round upon Maximin and the priests, and said, ' Ye admire this temple, the work of human hands; these fair ornaments and precious gems, these statues, that look as if they could move and breathe : admire rather the temple of the universe—the heavens, the earth, the sea, and all that is therein : admire rather the course of those eternal stars, which from the beginning of all creation have pursued their course towards the west and returned to us in the east, and never pause for rest. And when ye have admired these things, consider the greatness of HIM who made them, who is the great God, even the God of the Christians, unto whom these thy idols are less than the dust of the earth. Miserable are those who place their faith where they can neither find help in the moment of danger nor comfort in the hour of tribulation ! ' [1]

[1] ' The heaven indeed is high ; the earth is great ; the sea immense ; the stars are beautiful : but *He* who made all these things must needs be greater and more beautiful.'—*Sermon of St. Eloy.*

Maximin being confounded by her arguments, and yet more by her eloquence, which left him without reply, ordered that fifty of the most learned philosophers and rhetoricians should be collected from all parts of his empire, and promised them exceeding great rewards if they overcame the Christian princess in argument. These philosophers were at first indignant at being assembled for such a futile purpose, esteeming nothing so easy; and they said ' Place her, O Cæsar! before us, that her folly and rashness may be exposed to all the people.' But Catherine, nowise afraid, recommended herself to God, praying that he would not allow the cause of truth to suffer through her feebleness and insufficiency. And she disputed with all these orators and sages, quoting against them the Law and the Prophets, the works of Plato and the books of the Sibyls, until they were utterly confounded, one after another, and struck dumb by her superior learning. In the end they confessed themselves vanquished and converted to the faith of Christ. The emperor, enraged, ordered them to be consumed by fire; and they went to death willingly, only regretting that they had not been baptized; but Catherine said to them, ' Go, be of good courage, for your blood shall be accounted to you as baptism, and the flames as a crown of glory.' And she did not cease to exhort and comfort them, till they had all perished in the flames.

Then Maximin ordered that she should be dragged to his palace; and, being inflamed by her beauty, he endeavoured to corrupt her virtue, but she rejected his offers with scorn; and being obliged at this time to depart on a warlike expedition, he ordered his creature, Porphyry (called in the French legend ' Le Chevalier Porphire '), to cast her into a dungeon, and starve her to death; but Catherine prayed to her heavenly bridegroom, and the angels descended and ministered to her. And at the end of twelve days the empress and Porphyry visited the dungeon, which, as they opened the door, appeared all filled with fragrance and light. Whereupon they fell down at the feet of St. Catherine, and with two hundred of their attendants declared themselves Christians.

When Maximin returned to Alexandria, he was seized with fury. He commanded his wife, the empress, with Porphyry and

the other converts, to be put to a cruel death; but being more than ever inflamed by the beauty and wisdom of Catherine, he offered to make her his empress, and mistress of the whole world, if she would repudiate the name of Christ.  But she replied with scorn, 'Shall I forsake my glorious heavenly spouse to unite myself with thee, who art base-born, wicked, and deformed?'   On hearing these words, Maximin roared like a lion in his wrath; and he commanded that they should construct four wheels, armed with sharp points and blades—two revolving in one direction, two in another—so that between them her tender body should be torn into ten thousand pieces. And St. Catherine made herself ready to go to this cruel death; and as she went, she prayed that the fearful instrument of torment prepared for her might be turned to the glory of God.  So they bound her between the wheels, and, at the same moment, fire came down from heaven, sent by the destroying angel of God, who broke the wheels in pieces, and, by the fragments which flew around, the executioners and three thousand people perished in that day.

Yet for all this the thrice-hardened tyrant repented not, but ordered that Catherine should be carried outside the city, and there, after being scourged with rods, beheaded by the sword:—which was done.   And when she was dead, angels took up her body, and carried it over the desert, and over the Red Sea, till they deposited it on the summit of Mount Sinai.   There it rested in a marble sarcophagus, and in the eighth century a monastery was built over her remains, which are revered to this day: but the wicked tyrant, Maximin, being overcome in battle, was slain, and the beasts and birds devoured him; or, as others relate, an inward fire consumed him till he died.

In this romantic legend what a storehouse of picturesque incident! —And, accordingly, we find that poets and painters have equally availed themselves of it.  As ballads, as drama, as romance, it circulated among the people, and lent an interest to the gracious and familiar effigies which everywhere abound.   In England St. Catherine was especially popular.   About the year 1119, Geoffrey, a learned Norman, was invited from the University of Paris to superintend the direction of the schools of the Abbey of Dunstable, where he com-

posed a play entitled ' St. Catherine,' and caused it to be acted by his scholars. This was, perhaps, the first spectacle of the kind that was ever attempted, and the first trace of theatrical representation that ever appeared in England. Dryden's tragedy of ' Tyrannic Love ' is founded on the legend of St. Catherine, and was intended to gratify the queen, Catherine of Braganza, by setting forth the glory of her patron saint.

In the original oriental legend the locality assigned for the story of St. Catherine was at least well chosen, and with a view to probability. Alexandria, famous for its philosophical and theological schools, produced, not one, but many women, who, under the tuition of Origen and other famous teachers, united the study of Greek literature with that of the Prophets and Evangelists; some of them also suffered in the cause of Christianity. But it is a curious fact connected with the history of St. Catherine, that the real martyr, the only one of whom there is any certain record, was not a Christian, but a heathen; and that her oppressors were not Pagan tyrants, but Christian fanatics.

Hypatia of Alexandria, daughter of Theon, a celebrated mathematician, had applied herself from childhood to the study of philosophy and science, and with such success, that, while still a young woman, she was invited by the magistrates to preside over one of the principal schools in the city. She, like St. Catherine, was particularly addicted to the study of Plato, whom she preferred to Aristotle. She was also profoundly versed in the works of Euclid and Apollonius of Pergamus; and composed a treatise on Conic Sections, and other scientific works. She was remarkable, also, for her beauty, her contempt for feminine vanities, and the unblemished purity of her conduct. As, however, she resolutely refused to declare herself a Christian, and was on terms of friendship with Orestes, the Pagan governor of Alexandria, she was marked out by the Christian populace as an object of vengeance. One day, as she was proceeding to lecture in her school, a party of these wretched fanatics dragged her out of her chariot into a neighbouring church, and murdered her there with circumstances of revolting barbarity.

I think it very probable that the traditions relating to her death

were mixed up with the legend of St. Catherine, and took that particular character and colouring which belonged to the Greco-Christian legends of that time.[1]

The devotional representations of St. Catherine must be divided into two classes. I. Those which exhibit her as the patron saint and martyr, alone or grouped with others. II. The mystical subject called ' The Marriage of St. Catherine.'

I. As patroness she has several attributes. She bears the palm as martyr; the sword expresses the manner of her death; the crown is hers of right, as sovereign princess; she holds the book as significant of her learning; she tramples on the pagan tyrant. All these attributes may be found in the effigies of other saints; but the especial and peculiar attribute of St. Catherine is the wheel. When entire, it is an emblem of the torture to which she was exposed: in the later pictures it is oftener broken; it is then an historical attribute, it represents the instrument by which she was to have been tortured, and the miracle through which she was redeemed. She leans upon it, or it lies at her feet, or an angel bears it over her head. In Raphael's St. Catherine, in our National Gallery, she leans on the wheel, and no other attribute is introduced: this, however, is very uncommon; the characteristic sword and the book are generally present, even where the crown and palm are omitted. The grim turbaned head of Maximin, placed beneath her feet, is confined, with very few exceptions, to the sculptural and Gothic effigies and the stained glass of the fourteenth century.

In the earliest Greek mosaics and pictures, St. Catherine wears the richly embroidered dress given in Greek Art to all royal personages; the diadem on her head, a book and a cross in her hand, and no wheel. She has, generally, a dignified but stern expression.

---

[1] It was perhaps the early relations of Venice with the East which rendered St. Catherine so popular in that city as patroness. Her festival is called the *Festa dei Dotti*, and was instituted in her honour by the Doge Pietro Gradenigo, in 1307.

All the colleges and universities of the Venetian States, Padua especially, were placed under her protection, and opened, after the recess, on the day of her festival.

In the best examples of early Italian Art, and in those of the Giotto school, the prevailing character is simplicity and earnestness. In the Milan school there is, generally, more of intellect and refinement; and, in particular, an ample brow, with the long fair hair parted in front. In the Venetian pictures she is generally most sumptuously dressed in ermine and embroidery, and all the external attributes of royalty. In the Florentine pictures she has great elegance, and in the Bologna school a more commanding majesty. In the early German school we find that neglect of beauty which is characteristic of the school, but the intellectual and meditative dignity proper to the saint is, in the best masters, powerfully rendered.

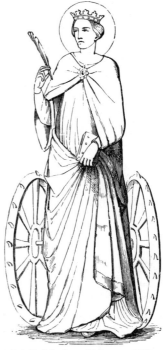

Representations of St. Catherine as patroness so abound in every form of Art, and are so easily recognised, that I shall mention only a few among them, either as examples of excellence, or of some particular treatment in the character and attributes which may lead the reader to observe such familiar effigies with more of interest and discrimination, and with reference to that appropriate character which the circumstances of her story should lead us to require.

1. School of Giotto. ' St. Catherine, as patron saint and martyr, stands between two wheels, holding her book and palm ; ' a beautiful picture, in the possession of M. Auguste Valbreque, who allowed me to make a sketch from it: the *two* wheels are unusual (117).

117   St. Catherine   (Giotto   A.D. 1320)

2. Greco-Italian. St. Catherine is seated on a throne, wearing the royal crown, and with an air of profound meditation. Scattered around, and at her feet, a number of books, mathematical instruments, and

118    Sculpture   (Strasburg Cathedral)          119   Gothic Sculpture    (Chapel of Henry VII.)

tablets, on which are traced calculations and problems, also a celestial
sphere.    She is here the especial patroness of science and philosophy :
—the Urania of the Greeks.[1]

3. Siena School.    She stands, crowned, and holding the book and
palm.    On the flat dark background of the picture are painted the
implements of the mechanical arts, such as shears, hammers, saws, a
carpenter's rule and plane, a pair of compasses, a pestle and mortar,

[1] Florence, Rinuccini Gal.

combs for carding wool, a spindle and distaff, &c. She is here the especial patroness of the Arts :—the Greek Minerva.

4. Gothic Sculpture. She stands with a scroll in her raised hand, trampling a philosopher under her feet. On reflection, I am not sure that this fine figure is a St. Catherine, but perhaps Wisdom or Science in the allegorical sense.

5. Ghirlandajo.[1] She stands, crowned, and partly veiled, with one hand on the wheel, the other sustains the folds of her drapery; a ring conspicuous on her finger, in allusion to her mystical espousals. The face has little beauty and rather a severe expression, but the figure and attitude are full of dignity, and the drapery most elegant.

6. Gothic Sculpture. She stands with the book and sword, wearing the royal crown; under her feet the wheel and the Emperor Maximin. In the same style are the effigies in the stained glass of the thirteenth and fourteenth centuries.

7. Raphael. She leans on her wheel, looking up. The beautiful picture is in our National Gallery. Raphael's original first thought for the head, sketched with a pen, is at Oxford; the more finished drawing is in the possession of the Duke of Devonshire.

8. Siena School. She stands, crowned, with her book and palm; a small broken wheel, worked in gold, suspended from her neck as an ornament.

9. Hans Hemling (?). St. Catherine kneeling, in a Coronation of the Virgin. She is crowned and richly attired. The broken wheel is suspended as an ornament at the end of a gold chain, fastened to her girdle: just as a German woman wears her bunch of keys.[2]

10. Albert Dürer. She is crowned; seated on a chair, which looks like a professor's chair; at her side the sword; in front a portion of a broken wheel (120).

11. Intarsiatura. She stands, crowned; in the left hand the palm, in the other the sword. The head of the tyrant is at her feet, and the point of the sword pierces his mouth, showing that she had vanquished

---

[1] Fl. Acad.

[2] The Coronation of the Virgin, in the gallery of Prince Wallerstein, now in Kensington Palace, is by some attributed to Hemling.

120      St. Catherine   (Albert Dürer.   A.D. 1510)

him in argument. A figure of singular elegance, in the Florentine manner, in the Church of S. Giovanni at Malta.

12. Milan School: Leonardo, or Luini. She is crowned with myrtle, and holds her book ; on each side a most beautiful angel, one of whom bears the wheel, the other the palm. The expression full of intellect and sweetness.[1]

13. Cesare da Sesto. She is looking down with a contemplative air, her long golden hair crowned with a wreath of myrtle, and leaning with both hands on her wheel. Most beautiful and refined.[2]

14. Francia. She is crowned, as patron saint, and looking down, one hand resting on her wheel. The figure amply draped and full of dignity. The engraving by Marc' Antonio is rare and beautiful.

[1] In the collection of Mr Howard of Corbie.        [2] Frankfort Museum.

15. Luini School.[1] She is between two wheels, with long dishevelled hair, and hands clasped in supplication. She is here the martyr only.

16. Palma.[2] St. Catherine, crowned and richly draped, at the feet of the Madonna. It is the portrait of his daughter, the beautiful Violante.

The figures of St. Catherine by Titian, Paul Veronese, and Tintoretto, all have the air of portraits, and, in general, are sumptuously crowned and attired, with luxuriant fair hair, and holding the palm oftener than the book. She appears, in such pictures, as the patron saint of Venice. There is a famous picture, by Titian, of the unhappy Catherine Cornaro, Queen of Cyprus, in the character of St. Catherine.

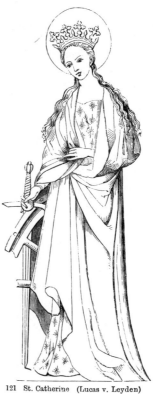

121 St. Catherine (Lucas v. Leyden)

17. Paul Veronese. St. Catherine, kneeling on her broken wheel, looks up at the Madonna and Child on a throne above. She is here attired as a Venetian lady of rank, and wears the royal crown.

18. Annibal Caracci. St. Catherine, as patroness of the arts and sciences, and St. Luke as patron saint of painting, on each side of the Madonna and Child.

19. Guido. She is kneeling, as martyr, with clasped hands and flowing hair; the figure being taken from one of the disconsolate mothers in the famous Massacre of the Innocents, slightly altered, is deficient in character. The wheels are in the background.[3]

---

[1] Pitti Pal.  [2] Vienna Gal.  [3] Windsor Gal.

20.  St. Catherine reading.  To distinguish her from other saints who also read, a small wheel is embroidered on her book.

21.  Domenichino.  She is standing, as patron saint, with crown, sword, palm, and wheel.  The attributes crowded; the figure majestic, but mannered, and without much character.  There is also the same figure half-length at Windsor.

22.  Domenichino.  She is standing, as martyr; an angel descends with the crown and palm: very dignified and beautiful.[1]

23.  St. Catherine reading; she rests one hand, which holds the palm, on her wheel.  In such pictures she is the patroness of students and scholars.  There is an example at Hampton Court.

When St. Catherine is grouped with other saints, her usual pendant is St. Barbara, sometimes also Mary Magdalene; in the Venetian pictures, frequently St. George.  In the German pictures, St. Catherine is often grouped with St. Ursula.  As patroness of learning, she is sometimes in companionship with one or other of the Doctors of the Church; most frequently with St. Jerome.

The MARRIAGE OF ST. CATHERINE, however treated, must be considered as a strictly devotional subject: it is not an incident; it is an allegorical vision, implying the spiritual union between Christ and the redeemed soul.  This is the original signification of the subject, and there can be no doubt that the religious interpretation of the 'Song of Solomon,' with all its amatory and hymeneal imagery, led the fancy to this and similar representations.  Whatever may be thought of the Marriage of St. Catherine in this mystical sense, we cannot but feel that as a subject of Art it is most attractive; even in the most simple form, with only three persons, it combines many elements of picturesque and poetical beauty.  The matronly dignity of the maternal Virgin, the god-like infancy of the Saviour, the refined loveliness and graceful humility of the saint, form of themselves a group susceptible of the most various, the most delicate, shades of expression.

The introduction of angels as attendants, or of beatified personages as spectators, or other ideal accessories, must be considered as strictly

[1] Sutherland Gal.

in harmony with the subject, lending it a kind of scenic and dramatic interest, while it retains its mystical and devotional character.

The Marriage of St. Catherine is one of the subjects in early Greek Art; but it occurs very seldom in Italian Art before the middle of the fifteenth century: in the sixteenth it became popular, and, for obvious reasons, it was a favourite subject in nunneries. Why, I do not know, but it has always been very rare in German Art; and therefore it is the more remarkable that the earliest example that I can cite is from one of the earliest artists of the genuine German school, the anonymous engraver whom we know only as ' Le graveur de 1466.' Whoever he may have been, he was certainly a man of a most original and poetical turn of mind ; he lived in the very infancy of the art, being, I suppose, the first German who took the burin in hand after the invention of copperplate engraving; but his works, in spite of their rudeness in drawing and execution, are a storehouse of poetical ideas. What, for instance, can be more fanciful, and more true to the mysticism of the subject, than his arrangement of the ' Marriage of St. Catherine '? The scene is Paradise ; the Virgin-mother, seated on a flowery throne, is in the act of twining a wreath, for which St. Dorothea presents the roses ; in front of the Virgin kneels St. Catherine, and beside her stands the Infant Christ (here a child about five or six years old), and presents the ring : on one side, St. Agnes, St. Barbara, St. Agatha, and St. Margaret ; on the other, St. Mary Magdalene and St. Apollonia ; the figures being disposed in a semicircle. Behind the throne of the Virgin is seen a grand chorus of angels, holding scrolls of music in their hands, and singing ' Gloria in excelsis Deo !'—the Holy Spirit, in form of a dove, is hovering over the whole. The conception, it must be admitted, is in the highest degree poetical ; in the same degree, the execution is rude, and the drawing meagre.

1. Correggio. Two very celebrated pictures. In the first example, which is life-size, St. Catherine bends down with the softest, meekest tenderness and submission, and the Virgin unites her hand to that of the Infant Christ, who looks up in His mother's face with a divine yet infantine expression. St. Sebastian stands by holding his arrows.[1] It is of this picture that Vasari truly said that the heads

[1] Louvre, No. 27.

122                      Marriage of St. Catherine   (Titian)

appeared to have been painted in Paradise.  In the background is
seen the martyrdom of the two saints.

The other example is a small picture, also of exquisite beauty : here
the attendant is an angel.[1]

2.  Cola dell' Amatrice.   The Virgin-mother is seated on a sort of
low bench.   The Child, standing on her knees, presents the ring to
St. Catherine, who is also standing, simply attired, and with no
attribute but the sword, which she holds upright :—this treatment
is peculiar.

3.  Titian.   The Infant Christ is seated on a kind of pedestal, and
sustained by the arms of the Virgin.   St. Catherine kneels before
him, and St. Anna, the mother of the Virgin, gives St. Catherine
away, presenting her hand to receive the ring : St. Joseph is standing
on the other side ; two angels behind the saint look on with an ex-
pression of celestial sympathy.   In general the Venetian painters
lavished on this favourite subject the richest, most fanciful, most
joyous accompaniments : as in a picture by P. Veronese, where the
scene is a palace or a luxurious landscape ; St. Catherine is in the

[1] Naples, Musée.

123     Marriage of St. Catherine   (Cola dell' Amatrice, 1533)

gorgeous bridal attire of a princess, and a choir of angels chant
hymns of joy.    There is a picture by Titian in which St. Catherine,
kneeling by the cradle of the Infant Saviour, has taken Him in her
arms, and presses Him to her bosom with the action of a fond nurse;
so completely was the solemn and mystical allegory of the nuptial
bond forgotten or set aside ! [1]

4. Perugino.    The Virgin, seated, holds the Infant Saviour stand-
ing on her knee; He bends forward to put the ring on St. Catherine's
right hand.    Joseph is seen behind in meditation.

5. Parmigiano.    The Virgin as usual with the Infant Christ upon
her knee; St. Catherine, resting one hand upon her wheel, presents

[1] Pitti Pal., Fl.

the other; and the Infant Christ, while He puts the ring on her finger, throws himself back, looking up in His mother's face, as if He were at play.   Beneath is the head of an old man, with a long grey beard, holding a book : whether the painter intended him for Joseph, who is often present on this occasion, or for the old hermit of the legend, is not clear.[1]

6. Rubens makes the ceremony take place in presence of St. Peter, St. Paul, and a vast company of saints and martyrs.[2]

7. Vandyck.   The Virgin holds a wreath of flowers in her hand ready to crown the saint at the same moment that she receives the ring from Christ; the expression of St. Catherine as she bends in adoration is most charming; in one hand she holds the palm-branch, resting it upon the wheel.   The exceeding beauty of the Virgin has obtained for this picture the appellation of ' la plus belle des Vierges.'[3]

Sometimes the *Divoto* for whom the picture has been painted is supposed to be present.   I remember a Marriage of St. Catherine in presence of the Emperor Matthias and his court.   I have seen some instances in which the divine Infant, instead of presenting the nuptial ring, places a wreath of roses on her head.   In all these examples Christ is represented as a child.   In one instance only I have seen Him figured as a man about thirty, standing on one side attended by a company of angels, while Catherine stands opposite attended by a train of virgin-martyrs.

I do not remember a single instance of ' The Marriage of St Catherine ' in the stained glass of the fourteenth century; but such may exist : the other subjects from her history are commonly met with.

The *Sposalizio* of St. Catherine of Alexandria, the princess-martyr, must not be confounded with the *Sposalizio* of St. Catherine of Siena, who was a Dominican nun.[4]

Both are sometimes represented in the same picture.

8. Ambrogio Bogognone.   The Virgin is seated on a splendid throne, holding the divine Child; on the right kneels St. Catherine of Alexandria ; on the left St. Catherine of Siena.   The Infant presents a

---

[1] Both pictures are in the Grosvenor Gal.

[2] A magnificent picture, containing more than twenty figures, in the church of the Augustines at Antwerp.

[3] In the Queen's Gal., Buckingham Palace.     [4] See the 'Monastic Orders,' p. 395.

ring to each, the Mother guiding His little hands :—a most beautiful picture.[1]

Some of the most striking incidents in the life of St. Catherine have been treated historically, as separate subjects.

1. ' The Dispute with the fifty Philosophers ; ' the number of the philosophers generally represented by a few persons. Pinturicchio has painted this subject in a large crowded fresco. The scene is the interior of a temple: Maximin is on his throne; and before him, standing, St. Catherine, attired in a richly embroidered dress ; in one hand her book, the other raised; around the throne of the emperor, many philosophers, some arguing, some demonstrating, some meditating doubtfully, others searching their great books; farther off, spectators and attendants : about fifty figures in all.[2]

Vasari. St. Catherine, with her robe and hair flying loose, and in a most theatrical attitude, disputes with the philosophers, who are turning over their books : the emperor looks down from a balcony above.[3]

Where St. Catherine is standing, or sitting on a raised throne, as one teaching, rather than disputing, and with seven philosophers around her, then the subject evidently represents the ' seven wise masters ' whom her father had assembled to teach her, and who became her disciples; and St. Catherine should look like the magnificent princess in Tennyson's poem—

> Among her grave professors, scattering gems
> Of art and science.

2. The subject usually called the ' Martyrdom of St. Catherine,' her exposure to the torture of the wheels, should rather be called the Deliverance of St. Catherine. It is one of the most frequent subjects in early Art. The leading idea is always the same, and the subject easily recognised, however varied in the representation. St. Catherine is seen between two or four wheels armed with iron teeth or spikes, while two or more executioners prepare to turn the wheels; or she is kneeling beside the instrument of torture: the emperor and his attendants are sometimes introduced: an angel, descending from

---

[1] When I saw it, in possession of M. Grahl of Dresden.

[2] Vatican, Rome.  [3] Capitol, Rome.

heaven amid thunder and lightning, or bearing an avenging sword, breaks the wheels, and scatters horror and confusion among the pagans.

The most beautiful instance I can remember is the large picture by Gaudenzio Ferrari. She is represented in a front view, kneeling, her hair dishevelled, her hands clasped, and in the eyes, upraised to the opening heavens above, a most divine expression of faith and resignation ; on each side are the wheels armed with spikes, which the executioners are preparing to turn : behind sits the emperor on an elevated throne, and an angel descends from above armed with a sword. In this grand picture the figures are life-size.[1]

By Albert Dürer, a most spirited woodcut, rather coarse, however, in execution. She is kneeling, with bowed head; the wheels are broken by a tempest from heaven ; the executioners look paralysed with horror.

There is a fine dramatic composition by Giulio Romano, in which the wheels are seen shivered by lightning and stones from heaven, which are flung down by angels; the executioners and spectators are struck dead or confounded.

3. ' The Vision of St. Catherine.' She is represented sleeping in the arms of an angel. Another angel with outspread wings appears to address her. Infant angels, bearing the palm, the crown, the wheel, and the sword, hover around. I have seen but one example of this subject; it is engraved in the Teniers Gallery.

4. ' The Decapitation of St. Catherine' is, properly, her *martyrdom.* This subject is of frequent occurrence, and little varied; in general, the broken wheels are introduced in the background, in order to distinguish St. Catherine from other female saints who were also decapitated. There is a very fine and curious engraving, in which St. Catherine is kneeling; the executioner stands near her, and three angels extend a linen cloth to receive and bear away her body. Maximin and others are behind.[2]

Spinello. In the foreground, St. Catherine is decapitated; above are seen four angels bearing her body over sea and land ; and in the far distance, two angels bury her on the summit of Mount Sinai.[3]

5. ' St. Catherine buried by the Angels.' Of this charming subject,

---

[1] Milan, Brera.        [2] Bartsch, vi. 374.        [3] Berlin Gal.

124       Angels bear St. Catherine to Mount Sinai  (Mücke)

so frequently introduced into the background of the scene of her martyrdom, there are many examples in a separate form.

There is a fresco by Luini, in the Brera at Milan, of exceeding beauty. Three angels sustain the body of St. Catherine, hovering above the tomb in which they prepare to lay her. The tranquil refined character of the head of the saint, and the expression of death, are exceedingly fine (116).

In an elegant little picture by Giles de Rye, two angels lay her in a marble sarcophagus, and a third scatters flowers.[1] There is another by Cespedes at Cordoba.[2]

There is a modern version of this fine subject, by a German painter (Mücke), which has become popular: four angels bear the body of St. Catherine over sea and land to Mount Sinai: one of the foremost carries a sword, the instrument of her martyrdom. The floating, onward movement of the group is very beautifully expressed (124).

In the Spanish Gallery of the Louvre, now dispersed, there was

[1] Vienna Gal.      [2] v. Stirling's 'Artists of Spain,' p. 339.

a curious votive picture by F. Herrera, of which one would like to
know the history. A nobleman of Seville, and his family, are
imprisoned in a dungeon; they implore the aid of St. Catherine,
who appears to them, habited in the rich Spanish costume of the
time (about 1620), and promises them deliverance.

Another legend of St. Catherine is represented in a small old
picture by Ambrogio di Lorenzo:[1] on one side are seen two nuns
vainly imploring a physician to heal one of the sisterhood who is sick;
on the other, the sick nun is seen lying in her cell; St. Catherine
descends from heaven to heal her. These and similar pictures may
be considered as votive offerings to St. Catherine, as the giver of
good counsel, in which character she is particularly venerated.

The life of St. Catherine forms a beautiful and dramatic series, and
is often met with in the chapels dedicated to her. And it is worthy
of remark that the mystical 'marriage' is scarcely ever included in
the historical series, but reserved as an altar-piece, or treated apart.

On a window of the Cathedral at Angers—

1. St. Catherine disputes with the emperor and the philosophers.
Maxentius sits on a throne with a sword in his hand; she stands
before him with a book. 2. She is bound between two wheels; a
hand out of heaven breaks the wheels. 3. St. Catherine, in prison,
converts the empress. 4. Christ visits her in prison; an angel
brings her a crown. 5. Catherine is bound and scourged by two
executioners. 6. The empress is beheaded on one side; and St.
Catherine on the other. 7. Three angels bury St. Catherine; two
lay her in the sepulchre; one stands by, holding her severed head in
a napkin.

The series in her chapel at Assisi is much ruined. It appeared to
me to consist of the usual scenes. In the conversion of the em-
press she is seated inside the prison, listening to the instruction
of Catherine, while Porphyry stands without, holding her palfrey.

I observed, in the last subject of the series, that St. Catherine instead
of being buried by three angels, which is the usual manner, is borne
over land and sea by a whole troop of angels, ten or twelve in number.

By Masaccio. In the chapel of St. Catherine, in the church of San

----

[1] Berlin Gal.

Clemente, at Rome, we find this celebrated series: in spite of its ruined condition, the grave sentiment and refinement of the principal figures are still most striking. 1. She refuses to adore the idols. 2. She converts the empress. She is seen through a window seated inside a prison, and the empress is seated outside of the prison, opposite to her, in a graceful listening attitude. 3. The empress is beheaded, and her soul is carried by an angel into heaven. 4. St. Catherine disputes with the philosophers. She is standing in the midst of a hall, the forefinger of one hand laid on the other, as in the act of demonstrating. She is represented fair and girlish, dressed with great simplicity in a tunic and girdle,—no crown, nor any other attribute. The sages are ranged on each side, some lost in thought, others in astonishment: the tyrant is seen behind, as if watching the conference; while through an open window we behold the fire kindled for the converted philosophers, and the scene of their execution. 5. Catherine is delivered from the wheels, which are broken by an angel. 6. She is beheaded. In the background angels lay her in a sarcophagus on the summit of Mount Sinai.

125      Angels bury St. Catherine  (Masaccio)

## St. Barbara.

*Ital.* Santa Barbara.   *Fr.* Sainte Barbe.

Patron saint of armourers and gunsmiths ; of fire-arms and fortifications.   She is invoked
against thunder and lightning, and all accidents arising from explosions of gunpowder.
Patroness of Ferrara, Guastala, and Mantua.   (Dec. 4, A.D. 303.)

THE legend of St. Barbara was introduced from the East about the
same time with that of St. Catherine.   She is the armed Pallas or
Bellona of the antique mythology, reproduced under the aspect of a
Christian martyr.

'There was a certain man named Dioscorus, who dwelt in Helio-
polis ; noble, and of great possessions ; and he had an only daughter,
named Barbara, whom he loved exceedingly.   Fearful lest, from her
singular beauty, she should be demanded in marriage and taken
from him, he shut her up in a very high tower, and kept her secluded
from the eyes of men.   The virtuous Barbara, in her solitude, gave
herself up to study and meditation ; from the summit of her tower
she contemplated the stars of heaven and their courses ; and the
result of her reflections was, that the idols of wood and stone wor-
shipped by her parents could not be really gods—could not have
created the wonders on which she meditated night and day.   So she
contemned, in her heart, these false gods ; but as yet she knew not
the true faith.

'Now, in the loneliness of her tower, the fame reached her of a
certain sage who had demonstrated the vanity of idolatry and who
taught a new and holy religion.   This was no other than the famous
doctor and teacher, Origen, who dwelt in the city of Alexandria.
St. Barbara longed beyond measure to know more of his teaching.
She therefore wrote to him secretly, and sent her letter by a sure
messenger, who, on arriving at Alexandria, found Origen in the
house of the Empress Mammea, occupied in expounding the Gospel.
Origen, on reading the letter of St. Barbara, rejoiced greatly ; he
wrote to her with his own hand, and sent to her one of his disciples,
disguised as a physician, who perfected her conversion, and she
received baptism from his hands.

'Her father, Dioscorus, who was violently opposed to the Christians, was at this time absent: but previous to his departure he had sent skilful architects to construct within the tower a bath-chamber of wonderful splendour. One day St. Barbara descended from her turret to view the progress of the workmen; and seeing that they had constructed two windows, commanded them to insert a third. They hesitated to obey her, saying, "We are afraid to depart from the orders we have received." But she answered, "Do as I command: ye shall be held guiltless." When her father returned he was displeased; and he said to his daughter, "Why hast thou done this thing, and inserted three windows instead of two?"—and she answered, "Know, my father, that through three windows doth the soul receive light—the Father, the Son, and the Holy Ghost; and the Three are One." Then her father, being enraged, drew his sword to kill her, and she fled from him to the summit of the tower, and he pursued her; but by angels she was wrapt from his view, and carried to a distance. A shepherd betrayed her by pointing silently to the place of her concealment; and her father dragged her thence by the hair, and beat her, and shut her up in a dungeon;—all the love he formerly felt for his daughter being changed into unrelenting fury and indignation when he found she was a Christian. He denounced her to the proconsul Marcian, who was a cruel persecutor of the Christians: the proconsul, after vainly endeavouring to persuade her to sacrifice to his false gods, ordered her to be scourged and tortured horribly; but St. Barbara only prayed for courage to endure what was inflicted, rejoicing to suffer for Christ's sake. Her father, seeing no hope of her yielding, carried her to a certain mountain near the city, drew his sword, and cut off her head with his own hands; but as he descended the mountain, there came on a most fearful tempest, with thunder and lightning, and fire fell upon this cruel father and consumed him utterly, so that not a vestige of him remained.'[1]

In the devotional pictures, St. Barbara bears the sword and palm in common with other martyrs; when she wears the diadem, it is as martyr, not as princess: she has also the book, and is often

[1] 'Legenda Aurea.'

reading, in allusion to her studious life; but her peculiar, almost invariable, attribute is the tower, generally with three windows, in allusion to the legend.

St. Barbara, as protectress against thunder and lightning, firearms, and gunpowder, is also invoked against sudden death; for it was believed that those who devoted themselves to her should not die impenitent, nor without having first received the holy sacraments. She therefore carries the sacramental cup and wafer, and is the only female saint who bears this attribute. She is usually dressed with great magnificence, and almost always in red drapery. The tower is often a massy building in the background, and she holds the sword in one hand, and the Gospel or palm in the other: occasionally, in early pictures, and early German prints, she holds a little tower in her hand, merely as a distinguishing attribute; or she is leaning on it as a pedestal.

In a beautiful picture of the Van Eyck school which I saw in the museum at Rouen, representing the Virgin and Child throned in the midst of female saints, St. Barbara is seated on the left of the Madonna, bending over a book, and wearing on her head a rich and tasteful diadem of gems and gold, the front of which is worked into the form of a triple tower. I have seen the tower modelled in gold, suspended in a golden chain from her girdle.

I have seen several pictures of St. Barbara in which she holds a feather in her hand; generally a peacock's feather. I have never met with any explanation of this attribute; and am inclined to believe, as it is only found in the German pictures, that it refers to an old German version of her legend, which relates that when St. Barbara was scourged by her father, the angels changed the rods into feathers.

The expression of the head varies with the fancy of the painter; but in the best pictures, at least in all those that aspire to character, the countenance and attitude convey the idea of thoughtfulness, dignity, and power. Luini, in a fresco group in the Brera, where she stands opposite to St. Antony, has given her this expression of ' umiltà superba.' Domenichino has given her this look, with large lustrous eyes, full of inspiration.

1. The most beautiful of the single figures to which I can refer is the chef-d'œuvre of Palma Vecchio, placed over the altar of St. Barbara in

1 *S.ᵗ Barbara enthroned*
2 *S.ᵗ Barbara building her tower.*

the church of Santa Maria Formosa at Venice. She is standing in a majestic attitude, looking upwards with inspired eyes, and an expression like a Pallas. She wears a tunic or robe of a rich warm brown, with a mantle of crimson; and a white veil is twisted in her diadem and among the tresses of her pale golden hair: the whole picture is one glow of colour, life, and beauty; I never saw a combination of expression and colour at once so soft, so sober, and so splendid. Cannon are at her feet, and her tower is seen behind.[1] Beneath, in front of the altar, is a marble bas-relief of her martyrdom; she lies headless on the ground, and fire from heaven destroys the executioners.

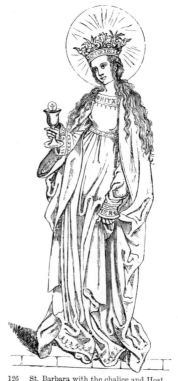

There is a very fine single figure of St. Barbara holding her cup and wafer, by Ghirlandajo.[2]

2. Almost equal in beauty, but quite in the German style, is a full-length by Holbein in the Munich Gallery (126).

3. Matteo da Siena (1479). Enthroned as patron saint, she holds in her left hand a tower, within the door of which is seen the cup and wafer; her right hand holds the palm, and two angels, bearing

126    St. Barbara with the chalice and Host
(Holbein)

---

[1] This is the most celebrated of the numerous portraits of Violante Palma, Titian's first love, according to the well-known tradition, and whose beautiful face and form are to be traced in some of his early pictures, as well as those of Palma and Giorgione. Her portrait by Giorgione is in the Manfrini Palace; she is holding a guitar. Her portrait by her father is at Dresden; and her portrait by Titian, as Flora, in the Florence Gallery.

[2] Berlin Gal.

a crown, hover above her head; two other angels with musical instruments are at her feet; on the right of St. Barbara stands St. Catherine, and on the left St. Mary Magdalene.[1]

I give an etching of the principal figure.

4. Cosimo Roselli. St. Barbara, holding the tower in one hand, in the other the palm, stands upon her father, who is literally sprawling on the ground under her feet; on one side stands St. John the Baptist, on the other St. Matthias the apostle.[2] This is a strange, disagreeable picture, very characteristic of the eccentric painter: but for the introduction of the tower, I should have taken it for a St. Catherine trampling on the Emperor Maximin.

5. Michael Coxis. St. Barbara is represented holding a feather in her hand (127). In two pictures (old German) it is distinctly a white ostrich feather; in others, it is a peacock's feather. In a Madonna picture by Vander Goes, the Virgin is seated with the Child on her knee; two angels crown her; on the right, St. Catherine, with the sword and part of the wheel lying before her, presents an apple to the Infant Christ; on the left is St. Barbara, with a book on her knee, and holding a peacock's feather in her hand. The whole exquisite for finish and beauty of workmanship.[3]

It is usual in a sacred group (*Sacra Conversazione*) to find St. Catherine and St. Barbara in companionship, particularly in German Art; and then it is clear to me that they represent the two powers which in the Middle Ages divided the Christian world between them. St. Catherine appears as the patroness of schoolmen, of theological learning, study, and seclusion; St. Barbara as patroness of the knight and the man-at-arms—of fortitude and active courage. Or, in other words, they represent the active and the contemplative life, so often contrasted in the mediæval works of Art.[4]

There is a beautiful and well-known drawing by J. Van Eyck, in which St. Barbara is seated in front, with outspread ample drapery and long fair hair flowing over her shoulders. Behind her is a magnificent Gothic tower, of most elaborate architecture, on which a number of masons and builders are employed.

[1] Siena, San Domenico.          [2] Fl. Acad.
[3] Florence Gal.          [4] 'Legends of the Madonna,' p. 97.

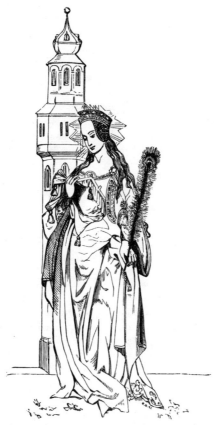

127  St. Barbara with a feather (Michael Coxis. Munich Gal.)

St. Barbara is frequently introduced into pictures of the throned Madonna. The most celebrated example is the 'Madonna di San Sisto' of Raphael, in which she is kneeling to the left of the Virgin; on the other side is St. Sixtus. The expression in the two saints is admirably discriminated. St. Sixtus implores the Virgin in favour of the brotherhood for whom the picture was painted; St. Barbara

requires for the Virgin the devotions of the faithful. I have already observed that, where saints are grouped together, the usual pendant of St. Barbara is St. Catherine, unless there are special reasons for introducing some other personage,—as in this instance: the picture having been painted for the monastery of San Sisto at Piacenza.

Historical pictures of St. Barbara are confined to few subjects.

1. In a small ancient picture, evidently part of a predella, St. Barbara with two female attendants is seen standing before a tower, which has a drawbridge let down over a moat; she seems about to enter; several masons are at work building the tower. (As in the etching.) In the other half of the picture she is lying in a shrine hung with votive offerings, and the crippled and the sick appear before it as suppliants.

2. Pinturicchio, large fresco in the Vatican. In the centre the mystical tower; on one side, she is flying from her father; on the other, the wall opens, and she escapes. The treacherous shepherd is seen in the distance.

3. Rubens. St. Barbara flies from her father to the top of a tower; he, in the likeness of a 'turbaned Turk,' is seen pursuing her, sword in hand: a small sketch in the Dulwich Gallery.

In pictures of the martyrdom of St. Barbara, the leading idea or *motif* does not vary; she is on her knees, and her father, always in a turban, the heathen attribute, seizes her by the hair with one hand, holding his sword in the other. Generally we find the tower in the background, or a peaked mountain, to express the locality. Among many engravings of this scene may be mentioned a very curious and beautiful old print, in which Dioscorus is in the very act of striking off her head; the tower is seen behind, and in the window stands the sacramental cup.[1]

A picture of striking beauty is the Martyrdom of St. Barbara over her altar in the church of S. Maria-delle-Grazie at Brescia. She kneels in a white tunic embroidered with gold. Her pagan father, turbaned as usual, has seized her by the hair: she looks up full

---

[1] Le Graveur de 1466. Bartsch, vi. 31.

of faith and love divine. There are several spectators, two on horse-back, others on foot; and, in the vigorous painting of the heads and magnificent colour, the picture resembles Titian. It is by his Brescian pupil and friend, Pietro Rosa.

In the church of St. Barbara at Mantua is her martyrdom, by Brusasorci, over the high altar; and in the church of St. Barbara at Ferrara there is a most beautiful altar-piece, by G. Mazzuoli, repre-senting the saint in the midst of a choir of virgin-martyrs, who seem to welcome her into their celestial community.

As patroness of firearms and against sudden death, the effigy of St. Barbara is a frequent ornament on shields, armour, and particularly great guns and fieldpieces. I found her whole history on a suit of armour which the Emperor Maximilian sent as a present to Henry VIII. in 1509, and which is now preserved in the Tower. On the breast-plate is St. George as patron of England, vanquishing the dragon; on the back-plate, St. Barbara standing majestic, with her tower, her cup, and her book. On the horse-armour we have the history of the two saints, disposed in a regular series, each scene from the life of St. George being accompanied by a corresponding scene from the life of St. Barbara. 1. St. George, mounted on horseback, like a knight of romance riding forth in search of adventures: St. Barbara, attended by two maidens, directs the building of her tower; a man is ascending a ladder with a hod full of bricks. 2. St. George is accused before the Emperor. St. Barbara is pursued by her father. 3. St. George is tortured by the wheels. St. Barbara is scourged. 4. St. George is beheaded by an executioner. St. Barbara is beheaded by her father, who seizes her by the hair in the usual manner, amid the raging of a tempest.

The designs are in the manner of Hans Burgmair's Triumph of Maximilian, and, probably by the same hand, elaborately engraved on the plates of the armour; the figures about six inches high. The arabesque ornaments which surround the subjects are of singular elegance, intermingled with the rose and pomegranate, the badge of Henry and Catherine of Aragon. The armour, being now exhibited to

advantage on a wooden man and horse, can easily be examined.    In
the description published in the 'Archæologia,' and the 'Guide to
the Tower,' there are a few mistakes; for instance, the 'scourging of
St. Barbara' is styled 'the scourging of St. Agatha,' who had no
concern in any way with war or armour.    Altogether, this suit of
armour is a curious and interesting illustration of the religious and
chivalric application of the Fine Arts.[1]

[1] I find only one church in England dedicated to St. Barbara, at Ashton-under-Hill, in
Gloucestershire.

128                St. Barbara wearing her tower as an ornament.

## St. Ursula and her Companions.

*Lat.* S. Ursula. *Ital.* Santa Orsola. *Fr.* Sainte Ursule.
Patroness of young girls, particularly school-girls, and of all women who devote
themselves especially to the care and education of their own sex. (Oct. 21.)

CERTAIN writers in theology, pitiably hard of belief, have set their
wits to work—rather unnecessarily, as it appears to me—to reduce
this extravagant and picturesque legend within the bounds of
probability: but when they have proved to their own satisfaction
that XI. M. V. means eleven Martyr Virgins, and not eleven
thousand;—that the voyage over the unstable seas, amid storm and
sunshine,—the winds sometimes fair, sometimes furiously raging,—
signifies the voyage of life, with all its vicissitudes; and the whole
story merely a religious allegory;—when this has all been laid down
incontrovertibly, we are not much advanced: for one thing is clear;
our ancestors, to whom all marvels and miracles in a religious garb
came equally accredited, understood the story literally. Endowed with
a sort of ' chevril ' faith, which stretched ' from an inch narrow to an
ell broad,' they found it quite as easy to believe in eleven thousand
virgins as in eleven; nor was there in its chronological and
geographical absurdities anything to stagger the faith of the
ignorant. In spite of the critical sneers of the learned, it kept its
hold on the popular fancy. It was especially delightful to the
women, whom it placed in a grand and poetical point of view;—

> And though small credit doubting wits might give,
> Yet maids and innocents would still believe!

The painters, in their efforts to give the story in a consistent form,
have had the most difficult part of the task, inasmuch as it has been
found embarrassing to bring the eleven thousand martyrs into any
reasonable compass; and the contrivances to which they have re-
sorted for the purpose are sometimes very picturesque and ingenious.

There are several different versions of this wild legend. In
general it seems admitted as a fact, that, at a period when Chris-
tianity and civilisation were contending for the mastery over

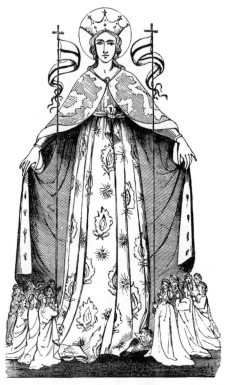

129        St. Ursula   (From a picture by St. Caterina di Vigri.   Bologna Gal.)

paganism and barbarism in the north of Germany, a noble maiden
and several of her companions were murdered for their faith, some-
where in the neighbourhood of Cologne.    Such incidents were
not then uncommon.   The exact date of the event is not fixed:
some mention the year 237 as the probable date; others 383; and
others again 451, when the Huns invaded Belgium and Gaul.
The tradition can be traced back to the year 600; in the year 846
the German Martyrology of Wandelbert extended its popularity
through the north of Europe.   The first mention of the definite
number of eleven thousand virgins was by Herman, bishop

of Cologne, in 922, and is said to be founded on a mistake of the abbreviation XI. M. V., i.e., eleven martyr virgins, for ' undecimilla virginis,' eleven thousand virgins.   Others reduce the eleven thousand to one ; they say that a virgin named *Undecimilla* perished with St. Ursula, which gave rise to the mistake.   All these attempts to reduce the legend to a fact, leave us, however, in the same predicament: we must accept it in the popular form in which it has been handed down to us, and which, from the multiplicity of the representations in Germany and Italy, has assumed a high degree of importance.   In some versions of the story—for instance, in the Spanish version of Ribadeneira—the journey to Rome is omitted; the names of the personages and the minor incidents vary in all. I shall adhere to the Cologne version, as that which has been the most popular, and, I believe, invariably followed in German and Italian Art.

' Once on a time there reigned in Brittany a certain king, whose name was Theonotus,[1] and he was married to a Sicilian princess whose name was Daria.   Both were Christians, and they were blessed with one daughter, whom they called Ursula, and whom they educated with exceeding care.[2]   When Ursula was about fifteen, her mother, Queen Daria, died, leaving the king almost inconsolable; but Ursula, though so young, supplied the place of her mother in the court.   She was not only wonderfully beautiful, and gifted with all the external graces of her sex, but accomplished in all the learning of the time.   Her mind was a perfect storehouse of wisdom and knowledge: she had read about the stars, and the courses of the winds; all that had ever happened in the world from the days of Adam she had by heart; the poets and the philosophers were to her what childish recreations are to others: but, above all, she was profoundly versed in theology and school divinity, so that the doctors were astonished and confounded by her argumentative powers.   To these accomplishments were added the more excellent gifts of humility, piety, and charity, so that she was esteemed the

---

[1] In the Italian versions of the Legend, he is called ' Il Re Mauro.'

[2] The derivation and meaning of the name, since so popular in Europe, is thus given by Surius :—*Hinc itaque, quia exemplo David immanem ursum scilicet diabolum quandoque suffocatura erat, Deo disponente (qui quos vocat prædestinat), parentibus illi in baptismate præsagum nomen* URSULA *indicatum est.*

most accomplished princess of the time.  Her father, who loved her
as the light of his eyes, desired nothing better than to keep her
always at his side.  But the fame of her beauty, her virtue, and her
wondrous learning, was spread through all the neighbouring lands,
so that many of the neighbouring princes desired her in marriage :
but Ursula refused every offer.

'Not far from Brittany, on the other side of the great ocean, was
a country called England, vast and powerful, but the people were
still in the darkness of paganism ; and the king of this country had
an only son, whose name was Conon, as celebrated for his beauty of
person, his warlike prowess, ánd physical strength, as Ursula for her
piety, her graces, and her learning.  He was now old enough to
seek a wife ; and his father, King Agrippinus, hearing of the great
beauty and virtue of Ursula, sent ambassadors to demand her in
marriage for his son.

'When the ambassadors arrived at the palace of the King of Brit-
tany, they were very courteously received, but the king was secretly
much embarrassed, for he knew that his daughter had made a vow
of perpetual chastity, having dedicated herself to Christ; at the same
time, he feared to offend the powerful monarch of England by refus-
ing his request : therefore he delayed to give an answer, and, having
commanded the ambassadors to be sumptuously lodged and enter-
tained, he retired to his chamber, and, leaning his head on his hand,
he meditated what was best to be done ; but he could think of no
help to deliver him from this strait.

' While thus he sat apart in doubt and sadness, the princess entered,
and, learning the cause of his melancholy, she said with a smile, " Is this
all ?  Be of good cheer, my king and father! for, if it please you, I will
myself answer these ambassadors."  And her father replied, "As thou
wilt, my daughter."  So the next day, when the ambassadors were again
introduced, St. Ursula was seated on a throne by her father's side,
and, having received and returned their salutation with unspeakable
grace and dignity, she thus addressed them :—" I thank my lord
the King of England, and Conon his princely son, and his noble
barons, and you, sirs, his honourable ambassadors, for the honour ye
have done me, so much greater than my deserving.  I hold myself
bound to your king as to a second father, and to the prince his son

as to my brother and bridegroom, for to no other will I ever listen. But I have to ask three things. First, he shall give for me as my ladies and companions ten virgins of the noblest blood in his kingdom, and to each of these a thousand attendants, and to me also a thousand maidens to wait on me. Secondly, he shall permit me for the space of three years to honour my virginity, and, with my companions, to visit the holy shrines where repose the bodies of the saints. And my third demand is, that the prince and his court shall receive baptism; for other than a perfect Christian I cannot wed.'

'Now you shall understand that this wise princess, Ursula, made these conditions, thinking in her heart, " either the King of England will refuse these demands, or, if he grant them, then eleven thousand virgins are redeemed and dedicated to the service of God." The ambassadors, being dismissed with honour, returned to their own country, where they made such a report of the unequalled beauty and wisdom of the princess that the king thought no conditions too hard, and the prince his son was inflamed by desire to obtain her; so he commanded himself to be forthwith baptized; and the king wrote letters to all his vassals in his kingdom of France, in Scotland, and in the province of Cornwall, to all his princes, dukes, counts, barons, and noble knights, desiring that they would send him the required number of maidens, spotless and beautiful, and of noble birth, to wait on the Princess Ursula, who was to wed his heir the Prince Conon; and from all parts these noble virgins came trooping, fair and accomplished in all female learning, and attired in rich garments, wearing jewels of gold and silver. Being assembled in Brittany, in the capital of King Theonotus, Ursula received them not only with great gladness and courtesy, but with a sisterly tenderness, and with thanksgiving, praising God that so many of her own sex had been redeemed from the world's vanities: and the fame of this noble assembly of virgins having gone forth to all the countries round about, the barons and knights were gathered together from east and west to view this spectacle; and you may think how much they were amazed and edified by the sight of so much beauty and so much devotion.

'Now when Ursula had collected all her virgins together, on a fresh and fair morning in the spring time, she desired them to meet in a

meadow near the city, which meadow was of the freshest green, all over enamelled with the brightest flowers; and she ascended a throne which was raised in the midst, and preached to all the assembled virgins of things concerning the glory of God, and of his Son our Lord and Saviour, with wonderful eloquence; and of Christian charity, and of a pure and holy life dedicated to Heaven. And all these virgins, being moved with a holy zeal, wept, and, lifting up their hands and their voices, promised to follow her whithersoever she should lead. And she blessed them and comforted them; and as there were many among them who had never received baptism, she ordered that they should be baptized in the clear stream which flowed through that flowery meadow.

'Then Ursula called for a pen, and wrote a letter to her bridegroom, the son of the King of England, saying, that as he had complied with all her wishes and fulfilled all her demands, he had good leave to wait upon her forthwith. So he, as became a true knight, came immediately; and she received him with great honour; and, in presence of her father, she said to him, "Sir, my gracious prince and consort, it has been revealed to me in a vision that I must depart hence on my pilgrimage to visit the shrines in the holy city of Rome, with these my companions; thou meanwhile shalt remain here to comfort my father and assist him in his government till my return; or if God should dispose of me otherwise, this kingdom shall be yours by right." Some say that the prince remained, but others relate that he accompanied her on her voyage; however this may be, the glorious virgin embarked with all her maidens on board a fleet of ships prepared for them, and many holy prelates accompanied them. There were no sailors on board, and it was a wonder to see with what skill these wise virgins steered the vessels and managed the sails, being miraculously taught; we must therefore suppose that it was by no mistake of theirs, but by the providence of God, that they sailed to the north instead of the south, and were driven by the winds into the mouth of the Rhine as far as the port of Cologne. Here they reposed for a brief time, during which it was revealed to St. Ursula, that on her return she and her companions should on that spot suffer martyrdom for the cause of God: all which she made known to her companions; and they all together lifted up their voices in hymns of thanksgiving that they should be found worthy so to die.

'So they proceeded on their voyage up the river till they came to the city of Basil; there they disembarked, and crossed over the high mountains into the plains of Liguria. Over the rocks and snows of the Alps they were miraculously conducted, for six angels went before them perpetually, clearing the road from all impediments, throwing bridges over the mountain torrents, and every night pitching tents for their shelter and refreshment. So they came at length to the river Tiber, and, descending the river, they reached Rome, that famous city where is the holy shrine of St. Peter and St. Paul.

'In those days was Cyriacus bishop of Rome: he was famous for his sanctity; and hearing of the arrival of St. Ursula and all her fair and glorious company of maidens, he was, as you may suppose, greatly amazed and troubled in mind, not knowing what it might portend. So he went out to meet them, with all his clergy in procession. When St. Ursula, kneeling down before him, explained to him the cause of her coming, and implored his blessing for herself and her companions, who can express his admiration and contentment! He not only gave them his blessing, but commanded that they should be honourably lodged and entertained; and, to preserve their maidenly honour and decorum, tents were pitched for them outside the walls of the city on the plain towards Tivoli.

'Now it happened that the valiant son of King Agrippinus, who had been left in Brittany, became every day more and more impatient to learn some tidings of his princess-bride, and at length he resolved to set out in search of her; and, by a miracle, he had arrived in the city of Rome on the self-same day, but by a different route. Being happily reunited, he knelt with Ursula at the feet of Cyriacus and received baptism at his hands, changing his name from Conon to that of *Ethereus*, to express the purity and regeneration of his soul. He no longer aspired to the possession of Ursula, but fixed his hope on sharing with her the crown of martyrdom on earth, looking to a perpetual reunion in heaven, where neither sorrow nor separation should touch them more.

'After this blessed company had duly performed their devotions at the shrine of St. Peter and St. Paul, the good Cyriacus would fain have detained them longer; but Ursula showed him that it was

necessary they should depart in order to receive the crown " already laid up for them in heaven." When the bishop heard this, he resolved to accompany her. In vain his clergy represented that it did not become a Pope of Rome and a man of venerable years to run after a company of maidens, however immaculate they might be. Cyriacus had been counselled by an angel of God, and he made ready to set forth and embark with them on the river Rhine.

' Now it happened that there were at Rome in those days two great Roman captains, cruel heathens, who commanded all the imperial troops in Germania. They, being astonished at the sight of this multitude of virgins, said one to the other, " Shall we suffer this? If we allow these Christian maidens to return to Germania, they will convert the whole nation; or if they marry husbands, then they will have so many children—no doubt all Christians—that our empire will cease; therefore let us take counsel what is best to be done." So these wicked pagans consulted together, and wrote letters to a certain barbarian king of the· Huns, who was then besieging Cologne, and instructed him what he should do.

' Meantime St. Ursula and her virgins, with her husband and his faithful knights, prepared to embark: with them went Pope Cyriacus, and in his train Vincenzio and Giacomo, cardinals; and Solfino, archbishop of Ravenna; and Folatino, bishop of Lucca; and the bishop of Faenza, and the patriarch of Grado, and many other prelates: and after a long and perilous journey they arrived in the port of Cologne.

' They found the city besieged by a great army of barbarians encamped on a plain outside the gates. These pagans, seeing a number of vessels, filled, not with fierce warriors, but beautiful virgins, unarmed youths, and venerable bearded men, stood still at first, staring with amazement; but after a short pause, remembering their instructions, they rushed upon the unresisting victims. One of the first who perished was the Prince Ethereus, who fell, pierced through by an arrow, at the feet of his beloved princess. Then Cyriacus, the cardinals, and several barons, sank to the earth, or perished in the stream. When the men were despatched, the fierce barbarians rushed upon the virgins just as a pack of gaunt hungry wolves might fall on a flock of milk-white lambs. Finding that the noble maidens resisted their brutality,

their rage was excited, and they drew their swords and massacred them all.  Then was it worthy of all admiration to behold these illustrious virgins, who had struggled to defend their virtue, now meekly resigned, and ready as sheep for the slaughter, embracing and encouraging each other!  Oh, then! had you seen the glorious St. Ursula, worthy to be the captain and leader of this army of virgin martyrs, how she flew from one to the other, heartening them with brave words to die for their faith and honour!  Inspired by her voice, her aspect, they did not quail, but offered themselves to death; and thus by hundreds and by thousands they perished, and the plain was strewed with their limbs and ran in rivers with their blood.  But the barbarians, awed by the majestic beauty of St. Ursula, had no power to strike her, but carried her before their prince, who, looking on her with admiration, said to her, "Weep not, for though thou hast lost thy companions, I will be thy husband, and thou shalt be the greatest queen in all Germany."  To which St. Ursula, all glowing with indignation and a holy scorn, replied, "O thou cruel man!—blind and senseless as thou art cruel! thinkest thou I can weep? or dost thou hold me so base, so cowardly, that I would consent to survive my dear companions and sisters?  Thou art deceived, O son of Sathan! for I defy thee, and him whom thou servest!"  When the proud pagan heard these words, he was seized with fury, and bending his bow, which he held in his hand, he, with three arrows, transfixed her pure breast, so that she fell dead, and her spirit ascended into heaven, with all the glorious sisterhood of martyrs whom she had led to death, and with her betrothed husband and his companions; and there, with palms in their hands and crowns upon their heads, they stand round the throne of Christ; and live in his light and in his approving smile, blessing him and praising him for ever.—Amen!'

In devotional pictures of St. Ursula the usual attributes are—the crown as princess, the arrow as martyr, and the pilgrim's staff, surmounted by the white banner with the red cross, the Christian standard of victory.  She has also a dove, because a dove revealed to St. Cunibert where she was buried.  There is great variety in these representations of St. Ursula; and I shall give some examples.

1. As patron saint, she stands alone, wearing the royal crown,

attired in a richly embroidered robe, and over it a scarlet mantle lined
with ermine; in one hand a book, in the other an arrow. This, I think,
is the usual manner, varied of course in expression and deportment
by the taste of the artist.

2. She stands as patron saint, a majestic figure, in a rich dress with
regal ornaments, a green or scarlet mantle lined with ermine; in one
hand her arrow, and in the other her banner with the red cross.   This
is the Venetian idea of St. Ursula.   She is thus represented by Cima
da Conegliano, Carpaccio, and Palma Vecchio.

3. This sketch, from a Spanish
St. Ursula, will give some idea of
the very peculiar style of Zurba-
ran (130).

4. As martyr, she is kneeling
or standing, her golden hair flow-
ing upon her shoulders, sometimes
crowned, sometimes not; her
hands clasped, her bosom trans-
fixed by an arrow; around her, on
the ground, her maidens dead.
She is thus represented in a most
exquisite   miniature   in   the
'Heures d'Anne de Bretagne;'
and also in a large print after
Lorenzini, in which she stands
crowned with her standard of
victory, and a steadfast, triumph-
ant expression, while her attend-
ant virgins are martyred in the
background.

130      St. Ursula  (Zurbaran)

5. She is standing, or seated on a raised throne or pedestal; her
hair bound by a fillet of gems: her arrow in her hand; on each side
several of her virgin companions, two of whom bear standards; as in
a picture by Martino da Udine, wherein the idea of an immense and
indefinite number is well conveyed by an open door or porch on each
side, from which the virgins appear to issue.[1]

[1] Milan, Brera.

6. She is standing, holding open with both hands her wide and ermined mantle; underneath its shelter are many virgins wearing crowns. She is here the patroness of young maidens in general, and is thus represented in a very curious picture by Caterina da Vigri, who was herself a saint, perhaps the only female artist who was ever canonized, and whose story is given among the Monastic Legends (129).

7. In the famous altar-piece of the Cathedral of Cologne, St. Ursula is standing, gorgeously crowned and attired, and surrounded by her train of virgins.

8. She stands to the left of the Virgin, crowned with flowers, and holding a dove: in a Madonna picture by Brusasorci.[1]

9. She is standing, with one or more arrows in one hand, and a book in the other. Around her, or sheltered under the wide ample folds of her royal robe, which is sometimes held open by angels, a number of young girls, some holding their books, others conning their tasks, others clasping their hands in adoration. She is here the especial patroness of school-girls, and is thus represented by Lorenzo di Credi, by Hans Hemling, and I. von Meckenen.

10. The marble statue of St. Ursula, lying dead with the dove at her feet, is very beautiful,[2] and is said to have suggested to Rauch the pose of his reclining statue of Queen Louisa of Prussia.

[1] Louvre, No. 348.

131  St. Ursula  (Hans Hemling. Bruges)

[2] Cologne. Ch. of St. Ursula.

It is an exception when in devotional pictures of St. Ursula the Prince Ethereus is introduced, as in a beautiful group by Hans Burgmair, where she is throned with her husband, both in sumptuous robes, and her virgins in the background.[1]

We must be careful not to confound St. Ursula either with St. Christina or with St. Reparata. A female saint, with an arrow in her hand or in her bosom, and no other attribute, may represent St. Christina; but Christina is never seen with the regal ornaments. In the Florentine pictures St. Reparata has the crown, the ermined robe, and the standard of victory, but never the arrow. Reparata has also the palm; while in pictures of St. Ursula the palm is often replaced by the standard or the arrow.

The separate historical subjects from her life are confined to two— her voyage, and her martyrdom.

1. In a bark, with swelling sails, St. Ursula is seated, wearing her crown; she holds a large open book, and is either reading, or chanting hymns; a number of virgins are seated round her, some with musical instruments, others reading: at the helm, one of the virgins; sometimes, however, it is a priest or a winged angel. Of this beautiful subject I have seen few examples, and those anonymous, principally drawings or miniatures. If taken in its allegorical signification, as the religious voyage over the ocean of life,—Faith at the prow, and charity at the helm,—the representation becomes mystical and devotional rather than historical, particularly where angels are introduced as steering or propelling the vessel.

2. The Martyrdom of St. Ursula is represented in two ways: either she and her maidens are massacred on board her vessel; or she has landed, and presents herself to the enemy: in either case she is shot with arrows by a soldier (it is a deviation from the legend, as generally accepted, when St. Ursula perishes by the sword and not the arrow); the barbarian general stands by. Her virgins and companions are lying dead around her, or the slaughter is going on in the background; and the locality is usually expressed by the well-known tower, or the cathedral of Cologne in the distance.

[1] Augsburg.   Dibdin's 'Decameron,' vol. iii. p. 213.

There is a little picture in the collection of Prince Wallerstein, now in Kensington Palace, in which St. Ursula has just stepped on the shore, a sort of a quay with buildings ; she is attired like a princess, her hands meekly joined, her long golden hair flowing down on her shoulders, and in her face a most divine expression of mild melancholy resignation : two of her maidens bear her train behind, and seem to encourage each other ; two soldiers in rich warlike costume are bending their bows; the massacre goes forward in the distance.

The history of St. Ursula treated as a series occurs frequently in the stained glass and Gothic sculpture of the thirteenth and fourteenth centuries. In painting we have two renowned examples ; the first Italian, the second Flemish ; and both nearly contemporary.

The earliest work of Vittore Carpaccio in Venice was the magnificent series of the life of St. Ursula, painted, in 1490, for the chapel of the Scuola di Sant' Orsola, a beneficent institution, founded for the support and education of female orphans, consequently placed under the protection of the patron saint of maidenhood. Carpaccio has taken the principal incidents of her life in the following order :—

1. The arrival of the ambassadors of the King of England, to require the hand of the Princess Ursula for his son. The King of Brittany receives them seated on a splendid throne, and surrounded by his attendants ; in a compartment to the right the king is again seen leaning his head on his hand in a melancholy mood, and Ursula, standing before her father, appears to comfort him : on the steps leading to the chamber sits an old duenna.

2. The King of Brittany dismisses the ambassadors of the King of England with the conditions imposed by advice of his daughter. In a compartment to the right, St. Ursula is seen sleeping on her bed : she has a vision of the crown of martyrdom prepared for her.

3. The ambassadors of the King of England return with the answer of the Princess Ursula, and the King's son declares his intention of going to seek her.

4. On one side is seen the meeting between the Prince of England and his bride St. Ursula. On the other side they take leave of the King of Brittany to embark on their pilgrimage ; the ships are seen in the background, with a great company of nobles and virgins.

5. St. Ursula, with her virgins and her companions, arrives at the port of Cologne.

6. St. Ursula, with the prince her husband, and the virgins her companions, arrives at Rome; they are met outside the gates of the city by the Pope Cyriacus, attended by the cardinals and bishops. She and the prince are seen kneeling at the feet of the Pope: two attendants behind carry the royal crowns. The virgins, with the pilgrims and their banners, are seen following; in the distance the Castle of St. Angelo, which marks the locality.

7. The martyrdom of St. Ursula and her companions at Cologne on one side: on the other is seen the interment of the saint; she is represented extended on the bier with her long golden hair; the bodies of other virgins follow in the distance.

8. The glorification of St. Ursula. She is seen standing on a kind of pedestal of green boughs, formed of the palms of the eleven thousand virgins bound together; she looks up, her hair flowing over her shoulders, and her hands joined in prayer; six little angels hover round her; two of them hold over her head the celestial crown. On each side kneels a virgin with a banner, and there are about thirty other kneeling figures; among them Pope Cyriacus, and several prelates: all the heads are full of beauty, life, and character. The background is a landscape seen through lofty arches. The figures throughout wear the Venetian costume of the fifteenth century.

The richness of fancy, the lively dramatic feeling, the originality and naiveté with which the story is told, render these series one of the most interesting examples of early Venetian Art. Zanetti says that he used to go to the chapel of St. Ursula and conceal himself, to observe the effect which these pictures produced on the minds of the people as expressed in their countenances. ' I myself,' he adds, ' could hardly turn away my eyes from that charming figure of the saint, where, asleep on her maiden couch,—all grace, purity, and innocence,—she seems, by the expression on her beautiful features, to be visited by dreams from Paradise.'[1]

---

[1] A set of old engravings from this series has been lately purchased for the Print-room of the British Museum.

About the same period, Hans Hemling painted the magnificent shrine of St. Ursula in St. John's Hospital at Bruges. It is a Gothic chest or casket, constructed to contain the arm of the saint, and adorned with a series of miniatures. The incidents selected by Hemling are not precisely those chosen by Vittore Carpaccio. He appears to have confined himself to her pilgrimage and her martyrdom :—

1. St. Ursula and her companions arrive at Cologne on their way to Rome. Ursula, in the attire of a princess, her hair braided with jewels, is in the act of stepping on shore; one of her virgins holds up her train, another holds out her arm to support and assist her. A number of her companions are seen entering the gates of the city; the cathedral and the towers of Cologne are in the background.

2. The arrival of St. Ursula and her companions at Basle. In the foreground of the picture are two vessels crowded with female figures. In the background the city and cathedral of Basle; and in the extreme distance the Alps, towards which the virgins are seen travelling along a road.

3. The arrival of St. Ursula at Rome. The Pope receives her under the portico of a church, and gives her his benediction; behind her kneels the bridegroom-prince; on the other side is seen the baptism of several of the prince's companions, and in the background St. Ursula is seen confessing, and receiving the sacrament.

4. The second arrival in the neighbourhood of Basle. Two vessels in the foreground, on board of which are seen St. Ursula with her husband, and Pope Cyriacus with a number of his prelates. Some of the virgins are seen going off in a boat.

5. The massacre of the pilgrims on their arrival at Cologne. The two vessels are seen crowded with the martyrs; soldiers in the foreground are shooting at them with crossbows; a fierce soldier is seen plunging his sword into the bosom of the Prince of England, who falls into the arms of St. Ursula.

6. The martyrdom of St. Ursula. She is standing before the tent of the general of the barbarians; a number of soldiers are around; one of them, with his bow bent, prepares to transfix her.

Kugler's account of these subjects is not quite accurate; but his praise of the beauty of the execution, and the truth of feeling and

expression in some of the heads, is perfectly just. They are each about eighteen inches high,—historical pictures finished with all the precision and delicacy of a miniature on vellum. There is a good set of engravings (coloured after the originals) in the British Museum.

I saw in the Hôtel de Cluny at Paris two curious pictures from the story of St. Ursula. In the first, the King of England sends ambassadors to the King of Brittany; in the second, the ambassadors are received by the King of Brittany, and Ursula, seated on a throne beside her father, delivers her answer to their request. The artist has taken great pains to distinguish the heathen and barbarous court of England from the civilised and Christian court of Brittany.

## St. Margaret.

*Ital.* Santa Margarita. *Fr.* Sainte Marguerite. *Ger.* Die Heilige Margaretha.
Patron saint of women in childbirth. Patroness of Cremona. (July 20, A.D. 306.)

The legend of St. Margaret, which is of Greek origin, was certainly known in Europe as early as the fifth century, being among those which were repudiated as apocryphal by Pope Gelasius in 494. From that time we hear little of her till the eleventh century, when her legend and her name—which signifies a pearl, and has been given to that little lowly flower we call the daisy—were both introduced from the East by the first crusaders, and soon became popular all over Europe.[1]  In the fourteenth century we find her one of the most favourite saints, particularly amongst women, by whom she was invoked against the pains of childbirth. She was also the chosen type of female innocence and meekness;—the only one of the four great patronesses who is not represented as profoundly learned :—

> Mild Margarete, that was God's maid ;
> Maid Margarete, that was so meeke and mild ;

---

[1] The first personage of distinction in Europe who bore this name was Margaret, the sister of Edgar Atheling, and Queen of Malcolm III. of Scotland. She received the name in Hungary, where she was born in 1046, and introduced it into the west of Europe. She was herself canonised as a saint, and so greatly beloved in England and Scotland, that it contributed, perhaps, to render the name popular :—there were then as many *Margarets* as there are now *Victorias*.

and other such phrases, in the old metrical legends, show the *feeling* with which she was regarded.[1]

Her story is singularly wild. She was the daughter of a priest of Antioch, named Theodosius; and in her infancy, being of feeble health, she was sent to a nurse in the country. This woman, who was secretly a Christian, brought up Margaret in the true faith. The holy maid, while employed in keeping the few sheep of her nurse, meditated on the mysteries of the Gospel, and devoted herself to the service of Christ. One day the governor of Antioch, whose name was Olybrius, in passing by the place, saw her, and was captivated by her beauty. He commanded that she should be carried to his palace, being resolved, if she were of free birth, to take her for his wife; but Margaret rejected his offers with scorn, and declared herself the servant of Jesus Christ. Her father and all her relations were struck with horror at this revelation. They fled, leaving her in the power of the governor, who endeavoured to subdue her constancy by the keenest torments: they were so terrible that the tyrant himself, unable to endure the sight, covered his face with his robe; but St. Margaret did not quail beneath them. Then she was dragged to a dungeon, where Satan, in the form of a terrible dragon, came upon her with his inflamed and hideous mouth wide open, and sought to terrify and confound her; but she held up the cross of the Redeemer, and he fled before it. Or, according to the more popular version, he swallowed her up alive, but immediately burst; and she emerged unhurt: another form of the familiar allegory—the power of sin overcome by the power of the cross. He returned in the form of a man, to tempt her further; but she overcame him, and, placing her foot on his head, forced him to confess his foul wickedness, and to answer to her questions. She was again brought before the tyrant, and, again refusing to abjure her faith, she was further tortured; but the sight of so much constancy in one so young and beautiful only increased the number of converts, so that in one day five thousand were baptized, and declared themselves ready to die with her. Therefore the governor took counsel how this might be prevented, and it was advised that she should be beheaded forthwith. And as they led her forth to death, she thanked

1 There are no less than 238 churches in England dedicated in her honour.

and glorified God that her travail was ended; and she prayed that
those who invoked her in the pains of childbirth should find help
through the merit of her sufferings, and in memory of her deliver-
ance from the womb of the great dragon.   A voice from heaven
assured her that her prayer was granted; so she went and received
joyfully the crown of martyrdom, being beheaded by the sword.

In devotional pictures, the attribute of St. Margaret is the dragon.
She is usually trampling him under her feet, holding up the cross in
her hand.   Sometimes the dragon is bound with a cord; or his jaws

132       St. Margaret                    133      St. Margaret   (Lucas v. Leyden)
(Gothic sculpture, Henry VII.'s Chapel)

are distended as if to swallow her; or he is seen rent and burst,
and St. Margaret stands upon him unharmed,—as in the old metrical
legend in the Auchinleck MSS. :—

Maiden Margrete tho [*then*]
Loked her beside,
And sees a loathly dragon
Out of an hirn [*corner*] glide :
His eyen were ful griesly,
His mouth opened wide,
And Margrete might no where flee,
There she must abide.

Maiden Margrete
Stood still as any stone,
And that loathly worm,
To her-ward gan gone,
Took her in his foul mouth,
And swallowed her flesh and bone.
Anon he brast—
Damage hath she none !
Maiden Margrete
Upon the dragon stood ;
Blyth was her harte,
And joyful was her mood.

This is literally the picture which, in several instances, the artists
have placed before us (133).

As martyr she bears, of right, the palm and the crown ; and these,
in general, serve to distinguish St. Margaret from St. Martha, who
has also the attributes of the dragon and the cross.[1]   Here, however,
setting the usual attributes aside, the character ought to be so dis-
tinctly marked, that there should be no possibility of confounding
the beautiful and deified heroine of a spiritual warfare, with the
majestic maturity and staid simplicity of Martha.

In some pictures St. Margaret has a garland of pearls round her
head, in allusion to her name ; and I have seen one picture, and
only one, in which she wears a garland of daisies, and carries daisies
in her lap and in her hand.[2]

I shall now give some examples of St. Margaret treated devotion-
ally.

1. The famous St. Margaret of Raphael (in the Louvre) was
painted for Francis I., in compliment to his sister, Margaret of

---

[1] *v.* p. 382.          [2] Siena Acad.

Navarre. It represents the saint in the moment of victory, just stepping forward with a buoyant and triumphant air, in which there is also something exquisitely sweet and girlish; one foot on the wing of the dragon, which crouches open-mouthed beneath: her right hand holds the palm, her left sustains her robe. Her face is youth-

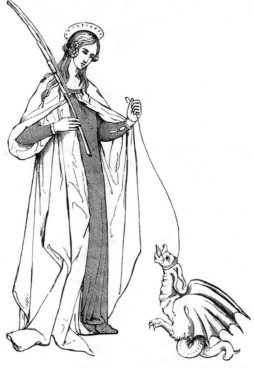

134        St. Margaret   (Intarsia, San Giovanni, Malta.   Fifteenth century)

ful, mild, and beautiful; the hair without ornament; the simplicity and elegance of the whole figure quite worthy of Raphael, whose aim has evidently been to place before us an *allegory*, and not an action: it is innocence triumphant over the power of sin. The St. Margaret in the Vienna Gallery, which has been styled by Passavant

and others a *duplicate* of this famous picture, is no duplicate, but altogether a different composition. The face is in profile, the attitude rather forced, and she holds the crucifix, instead of the palm. It is no doubt by Giulio Romano, and one of the many instances in which he took an *idea* from Raphael, and treated it in his own manner.

2. Parmigiano. The altar-piece, painted for the Giusti Chapel in the Convent of St. Margaret, at Bologna; it represents her kneeling, and caressing the Infant Christ, who is seated in the lap of his mother; behind the Virgin sits St. Augustine, and on the other side is St. Jerome; at the feet of St. Margaret is seen the dragon, open-mouthed, as usual.

3. Lucas v. Leyden. She is in a rich dress, stiff with embroidery, and reading a book; while seen, as crouching under the skirt of her robe, is the head of the dragon, which the painter has endeavoured, and not in vain, to render as hideous, as terrible, and as real as possible: in consequence, the effect is disagreeable: but the picture is wonderfully painted. In another example by the same painter, she has issued from the back of the dragon, holding the cross, through which she has conquered, in her hand (133): a part of her robe in the jaws of the dragon signifies that he had just swallowed her up.[1]

4. Luca Penni. She is trampling on the demon in human shape, which is unusual. Her martyrdom is seen in the background.[2]

5. Annibal Caracci. She is leaning on a pedestal in a meditative attitude, holding the Gospel; the dragon at her feet. A majestic figure life-size.[3]

6. Nicolò Poussin. She is kneeling on the vanquished dragon with extended arms, while two angels crown her.[4]

Historical pictures of St. Margaret are uncommon.

In the Christian Museum in the Vatican there is a St. Margaret, standing, in green drapery, richly embroidered with gold flowers, and bearing the cross: the dragon, here extremely small, is beneath her feet. Around are nine small compartments: in the upper one, Christ in the sepulchre, with the Virgin and St. John; and on each

[1] Munich Gal.    [2] Copenhagen.    [3] Sutherland Gal.    [4] Turin Gal.

side, four historical subjects. 1. St. Margaret, keeping sheep, is seen by the governor of Antioch. 2. She is brought before him, and declares her faith. 3. She is in prison, and visited by the Holy Spirit (or Peace) in form of a dove. 4. She is tortured cruelly, being suspended on a gallows, while executioners tear her with prongs. 5. She is swallowed up by the dragon in her dungeon. 6. She is in a caldron of boiling pitch. 7. She is decapitated. 8. Miracles are performed at her shrine.

We find the same selection of subjects in the ancient stained glass.

Vida has celebrated St. Margaret in two Latin hymns.

In the four illustrious virgin-saints I have just described, there is an individuality, which is strongly marked in their respective legends, and which ought to have been attended to in works of Art, though we seldom find it so. The distinctive character should be, in St. Catherine, dignity and intellect; in St. Barbara, fortitude and a resolute but reflecting air—she, too, was a *savante;* in St. Ursula, a devout enthusiasm, tempered with benignity; in St. Margaret, meekness and innocence,—

<div align="center">Si douce est la Marguerite.</div>

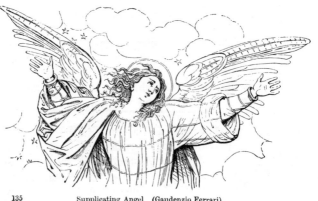

135            Supplicating Angel   (Gaudenzio Ferrari)

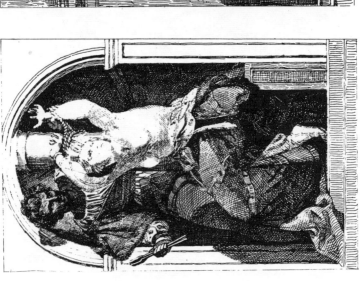

St. Laurence and St. Vincent.

St. Agatha and the Executioner.

# The Early Martyrs.

### 'THE NOBLE ARMY OF MARTYRS PRAISE THEE!'

WHEN, in the daily service of our Church, we repeat these words of the sublime hymn, I wonder sometimes whether it be with a full appreciation of their meaning? whether we do really reflect on all that this noble army of martyrs hath conquered for us?—Did they indeed glorify God through their courage, and seal their faith in their Redeemer with their blood? And if it be so, how is it that we Christians have learned to look coldly upon the effigies of those who sowed the seed of the harvest which we have reaped?—*Sanguis martyrum semen Christianorum!* We may admit that the reverence paid to them in former days was unreasonable and excessive; that credulity and ignorance have in many instances falsified the actions imputed to them; that enthusiasm has magnified their numbers beyond all belief; that when the communion with martyrs was associated with the presence of their material remains, the passion for relics led to a thousand abuses, and the belief in their intercession to a thousand superstitions. But why, in uprooting the false, uproot also the beautiful and the true? Surely it is a thing not to be set aside or forgotten, that generous men and meek women, strong in the strength and elevated by the sacrifice of a Redeemer, did suffer, did endure, did triumph for the truth's sake, did leave us an example which ought to make our hearts glow within us, in admiration and gratitude! Surely, then, it is no unfit employment for the highest powers of Art, that of keeping alive their blessed and heroic memory; and no desecration of our places of worship, that their effigies, truly, or at least worthily expressed, should be held up to our veneration, and the story of their sublime devotion sometimes brought to remembrance. And this was the opinion strongly expressed by Dr Arnold, whom no one, I suppose, will suspect of a leaning towards the idolatrous tendencies of Art. In speaking of a visit which he paid to the church of San Stefano at Rome, he remarks,— ' No doubt many of the particular stories thus painted will bear no

critical examination ; it is likely enough, too, that Gibbon has truly
accused the general statements of exaggeration.  But this is a thank-
less labour.   Divide the sum total of reported martyrs by twenty—
by fifty if you will; after all, you have a number of persons of all
ages and sexes suffering cruel torments and death for conscience'
sake, and for Christ's ; and by their sufferings manifestly with God's
blessing ensuring the triumph of Christ's Gospel.   Neither do I
think that we consider the excellence of this martyr-spirit half
enough.   I do not think that pleasure is a sin ; but though pleasure
is not a sin, yet surely the contemplation of suffering for Christ's sake
is a thing most needful for us in our days, from whom in our daily
life suffering seems so far removed.   And as God's grace enabled
rich and delicate persons, women and even children, to endure all
extremities of pain and reproach in times past, so there is the same
grace no less mighty now ; and if we do not close ourselves against
it, it might be in us no less glorified in a time of trial.'

And why, indeed, should we shut up our hearts against such in-
fluences, and force ourselves to regard as a snare what ought to be
a source of divine comfort and encouragement—of power, for the
awakening up of those whose minds are absorbed in selfish sorrows,
or for the strengthening of those who even now are contending for
the truth among us, and who perish martyrs, because there prevails
some form of social idolatry, against which they resist unto death !

Not that I quite sympathise with the occasion which gave rise to
the above beautiful passage in Dr Arnold's journal.   However I
may admire the sentiments expressed, to my taste martyrdoms are
abhorrent, and I remember that I never entered the church of San
Stefano without being sick at heart : those dolorous and sanguinary
death-scenes, which make its walls hideous, are no more fitted for
spiritual edification, than the spectacle of public executions avails to
teach humanity and respect for the law.   It is, however, a circum-
stance worthy of remark, as true now, and truer in the Middle Ages,
that the sympathy of the lower orders was less excited by the appa-
ratus of physical agony than by the bearing of the victim.   To them
the indomitable courage, the patient endurance, the glorious triumph
of the sufferer were more than the stake, the wheel, the rack, the scourge,
the knife.   The former were heart-soothing, soul-lifting, light-giv-

ing! the latter had been rendered by the Eccellinos, the Visconti, and other insane monsters of those days, mere commonplaces, the daily spectacle of real life. The most beautiful and edifying representations of the martyrs are not those which place them before us agonised under the lash or the knife of the executioner, but those in which they look down upon us from their serene beatitude,—their work done, their triumph accomplished, holding their victorious palm and wearing their crown of glory; while the story of their sufferings is suggested to the memory by the accompanying attribute— the sword, the arrow, or the wheel.

The writers of Church history reckon ten persecutions during three hundred years which elapsed between the reign of Nero and that of Constantine, and the saints who suffered within this period are commemorated as the early martyrs. I have not, in the subsequent essays, arranged them chronologically; for any such arrangement, with reference to Art, could have produced nothing but confusion. The principle of association through which certain of these personages will be found grouped together under particular circumstances, in particular localities, is infinitely more suggestive and poetical; and I have endeavoured to follow it out, as far as this could be done with any regard to order. But is it not unaccountable, and matter of regret as well as wonder, that some of the best-authenticated and most edifying of the early martyrdoms should be comparatively unknown as subjects of Art? In all the histories of the Christian Church, whether written by Protestant or Catholic, we find the mild heroism of Vivia Perpetua and the slave Felicitas,—the eloquence and courage of Justin, who exchanged the title of *Philosopher* for that of *Martyr*, —the fortitude of the aged Polycarp,—duly and honourably recorded. All these stories are beautifully narrated in Mr Milman's 'History of Christianity;' and I recommend them to the attention of those of our painters who may be seeking for incidents and characters connected with the history of our faith, at once new in Art, and unexceptionable in point of authenticity.

It appears that the first seven persecutions were local or accidental. It was in the reign of Hadrian that the populace first began to demand that the Christians should be put to death at the great festivals; an example having been already recorded in the reign of Trajan, when

St. Ignatius was thrown to the lions. Yet Hadrian, though incapable
of comprehending or appreciating the spirit of Christianity, defended
the Christians, and placed them under the protection of the laws.
The first *general* persecution by imperial decree was in the reign of
Decius, in which many Christians were martyred, and many also
fell from the faith. The tenth and last persecution, under Diocletian,
Galerius, and Maximin, was the most terrible of all; the number of
Christian martyrs who perished was undoubtedly great, but has
been much exaggerated. Almost all the legendary inventions and
spurious acts of martyrs are referred to these bloodthirsty tyrants,
who figure in the old legends as a sort of Ogres, demons incarnate,
existing on earth for no other purpose but to rage, blaspheme, and
invent tortures by which to test the heroism and constancy of the
servants of Christ.

To understand some of these stories of martyrdom, we must tran-
sport ourselves in fancy to the primitive ages of the Church. It was
then the established and universal belief among Christians that in-
fernal spirits were at once the authors and the objects of idolatry. It
was held for certain that the gods of the Pagans were demons who had
assumed the names and attributes of the popular divinities, and ap-
propriated the incense offered on the altars. The Christians, there-
fore, believed in the real existence of these false gods; but their
belief was mingled with detestation and horror. Idolatry was to
them no mere speculative superstition; it was, if I may so apply the
strong expression of Carlyle, ' a truth clad in hell-fire.' The slightest
leaning towards the heathen worship was not only treason against
the majesty of the true God, but a direct homage to those angels of
darkness who had been in rebellion against Him from the beginning.
Hence the language and bearing of the early martyrs were not only
marked by resistance, but by abhorrence and defiance; hence a
courage more than human sustained them; and hence, too, the furious
indignation of the priests and people, when they found their gods
not merely regarded with philosophical indifference as images or
allegories, but spurned as impure, malevolent, reprobate—yet living
and immortal—spirits.

The beatified martyrs were early introduced into church decoration.

I remember two instances as particularly striking. The first is, an ancient mosaic in the church of Sant' Apollinare Nuovo at Ravenna (A.D. 534). On the right hand as we enter, and immediately above the arches of the nave, we behold a long procession of twenty-one martyrs, carrying their crowns in their hands; they appear advancing towards a figure of our Saviour, who stands with an angel on each side, ready to receive them. On the wall to the left is a like procession of virgin martyrs, also bearing their crowns, and advancing to a figure of the throned Madonna, who, with an angel on each side, appears to be seated there to receive their homage.[1] These processions extend to the entrance of the choir, and the figures are colossal,—I suppose about seven or eight feet high. They are arranged in the following order[2]:—

| | | | |
|---|---|---|---|
| St. Clement. | St. Euphemia. | St. Ursinus. | St. Eulalia. |
| Justinus. | Paulina. | Apollinaris. | Agnes. |
| Laurence. | Daria.[3] | Sebastian. | Agatha. |
| Hippolytus. | Anastasia. | Demetrius. | Pelagia. |
| Cyprian. | Justina. | Polycarp. | Sabina. |
| Cornelius. | Perpetua. | Vincent. | Christina. |
| Cassian. | Felicitas. | Pancratius. | Eugenia. |
| John and | Vincentia. | Chrysogonus. | Anatolia. |
| Paul. | Valeria. | Sabinus. | Victoria. |
| Vitalis, | Crispina. | | |
| Gervasius, and | Lucia. | | |
| Protasius. | Cecilia. | | |

This list of martyrs is of very great importance, as being, I believe, the earliest in the history of Art. It shows us what martyrs were most honoured in the sixth century. It shows us that many names, then held in most honour, have since fallen into comparative neglect; and that others, then unknown or unacknowledged, have since become most celebrated. It will be remarked, that the virgins are led by St. Euphemia, and not by St. Catherine: that there is no St. Barbara, no St. Margaret, no St. George, no St. Christopher; all of whom figure

---

[1] There is a beautiful modern imitation of this old mosaic decoration in the church of St. Vincent de Paul at Paris, painted in fresco by M. Flandrin.

[2] According to Ciampini (v. *Vetera Monumenta*, vol. ii.), and a note I made on the spot; but, owing to a scaffolding raised against part of the wall, it was difficult to be accurate.

[3] The proper companion of St. Daria would be St. Chrysanthus.

conspicuously in the mosaics of Monreale at Palermo, executed five
centuries later.   In fact, of these forty-two figures executed at
Ravenna, by Greek artists in the service of Justinian, only five—
Euphemia, Cyprian and Justina, Polycarp and Demetrius—are
properly Greek saints ; all the rest are Latin saints, whose worship
originated with the Western and not with the Eastern Church.

In the church of Santa Prassede at Rome (A.D. 817) the arrange-
ment is altogether different from that at Ravenna, and equally
striking.   Over the grand arch which separates the choir from the
nave is a mosaic, representing the New Jerusalem, as described in
the Revelation.   It is a walled enclosure, with a gate at each end,
guarded by angels.   Within is seen the Saviour of the world, holding
in His hand the orb of sovereignty ; and a company of the blessed
seated on thrones : outside, the noble army of martyrs are seen
approaching, conducted and received by angels.   They are all arrayed
in white, and carry crowns in their hands.   Lower down on each side,
a host of martyrs press forward, with palms and crowns, to do homage
to the LAMB, throned in the midst.   None of the martyrs are dis-
tinguished by name, except those to whom the church is dedicated—
Santa Prassede and her sister Potentiana.   The peculiar propriety
and sentiment of the subject as relates to them, I shall point out
when treating of their legend hereafter.

In later Art, we find that in all devotional pictures which represent
Paradise, the Last Judgment, the Glorification of Christ, or the
Coronation of the Virgin, the glorious company of beatified martyrs
forms a part of the celestial pomp.   Some of these compositions are
of wonderful beauty, and much of the pleasure we derive from them
will depend on our knowledge of the history and character of these
heroes of the faith, and the origin of the attributes assigned to
them.

I consider it a fault, when, in such pictures, the apostles figure as
martyrs (as in Michael Angelo's Last Judgment), because they had
a still higher claim to our veneration, and should take their place
accordingly ; not with the attributes of earthly suffering, as victims ;

but with their books as the delegated teachers of mankind. Then, next after the apostles, come the martyrs; and we find that in all works of Art which may be cited as authorities a certain order is maintained. The first place is usually given to St. Stephen, the second to St. Laurence: when the Innocents are introduced, their proper place is under the throne, or immediately at the feet of Christ. Next to these, the most conspicuous figures are usually St. George and St. Maurice as warriors; St. Ignatius and St. Clement as bishops; St. Christopher with his staff, and St. Sebastian with his arrows. The martyrs venerated in the particular locality for which the picture was painted will also have a conspicuous place : for example, in the German pictures we shall probably find St. Boniface and St. Florian; in the Brescian pictures, St. Faustinus and St. Jovita; while, in pictures painted for the Dominicans, Peter, the famous martyr of their order, is conspicuous with his bleeding head and his monk's habit. The female martyrs are generally placed together, forming a beautiful group. St. Catherine, in general, takes the first place; next to her, St. Barbara with her tower; St. Agnes with her lamb; St. Lucia with her lamp (or her eyes); St. Cecilia crowned with roses ; and behind them a crowd of figures, with palms and glories not otherwise individualised. In such representations the leading idea is obviously borrowed from that magnificent passage in the 7th chapter of the Revelation: 'Lo! a great multitude, which no man could number, clothed with white robes, and with palms in their hands.' —'These are they which came out of great tribulation, and have washed their robes, and made them white in the blood of the Lamb ; therefore are they before the throne of God; and he shall feed them, and shall lead them to living fountains of waters, and shall wipe away all tears from their eyes.'

## The Innocents.

*Ital.* Gli Innocenti Fanciulli Martiri. I Santi Bambini Martiri. *Fr.* Les Innocents. *Ger.* Die Unschuldigen Kindlein. (Dec. 28.)

The 'Massacre of the Innocents,' as an action or event, belongs to the history of our Saviour, and I shall say nothing of it here. But the Innocents themselves, as personages, as the first-fruits of martyr-

dom, have been regarded with an especial homage from the earliest ages of the Church. Not the least divine trait in the character of the Saviour was the love, the reverence, He inculcated for ' little children ; ' and is there not something most natural, most touching, in the early belief that He would regard with peculiar favour, with a more compassionate tenderness, the souls of those innocents who perished, if not in His cause, at least because of *Him?* In their character of martyrs they find an appropriate place in devotional and ecclesiastical Art; and some of these representations are of peculiar interest and beauty. I shall give one or two examples.

In the mosaics of the old Basilica of St. Paul, at Rome, the Innocents are represented by a group of small figures holding palms, and placed immediately beneath the altar or throne, sustaining the Gospel, the cross, and the instruments of the passion of our Lord. Over these figures was the inscription, HI. S. INNOCENTES.[1]

I saw in one of the old French cathedrals, I think at Aix, a picture, not good nor agreeable as a work of Art, but striking from the peculiar conception. In the midst an altar, and on it the cross, and the Lamb without blemish : around, on the earth, lay the martyred Innocents, bleeding, dead ; a little higher up, their spirits were seen ascending with palms in their hands ; and above all, the Infant Christ, enthroned, received them into heaven with outstretched arms.

In a ' Flight into Egypt,' by F. Vanni, three or four martyred Innocents lie in the foreground.[2]

But the most beautiful devotional representation of the martyred Innocents, the most appropriate, the most significant in sentiment, I could cite, is the altarpiece in the church of the Foundling Hospital at Florence (which I may observe, *en passant*, preceded by two hundred years the first institution of that kind in France, by more than three hundred the first in England[3]). This altarpiece represents the Virgin and the Infant Christ enthroned in glory ; around the throne the elect ; and among them, the most conspicuous are the Innocents, lovely

---

[1] A.D. 450. Since the great fire of 1823 these mosaics have been restored.

[2] Etruria Pittrice.

[3] I speak of the present magnificent foundation at Florence, dating from 1448. So early as 1193 there was a hospital there for poor forsaken children : the first, in all probability, that ever existed.

children, with every variety of sweet infantine faces, who look up to the Saviour as in supplication, and point to their wounds, which yet are not rendered too obtrusive. The sentiment conveyed is this: 'Behold us, who have suffered because of thee, O Saviour! and, for our sake, have mercy and have pity on the forsaken little ones who are brought hither and laid down at thy feet!'

There is a picture in the Louvre by Rubens, known as '*La Vierge aux Anges.*' It represents the Virgin and Child, surrounded by a host of children,—for they are beatified children, not winged angels; many bear palms: they are exquisite for infantine beauty, and I have sometimes thought that Rubens must have intended them for the souls of the Innocents, and not for angels; but I have no authority for this supposition, and can only say that such was the impression conveyed to my mind.[1]

## St. Stephen, Deacon and Proto-martyr.

*Lat.* S. Stephanus. *Ital.* San Stefano. *Fr.* St. Étienne. *Ger.* Der Heilige Stefan. (Dec. 26.)

THE brief and simple account of Stephen as given in the sixth and seventh chapters of the Acts of the Apostles, I presume to be familiar to the reader. Little has been added by the fancy or the veneration of his votaries. He is held in the highest honour as the first who shed his blood in testimony to Christ, and described as a man full of faith and power and of the Holy Ghost. Having been chosen deacon during the first ministry of Peter, and before the conversion of Paul, and after performing ' great wonders and miracles among the people,' he was, upon the evidence of false witnesses, accused of speaking blasphemous words against the Temple and against the Jewish law—that temple which is now destroyed, that law which has been superseded by a diviner, a more

---

[1] On a further examination of this picture, I came to the conclusion that Rubens had not intended to represent either the Innocents or Cherubim, but the Spirits (angels) of beatified children, in allusion to the text, Matt. xviii. 10.

universal, law of 'peace on earth, and good-will towards men :'
whereupon he was condemned to death, and stoned by the infuriated
people outside the gates of the city.

So far the Scripture record.  The legend, which accounts for the
discovery of his relics, and their present resting-place in the Basilica
of San Lorenzo at Rome, is thus given :—

'No one knew what had become of the body of the saint till about
four hundred years afterwards ; when Lucian, a priest of Carsagamala
in Palestine, was visited in a dream by Gamaliel, the doctor of the
law at whose feet Paul was brought up in all the learning of the
Jews ; and Gamaliel revealed to him that after the death of Stephen
he had carried away the body of the martyred saint, and had buried
it in his own sepulchre, and had also deposited near to it the bodies
of Nicodemus and other saints ; and this dream having been repeated
three times, Lucian went with others deputed by the bishop, and
dug with mattocks and spades in the spot which had been indicated,
—a sepulchre in a garden—and found what they supposed to be the
remains of St. Stephen, their peculiar sanctity being proved by many
miracles.  These relics were first deposited in Jerusalem, in the
church of Sion, and afterwards by the younger Theodosius carried to
Constantinople, and thence by Pope Pelagius conveyed to Rome, and
placed in the same tomb with St. Laurence.  It is related, that when
they opened the sarcophagus and lowered into it the body of St.
Stephen, St. Laurence moved on one side, giving the place of honour
on the right hand to St. Stephen : hence the common people of Rome
have conferred on St. Laurence the title of "Il cortese Spagnuolo,"
—"the courteous Spaniard."'[1]

In devotional pictures, the figure of St. Stephen, which is of constant
recurrence, seldom varies in character, though it does so in the choice
and arrangement of the attributes.  He is generally represented young,
of a mild and beautiful aspect, habited in the rich dress of a deacon,
the Dalmatica being generally of crimson, covered with embroidery ;
it is square and straight at the bottom, with loose sleeves and heavy

[1] St. Stephen is not so popular as many saints less accredited.  There are only forty
churches in England dedicated to him.

gold tassels hanging down from the shoulders before and behind. He bears the palm almost invariably, as proto-martyr. The stones, which are his peculiar attribute, are either in his hand or in his drapery, or on his head and shoulders, or lying at his feet; or sometimes on the Scriptures, which he holds in his hand, showing the manner of death he suffered for the Gospel, and in allusion also to his preaching before his death. In such figures, when imperfectly executed, it is necessary to distinguish the three balls of St. Nicholas from the stones of St. Stephen. When the stones are introduced, and are palpably and indubitably stones, then it is impossible to mistake Stephen for any other saint: but they are often omitted; it then becomes difficult to distinguish St. Stephen from St. Vincent, who also bears the palm and the deacon's habit. In the Scripture story there is no allusion to the age of Stephen at the time he suffered; but in Italian Art he is always young and beardless, perhaps in allusion to the description of his appearance when accused: 'They saw his face as it had been the face of an angel,' which of course could not well apply to an old or bearded man; and he has always a meek expression, being not only proto-martyr, but also considered as the type, next to Christ, of forgiveness of injuries :—' Lord, lay not this sin to their charge !'

This is the conception in Italian and German Art, but in Spanish Art I have seen St. Stephen bearded, and with the lineaments of a man of thirty.

136     St. Stephen  (V. Carpaccio)

I will give a few examples in which St. Stephen figures as protomartyr or as deacon :—

1. Mosaic.[1] As deacon, he stands with St. Laurence; each holds a censer (turibolo), anciently the office of the deacon.[2]

2. He stands holding his palm in one hand, in the other a book; stones upon his head and upon his shoulders: as in a picture by Carpaccio.[3]

3. In a beautiful fresco by Brusasorci, he presents the martyred Innocents to Christ. The children go before him, bearing palms in their little hands. He, with a paternal air, seems to recommend them to Christ, who is in a glory above.[4]

4. Francia. St. Stephen as martyr, his palm in one hand, in the other a book, on which are three stones stained with blood.

5. He stands holding a banner, on which is a white lamb and a red cross; stones on his head: in an anonymous Siena picture.[5] This is the only instance in which I have seen St. Stephen holding a banner. The painters of the Siena school indulged in various caprices and peculiarities, often highly poetical; but they must never be regarded as authorities, except in their own local saints.

6. St. Stephen stands on a throne as patron, holding his palm and book; two angels from above crown him: on each side, St. Augustine and St. Nicholas, in a very fine picture by Calisto Piazza.[6]

7. He stands with other saints, distinguished by his palm, his deacon's dress, and his wounded and bleeding head. (The wounds on his *head* distinguish him from St. Laurence and St. Vincent.)

8. Albert Dürer. St. Stephen standing with his palm in one hand, with the other holds up the skirt of his deacon's robe, in which are seen several stones stained with blood.

The martyrdom of St. Stephen (which led the way to so many other martyrdoms in the same righteous and sacred cause, and is the first event of any essential importance after the disciples were left to fight the battle of their Lord on earth) has been often represented; and is so easily recognised, that I shall not dwell upon it further than to mention a few striking examples. Of course the

[1] Monreale, Palermo.

[2] But not in the time of Stephen;—the use of incense in churches dates from the fourth century.

[3] Milan, Brera.    [4] Verona: in S. Eufemia.    [5] Florence Gal.    [6] Milan, Brera.

*motif* does not vary; we have the infuriated crowd, the mild unresisting victim, and Saul, looking on and 'consenting to his death:' but, from the number of figures, the arrangement and the sentiment are capable of great variety.

1. The earliest example I have ever seen is an old Greek picture. St. Stephen is kneeling; around him are seen rude representations of walls and gates, eight figures throwing stones, and the Almighty hand, holding the martyr's crown, is over his head.[1]

2. Raphael has treated the subject classically. The figure of Stephen kneeling, with outstretched arms, as if he offered himself as victim, is very fine. The other figures look more like Romans than Jews; Saul, in the dress of a Roman warrior, is seated under a tree.[2] In the Martyrdom of St. Stephen at Genoa, painted by Giulio Romano (*it is said* from a cartoon by Raphael), the composition seemed to me confused, and the picture when at Paris was shamefully repainted.

3. Cigoli. A composition of eight figures. Stephen, struck down by a stone, falls backward. The ferocity of the executioners is painfully prominent; one of them kicks him. The Trinity is seen in a glory above, and an angel descends with a crown and palm. The picture is admirable for vigour and for pathos; but it is more like a murder than a martyrdom.[3]

4. The martyrdom of St. Stephen, in a fine engraving.[4] A little child is bringing stones in its vest to help the executioners. This has always appeared to me a fault both of taste and feeling: the introduction of a child thus employed adds a touch of horror, but is surely unchristian in spirit, and unwarranted by the text. The incident, however, occurs so frequently in pictures that it may possibly be founded on some legend of St. Stephen unknown to me.

5. Domenichino. In our National Gallery, a picture in which the subject is very dramatically treated.

6. Annibal Caracci has treated the same subject several times with great force of expression. There is a beautiful sketch in the Sutherland Gallery.

7. Lebrun. St. Stephen, lying on the ground, his face turned towards heaven with an expression of mild trusting faith, has just

[1] Eng. in D'Agincourt, pl. 34.  [2] Vatican.
[3] Florence Gal.  [4] By C. Cort (1576), after Marcello Venusti.

received his death-blow; the executioners stand, as it were, in sus-
pense, looking on. This is, beyond all comparison, the finest picture
which Lebrun ever painted; the pathos and truth of the sentiment
and the absence of everything forced or theatrical, are so unlike the
usual character of his works, that I could not at first believe it to be
his.[1]

8. Le Sueur. St. Stephen, lying dead on the ground, is bewailed
by the disciples and the women, who prepare to carry him to the
tomb (Acts viii. 2).

The life of St. Stephen, in a succession of subjects, is frequent in
the ancient stained glass, and has been treated in mural frescoes and
as a series of pictures. Some examples are famous in the history of
Art, and in all the instances I can remember the incidents represented
are the same.

I. Fra Angelico, when summoned to Rome by Nicholas V. in 1447,
painted the history of St. Stephen and St. Laurence on the walls of a
chapel in the Vatican, now called 'la Cappella di Niccolò V.,' and
sometimes 'la Cappella di San Lorenzo.' The scenes from the life
of St. Stephen are arranged in the following order:—

1. St. Stephen is invested with the office of deacon. It is not said
in the Acts that he was appointed by St. Peter, but it is so repre-
sented by Angelico: kneeling, he receives from St. Peter the sacra-
mental cup. In the early Church it was the office of the deacon to
take charge of the cup and of all things pertaining to the altar. The
six other deacons are in the background. 2. St. Stephen ministers
to the poor: for this purpose he was appointed deacon. Three of the
figures represent widows, in allusion to the text (Acts vi. 1). 3. St.
Stephen preaches to the people. He is standing on a step; his
audience, consisting chiefly of women and children, are seated
before him. Several men, evidently unconverted, stand in the
background:—'But they were not able to resist the wisdom and
the spirit by which he spake; then they suborned false witnesses,
and brought him to the council' (Acts vi. 10). 4. 'Then said the
high-priest, Are these things so?' Stephen stands in front, the

[1] Louvre.

high-priest has just put the interrogation, and Stephen, with his hand raised, is about to reply:—' Men, brethren, and fathers, hearken!' (Acts vii. 2). Several old men stand round with malicious faces; one of these, evidently his accuser, has the dress and shaven crown of a monk. 5. Stephen is dragged forth to martyrdom. The scene represents the walls of the city, and they are hailing him through the gate. ' They cried out with a loud voice, and stopped their ears, and ran upon him with one accord' (Acts vii. 57). 6. The Martyrdom of Stephen. He is kneeling, with clasped hands; Saul, who is not here a young man, but with the bald head and pointed beard, which is the characteristic type, stands to the left, calmly looking on. The last composition is ineffective, and inferior to all the others.

Angelico has represented Stephen as a young man, beardless, and with a most mild and candid expression. His dress is the deacon's habit, of a vivid blue.

II. The set of pictures by Carpaccio, which once existed entire in Venice, is now distributed through several galleries.

1. St. Stephen consecrated deacon by St. Peter, with six others; they are all kneeling before him: in the background, sea and mountains.[1] 2. The preaching of Stephen. He stands upon a pedestal or pulpit, in the court of the Temple, in an attitude of demonstration. The multitude around him; many in strange dresses from different parts of the world.[2] 3. St. Stephen disputing with the doctors.[3] 4. The last picture of the series, the Martyrdom, I have not met with.

Carpaccio also has represented Stephen as young and of a beautiful countenance; he wears the deacon's habit, which is red, embroidered with gold.

III. Much finer than either of these is the series by Juan Juanes. It consists of the usual subjects, but the treatment is very peculiar, and stamped by the character of the Spanish school. The figures are life-size.[4]

1. The series commences with his consecration as deacon. 2. Then follows the dispute in the synagogue. There are ten figures of doctors

[1] Berlin Gal.   [2] Louvre.   [3] Milan, Brera.   [4] Madrid Gal.

' Cyrenians, Alexandrians, and those of Cilicia and Asia ; ' the heads extremely fine and varied.   Stephen stands with one hand extended as demonstrating; in the other he holds the Scriptures of the Old Testament, out of which he confuted his opponents.   3. Stephen accused.   The doctors stop their ears : he points through an open window, where Christ is seen in glory—' Behold! I see the heavens opened, and the Son of Man standing on the right hand of God!' The high-priest is on a throne, and the architecture and all the accessories are magnificent.   4. Stephen is dragged forth to martyr- dom.   The executioners have their mouths open with a dog-like grin of malice ; one raises his hand to strike the saint; Saul walks by his side, with the dignified, resolute air of a persecutor from conviction, who is discharging a solemn duty, and is well contrasted with the vulgar cruelty of the mob.   Studies for such scenes must have been common in Spain; many a Dominican inquisitor might have sat for Saul.'[1]   5. St. Stephen is stoned in the act of prayer : ' Lord, lay not this sin to their charge.'   6. He is buried by the disciples, being laid in the tomb in his deacon's dress.   Many are weeping, and the whole composition is extremely fine and solemn.

In this series Stephen is represented as a man about thirty, with a short black beard and the Spanish physiognomy; his deacon's habit is blue (as in the series by Angelico); which is remarkable, because this colour is now never used in sacred vestments.

St. Stephen and St. Laurence, both deacons, both martyrs, both young, and having the same character of mild devotion, are frequently represented in companionship.

### St. Laurence, Deacon and Martyr.

*Lat.* S. Laurentius.   *Ital.* San Lorenzo.   *Fr.* St. Laurent.   *Ger.* Der Heilige Laurentius or Lorenz.   Patron of Nuremburg, of the Escurial, and of Genoa.   (Aug. 10, A.D. 258.)

It is singular that of this young and renowned martyr, honoured at Rome next to St. Peter and St. Paul, so little should be known, and it

---

[1] *v.* Sir E. Head's ' Handbook of Spanish Art,' p. 71, for a good description of this series. Also, Mr Stirling's ' Annals of the Artists of Spain.'

is no less singular that there has been no attempt to fill up the lack of material by invention. Of his existence, and the main circumstances of his martyrdom, as handed down by tradition, there can be little doubt. The place of his birth, the period at which he lived, and the events of his life, have all been matters of dispute, and have been left uncertain by the best writers. His legend is thus related in the *Flos Sanctorum*.

About the time when Valerian was a prisoner to Sapor, king of Persia, and his son Gallienus reigned in the East, lived Sixtus II., bishop of Rome, the twenty-fourth in succession from St. Peter; and he had for his deacon a young and pious priest named Laurence, who was a Spaniard, a native of Osca, or Huesca, in the kingdom of Aragon—(in which city the father and mother of St. Laurence are honoured as saints, under the names of Orentius and Patienzia.) Being very young on his arrival in Rome, he walked so meekly and so blamelessly before God, that Sixtus chose him for his archdeacon, and gave into his care the treasures of the Church, as they were then styled; which treasures consisted in a little money, some vessels of gold and silver, and copes of rich embroidery for the service of the altar, which had been presented to the Church by certain great and devout persons, Julia Mammea, mother of the Emperor Alexander Severus; Flavia Domitilla; the Emperor Philip, and others. And Sixtus, being denounced to the prefect of Rome as a Christian, was led away to prison and soon after sentenced to death; which when Laurence the deacon saw, he was in great affliction, and he clung to his friend and pastor, saying, 'Whither goest thou, O my father, without thy son and servant? am I found unworthy to accompany thee to death, and to pour out my blood with thine in testimony to the truth of Christ? St. Peter suffered Stephen, his deacon, to die before him: wilt thou not also suffer me to prepare thy way?' All this he said, and much more, shedding many tears; but the holy man replied, 'I do not leave thee, my son; in three days thou shalt follow after me, and thy battle shall be harder than mine; for I am old and weak, and my course shall soon be finished; but thou, who art young and strong and brave, thy torments will be longer and more severe, and thy triumph the greater: therefore grieve not, for Laurence the Levite shall follow Sixtus the Priest.' Thus he

comforted the young man, and moreover commanded him to take all
the possessions of the church and distribute them to the poor, that
they might in no case fall into the hands of the tyrant.   And
after this Sixtus was put to death.   Then Laurence took the money
and treasures of the Church, and walked through all the city of Rome,
seeking out the poor and the sick, the naked and the hungry; and
he arrived by night at a house on the Celian Hill where dwelt a
devout Christian widow whose name was Cyriaca, who kept many
fugitive Christians concealed in her house, and ministered to them
with unceasing charity.   And when Laurence came there, he found
her sick, and healed her by laying his hands upon her.   Then he
washed the feet of the Christians who were in the house, and gave
them alms: and in this manner he went from one dwelling to
another, consoling the persecuted, and dispensing alms and perform-
ing works of charity and humility.   Thus he prepared himself for his
impending martyrdom.

The satellites of the tyrant, hearing that the treasures of the Church
had been confided to Laurence, carried him before the tribunal, and
he was questioned, but replied not one word; therefore he was put
into a dungeon, under the charge of a man named Hippolytus, whom
with his whole family he converted to the faith of Christ, and bap-
tized; and when he was called again before the prefect, and required
to say where the treasures were concealed, he answered that in three
days he would show them.   The third day being come, St. Laurence
gathered together the sick and the poor to whom he had dispensed
alms, and, placing them before the prefect, said, 'Behold, here are
the treasures of Christ's Church.'   Upon this the prefect, thinking
he was mocked, fell into a great rage, and ordered St. Laurence to
be tortured till he had made known where the treasures were con-
cealed; but no suffering could subdue the patience and constancy
of the holy martyr.   Then the prefect commanded that he should be
carried by night to the baths of Olympias, near the villa of Sallust the
historian, and that a new kind of torture should be prepared for him,
more strange and cruel than had ever entered into the heart of a
tyrant to conceive; for he ordered him to be stretched on a sort of
bed, formed of iron bars in the manner of a gridiron, and a fire to be
lighted beneath, which should gradually consume his body to ashes;

and the executioners did as they were commanded, kindling the fire, and adding coals from time to time, so that the victim was in a manner roasted alive; and those who were present looked on with horror, and wondered at the cruelty of the prefect who could condemn to such torments a youth of such fair person and courteous and gentle bearing, and all for the lust of gold.

And in the midst of torments, Laurence, to triumph further over the cruelty of the tyrant, said to him, 'Seest thou not, O thou foolish man, that I am already roasted on one side, and that, if thou wouldst have me well cooked, it is time to turn me on the other?' And the tyrant and executioners were confounded by his constancy. Then St. Laurence lifted up his eyes to heaven and said, 'I thank thee, O my God and Saviour, that I have been found worthy to enter into thy beatitude!' and with these words his pure and invincible spirit fled to heaven.

The prefect and his executioners, seeing that the saint was dead, went their way in great wonder and consternation, leaving his body on the gridiron: and in the morning came Hippolytus and took it away, and buried it reverently in a secret place, in the Via Tiburtina. When this was known to the prefect, he seized Hippolytus, and commanded him to be tied to the tail of a wild horse; and thus he perished. But God suffered not that this wicked and cruel prefect should escape the punishment of his crimes; for, sometime afterwards, as he sat in the amphitheatre of Vespasian, and presided over the public games, all of a sudden miserable pangs came over him, and he cried out upon St. Laurence and Hippolytus, and gave up the ghost!

But to St. Laurence was given a crown of glory in heaven, and upon earth eternal and universal praise and fame; for there is scarcely a city or town in all Christendom which does not contain a church and altar dedicated to his honour. The first of these was built by Constantine outside the gates of Rome, on the spot where he was buried; and another was built on the summit of the Pincian Hill, where he was martyred; and besides these, there are at Rome four others; and in Spain, the Escurial; and in Genoa, the Cathedral.[1]

Figures of St. Laurence in devotional pictures occur perpetually.

[1] In England about 250 churches are dedicated in honour of St. Laurence.

He, as well as St. Stephen, wears the deacon's dress, and has the palm as martyr; and where he bears his familiar attribute, the gridiron (*la graticola*), he is not to be mistaken; but there are instances in which the gridiron is omitted, and he carries a dish full of gold and silver money in his hand—the treasures of the church confided to his keeping; or he swings a censer; or carries a cross, for it was the province of the deacon to carry the cross in processions and other religious ceremonies. The deacon's dress has been described: in pictures of St. Laurence, who was the first archdeacon, the dress is usually splendid; in some pictures he wears a tunic covered with flames of fire, in allusion to his martyrdom (139). He is represented younger than Stephen, and with a look of calm sweetness almost angelic. The gridiron varies in form: it is sometimes a parallelogram, formed of transverse bars, on which he leans or sets his foot in triumph; sometimes it has the form of the common kitchen utensil; it is then no longer the attribute, but a mere emblem of the death he suffered. Sometimes a little gridiron is suspended round his neck, or he holds it in his hand, or it is embroidered on his robe.[1]

137    St. Laurence (Vivarini)

1. In a picture by Pinturicchio at Spello, St. Laurence stands with St. Francis by the throne of a beautiful Madonna; he leans on his *graticola*, and, with a truly

---

[1] I saw in one of the Italian churches, I think at Cremona, an antique fragment representing the story of Mucius Scævola thrusting his hand into the flames, which the guide pointed out as, '*un invitto soldato, che sarà, per certo, un santo martire!*' and which the people venerated as a St. Laurence.

poetical anticipation, has his martyrdom embroidered on his deacon's robe (138).

One of the most beautiful devotional figures of St. Laurence I have ever seen is by Ghirlandajo; it represents him looking up with an expression of ecstatic faith: his deacon's tunic is of crimson, with a green mantle in rich folds:[1] it forms one wing of an altar-piece.

138    St. Laurence (Pinturicchio)

The subjects from his life are few; the most frequent is, of course, his famous and frightful martyrdom,—a theme difficult to be treated, so as to render it bearable: we have it in every variety of style—sublime, horrible, grotesque; but it is so peculiar, that it can never be mistaken, and admits of little variation in the sentiment. The moment chosen is not, however, always the same; sometimes he is addressing to the prefect the famous ironical speech, which is but too near to the burlesque;[2] sometimes he is looking up to the opening heavens, whence the angel floats downwards with the palm and crown; executioners are blowing the fire, and bringing fuel to feed it. The time, which was night, the effect of the lurid fire, the undraped beautiful form of the young saint, whose attitude, in spite of the cruel manner of his agony, is susceptible of much grace; the crowd of spectators, with every variety of expression;—all these picturesque circumstances have been admirably employed by Titian in one of the most famous of his compositions, that which he painted for

[1] Munich, No. 564.

[2] It is literally, ' I am done, or roasted,—now turn me, and eat me.' (*Assatus est ; jam versa et manduca.*)

Philip II., to be placed in the Escurial, which was dedicated to St. Laurence.[1]

139   St. Laurence distributing the
        treasures of the Church
        (F. Angelico).

The 'Martyrdom of St. Laurence,' by Baccio Bandinelli the sculptor, is arranged as a scenic bas-relief, and is well known to artists as a study for attitude and form, and to collectors for the beauty of the engraving by Marc' Antonio.

'St. Laurence preparing for his martyrdom;' he stands with hands bound in a loose white tunic, which one of the executioners is about to remove; a very pretty pathetic picture by Elsheimer.[2]

A series of subjects from the life of St. Laurence is frequent in the stained glass of the thirteenth and fourteenth centuries;—there is a fine example in the Cathedral at Chartres.

The series of frescoes by Angelico in the chapel of Nicholas V. has that delicacy of sentiment which characterises the painter. 1. He is ordained deacon by Pope Sixtus, who, seated on a throne, gives to his keeping the consecrated cup. 2. He receives from Sixtus the treasures of the Church. 3. He distributes them to the poor Christians.[3]

4. He stands bound before the prefect Decius. Scourges and instruments of torture are lying on the ground. 5. He lies stretched on the gridiron.

In the series of old frescoes under the portico of the Basilica of San Lorenzo, the events of his life are most elaborately and minutely

---

[1] There are many repetitions and engravings.   [2] Munich Cabinet, viii. 154.

[3] 'The charity of St. Laurence,' after this beautiful fresco, has lately been engraved by Louis Gruner, for the Arundel Society, with a precision and purity of taste in the drawing and a flowing ease and elegance in the management of the burin, which recall the old engravers of the Raffaelesque school.

expressed : the series consists of the following subjects ; they are on the right hand as you enter, but in such a state of ruin as to be nearly unintelligible :—

1. Nearly effaced ; it probably represented his investiture as deacon. 2. St. Laurence washes the feet of the poor Christians. 3. He heals Cyriaca. 4. He distributes alms. 5. He meets St. Sixtus led to death, and receives his blessing. 6. He is brought before the prefect. 7. He restores sight to Lucillus. 8. He is scourged with thongs loaded with lead. 9. He baptizes Hippolytus. 10. (Effaced.) 11. He refuses to deliver the treasures of the Church. 12. (Effaced.) 13, 14, 15. His body wrapt in a shroud, carried away, and buried by Hippolytus.

Four of the compartments on the right hand, and now with difficulty made out, represent the contention between the devil and the angel for the soul of the Emperor Henry II., here represented because St. Laurence plays a conspicuous part in it. This wild legend is an amusing instance of the stories or parables invented by the churchmen of the time, and their obvious purpose :—

‘ One night, a certain hermit sat meditating in his solitary hut, and he heard a sound as of a host of wild men rushing and trampling by ; and he opened his window and called out, and demanded who it was that thus disturbed the quiet of his solitude ; and a voice answered, “ We are demons ; Henry the Emperor is about to die in this moment, and we go to seize his soul.” Then the hermit called out again, “ I conjure thee, that, on thy return, thou appear before me, and tell me the result.” The demon promised, and went on his way ; and in the same night the same ghastly sounds were again heard, and one knocked at the window, and the hermit hastened to open it, and behold it was the same demon whom he had spoken to before. “ Now,” said the hermit, “ how has it fared with thee ? ” “ Ill ! to desperation ! ” answered the fiend in a fury. “ We came at the right moment ; the emperor had just expired, and we hastened to prefer our claim ! when, lo ! his good angel came to save him. We disputed long, and at last the Angel of Judgment (St. Michael) laid his good and evil deeds in the scales, and behold ! our scale descended and touched the earth ;—the victory was ours ! when, all at once, yonder roasted fellow ” (for so he blasphemously styled the

blessed St. Laurence) " appeared on his side, and flung a great golden
pot " (so the reprobate styled the holy cup) " into the other scale,
and ours flew up, and we were forced to make off in a hurry; but at
least I was avenged on the golden pot, for I broke off the handle,
and here it is : " and having said these words, the whole company of
demons vanished.    Then the hermit rose up in the morning, hastened
to the city, and found the emperor dead; and the golden cup which
he had piously presented to the Church of St. Laurence was found
with only one handle, the other having disappeared that same night.'

The old frescoes give us this strange but significant story at full
length.    In the first compartment, a hermit is looking out of a
window, and there are some fragmentary portions of the devils just
visible : the second represents the death-bed of the emperor; at the
foot of it appear the demons : in the next, the angel and the demons
are contending; the soul of the emperor clasps the knees of the angel
as if for refuge : in the fourth appears St. Laurence to the rescue, one
of the fiends has fallen on his knees before him.   The whole series in
a barbarous style, and in a most ruined state.[1]

I met with this legend again in the famous Strozzi Chapel in the
S. Maria Novella at Florence.   The great frescoes of the Last Judg-
ment, so often pointed out as worthy of especial attention, generally
engross the mind of the spectator to the exclusion of minor objects;
few, therefore, have examined the curious and beautiful old altar-
piece, also by Orcagna (A.D. 1349).   It represents Christ giving the
keys to St. Peter, and attended by St. John, St. Paul, St. Thomas
Aquinas, St. Catherine, St. Michael, St. Laurence.   In the predella
below are scenes from the life of each of the saints represented above.
For example, under the figure of St. Laurence we have the conten-
tion for the soul of the Emperor Henry.   In the centre the emperor
is seen expiring amid his attendants : on one side, the flight of the
demons through the desert, the hermit looking out of his cave : on
the other, St. Michael holds the scales; the merits of the emperor
are weighed in the balance and found wanting; St. Laurence de-
scends and places the vase in one scale ; the demons are in a rage, and
one of them seems to threaten St. Laurence.   The whole concep-
tion very odd and grotesque, but the story told with infinitely more

[1] They are engraved in a small size in D'Agincourt's 'Histoire de l' Art,' pl. xcix. No. 8.

skill and spirit than in the rude old frescoes in the church of San Lorenzo.

Doublet, in his history of the Abbey of St. Denis, cites a passage in an ancient chronicle, wherein the demons lament, 'that wishing to carry away the soul of Charlemagne, they did not succeed because of the opposition of Michael the archangel, and the weight of the offerings made to the Church, which, being thrown into the scale of good works, weighed it down.' Such fabrications were frequent in those days, and are very suggestive in ours.

As the story of St. Hippolytus is closely connected with that of St. Laurence, I place it here.

## St. Hippolytus.

*Ital.* Sant' Ippolito.  *Fr.* Saint Hippolyte.  (Aug. 13, A.D. 258.)

HIPPOLYTUS was the name of the soldier who was stationed as guard over the illustrious martyr St. Laurence, by whose invincible courage and affectionate exhortations he was so moved that he became a Christian with all his family. After the terrible death of St. Laurence, at which he had been present, he, with some other Christians, carried away the body of the saint by night and buried it: all which has been already related; and it remains only to show how Hippolytus honoured the teaching of his master, and proved his faith.

Being brought before the tribunal of Decius, and accused of being a Christian, Hippolytus acknowledged himself as such, and declared that he was ready to die like St. Laurence rather than deny his Redeemer. Decius sent his lictors to the house of Hippolytus with orders to arrest all who were found there; and among others was his aged nurse, whose name was Concordia, and who, in consequence of the boldness with which she replied to the demands of the judge, was condemned to be scourged until she died; and Hippolytus, looking on, thanked God that his nurse, from whose bosom he had fed, had died worthily for Christ's sake; and having seen nineteen of his family beheaded, and still refusing to listen to the tempta-

tions of these wicked pagans, he was tied to the tails of wild horses,
and, in this cruel and terrible martyrdom, perished.

By a curious mingling of the Pagan mythology and Christian
traditions, Hippolytus has partaken of the attributes of his name-
sake the son of Theseus, and has been chosen as the patron saint of
horses. His name in Greek signifies 'one who is destroyed by
horses.' His popularity in France is probably owing to the transla-
tion of his relics from Rome to the Abbey of St. Denis in the eighth
century; but in the legends of this saint there prevails a more than
usual degree of obscurity and uncertainty.

1. In the old mosaic in the church of San Lorenzo, Rome, St.
Hippolytus in a warrior's dress stands behind St. Laurence.

The ancient devotional pictures of Hippolytus often represent him
as the jailer of St. Laurence, with a bunch of keys hanging to his
girdle.

2. In a little picture in the Academy at Florence he is thus re-
presented, and also holds in his hand an instrument of torture some-
thing like a currycomb with iron teeth.

3. The Martyrdom of St. Hippolytus was painted by Subleyras.
The picture, which is one of his most beautiful, is in the Louvre; [1]
Hippolytus lies on the ground, his hands bound, his feet tied to the
tails of two wild horses, which, starting, rearing, and with their
manes blown by the wind, are with difficulty restrained by a number
of soldiers; the head of the saint is remarkably fine as he looks up
to heaven with an expression of enthusiastic faith.

4. El Mudo painted for the Escurial, which, it will be remembered,
was dedicated to St. Laurence, Hippolytus and his companions bury-
ing the body of the saint by night. It is praised for the solemn
and pathetic effect of the composition, and is in truth a beautiful
subject.

5. In St. Salvator, Bruges, is the Martyrdom of Hippolytus by
Hans Hemling.

I have seen the story of Hippolytus frequently in the stained glass
and sculpture of the old French churches. In the modern church of

[1] École française, No. 506.

Notre Dame de Lorette, at Paris, the story of St. Hippolytus is painted in three compartments. 1. He is baptized by St. Laurence. 2. He buries the body of the saint. 3. He is tied to a wild horse.

## ST. VINCENT, DEACON AND MARTYR.

*Lat.* S. Vincentius Levita. *Ital.* San Vincenzio Diacono, San Vincenzino. *Fr.* Saint Vincent. Patron of Lisbon, of Valencia, of Saragossa ; one of the patrons of Milan ; patron saint of Chalons, and many other places in France. (Jan. 22, A.D. 304.)

THIS renowned saint and martyr of the early Christian Church has been most popular in Spain, the scene of his legend, and in France, where he has been an object of particular veneration from the sixth century. It is generally allowed that the main circumstances of the history of Vincent, deacon of Saragossa, of his sufferings for the cause of Christ, and his invincible courage, expressed by his name, rest on concurrent testimony of the highest antiquity, which cannot be rejected ; but it has been extravagantly *embroidered.* I give his legend here, as accepted by the poets and artists.

' He was born in Saragossa, in the kingdom of Aragon. Prudentius, in his famous Hymn, congratulates this city on having produced more saints and martyrs than any other city in Spain. During the persecution under Diocletian, the cruel proconsul Dacian, infamous in the annals of Spanish martyrdom, caused all the Christians of Saragossa, men, women, and children, whom he collected together by a promise of immunity, to be massacred. Among these were the virgin Eugracia, and the eighteen Christian cavaliers who attended her to death. At this time lived St. Vincent: he had been early instructed in the Christian faith, and with all the ardour of youth devoted himself to the service of Christ. At the time of the persecution, being not more than twenty years of age, he was already a deacon. The dangers and the sufferings of the Christians only excited his charity and his zeal; and after having encouraged and sustained many of his brethren in the torments inflicted upon them, he was himself called to receive the crown of martyrdom. Being brought before the tribunal of Dacian,

together with his bishop, Valerius, they were accused of being Christians and contemners of the gods. Valerius, who was very old, and had an impediment in his speech, answered to the accusation in a voice so low that he could scarcely be heard. On this, St. Vincent burst forth with Christian fervour,—"How is this, my father! canst thou not speak aloud, and defy this pagan dog? Speak, that all the world may hear; or suffer me, who am only thy servant, to speak in thy stead!" The bishop having given him leave to speak, St. Vincent stood forth, and proclaimed his faith aloud, defying the tortures with which they were threatened; so that the Christians who were present were lifted up in heart and full of gratitude to God, and the wicked proconsul was in the same degree filled with indignation. He ordered the old bishop to be banished from the city; but Vincent, who had defied him, he reserved as an example to the rest, and was resolved to bend him to submission by the most terrible and ingenious tortures that cruelty could invent. The young saint endured them unflinching. "When his body was lacerated by iron forks, he only smiled on his tormentors: the pangs they inflicted were to him delights; thorns were his roses; the flames a refreshing bath; death itself was but the entrance to life."[1] They laid him, torn, bleeding, and half consumed by fire, on the ground strewn with potsherds, and left him there; but God sent down his angels to comfort him; and when his guards looked into the dungeon, they beheld it filled with light and fragrance; they heard the angels singing songs of triumph, and the unconquerable martyr pouring forth his soul in hymns of thanksgiving: he even called to his jailers to enter and partake of the celestial delight and solace which had been vouchsafed to him; and they, being amazed, fell upon their knees and acknowledged the true God.

'But Dacian, perfidious as he was cruel, began to consider what other means might remain to conquer his unconquerable victim. Having tried tortures in vain, he determined to try seduction. He ordered a bed of down to be prepared, strewn with roses; commanded the sufferer to be laid upon it, and allowed his friends and disciples to approach him. they, weeping, staunched his wounds, and dipped their kerchiefs in his flowing blood, and kissed his hands and brow, and besought

---

[1] Prudentius, *Hymn to St. Laurence*. He calls the iron forks *astrelli*, or rakes.

him to live. But the martyr, who had held out through such pro-
tracted torments, had no sooner been laid upon the bed, than his
pure spirit, disdaining as it were these treacherous indulgences, fled
to heaven ; the angels received him on their wings, and he entered
into bliss ineffable and eternal.

' The proconsul, furious that his victim had escaped him, ordere˜
his body to be thrown out to the wild beasts : but behold the good-
ness of God ! who sent a raven to guard his sacred remains ; and
when a wolf approached to devour them, the raven obliged it to
retire. And when Dacian was informed that after many days the
body of Vincent remained untouched, he was ready to tear himself
for despite : he ordered his minions to take the body of the holy
martyr, to sew it up in an ox-hide, as was done towards parricides,
and to throw it into the sea. These impious satellites therefore
took the body, and, placing it in a bark, they rowed out far into the
sea, and flung it, attached to a mill-stone, overboard : they then
rowed back again to the shore ; but what was their astonishment,
when, on landing, they found that the body of St. Vincent had
arrived before them, and was lying on the sand ! They were so
terrified that they fled ; and there being none to bury him, the
waves of the sea, by the command of God, performed that pious office,
and hollowed a tomb for him in the sands, where he lay, protected
from all indignity, hidden from all human knowledge ; until, after
many years, the spot was miraculously revealed to certain Christians,
who carried his body to the city of Valencia, and buried it there.

' In the eighth century, when the Christians of Valencia were
obliged to flee from the Moors, they carried with them the body of
St. Vincent. The vessel in which they had embarked was driven by
the winds through the straits of Hercules, until they arrived at a
promontory, where they landed and deposited the remains of the
saint ; and this promontory has since been called Cape St. Vincent.
Here the sacred relics were again guarded by the ravens or crows,
and hence a part of the cliff is called *el Monte de las Cuervas.*
About the year 1147, Alonzo I. removed the relics to Lisbon,—two
of the crows, one at the prow and one at the stern, piloting the ship.
Thus, after many wanderings, the blessed St. Vincent rested in the
Cathedral of Lisbon ; and the crows which accompanied him hav-

ing multiplied greatly, rents were assigned to the chapter for their support.'

The legend of this illustrious martyr is one of the most ancient in the Church. The famous Latin Hymn of Prudentius (A.D. 403) recites all the details of his horrible martyrdom in a style which may pass in Latin, but would certainly be intolerable in English. St. Augustine and St. Ambrose testify that, in their time, the fame of St. Vincent the *Invincible* had penetrated wherever the name of Christ was known.[1] He has been honoured since the fourth century throughout Christendom, but more particularly in Spain, where, we are told, ' there is scarcely a city in the whole Peninsula without a church dedicated to him, in which he may be seen carved or painted : ' and the same may be said of France, where he has been honoured since the year 542. The church, now ' St.-Germain-des-Prés ' at Paris, was originally dedicated to St. Vincent in 559. The pretended translation of the relics to France, by means of a thieving, lying monk, I pass over, because it is discredited, and unconnected with my purpose in these Essays.[2]

In works of Art it is not always easy to distinguish St. Vincent from St. Stephen and St. Laurence; for he, too, is young and mild and beautiful ; he also wears the deacon's dress, and carries the palm : but his peculiar attribute is a crow or a raven, sometimes perched upon a millstone. Mr Ford mentions an effigy of St. Vincent at Seville, in which the saint is painted with his ' familiar crow, holding a pitchfork in his mouth : ' ' a rudder,' he thinks, ' would have been more appropriate.' I imagine that the iron fork is here the instrument of his martyrdom, and quite appropriate. In the Italian pictures St. Vincent has seldom any attribute but the palm, while St. Laurence and St. Stephen are seldom without their respective gridiron and stones. St. Vincent is frequently grouped with St. Laurence : the Spanish legend makes them brothers, but I find no authority for this relationship in the French and Italian Martyrologies.

[1] There are four churches in England dedicated in his honour.

[2] It is because of the supposed deposition of the relics of St. Vincent in the church of St. Germain, that St. Vincent and St. Germain are so often found together in French pictures. There is one in the Louvre (École française, No. 634) painted by Vien.

The most beautiful devotional figure of this martyr I have ever seen is a picture by Palma, in the S. Maria dell' Orto, at Venice, almost, if not quite, equal to his famous St. Barbara for colour and expression.   St. Vincent stands in the centre on a kind of platform : he is habited in the deacon's robe, here of a deep glowing red, richly embroidered; he holds the palm, and has no other attribute; the face is divinely beautiful—mild, refined, and elevated to a degree uncommon in the Venetian school.   Four saints stand round him ; St. Helen with her cross, a Dominican ( I think St. Vincent Ferrer), a pope, and a martyr-saint whom I cannot name : completely absorbed by admiration of the principal figure, I did not consider them with sufficient attention.   In a picture by Pollajuolo, also of extraordinary beauty, he is young, bearing his palm, and his crimson Dalmatica is embroidered with gold.[1]

A fresco by Aurelio Luini, once in the church of S. Vincenzino at Milan, now in the Brera, represents the youthful saint preparing to undergo the torture which he suffered with such marvellous constancy.   He is bound to a tree, and two executioners, with iron hooks in their hands, seem about to tear him.

A series of subjects from his life, frequent in the stained glass and sculpture of the thirteenth and fourteenth centuries, consists of the following scenes :—1. He is brought before the proconsul with the aged priest Valerius, who is attired as a bishop, while Vincent wears the deacon's dress.   2. He is tortured in various ways : he is torn with iron hooks, laid on a bed of red-hot iron, stretched upon the ground on potsherds.   3. Angels visit him in his dungeon.   4. He dies on the bed of roses.   5. His body lies exposed, guarded by a raven ; a wolf is also generally introduced.   6. His body, fastened to a millstone, floats on the surface of the sea.   In this manner his story is represented on one of the windows at Bourges, and on another at Chartres ; also in St. Vincent's at Rouen.

The very ancient frescoes in the portico of his church at the ' Tre Fontane,' near Rome, have perished, at least I could scarcely discern the traces of them, but they may be found in D'Agincourt.[2]   In this church he is honoured, in conjunction with St. Anastasius the

[1] Flcrence Gal.                    [2] ' Hist. de l'Art par les Monumens,' pl. xcviii.

Persian, a young saint who, being in Persia at the time the true
cross was carried thither by Chosroes, in 614, was converted by the
miracles it performed, or rather occasioned, and was martyred in
consequence.   His obscure legend I have not found, except in these
defaced old paintings.   He was first strangled, and then beheaded;
and his proper attribute is the axe.

## St. Vitus.

*Ital.* San Vito.   *Fr.* St. Vite, or St. Guy.   *Ger.* Der Heilige Veit, Vit, or Vitus.
Patron of Saxony, Bohemia, and Sicily.   (June 15, A.D. 303.)

Vitus, or Vito, was the son of a noble Sicilian.   His parents were
heathens; but his nurse, Crescentia, and his foster-father, Modestus,
who were secretly Christians, brought him up in the faith, and
caused him to be baptized.   At twelve years old, he openly professed
himself a Christian, to the great indignation of his father, and the
cruel governor, Valerian, who attempted, by the usual terrors and
tortures, to subdue his constancy.   He was beaten, and shut up in
a dungeon; but his father, looking through the keyhole, beheld him
dancing with seven beautiful angels; and he was so amazed and
dazzled by their celestial radiance, that he became blind in the same
moment, and only recovered his sight by the intercession of his son.
But his heart being hardened, he again persecuted Vitus, and treated
him cruelly; therefore the youth fled with his nurse and Modestus,
and crossed the sea to Italy, in a little boat, an angel steering at
the helm.   But, soon after their arrival, they were accused before
the satellites of the Emperor Diocletian, plunged into a caldron of
boiling oil, and thus received the crown of martyrdom.   This popular
saint has been reverenced in every part of Christendom from time
immemorial.   In Germany he is one of the fourteen *Nothhelfers* or
patron-saints, and as such figures often in the old German pictures, as
in a remarkable picture by Wohlgemuth in the Burg at Nuremberg,
and another still finer in the Moritz-Kapell.   He is the patron
saint of dancers and actors, and invoked against that nervous
affection commonly called ' *St. Vitus' Dance.* '   He is represented as a

beautiful boy holding his palm; he has a cock in his hand, or near him, whence he is invoked against too much sleep, by those who find a difficulty in early rising.[1]  Other attributes are—the lion, because in his martyrdom he was exposed to lions; a wolf, because his remains were watched by a wolf—a legend common to many saints; a caldron of boiling oil, the instrument of his martyrdom.

St. Vitus is found in the sacred pictures, principally at Venice and at Prague.  The fine cathedral at Prague is dedicated to him, and on his shrine there is a very good modern statue of him, standing, mild, beautiful, and young, with a cock beside him.

The Martyrdom of St. Vitus, standing in a caldron with fire underneath, and St. George and St. Wolfgang, as Protectors of Bavaria, on each side, by Bassetti of Verona, I saw at Munich.

---

[1] The origin of the cock as an attribute of St. Vitus is a disputed point.  It appears that from very ancient times it was a custom to offer up a cock to him, and so late as the beginning of the eighteenth century this was done by the common people of Prague.

120

# The Greek Martyrs.

I SHALL group together here those Greek martyrs who have been accepted and particularly reverenced by the Latin Church, though as subjects of Art and patron saints they have not become popular.

## ST. THECLA, VIRGIN AND MARTYR.

*Ital.* San Tecla.   *Fr.* Sainte Thècle.   *Ger.* Die Heilige Thekla.   Patroness of Tarragona.
(Sept. 23.)

SUCH was the veneration paid to this saint in the East, and in the early ages of Christianity, that it was considered the greatest praise that could be given to a woman to compare her to St. Thecla.  Some of the ancient fathers assure us that she had studied profane literature and philosophy, and was famous for her eloquence.[1]

Her story is contained in a work entitled 'The Acts of Paul and Thecla,' known and circulated in the first century, but condemned as spurious by St. John the Evangelist.

'It is related, that when the apostle Paul arrived at Anconium, he preached in the house of Onesiphorus : and a certain virgin, named Thecla, sat at a window in her house, from whence, by the advantage of a window in the house where Paul was, she listened to his sermons concerning God, concerning charity, concerning faith in Christ, and concerning prayer, until with exceeding joy she was subdued to the doctrines of the faith.

'Now this virgin Thecla was betrothed to a youth named Thamyris, who loved her much; but when she would not be prevailed upon to depart from the window, her mother sent to Thamyris, and complained to him that her daughter would not move from the window,

---

[1] Baillet, 'Vies des Saints.'   Tillemont, tom. ii. p. 66.

nor eat, nor drink, so intent was she to hear the discourses of Paul. So Thamyris went and spoke to her, and said, " Thecla! my betrothed! why sittest thou in this melancholy posture? turn to Thamyris, and blush!" Her mother, Theoclea, also chid her, but it was to no purpose. Then they wept exceedingly,—Thamyris that he had lost his betrothed, Theoclea that she had lost her daughter, and the maids that they had lost their mistress: so there was an universal mourning in the house. But all these things made no impression upon Thecla, who did not even turn her head; for she regarded only the discourse of Paul, and his words, which made her heart burn within her.

' Then the young man complained to the governor, and the governor ordered Paul to be bound, and to be put in prison till he should be at leisure to hear him fully. But in the night, Thecla, taking off her ear-rings, gave them to the turnkey of the prison, who opened the doors of the prison and let her in; and when she had made a present of a silver looking-glass to the jailer, she was allowed to enter the room where Paul was: and she sat down at his feet, and heard from him the great things of God. And when she beheld his courage, and listened to his eloquence, she kissed his chains in a transport of faith and admiration.

' When the governor heard these things, he ordered Paul to be scourged and driven out of the city, and Thecla to be burned. Then the young men and women gathered wood and straw for the burning of Thecla, who being brought naked to the stake extorted tears from the governor, for he was surprised, beholding the greatness of her beauty. Then the people kindled the pile; but though the flame was exceedingly large, it did not touch her, for God took compassion on her; the fire was extinguished, and she was preserved, and made her escape. And Paul, taking Thecla along with him, went for Antioch. There a man named Alexander accused her before the governor, and she was condemned to be thrown among the beasts, which when the people saw, they cried out, saying, " The judgments declared in this city are unjust!"

' But Thecla desired no other favour of the governor than that her chastity might be guarded till she should be cast to the wild beasts. The day arrived, and she was brought to the amphitheatre, in the

presence of a multitude of spectators, and, being stripped of her
drapery, she had a girdle put round her body, and was thrown into
the place appointed for fighting with the beasts, and the lions and
the bears were let loose upon her.    But the women who were in the
theatre were struck with compassion, and groaned and cried out,
" Oh, unrighteous judgment! Oh, cruel sight! The whole city ought
to suffer for such crimes!" and one of them, called Trissina, wept
aloud.    Meantime a lioness, which was of all the most fierce, ran
upon Thecla, and fell down at her feet; and the bears and the
he-lions lay as though they were fast asleep, and did not touch her.
Upon this the governor called Thecla from among the beasts, and
said to her, " Who art thou, woman, that not one of the beasts will
touch thee ? " and Thecla replied, " I am a servant of the living God,
and a believer in Jesus Christ his Son."    Then the governor ordered
her clothes to be brought, and said to her, " Put on your apparel,"
and he released her.

   ' Then Thecla went home with Trissina: but desiring much to see
Paul, she resolved to travel in search of him ; and Trissina sent large
sums of money to Paul by her hands, and also much clothing for the
poor.    So Thecla journeyed till she found Paul preaching the word
of God at Myra, in Lycia.    Thence she returned to Iconium, and
after many years spent in preaching and converting the people she
was led by the Spirit to a mountain near Seleucia, where she abode
many years, and underwent many grievous temptations, which she
overcame by the help of the Lord.    She enlightened many people,
and wrought so many miraculous cures, that all the inhabitants of
the city and adjacent countries brought their sick to that mountain,
and when they came to the door of her cave they were instantly
cured ; such great power had God bestowed on the Virgin Thecla!
—insomuch that the physicians of Seleucia were held of no account,
and lost all the profit of their trade, for no one regarded them.    And
they were filled with envy, and began to contrive how they should
destroy her ; for they said within themselves, " This woman must be
a priestess of the great Goddess Diana, and the wonders she per-
forms are by virtue of her chastity ; and if we can destroy that,
she will be vanquished : " and they hired some fellows, sons of Belial,
to go to the mountain and offer her violence.    So they went, and

141          St. Thecla (Lorenzo Costa)

the blessed Thecla came out to meet them, and they laid hold upon her, and she fled from them, praying for deliverance. And behold! the rock opened behind her, forming a cavity so large that a man might enter in; and she ran thither, and the rock closed upon her, and she was seen no more. The men stood perfectly astonished at so prodigious a miracle, and having caught hold of her veil, a piece of it remained in their hands as evidence of this great wonder.

'Thus suffered the blessed virgin and martyr Thecla, who came from Iconium at eighteen years of age, and afterwards, partly in journeys and travels, and partly in a monastic life in the cave, lived

seventy-two years; so that she was ninety years of age when the
Lord translated her.'

Although the lions spared St. Thecla, she is considered the first
female martyr, and is honoured as such in the Greek Church.   In the
Latin Church the particular veneration professed for her by St. Martin
of Tours, in the fourth century, contributed to render her highly
popular; yet I have met with very few representations of her.

In the devotional pictures and miniatures she generally wears a
loose mantle of dark brown or grey, and holds the palm.   Several
wild beasts are around her.

In a Madonna picture by Lorenzo Costa she stands on one side of
the Virgin and Child, arrayed in a long robe of a violet colour, holding
the palm; and with no other attribute: the figure and attitude are
singularly elegant; the countenance mild, thoughtful, and sweet[1] (141).

In a picture by Marinari she is seen in prison, her hands fettered,
and an angel presents to her fruit and flowers:[2] of this incident
there is no mention in the legend I have cited.   As yet I have not
met with any picture in which Paul and Thecla are represented
together: such may possibly exist.   The scene in the dungeon, with
Paul teaching and Thecla seated at his feet, would be a beautiful
subject.

### St. Euphemia of Chalcedonia, Virgin and Martyr.

*Ital.* Sant' Eufemia.   *Fr.* Sainte Euphémie.   (Sept. 16, A.D. 307.)

THIS Greek saint, with her soft musical name and the fame of her
beauty and her fortitude, is one of those whom the Eastern Church has
distinguished by the epithet *Great*.   She is particularly interesting in
the history of Art, for all that can be certainly known of her rests on
the description of a picture, which description, however, is so ancient,
and so well authenticated, that it leaves no doubt as to the principal
circumstances pertaining to her—her existence, her name, the manner
of her martyrdom, and the place where she suffered.   I have already
alluded to this picture, as an evidence of the style and signification
of such representations in very early times.

It has happened that a few of the homilies of Asterius, bishop of

[1] Bologna Gal.   [2] Engraved under this name in the *Etruria Pittrice;* perhaps a St. Dorothea.

Amasea in Pontus, who lived and wrote between 350 and 400, have been preserved to us, and among them is a homily preached on the day consecrated to the memory of St. Euphemia.[1] The bishop, to excite the imagination and the zeal of his congregation, displays a picture of the saint, at the same time describing it most eloquently in detail.

' We see her,' he says, ' in this picture, portrayed with all that beauty and grace which distinguished her in her lifetime, yet with that modesty and gravity which showed her inward spirit : and attired in the plain dark-brown mantle which in Greece was worn by the philosophers, and which expressed a renunciation of all worldly pleasures and vain ornaments.

' We see her brought before the Judge Priscus by two soldiers, one of whom drags her forward ; the other pushes her on behind. But though from modesty her eyes are cast down, there is an expression in her face which shows it is not fear. We see her, in another part of the picture, tortured by two executioners, one of whom has seized her long hair, and pulls back her head, to force her to raise it ; the other strikes her on the mouth with a wooden mallet ; the blood flows from her lips ; and at the piteous sight, tears flow from the eyes of the spectators ; their hearts melt within them.

' In the background is seen the interior of a dungeon. St. Euphemia, seated on the earth, raises her hands to heaven, and prays for mercy, and for strength to bear her sufferings : over her head, behold! the cross appears ; either to show her confidence in the sign of our redemption, or to signify that she too must suffer. Then, near to the prison, we see a pile of faggots kindled, and in the midst stands the beautiful and courageous martyr. She extends her arms towards heaven ; her countenance is radiant with hope, with faith, with joy.'

The description ends here, and Asterius does not mention any further circumstances attending her martyrdom ; but, according to the legend, the flames, as was usual in such cases, were rendered innocuous by miraculous intervention : she was then thrown to the lions, but they crouched and licked her feet, and refused to harm her.  Pris-

[1] It is cited in the collection of ' Les Pères de l'Église,' vol. v.

cus, on seeing this, was like to swoon with despite and mortification; so one of his soldiers, to do him a pleasure, rushed upon the maiden, and transfixed her with his sword. This form of the legend must have prevailed in the time of St. Ambrose; but in other Legendaries it is related that the lions attacked her, but did not devour her, and that the executioner finished her with the sword.

St. Euphemia suffered in the tenth persecution, at Chalcedonia in Bithynia, not far from Byzantium, and about the year 307 or 311. The picture described by Asterius must have been executed soon after the death of the saint, when her memory was fresh in the minds of the people, and at a period when classical Art, though on the decline, retained at least its splendid forms, and influenced all the Christian representations. We may therefore infer the beauty and the accuracy of the delineation; it shows also that the manner of representing many scenes in the same picture already prevailed.

So ancient was the worship paid to St. Euphemia, that within a century after her death there were four churches dedicated to her in Constantinople alone; others in Rome, Alexandria,[1] Carthage; in short, throughout the East and West, temples rose everywhere to her honour, and many wonderful miracles were imputed to her. In the beginning of the eighth century, Leo the Iconoclast ordered her church to be profaned, and her relics to be cast into the sea: but this only increased the devotion paid to her; the relics reappeared in the island of Lemnos, and thence were dispersed to many places, even to France. In the Western Church she was accepted as a saint in the fourth century, and a church was dedicated to her in Rome in the fifth. Every one who has visited Verona will recollect the beautiful church which bears her name.[2] Though so celebrated in the early times, her popularity has diminished; or has been superseded by the fame of later saints.

A very early mosaic represents St. Euphemia standing between

[1] See Vol. i. p. 150.

[2] Whether the St. Euphemia who is reverenced all through Lombardy be identical with the Greek saint is not clear. In the Italian legend she has a sister, *Innocentia,* who suffered martyrdom with her. The remains of St. Euphemia and St. Innocentia are said to have been brought from Aquileia and deposited in the Cathedral of Vicenza about 1350.—*v.* 'Cat. Sanctorum Italiæ,' p. 595.

two serpents, but I do not find any mention of serpents in the legends I have consulted.[1] In all the representations since the revival of Art, she has the lion and the sword. Thus she appears in a beautiful and dignified figure by Andrea Mantegna, with the lily, emblem of chastity, in one hand, in the other the palm. The sword in her bosom, the lion at her side.[2]

In the church of St. Euphemia at Milan, there is one most admirable picture, a throned Virgin and Child by Marco Oggione. The Virgin has all the intellectual dignity and character of the school of Leonardo; the Child bends towards St. Catherine, who kneels, presented by St. Ambrose; on the other side kneels St. Euphemia, presented by John the Baptist; she has an instrument of torture at her feet which looks like a saw. It is a magnificent example of the Milanese school.

In a picture by Simone Cantarini, she is represented standing with her lion at her side, and pointing to the Virgin in glory: she wears a yellow tunic buttoned down the front, a crimson mantle, and a white veil thrown over her head.[3]

142  St. Euphemia  (Andrea Mantegna)

In her church at Verona she stands over one of the altars, bearing her palm, and accompanied by her lions. I have never met with any historical picture from her life.

[1] At Florence St. Verdiana is represented between two serpents. She was a Vallombrosian nun. See 'Legends of the Monastic Orders.'

[2] Cremona. In the San Maurizio at Milan, there is a lovely figure of a female saint, crowned, with a sword in her bosom, called a St. Ursula, which I believe to represent St. Euphemia.    [3] Bologna Gal.

Many other Christian martyrs were exposed in the amphitheatres, principally at Rome, at Carthage, and at Lyons, where the taste for these horrid spectacles was most prevalent; but they are not interesting as subjects of Art. I must regret that the martyrdom of Vivia Perpetua and Felicitas has never been worthily treated: in fact, I have never seen any ancient representation of St. Perpetua, except in the mosaic at Ravenna;[1] and therefore, confining myself within the limits assigned to this work, I shall not dwell upon her fate. The well-authenticated story of these two women, of their high-hearted constancy and meek fortitude, has been told so beautifully by Mr Milman, that I pass it over with the less regret; only observing, that as her history is accepted as authentic by Protestants, it remains open to Protestant artists. It affords not one, but many scenes of surpassing interest, full of picturesque and dramatic sentiment, and capable of being treated with the utmost tragic pathos, without touching on the horrible and revolting. Perpetua binding up her tresses in the amphitheatre, after she had been exposed before the people and wounded by the wild beasts let loose upon her, is an image one can hardly endure to bring before the fancy; but Perpetua in prison; before her judges; turning from her father; taking leave of her infant child;[2] and rising superior to every temptation, every allurement, to deny her Redeemer: Perpetua going forth, accompanied by the slave Felicitas (herself recently a mother), to meet a frightful death, with a mild, womanly spirit, without assumption or defiance; both young, with nothing to sustain them but faith, and that courage from on high which has never been denied to those who steadfastly trust in the *Hereafter;*—these, surely, are themes which, in their lofty beauty, might be held not unworthy of Christian Art and Christian sympathy in our times. It is rare to find any sacred subject of deep and general interest almost untouched; but here the field is open.[3]

---

[1] *v.* p. 525.

[2] Herr Vogel of Dresden has lately painted a fine picture of St. Perpetua looking through the bars of her prison at her infant child.

[3] 'The Acts of St. Perpetua and St. Felicitas,' though considered authentic by all the best ecclesiastical writers, were unknown to the early artists. She is commemorated by Tertullian and St. Augustine, and her story at length may be found in Baillet, 'Vies des Saints,' March 7. See also, 'Vivia Perpetua, a Dramatic Poem, in Five Acts,' by Sarah Flower Adams.

St. Felicitas, the African slave and companion of St. Perpetua, must not be confounded with St. Felicitas, the noble Roman matron, whose story I have placed among the Roman Martyrs.

## St. Phocas of Sinope, Martyr.

*Ital.* San Focà. The Greek patron of gardens and gardeners. (July 3, A.D. 303.)

TOWARDS the end of the third century, a holy man named Phocas dwelt outside the gate of the city of Sinope, in Pontus, and lived by cultivating a little garden, the produce of which, after supplying his own necessities, he distributed to the poor. Uniting prayer and contemplation with labour and charity, his garden was to him an instructive book, his flowers supplied him with a fund of holy meditation, and his little cottage was open to all strangers and travellers who were in want of a lodging.

One night, as he sat at his frugal supper of herbs, some strangers knocked at his door, and he invited them to enter and repose themselves. He set food before them, and gave them water for their feet; and when they had eaten and were refreshed, he asked them concerning their business. They told him that they were sent there in search of a certain Phocas, who had been denounced as a Christian; and that they were commissioned to kill him wherever they should find him. The servant of God, without betraying any surprise, conducted them to a chamber of repose, and when they were at rest, he went into his garden and dug a grave amid the flowers. The next morning he went to his guests and told them that Phocas was found; and they, rejoicing, asked, 'Where is the man?' He replied, 'I myself am he.' They started back, unwilling to imbrue their hands in the blood of their host; but he encouraged them, saying, 'Since it is the will of God, I am willing to die in His cause.' Then they led him to the brink of the grave, struck off his head, and buried him therein.

This interesting old saint appears in the Greek pictures and mosaics. Those who visit St. Mark's at Venice will find him in the vestibule on the left hand, among the saints who figure singly on the vault, standing in colossal guise, with a venerable beard, in the dress of a gardener, and holding a spade in his hand. His name is inscribed, and also distinguishes a similar figure in the Cathedral of Monreale, at Palermo. Except in genuine Byzantine Art, I have not met with St. Phocas. The Latin patron saint of gardeners is St. Fiacre, an Irish saint domiciliated in France. Turn to his legend farther on.

### St. Pantaleon of Nicomedia, Martyr.

In Greek, Panteleemon, which signifies 'all-merciful.'    *Ital.* San Pantaleone.
Patron of physicians.   (July 27, fourth century.)

It is interesting to observe that saints of the medical profession have been especially popular in the great trading towns, such as Venice, Florence, Lyons, Marseilles ;—cities which, through their intercourse with the East, and the influx of strangers, were constantly exposed to the plague and other epidemic disorders. I have already spoken of St. Roch, St. Cosmo, and St. Damian, with reference to those localities. St. Pantaleon, another of these beatified physicians, is particularly interesting in Venetian Art, and his odd Greek name familiar to all who remember Venice. Those critics who seem inclined to doubt his real existence, and who have derived his name from the Venetian war-cry, *Pianta Leone!* 'Plant the Lion!' are, I think, mistaken, for he was a Greek saint of celebrity in the sixth century, when Justinian dedicated to him a church at Constantinople; and I think it more probable that the Venetians introduced him into their city from the Levant.

According to the legend, Pantaleon was born at Nicomedia in Bithynia, the son of a heathen father and a Christian mother, and, after having made himself master of all the learning and science of

the Greeks, he attached himself particularly to the study of medicine. The legend adds that he was remarkable for his beautiful person and graceful manners, and that he became the favourite physician of the Emperor Galerius Maximian.

During his residence in this heathen court, Pantaleon was in danger of forgetting all the Christian precepts which he had learned from his mother. But, fortunately, a venerable Christian priest, named Hermolaus, undertook to instruct him, and Pantaleon became an ardent Christian. When the persecution broke out, knowing that he could not remain concealed, like his master Hermolaus, he saw plainly that he must anticipate a cruel martyrdom; and, instead of endeavouring to escape, he prepared himself to meet it by those acts of charity for which his profession as physician afforded so many opportunities. He went about healing the sick, restoring sight to the blind, raising the dead, or those who were nigh to death. And being, in the midst of these good works, accused before the emperor, he obtained, as he had desired, the glorious crown of martyrdom, being beheaded together with his aged master Hermolaus, who came forth from his retreat to share his fate; but for Pantaleon, they first bound him to an olive tree, and, according to the poetical legend, no sooner had his blood bathed the roots of the tree than it burst forth into leaves and fruit.

This saint is uniformly represented young, beardless, and of a beautiful countenance. As patron, he wears the long loose robe of a physician, and sometimes, in allusion to the circumstances of his martyrdom, he holds the olive instead of the palm, or both together. As Martyr, he stands bound to an olive tree, with both hands over his head, and a nail driven through them into the trunk of the tree; the sword at his feet. In such pictures we must distinguish between St. Pantaleon and St. Sebastian.

His church at Venice is particularly interesting to those who love to study Venetian character. It is the parish church of a dense and populous neighbourhood, and I used to go there more for the sake of looking at the people—the picturesque mothers with their infants, the little children reciting their catechism—than to study Art and pictures. The walls are covered with the beneficent actions of the saint, and with scriptural incidents which have reference to the healing art. None of

these, however, are particularly good.   Among them are the following
subjects :—

1. The saint heals a sick child : by Paul Veronese.   2. He raises a
dead man.   3. His charities to the poor, and various miracles are upon
the ceiling, by Fumiani ; while in other parts of the church we see the
pool of Bethesda, the miracle of the loaves and fishes, and other works
of healing and charity.   St. Pantaleon was at one time very popular at
Lyons, but I know not whether any vestiges remain of the reverence
formerly paid to him there ; nor do I remember any picture representing
him except at Venice.

## St. Dorothea of Cappadocia, Virgin and Martyr.

*Ital.* Santa Dorotea.   *Fr.* Sainte Dorothée.   (Feb. 6, A.D. 303.)

' In the province of Cappadocia, and in the city of Cesarea, dwelt a
noble virgin, whose name was Dorothea.   In the whole city there
was none to be compared to her in beauty and grace of person.   She
was a Christian, and served God day and night with prayers, with
fasting, and with alms.

' The governor of the city, by name Sapritius (or Fabricius), was a
very terrible persecutor of the Christians, and hearing of the maiden,
and of her great beauty, he ordered her to be brought before him.   She
came, with her mantle folded on her bosom, and her eyes meekly cast
down.   The governor asked, "Who art thou?" and she replied, "I am
Dorothea, a virgin, and a servant of Jesus Christ."   He said, "Thou
must serve our gods, or die."   She answered mildly, " Be it so ; the
sooner shall I stand in the presence of Him whom I most desire to
behold."   Then the governor asked her, " Whom meanest thou?"   She
replied, "I mean the Son of God, Christ, mine espoused ! his dwelling
is Paradise ; by his side are joys eternal ; and in his garden grow celestial
fruits and roses that never fade."   Then Sapritius, overcome by her
eloquence and beauty, ordered her to be carried back to her dungeon.
And he sent to her two sisters, whose names were Calista and Christeta,

who had once been Christians, but who, from terror of the torments with which they were threatened, had renounced their faith in Christ. To these women the governor promised large rewards if they would induce Dorothea to follow their evil example; and they, nothing doubting of success, boldly undertook the task. The result, however, was far different; for Dorothea, full of courage and constancy, reproved them as one having authority, and drew such a picture of the joys they had forfeited through their falsehood and cowardice, that they fell at her feet, saying, "O blessed Dorothea, pray for us, that, through thy intercession, our sin may be forgiven and our penitence accepted!" And she did so. And when they had left the dungeon they proclaimed aloud that they were servants of Christ.

'Then the governor, furious, commanded that they should be burned, and that Dorothea should witness their torments. And she stood by, bravely encouraging them, and saying, "O my sisters, fear not! suffer to the end! for these transient pangs shall be followed by the joys of eternal life!" Thus they died: and Dorothea herself was condemned to be tortured cruelly, and then beheaded. The first part of her sentence she endured with invincible fortitude. She was then led forth to death; and, as she went, a young man, a lawyer of the city, named Theophilus, who had been present when she was first brought before the governor, called to her mockingly, "Ha! fair maiden, goest thou to join thy bridegroom? Send me, I pray thee, of the fruits and flowers of that same garden of which thou hast spoken: I would fain taste of them!" And Dorothea, looking on him, inclined her head with a gentle smile, and said, "Thy request, O Theophilus, is granted!" Whereat he laughed aloud with his companions; but she went on cheerfully to death.

'When she came to the place of execution, she knelt down and prayed; and suddenly appeared at her side a beautiful boy, with hair bright as sun-beams—

> A smooth-faced, glorious thing,
> With thousand blessings dancing in his eyes.

In his hand he held a basket containing three apples, and three fresh gathered and fragrant roses. She said to him, " Carry these to

Theophilus, say that Dorothea hath sent them, and that I go before him to the garden whence they came, and await him there." With these words she bent her neck, and received the death-stroke.

'Meantime the angel (for it was an angel) went to seek Theophilus, and found him still laughing in merry mood over the idea of the promised gift. The angel placed before him the basket of celestial fruit and flowers, saying, "Dorothea sends thee these," and vanished. What words can express the wonder of Theophilus? Struck by the prodigy operated in his favour, his heart melted within him; he tasted of the celestial fruit, and a new life was his; he proclaimed himself a servant of Christ, and, following the example of Dorothea, suffered with like constancy in the cause of truth, and obtained the crown of martyrdom.'

St. Dorothea is represented with roses in her hand; or crowned with roses;[1] or offering a basket of fruit and flowers to the Virgin or the Infant Christ; or attended by an angel holding a basket, in which are three apples and three roses. The last is the most peculiar and the most characteristic attribute; other saints have flowers, or are crowned with roses; Dorothea alone has the attendant angel holding the basket of fruit and flowers. She bears the palm of course, and occasionally the crown as martyr.

St. Dorothea is more popular in the German and Flemish than the Italian schools, and there are few early pictures of her. I found her in an old Siena picture, with roses in her lap, and holding a bouquet of roses in her hand.[2] Rubens and Vandyck have both painted her crowned with roses, and holding her palm. In a beautiful Madonna picture by Israel v. Melem, she stands on the left of the Virgin, crowned with roses, and with a basket of roses before her.[3]

St. Dorothea and her companions, St. Calista and St. Christeta, are represented in three ancient marble statues in the *Chiesa dell' Abazia* at Venice, attributed to the Maestro Bartolomeo (fourteenth century).

The principal incident of her legend is so picturesque and poetical,

---

[1] It is usual in catalogues and descriptions of pictures to find St. Dorothea called St. Rosalia or St. Rosa; a mistake arising from the attribute of the roses. St. Rosalia and St. Rosa will be found among the 'Monastic Legends.

[2] Siena Acad.                                    [3] Boisserée Gal.

143    St Dorothea  (German)            144    St. Dorothea  (Siena)

that one is surprised not to meet with it oftener ; in fact, I have never met with it; yet the interview between Dorothea and Theophilus, and afterwards between Theophilus and the angel, are beautiful subjects : the first scene has a tragic interest, and the latter an allegorical significance as well as a picturesque beauty, which should have recommended them to painters.

The martyrdom of St. Dorothea has been several times painted. The picture by Jacopo Ligozzi is a grand scenic composition, in the style of his master Paul Veronese, and almost equal to him. The scaffold, and near it, on horseback, the inexorable Sapritius, who

has just given the command to strike; the ferocious executioner; the figure of the gentle and beautiful victim, kneeling with an expression of placid faith; the angels hovering with garlands of roses above, and the various attitudes of the spectators;—are all admirably painted in the dramatic, or rather scenic, style proper to the school.[1]

Carlo Dolce. St. Dorothea kneeling, with hands bound, and by her side the angel with his basket of celestial fruit and flowers: one of his best pictures; the sweetness and elegance of his manner suited the subject, and he is here less tame than usual.[2]

Rubens. St. Dorothea standing, with roses and palm.

Vandyck. St. Dorothea standing, with her palm, roses, and apples from Paradise.[3]

The legend of Dorothea is the subject of Massinger's tragedy of 'The Virgin Martyr;' he was assisted by Decker, to whom the critics attribute much that is coarse, offensive, and profane in the dialogue. It contains, however, scenes and passages of great beauty; and these are given without alloy in Murray's 'Family Library.'[4] One critic observes that of the character of the heroine 'it is impossible to speak too highly; her genuine and dignified piety, her unshaken constancy, her lofty pity for her persecutors, her calm contempt of torture, and her heroic death, exalt the mind in no ordinary degree.' The religious action is varied and rendered more romantic by making Antoninus, the brave and amiable son of the cruel Sapritius, in love with Dorothea; for her sake he refuses the daughter of Diocletian, and Dorothea's last prayer is for him :—

> Grant that the love of this young man for me,
> In which he languishes to death, may be
> Changed to the love of Heaven !

Her prayer is granted; Antoninus is converted, and dies of grief on witnessing her cruel martyrdom. The last scene between Theophilus and the Emperor Diocletian is ascribed wholly to Massinger. It contains the fine passage in which the Christian saint is exalted above the classical heroines of antiquity :—

[1] Brescia, PP. Conventuali.

[2] Darmstadt Gal.

[3] Both pictures are engraved by Galle.

[4] Dramatic Series, vol. i.

                    Dorothea but hereafter named
You will rise up with reverence, and no more,
As things unworthy of your thoughts, remember
What the canonised Spartan ladies were,
Which lying Greece so boasts of. Your own matrons,
Your Roman dames, whose figures you yet keep
As holy relics, in her history
Will find a second urn: Gracchus' Cornelia,
Paulina, that in death desired to follow
Her husband Seneca, nor Brutus' Portia,
That swallowed burning coals to overtake him,—
Though all their several worths were given to one,
With this is to be mention'd.
                    They, out of desperation,
Or for vainglory of an after-name,
Parted with life : this had not mutinous sons
As the rash Gracchi were ; nor was this saint
A doting mother as Cornelia was.
This lost no husband in whose overthrow
Her wealth and honour sank ; no fear of want
Did make her being tedious ; but aiming
At an immortal crown, and in his cause
Who only can bestow it, who sent down
Legions of ministering angels to bear up
Her spotless soul to heaven, who entertained it
With choice celestial music equal to
The motion of the spheres ; she, uncompell'd,
Changed this life for a better.

## ST. CYPRIAN AND ST. JUSTINA OF ANTIOCH.

*Ital.* San Cipriano il Mago e Santa Giustina. *Fr.* St. Cyprien le Magicien et Sainte Justine.
(Sept. 26, A.D. 304.)

IT is surprising that this very beautiful and antique legend has not oftener been treated as a subject of Art. It is full of picturesque capabilities of every kind. Calderon founded on it one of his finest *autos*, the ' Magico Prodigioso ; ' part of which—the scene in which the maiden is tempted by demons—Shelley has beautifully translated. Though I have never met with the story in Western Art, except in one or two miniatures, others may have been more fortunate, for which reason, and because of its singular beauty, I give it at length.

‘ In the city of Antioch dwelt a virgin wonderfully fair, and good,
and wise; her name was Justina.　She was the daughter of a priest
of the idols; but having listened to the teaching of the Gospel, she
not only became a Christian herself, but converted her parents to
the true faith.　Many looked upon this beautiful maiden with eyes
of love; among them a noble youth of the city of Antioch, whose
name was Aglaides; and he wooed her with soft words and gifts,
but all in vain, for Justina had devoted herself to the service of God
and a life of chastity and good works, and she refused to listen to
him ; and he was well nigh in desperation.

‘ Now in the same city of Antioch dwelt Cyprian the magician, a
man deeply versed in all the learning of the pagan philosophers, and
moreover addicted from his youth to the study of astrology and
necromancy.　When he had exhausted all the learning of his own
country, he travelled into the East, into the land of the Chaldees,
and into Egypt ; and to Argos, and to Athens; and he had made him-
self familiar with all terrible and forbidden arts.　He had subjected
to his might the spirits of darkness and the elements ; he could
command the powers of hell; he could raise storms and tempests,
and transform men and women into beasts of burthen.　It was said
that he offered the blood of children to his demons, and many other
crimes were imputed to him, too dreadful to be here related.

‘ Aglaides being, as I have said, in despair and confusion of mind
because of the coldness of Justina, repaired to Cyprian; for he said,
“ Surely this great magician, who can command the demons and
the elements, can command the will of a weak maiden: ” then he
explained the matter to him, and required his help.　But no sooner
had Cyprian beheld the beautiful and virtuous maiden, than he be-
came himself so deeply enamoured, that all rest departed from him,
and he resolved to possess her.　As yet, nothing had been able to
resist his power, and, full of confidence, he summoned his demons
to his aid.　He commanded them to fill the mind of the chaste
Justina with images of earthly beauty, and to inflame and pollute
her fancy with visions of voluptuous delight.　She was oppressed,
she was alarmed, she felt that these were promptings of the Evil One,
and she resisted with all her might, being well assured that as long
as her will remained unconquered, Christ and the Virgin would help

her;—and it was so; for when she invoked them against her enemy, he left her in peace, and fled.

'When Cyprian found that his demon was foiled, he called up another, and then another, and at length the Prince of Darkness himself came to his aid : but it was all in vain. Justina was fearfully troubled, her pure and innocent mind became the prey of tumultuous thoughts ; demons beset her couch, haunted her sleep, poisoned the very atmosphere she breathed; but she said to her almost failing heart, " I will not be discouraged, I will strive with the evil which besets me; thought is not in our power, but action is; my spirit may be weak, but my will is firm; what I do not *will*, can have no power over me." Thus, although grievously tempted and tormented, she stood fast, trusting in the God whom she worshipped, and conquered at last, not by contending, but by never owning herself subdued, and strong in her humility only by not consenting to ill. So the baffled demon returned to his master, and said, " I can do nothing against this woman ; for, being pure and sinless in will, she is protected by a power greater than thine or mine ! "

'Then Cyprian was astonished, and his heart was melted; and he said to the demon, " Since it is so, I contemn thee and thy power ; and I will henceforth serve the God of Justina." He went therefore, full of repentance and sorrow, and, falling at her feet, acknowledged the might of her purity and innocence, and confessed himself vanquished ; upon which she forgave him freely, and rejoiced over him ; and in her great joy she cut off her beautiful hair, and made an offering of it before the altar of the Virgin, and gave much alms to the poor.

'Soon afterwards Cyprian was baptized and became a fervent Christian ; all his goods he distributed to the poor, and became as remarkable for his piety, abstinence, and profound knowledge of the Scriptures, as he had formerly been for his diabolical arts, his wickedness, his luxury, and his pride. Such was his humility that he undertook the meanest offices for the service of the faithful, and he and Justina mutually strengthened and edified each other by their virtues and by their holy conversation.

'At this time broke forth the last and most terrible persecution against the Christians ; and when the governor of Antioch found that no menaces could shake the faith of Cyprian and Justina, he ordered

them to be thrown together into a caldron of boiling pitch; but by
a miracle they escaped unharmed. The governor then, fearing the
people, who venerated Cyprian and Justina, sent them with an escort
to the Emperor Diocletian, who was then at Nicomedia, languishing
in sickness; and the emperor, hearing that they were Christians,
without any form of trial, ordered them to be instantly beheaded;
which was done. Thus they received together the crown of martyr-
dom, and in name and in fame have become inseparable.'

When St. Cyprian and St. Justina are represented together, he is
arrayed in the habit of a Greek bishop, without a mitre, bearing the
palm and sword, and trampling his magical books under his feet:
she holds the palm; and a unicorn, the emblem of chastity, crouches
at her feet.

In that Greek MS. of the works of Gregory Nazianzen to which I
have so often referred, as containing the earliest known examples of
the treatment of legendary subjects, I found the story of Cyprian and
Justina in four miniatures.[1]

1. Justina seeks refuge at the feet of Christ from the demon who
pursues her.   2. Cyprian engaged in his magical incantations,
burning incense, &c., and a demon rises behind him.   3. He is
kneeling as a penitent at the feet of Justina.   4. They suffer
martyrdom together. The figures, ruined as they are, most freely
and nobly designed.

Every one who has been at Vienna will probably remember the St.
Justina of the Belvedere, so long attributed to Pordenone, but now
known to be the production of a much greater man, Bonvicino of
Brescia (Il Moretto). She stands in a landscape; one hand sustains
her drapery, the other holds her palm; she looks down, with an air
of saintly dignity blended with the most benign sweetness, on a
kneeling votary. This sketch (145) will give an idea of the com-
position; but nothing—no copy, no description—could convey the
expression of the countenance, which has the character of Venetian
beauty, elevated by such a serious and refined grace, that the effect
of the combination is quite inconceivable. There is a tradition rela-

---

[1] Paris Bib. Nat.  MSS. grecs, A.D. 867.

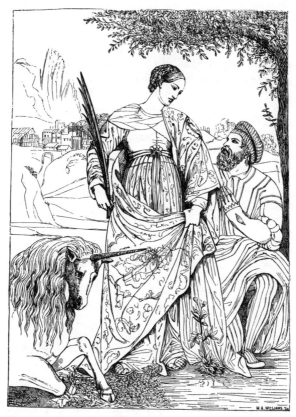

145          St. Justina and Alphonso I. of Ferrara   (Moretto)

tive to this picture which greatly enhances its interest; it is said to represent Alphonso I. of Ferrara at the feet of Donna Laura Eustochio: she was a beautiful woman of low origin, whom Alphonso married after the death of Lucretia Borgia; some say she had been his mistress, but this is not certain; and, at all events, when Duchess of Ferrara she won by her virtues the respect and love of all classes:

the people of Ferrara held her in such reverence, that once, when threatened by an inundation, they imputed their preservation solely to her prayers.[1]

It is not easy to distinguish St. Justina of Antioch from another saint of the same name, St. Justina of Padua, the more especially as the painters themselves appear to have confounded them. The reader, therefore, will do well to turn at once to the legend of Justina of Padua, farther on: she is much more popular in Western Art than the Greek heroine and martyr of Antioch, but not nearly so interesting.

### St. Apollonia of Alexandria, Virgin and Martyr.

*Fr.* Sainte Apolline.   Patroness against toothache, and all diseases of the teeth.
(Feb. 9, A.D. 250.)

' There dwelt in the city of Alexandria a magistrate who had great riches, but he and his wife also were heathens. They had no children, and day and night they besought their false gods to grant them a son or a daughter to inherit their wealth. Meantime, for so it pleased God, three pious pilgrims, servants of the Lord, arrived in the city, and, being hungry and weary, they begged an alms for the love of the Redeemer and the Blessed Virgin his mother. Now as they were thus begging opposite to the house of the magistrate, his wife, being astonished, called to them and said, "What new manner of begging is this? in whose name do ye ask alms?" Then the pilgrims preached to her the merits of Christ and of the Virgin. The woman, being greatly moved by their words, asked whether it were possible that the Virgin-mother of God, of whom they spoke, could grant her prayer to have a child? And they answered, "Without doubt." Thereupon she called them in, and gave them alms, and meat and drink; and addressed her prayer, full of faith, to the Holy Virgin. Her prayer was heard, and she brought forth a daughter, to whom she gave the name of Apollonia.

---

[1] According to Ticozzi, Titian painted her several times, *e nuda e vestita.* I have never seen in any gallery a portrait by Titian recognised as the portrait of Donna Laura; but, for several reasons, on which I cannot enlarge in this place, I believe the famous picture in the Louvre, styled 'Titian's Mistress,' to be the portrait of this peasant-duchess. She died in 1573.

'As the maiden grew up and flourished as a flower in grace and beauty, her mother ceased not to relate to her the wonderful circumstances of her birth : and thus she became a true Christian at heart, and with a longing wish to be baptized. With this purpose, and directed by an angel, she found her way to St. Leonine, the disciple of St. Anthony, and desired to be made a Christian ; so he baptized her; and suddenly there appeared an angel holding a garment of dazzling white, which he threw over the maiden, saying, " This is Apollonia, the servant of Jesus ! go now to Alexandria, and preach the faith of Christ." She, hearing the divine voice, obeyed, and preached to the people with wondrous eloquence. Many were converted ; others ran to complain to her father, and to accuse her of breaking the law; but she defended herself; and her father, incensed, gave her up to the power of the heathen governor, who commanded her instantly to fall down and worship the idol set up in the city. Then St. Apollonia, being brought before the idol, made the sign of the cross, and commanded the demon who dwelt within it to depart; and the demon, uttering a loud cry, broke the statue, and fled, shrieking out, " The Holy Virgin Apollonia drives me forth ! " The tyrant, seeing this, ordered her to be bound to a column ; and all her beautiful teeth were pulled out, one by one, with a pair of pincers ; then a fire was kindled, and as she persisted in the faith, she was flung into it, and gave up her soul to God, being carried into heaven by His angels.'

The cautious Baillet admits that the Virgin Apollonia was put to death in a tumult of the people against the Christians, and that 'ils lui cassèrent d'abord toutes les dents par des coups horribles.' But the above is the legend followed by the painters.

St. Apollonia is represented with the palm as martyr, and holding a pair of pincers with a tooth : or the pincers, as in later pictures, are placed near her; in the beautiful picture of St. Apollonia in our National Gallery, the pincers are lying on a table; in a picture by Hemlinck, she wears a golden tooth, suspended as an ornament to her neck-chain. There is a St. Apollonia by Furini in the Rinuccini Palace at Florence, a head of singular beauty, bent back, as if preparing for the torture; the ferocious executioner seen behind. She

does not, however, appear to be popular as a patron saint, nor are pictures of her very common. The finest I have seen is that by Francesco Granacci in the Munich Gallery. It is a single figure, nearly life-size, and forms one wing of a beautiful altar-piece, which Granacci painted for the sake of a favourite niece, who was a nun in the convent of St. Apollonia at Florence. Granacci was a favourite pupil of Michael Angelo, and caught some of his grandeur of form; but in his treatment of a subject he rather resembles Ghirlandajo. On the predella beneath he represented in six compartments the life of the saint. 1. St. Apollonia, after her baptism, hears the voice of angels sending her forth to preach the Gospel. 2. She is preaching to the people,—a noble figure; her auditors are principally old men, who appear to be pondering her words. 3. She is brought before the judge, who, according to one version of the legend, was her father, and just such a cruel pagan as the father of St. Barbara. 4. She is bound to a pillar, and scourged; the scene is a guard-room or prison, with soldiers in the background. 5. She is seated with her hands bound, and has all her teeth pulled out by an executioner. 6. She kneels, and a soldier behind is about to strike off her head with an axe. This predella, separated, as it often happens, from the principal subject, is now in the ' Accademia delle Belle Arti,' at Florence.

It is necessary to observe that St. Apollonia has a pair of pincers, and St. Agatha a pair of shears, which in some of the old pictures are not well discriminated.

The Martyrdom of St. Apollonia is sometimes found in the chapels dedicated to her. She is generally bound to a pillar, and an executioner stands near: I have never seen him in the very act of pulling out her teeth, except in one or two coarse miniatures. In the Duomo at Milan, which does not abound in good pictures, one of the best is Procaccino's Martyrdom of St. Apollonia.

## The Seven Sleepers of Ephesus.

*Ital.* I Sette Dormienti.   *Fr.* Les Sept Dormants.   Les Sept Enfants d'Éphèse.
*Ger.* Die Sieben Schläfer.   (June 27.)

DURING the persecution under the Emperor Decius, there lived in the city of Ephesus, seven young men, who were Christians; their names were Maximian, Malchus, Marcian, Dionysius, John, Serapion, and Constantine; and as they refused to offer sacrifice to the idols, they were accused before the tribunal. But they fled and escaped to Mount Cœlian, where they hid themselves in a cave. Being discovered, the tyrant ordered that they should roll great stones to the mouth of the cavern, in order that they might die of hunger. They, embracing each other, fell asleep.

And it came to pass in the thirtieth year of the reign of the Emperor Theodosius, that there broke out that dangerous heresy which denied the resurrection of the dead. The pious emperor, being greatly afflicted, retired to the interior of his palace, putting on sackcloth and covering his head with ashes: therefore God took pity on him, and restored his faith by bringing back these just men to life; which came to pass in this manner. A certain inhabitant of Ephesus, repairing to the top of Mount Cœlian to build a stable for his cattle, discovered the cavern; and when the light penetrated therein, the sleepers awoke, believing that their slumber had only lasted for a single night; they rose up, and Malchus, one of the number, was despatched to the city to purchase food. He, advancing cautiously and fearfully, beheld, to his astonishment, the image of the cross surmounting the city-gate. He went to another gate, and there he found another cross. He rubbed his eyes, believing himself still asleep, or in a dream, and entering the city he heard everywhere the name of Christ pronounced openly; and he was more and more confounded. When he repaired to the baker's, he offered in payment an ancient coin of the time of the Emperor Decius, and they looked at him with astonishment, thinking that he had found a hidden treasure. And when they accused him, he knew not what to reply. Seeing his confusion, they bound him and dragged him through the

streets with contumely; and he looked round, seeking some one whom he knew, but not a face in all the crowd was familiar to him.    And being brought before the bishop, the truth was disclosed to the great amazement of all.    The bishop, the governor, and the principal inhabitants of the city, followed him to the entrance of the cavern, where the other six youths were found.    Their faces had the freshness of roses, and the brightness of a holy light was around them. Theodosius himself, being informed of this great wonder, hastened to the cavern, and one of the sleepers said to him, 'Believe in us, O Emperor! for we have been raised before the Day of Judgment, in order that thou mightest trust in the resurrection of the dead!'    And having said this, they bowed their heads and gave up their spirits to God.    They had slept in their cavern for 196 years.

Gibbon, in quoting this poetical fable, observes that the tradition may be traced to within half a century of the supposed miracle.    About the end of the sixth century, it was translated from the Syriac into the Latin, and was spread over the whole of Western Christendom. Nor was it confined to the Christian world.    Mahomet has introduced it as a divine revelation into the Koran.    It has penetrated into Abyssinia.    It has been found in Scandinavia: in fact, in the remotest regions of the Old World, this singular tradition, in one form or another, appears to have been known and accepted.

The Seven Sleepers of Ephesus, extended in their cave, side by side, occur perpetually in the miniatures, ancient sculpture, and stained glass of the thirteenth and fourteenth century.    Thus they are represented in the frieze of the Chapel of Edward the Confessor at Westminster.    In general the name of each is written over his head. They carry palms as martyrs.    I have never seen them with any other attributes, but in the German 'Iconographie' it is said that 'In an old representation,' not otherwise described as to age or locality, the Seven Sleepers are thus individualised:—John and Constantine bear each a club, Maximian has a knotted club, Malchus and Marcian have axes, Serapion a torch, and Dionysius a large nail. What these attributes may signify,—whether alluding to the trades they exercised, or the kind of martyrdom to which they were condemned, but did not suffer,—is not explained; and I have never met with any effigies thus discriminated.

# The Latin Martyrs.

## THE FOUR GREAT VIRGINS OF THE LATIN CHURCH.

### St. Cecilia, Virgin and Martyr.

*Fr.* Sainte Cécile.  The name in Italian, German, and Spanish is the same as in English and Latin.  Patroness of music and musicians.  (Nov. 22, A.D. 280.)

St. Cecilia and St. Catherine present themselves before the fancy as the muses of Christian poetic art;—the former presiding over music and song, the latter over literature and philosophy.   In their character of patron saints, we might therefore expect to find them oftener combined in the same picture; for the appropriate difference of expression in each—the grave, intellectual, contemplative dignity of St. Catherine, and the rapt inspiration of St. Cecilia—present the most beautiful contrast that a painter could desire.   It is, however, but seldom that we find them together: when grouped with other saints, St. Cecilia is generally in companionship with St. Agnes, and St. Catherine with St. Barbara or Mary Magdalene.   To understand this apparent anomaly, we must bear in mind that, while the Greek patronesses, St. Catherine, St. Euphemia, St. Barbara, St. Margaret, are renowned throughout all Christendom, the Four Great Virgins of the Latin Church (for such is their proper designation), St. Cecilia, St. Agnes, St. Agatha, and St. Lucia, are almost entirely confined to Western Art, and fall naturally into companionship.   Of these, the two first were Roman, and the two last Sicilian martyrs.

The beautiful legend of St. Cecilia is one of the most ancient handed down to us by the early Church.   The veneration paid to her can be traced back to the third century, in which she is supposed to have lived; and there can be little doubt that the main incidents of her life and martyrdom are founded in fact, though mixed up with the usual amount of marvels, parables and precepts, poetry and

allegory, not the less attractive and profitable for edification in times when men listened and believed with the undoubting faith of children. In this as in other instances, I shall make no attempt to separate historic truth from poetic fiction, but give the legend according to the ancient version, on which the painters founded their representations.

' St. Cecilia was a noble Roman lady, who lived in the reign of the Emperor Alexander Severus. Her parents, who secretly professed Christianity, brought her up in their own faith, and from her earliest childhood she was remarkable for her enthusiastic piety : she carried night and day a copy of the Gospel concealed within the folds of her robe ; and she made a secret but solemn vow to preserve her chastity, devoting herself to heavenly things, and shunning the pleasures and vanities of the world. As she excelled in music, she turned her good gift to the glory of God, and composed hymns, which she sang herself with such ravishing sweetness that even the angels descended from heaven to listen to her, or to join their voices with hers. She played on all instruments, but none sufficed to breathe forth that flood of harmony with which her whole soul was filled : therefore she invented the organ, consecrating it to the service of God.

' When she was about sixteen, her parents married her to a young Roman, virtuous, rich, and of noble birth, named Valerian. He was, however, still in the darkness of the old religion. Cecilia, in obedience to her parents, accepted of the husband they had ordained for her ; but beneath her bridal robes she put on a coarse garment of penance, and, as she walked to the temple, renewed her vow of chastity, praying to God that she might have strength to keep it :— and it so fell out ; for, by her fervent eloquence, she not only persuaded her husband Valerian to respect her vow, but converted him to the true faith. She told him that she had a guardian angel who watched over her night and day, and would suffer no earthly lover to approach her,—

> I have an angel which thus loveth me—
> That with great love, whether I wake or sleep,
> Is ready aye my body for to keep.[1]

---

[1] *v.* Chaucer,—who has given an almost literal version of the old legend in the ' Second Nonnes Tale.'

And when Valerian desired to see this angel, she sent him to seek the aged St. Urban, who, being persecuted by the heathen, had sought refuge in the catacombs. After listening to the instruction of that holy man, the conversion of Valerian was perfected, and he was baptized. Returning then to his wife, he heard, as he entered, the most enchanting music; and, on reaching her chamber, beheld an angel, who was standing near her, and who held in his hand two crowns of roses gathered in Paradise, immortal in their freshness and perfume, but invisible to the eyes of unbelievers. With these he encircled the brows of Cecilia and Valerian, as they knelt before him; and he said to Valerian, " Because thou hast followed the chaste counsel of thy wife, and hast believed her words, ask what thou wilt, it shall be granted to thee." And Valerian replied, " I have a brother named Tiburtius, whom I love as my own soul; grant that his eyes also may be opened to the truth." And the angel replied with a celestial smile, " Thy request, O Valerian, is pleasing to God, and ye shall both ascend to His presence, bearing the palm of martyrdom." And the angel, having spoken these words, vanished. Soon afterwards Tiburtius entered the chamber, and perceiving the fragrance of the celestial roses, but not seeing them, and knowing that it was not the season for flowers, he was astonished. Then Cecilia, turning to him, explained to him the doctrines of the Gospel, and set before him all that Christ had done for us;—contrasting his divine mission, and all he had done and suffered for men, with the gross worship of idols, made of wood and stone; and she spoke with such a convincing fervour, such a heaven-inspired eloquence, that Tiburtius yielded at once, and hastened to Urban to be baptized and strengthened in the faith. And all three went about doing good, giving alms, and encouraging those who were put to death for Christ's sake, whose bodies they buried honourably.

' Now there was in those days a wicked prefect of Rome, named Almachius, who governed in the emperor's absence; and he sent for Cecilia and her husband and brother, and commanded them to desist from the practices of Christian charity. And they said, " How can we desist from that which is our duty, for fear of anything that man can do unto us?" The two brothers were then thrown into a dungeon, and committed to the charge of a centurion named Maximus,

whom they converted, and all three, refusing to join in the sacrifice
to Jupiter, were put to death.  And Cecilia, having washed their
bodies with her tears, and wrapped them in her robes, buried them
together in the cemetery of Calixtus.  Then the wicked Almachius,
covetous of the wealth which Cecilia had inherited, sent for her, and
commanded her to sacrifice to the gods, threatening her with horrible
tortures in case of refusal; she only smiled in scorn : and those who
stood by wept to see one so young and so beautiful persisting in what
they termed obstinacy and rashness, and entreated her to yield; but
she refused, and by her eloquent appeal so touched their hearts, that
forty persons declared themselves Christians, and ready to die with
her.  Then Almachius, struck with terror and rage, exclaimed, " What
art thou, woman ? " and she answered, " I am a Roman of noble
race."  He said, " I ask of thy religion ? " and she said, " Thou
blind one, thou art already answered ! " Almachius, more and more
enraged, commanded that they should carry her back to her own
house, and fill her bath with boiling water, and cast her into it ; but it
had no more effect on her body than if she had bathed in a fresh spring.
Then Almachius sent an executioner to put her to death with the
sword ; but his hand trembled, so that after having given her three
wounds in the neck and breast, he went his way, leaving her bleeding
and half dead.  She lived, however, for the space of three days,
which she spent in prayers and exhortations to the converts, dis-
tributing to the poor all she possessed ; and she called to her St.
Urban, and desired that her house, in which she then lay dying,
should be converted into a place of worship for the Christians.  Thus,
full of faith and charity, and singing with her sweet voice praises and
hymns to the last moment, she died at the end of three days.  The
Christians embalmed her body, and she was buried by Urban in the
same cemetery with her husband.'

   According to her wish, the house of Cecilia was consecrated as a
church, the chamber in which she suffered martyrdom being regarded
as a spot of peculiar sanctity.  There is mention of a council held in
the church of St. Cecilia by Pope Symmachus, in the year 500.  After-
wards, in the troubles and invasions of the barbarians, this ancient
church fell into ruin, and was rebuilt by Pope Paschal I. in the ninth

century. It is related that, while engaged in this work, Paschal
had a dream, in which St. Cecilia appeared to him, and revealed the
spot in which she lay buried; accordingly search was made, and her
body was found in the cemetery of Calixtus, wrapt in a shroud of
gold tissue, and round her feet a linen cloth dipped in her blood:
near her were the remains of Valerian, Tibertius, and Maximus,
which, together with hers, were deposited in the same church, now
St. Cecilia-in-Trastevere. The little room, containing her bath, in
which she was murdered or martyred, is now a chapel. The rich
frescoes with which it was decorated are in a state of utter ruin from
age and damp; but the machinery for heating the bath, the pipes,
the stoves, yet remain. This church, having again fallen into ruin,
was again repaired, and sumptuously embellished in the taste of
the sixteenth century, by Cardinal Sfondrati. On this occasion the
sarcophagus containing the body of St. Cecilia was opened with
great solemnity in the presence of several cardinals and dignitaries
of the Church, among others Cardinal Baronius, who has given us
an exact description of the appearance of the body, which had been
buried by Pope Paschal in 820, when exhumed in 1599. ' She
was lying,' says Baronius, ' within a coffin of cypress wood, enclosed
in a marble sarcophagus; not in the manner of one dead and buried,
that is, on her back, but on her right side, as one asleep; and in
a very modest attitude; covered with a simple stuff of taffety, having
her head bound with cloth, and at her feet the remains of the cloth
of gold and silk which Pope Paschal had found in her tomb.'
Clement VIII. ordered that the relics should remain untouched,
inviolate; and the cypress coffin was enclosed in a silver shrine, and
replaced under the altar. This reinterment took place in presence of
the pope and clergy, with great pomp and solemnity, and the people
crowded in from the neighbouring towns to assist at the ceremony.
Stefano Maderno, who was then in the employment of the Cardinal
Sfondrati as sculptor and architect, and acted as his secretary, was not,
we may suppose, absent on this occasion; by the order of the Cardinal
he executed the beautiful and celebrated statue of ' St. Cecilia lying
dead,' which was intended to commemorate the attitude in which she
was found. It is thus described by Sir Charles Bell :—' The body lies
on its side, the limbs a little drawn up; the hands are delicate and

fine,—they are not locked, but crossed at the wrists : the arms are stretched out.   The drapery is beautifully modelled, and modestly covers the limbs.   The head is enveloped in linen, but the general form is seen, and the artist has contrived to convey by its position, though not offensively, that it is separated from the body.   A gold circlet is round the neck, to conceal the place of decollation(?).   It is the statue of a lady, perfect in form, and affecting from the resemblance to reality in the drapery of white marble, and the unspotted appearance of the statue altogether.   It lies as no living body could lie, and yet correctly, as the dead when left to expire,—I mean in the gravitation of the limbs.'

146                Statue of St. Cecilia, in her Church at Rome.

It must be remembered that Cecilia did not suffer decollation ; that her head was *not* separated from the body; and the gold band is to conceal the wound in the neck : otherwise, this description of the statue agrees exactly with the description which Cardinal Baronius has given of the body of the saint when found in 1599.

The ornaments round the shrine, of bronze and rare and precious marbles, are in the worst taste, and do not harmonise with the pathetic simplicity of the figure.

At what period St. Cecilia came to be regarded as the patron saint of music, and accompanied by the musical attributes, I cannot decide. It is certain that in the ancient devotional representations she is not so distinguished ; nor in the old Italian series of subjects from her life have I found any in which she is figured as singing, or playing upon instruments.

The oldest representation of St. Cecilia I have met with is a rude picture or drawing discovered on the wall of the catacomb called the cemetery of San Lorenzo. It is a half-length, with the martyr's crown on her head, and her name inscribed.[1]

147          Shrine of St. Cecilia.

Next to this is the colossal mosaic figure in the apsis of her church at Rome. The composition is one of the most majestic of these grand devotional groups. In the centre stands the Redeemer; the right hand, raised, gives the benediction in the Greek manner; in the left he has a roll of writing: on his left hand stands St. Peter, with the keys, beyond him St. Cecilia with a crown in her hand and her husband St. Valerian: on the right of Christ is St. Paul, and behind him St. Agatha, with a crown on her head, and Pope Paschal I., by whom the edifice was dedicated. The date of this mosaic is about 817.

The third in point of antiquity to which I can refer is an undoubted picture of Cimabue, painted for the old church of St. Cecilia at Florence (now destroyed). She is here quite unlike all our conventional ideas of the youthful and beautiful patroness of music,—a grand

[1] D'Agincourt, pl. xi., sixth or seventh century.

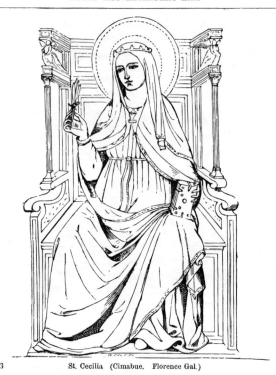

143                    St. Cecilia  (Cimabue.  Florence Gal.)

matronly figure seated on a throne, holding in one hand the Gospel, in
the other the palm.   The head-dress is a kind of veil; the drapery, of a
dark blue, which has turned greenish from age, is disposed with great
breadth and simplicity : altogether it is as solemn and striking as the
old mosaic.   This picture stood over the high altar of her church, and
around it are eight small compartments representing scenes from her
life ; the incidents selected being precisely those which were painted in
the portico of her church at Rome, and which in the time of Cimabue
existed entire.

Previous to the beginning of the fifteenth century St. Cecilia is
seldom seen with her musical instruments.   She has generally, when
grouped with other martyrs, the palm and the crown of red and white

149                St. Cecilia  (Raphael)

roses, with occasionally an attendant angel.   But St. Dorothea has
also the palm, the crown of roses, and the angel; it is therefore
necessary to observe, first, that Dorothea generally carries a book,
while St. Cecilia, when she has anything in her hand besides the
palm, has a scroll of music; secondly, St. Dorothea, besides the roses
on her head, has frequently roses in her hand, or in a basket; thirdly,
the angel attending on St. Cecilia carries a garland, or some musical
instrument, while the angel attending on St. Dorothea carries fruit
and flowers in a basket.   When accompanied by her musical attri-
butes, St. Cecilia is easily distinguished; she is in general richly
dressed, wearing jewels, or a turban on her head, when she does not
wear her wreath of red and white roses,—the roses gathered in
Paradise: she holds the palm and music in her hand; an organ or

some other musical instrument is placed near her. Sometimes she
is touching the organ, and singing to her own accompaniment; or
she is playing on the viol; the attendant angel near her either holds
the scroll or the palm, or he crowns her with roses.

The most celebrated of the modern representations of St. Cecilia,
as patroness of music, is the picture by Raphael, painted by him
for the altar-piece of her chapel in the church of San Giovanni-in-
Monte, near Bologna. She stands in the centre, habited in a rich
robe of golden tint, and her hair confined by a band of jewels. In
her hand she bears a small organ—but seems about to drop it as
she looks up, listening with ecstatic expression to a group of angels,
who are singing above. Scattered and broken at her feet lie the
instruments of secular music, the pipe, flute, tabor, &c. To the
right of St. Cecilia stands St. Paul, leaning on his sword: behind
him is St. John the Evangelist, with the eagle at his feet: to the
left, in front, the Magdalene, as already described, and behind her
St. Augustine.

Raphael's original drawing, engraved by Marc' Antonio, has
always appeared to me preferable to the finished picture. The
sketch (149) is from the simple beautiful figure of the St. Cecilia.

Sir Joshua Reynolds has given us a parody of this famous picture,
in his portrait of Mrs Billington; but, instead of the organ, he has
placed a music-book in her hands—a change which showed both his
taste and his judgment, and lent to the borrowed figure an original
significance.[1]

We will turn now to a German St. Cecilia. In the picture by
L. v. Leyden, in the Munich Gallery, she is standing, magnificently
attired in a violet-coloured tunic, and over it a crimson mantle; her
hair bound with a small jewelled turban; a little angel with frizzled
hair, much like a wig, sustains a small organ, on which she plays with
one hand, blowing the bellows with the other. The expression of the
face as she listens, rapt, to her own sweet music—the odd but poetical
conception—and the vivid splendour of the colouring, are very remark-
able. The figure is about one third the size of life (150).

[2] It gave occasion also to the happy compliment paid to the singer by Haydn. 'What
have you done?' said he to Sir Joshua. 'You have made her listening to the angels; you
should have represented the angels listening to *her*.'

150       St. Cecilia  (Lucas v. Leyden)

By Moretta we have two beautiful representations of St. Cecilia as patroness, attended by other saints.

1. She stands in the centre of the picture, holding the organ under her left arm; with the right she embraces St. Lucia: on the other side stands St. Barbara gracefully leaning on her tower: St. Agnes and St. Agatha are seen behind, and the Holy Spirit descends upon the group from above. From this fine picture (in the San Clemente at Brescia) I give an etching.

2. In the picture in San Giorgio at Verona. Here the composition is varied. St. Cecilia is in the centre, crowned with roses, and attired in magnificent red drapery: she looks up with an expression of adoration; the organ and scrolls of music are at her feet. On the right are St. Lucia looking down, and St. Catherine looking up; on the left St. Barbara, also looking up, and St. Agnes with her lamb,

looking down.[1] Both these pictures are full of character and expression; and here St. Cecilia is not only patroness of music, but patron saint in a more general and exalted sense.

Sometimes a dramatic feeling has been given to these representations; for instance, where St. Cecilia is playing to the Virgin, and St. Antony of Padua is listening, as in a picture by Garofalo. Again, where St. Cecilia is seated before an organ, attired in the rich Florentine costume of the sixteenth century; near her stands St. Catherine listening to the heavenly strains of her companion: as in a picture by Giulio Campi.[2] In a composition by Parmigiano she is playing on the spinet, which is held before her by two angels—an idea which appears to have been borrowed by Paul Delaroche.

Domenichino was at Rome on the occasion of the opening of the sarcophagus of St. Cecilia in the reign of Clement VIII., and when the discovery of the relics entire had kindled the popular enthusiasm to an extraordinary degree: during the next half-century there were few artists who did not attempt a St. Cecilia; but Domenichino led the way. He painted six single figures of St. Cecilia as patron saint. Of these, one of the most beautiful is the half-length which represents her in rich drapery of violet and amber, crowned with red and white roses; an angel bearing her palm is seen behind, and an organ to the left; she holds a scroll of music in her hand.[3] The noble air of the head, and the calm intellectual expression of the features, seem, however, better suited to a St. Catherine than to a St. Cecilia. She is here a great-patron saint in the general sense, and the attributes serve to individualise her. In the picture in the Louvre, an angel stands before her, holding open the music-book, from which she sings, accompanying herself on the viol. In the Borghese picture she wears a magnificent jewelled turban, and is listening with an entranced expression to the song of invisible angels.

---

[6] When standing before this picture with a friend who had given more attention to physiology than to art, he was struck by the peculiar expression in the eyes of St. Cecilia, which he said he had often remarked as characteristic of musicians by profession, or those devoted to music,—an expression of *listening* rather than *seeing*.

[2] Cremona. S. Sigismondo.

[3] It was in the collection of Mr Wells of Red-leaf, and there is a fine engraving by Sharp.

151        St. Cecilia (Zurbaran)

But, in *expression*, Lord Lansdowne's Domenichino excels all the rest; and here St. Cecilia combines the two characters of Christian martyr and patroness of music. Her tunic is of a deep red with white sleeves, and on her head she wears a kind of white turban, which, in the artless disposition of its folds, recalls the linen head-dress in which her body was found, and no doubt was intended to imitate it. She holds the viol gracefully, and you almost hear the tender tones she draws from it; she looks up to heaven; her expression is not ecstatic, as of one listening to the angels, but devout, tender, melancholy—as one who anticipated her fate, and was resigned to it; she is listening to her own song, and her song is, 'Thy will be done!'

The sketch after Zurbaran will give an idea of the fantastic Spanish manner of representing female saints in court dresses (151).

I might cite many other beautiful examples of St. Cecilia exhibited as patroness of music, but the subject is one which needs no interpretation. It is a frequent and appropriate decoration on the doors of organs. I remember an organ on the inner doors of which were painted, on one side St. Gregory teaching the choristers, on the other St. Cecilia singing with the angels.

She is very seldom represented in devotional pictures as the virgin-martyr only; but I remember one striking example; it is in a picture by Giulio Procaccino. She leans back, dying, in the arms of an angel; her hands bound, her hair dishevelled; the countenance raised to heaven, full of tender enthusiastic faith: one angel draws the weapon from her breast; another, weeping, holds the palm and a wreath of roses. This picture was evidently painted for a particular locality, being on a high, narrow panel, the figure larger than life, and the management of the space and the foreshortening very skilful and fine.[1]

I know not any picture of St. Cecilia *sleeping*, except Alfred Tennyson's :—

> There, in a clear wall'd city on the sea,
> Near gilded organ-pipes—her hair
> Bound with white roses—slept St. Cecily;—
> An angel looked at her !

Very charming !—but the roses brought from Paradise should be *red* and *white*, symbolical of love and purity, for in Paradise the two are inseparable, and purity without love as impossible as love without purity. There is a very lovely figure of St. Cecilia by Luini; she stands crowned with white roses and anemones, with the palm and book and organ-pipes at her feet.[2]

Detached scenes from the life of St. Cecilia do not often occur. Those generally selected are 'the angel crowning her and her husband,' and her 'martyrdom.'

The first, which is a most attractive subject, I have never seen well

---

[1] Milan, Brera.        [2] San Maurizio, Milan.

treated; all the examples which have fallen under my notice are vapid or theatrical. There is one in the Gallery of Count Harrach at Vienna, a Venetian picture of the Cagliari school, which is interesting: the faces are like portraits.

Her martyrdom is represented in two ways; she is either exposed to the flames in her bath, or stabbed by the executioner.

In the Illuminated Greek Menology (ninth century), perhaps the oldest existing example, she is murdered in her bath; Valerian and Tiburtius lie headless on the ground. The bath is often in the form of a great caldron, with flames beneath, and sometimes we find the superscription (Ps. lxvi. 12), *Per ignem et aquam*, &c., 'We went through fire and through water, but Thou broughtest us out into a wealthy place.'

There can be no doubt that the so-called '*Martyrdom of St. Felicità*,' engraved after Raphael by Marc' Antonio, and one of his finest prints, is the Martyrdom of St. Cecilia, and that the two headless figures on the ground represent Valerian and Tiburtius. There exists a woodcut of the same composition, executed before the death of Raphael (about 1517), inscribed 'The Martyrdom of St. Cecilia,' which seems to set the question at rest.

In the later examples she is generally kneeling, and the executioner seizes her by the long hair and prepares to plunge his sword into her bosom; the organ is in the background, a violin and a book lie near her, and an angel descends from above with the wreath of roses: as in a much-praised picture by Riminaldi, painted for the chapel of St. Cecilia at Pisa.[1]

The composition by Poussin is very fine and dramatic. Cecilia has received her death-wound, and is dying on the marble floor of her palace, supported in the arms of her women; St. Urban and others stand by lamenting. Here, as well as in Domenichino's fresco, two women are occupied in wiping up the blood which flows from her wounds. The introduction of this disagreeable and superfluous incident may be accounted for by the tradition that the napkin stained with her blood was found in the catacombs at her feet.

[1] Florence, Pitti Pal.

The Martyrdom of St. Cecilia, by Lionello Spada, in the San Michele-in-Bosco at Bologna, is much praised by Lanzi. She is exposed to the flames in her bath:—' *con un fuoco così vero e vivace che in solo mirando rende calore.*' It is now scarcely visible.

In the Munich Gallery is a half-length St. Cecilia attributed to Leonardo, but not by him; which rather reminded me, in dress and arrangement, of the Giovanna d'Arragona in the Louvre.

The life of St. Cecilia treated as a series affords a number of beautiful and dramatic subjects. There are several examples, some of them famous in the history of Art. The most ancient of which there is any mention is, or rather *was*, a set of frescoes painted in the portico of her church at Rome, supposed to have been executed by Byzantine painters in the ninth century by order of Pope Paschal I. These were utterly destroyed when the church was rebuilt in the seventeenth century, with the exception of one compartment; but correct copies had been previously made, which exist in the library of the Barberini Palace. The series comprises the following subjects :—

1. The marriage feast of Valerian and St. Cecilia.  2. St. Cecilia seated in discourse with her husband.

3. Valerian mounts his horse and goes to seek St. Urban.  4. The baptism of Valerian.

5. An angel crowns Valerian and Cecilia.  6. Cecilia preaches to the guards.

7. She is exposed to the flames in her bath.  8. Her martyrdom.

9. She is laid in the tomb.  10. She appears in a vision to Pope Paschal.

The compartment containing the last two subjects remains entire, and is fixed against the wall in the interior of her church to the right of the high altar. Pope Paschal is seen asleep on his throne with his tiara on his head; the saint stands before him, and appears to be revealing the place of her burial in the catacombs; on the other side the same Pope is seen with his attendants in the act of laying her body in the sarcophagus : the story is very expressively though artlessly told; the style Greco-Italian. It is worth remarking, that St. Cecilia here wears a head-dress like a turban, and that when her body was found her head

was bound in folds of cloth. As great attention was drawn to these remains just when Domenichino and others of the Caracci school were painting at Rome, the idea may have been thus suggested of representing her in a sort of turban, as we see her in so many pictures of the seventeenth century.

On each side of the figure of St. Cecilia by Cimabue (already described) are four small subjects from her life; the scenes selected are the same as in the old frescoes of Pope Paschal, but the treatment is widely different.

1. Cecilia, seated at a banquet with three others, and five attendants, of whom two are playing on the tabor and pipe. 2. Cecilia, seated on a couch, converses with her husband Valerian, who stands before her. She is exhorting him to observe the vow she had made to Heaven before her nuptial vow to him. 3. Urban baptizes Valerian. 4. An angel crowns Cecilia and Valerian. 5. Cecilia converts Tiburtius. 6. Cecilia preaches to the people. 7. She is brought before the prefect. 8. She is put into the bath full of boiling water: three executioners surround her.

Francia, assisted by Lorenzo Costa, painted the life of St. Cecilia in ten compartments round the walls of her chapel at Bologna. The building is now desecrated, and forms a kind of public passage leading from one street to another. The only compartment in tolerable preservation is the scene of the marriage of St. Cecilia and Valerian, charming for simplicity and expression : she seems to shrink back reluctant, while her mother takes her hand and places it in that of Valerian. In the same series, Urban instructing Valerian, and the alms of St. Cecilia, both by Lorenzo Costa, are very beautiful. Of the other compartments only a figure here and there can be made out.

By Pinturicchio there is a series of five small pictures from the life of St. Cecilia in the Berlin Gallery.

Lastly, there is the series by Domenichino, celebrated in the history of Art. A short time after the discovery of the relics of St. Cecilia, a chapel was dedicated to her in the church of San Luigi at Rome ;

and Domenichino was employed to decorate it with the history of the Saint.

The story is told in five large compositions.

1. Cecilia distributes her possessions to the poor. She is in the background standing on the terrace or balcony of her house, while a crowd of eager half-naked wretches are seen in the front; twenty-two figures in all. It is a rich dramatic composition, but the attention, instead of being concentrated on the benign saint, is distracted by the accessories, among which are two naughty boys quarrelling for a garment. This is surely a discord in point of sentiment. 2. An angel crowns with roses St. Cecilia and Valerian as they kneel on each side. 3. St. Cecilia refuses to sacrifice to idols. 4. Her martyrdom. She lies wounded to death on some marble steps;—her attitude very graceful and pathetic. St. Urban looks on pitying; two women are wiping up the blood. In all, fifteen figures.

On the ceiling of the chapel is the apotheosis of the saint. She is carried into heaven by angels. One bears the organ, others the sword, the palm, and the crown.

On the whole, St. Cecilia is not so frequent a subject of painting as we might have expected from the beauty and antiquity of her legend. She is seldom seen in the old French works of Art: she has been a favourite with the Roman and Bolognese schools, but comparatively neglected by Venetian, Spanish, and German painters; and in point of general popularity she yields both to St. Catherine and St. Barbara.[1]

## St. Agnes, Virgin and Martyr.

*Lat.* Sancta Agnes.    *Ital.* Sant' Agnese.    *Spa.* Santa Inez.    *Fr.* Sainte Agnès.
(Jan. 21, A.D. 304.)

THE legend of this illustrious virgin is one of the oldest in the Christian Church. It is also, in its main points, one of the most authentic.

[1] We have two churches in England dedicated to her: one at Adstock in Bucks, and another at West Bilney, in Norfolk.

St. Jerome, writing in the fourth century, informs us that, in his time, the fame of St. Agnes was spread through all nations, and that homilies and hymns, and other effusions in prose and verse, had been written in her honour in all languages. Her tender sex, her almost childish years, her beauty, innocence, and heroic defence of her chastity, the high antiquity of the veneration paid to her, have all combined to invest the person and character of St. Agnes with a charm, an interest, a reality, to which the most sceptical are not wholly insensible.

The legend does not tell us who were her parents, nor what their rank in life, but takes up her history abruptly. Thus :—

' There lived in the city of Rome a maiden whose name was Agnes (whether this name was her own, or given to her because of her lamb-like meekness and innocence, does not seem clear). She was not more than thirteen years old, but was filled with all good gifts of the Holy Spirit, having loved and followed Christ from her infancy, and was as distinguished for her gracious sweetness and humility as for her surpassing beauty.

' It chanced that the son of the prefect of Rome beheld her one day as he rode through the city, and became violently enamoured, and desired to have her for his wife. He asked her in marriage of her parents, but the maiden repelled all his advances. Then he brought rich presents, bracelets of gold and gems, and rare jewels and precious ornaments, and promised her all the delights of the world if she would consent to be his wife. But she rejected him and his gifts, saying, " Away from me, tempter! for I am already betrothed to a lover who is greater and fairer than any earthly suitor. To him I have pledged my faith, and he will crown me with jewels, compared to which thy gifts are dross. I have tasted of the milk and honey of his lips, and the music of his divine voice has sounded in mine ears : he is so fair that the sun and moon are ravished by his beauty, and so mighty that the angels of heaven are his servants ! "

' On hearing these words, the son of the prefect was seized with such jealousy and rage, that he went to his home and fell upon his bed and became sick, almost to death ; and when the physicians were called, they said to the father, " This youth is sick of unrequited love, and our art can avail nothing." Then the prefect questioned

his son, and the young man confessed, saying, " My father, unless thou procure me Agnes to be my wife, I die."

'Now the prefect, whose name was Sempronius, tenderly loved his son; and he repaired, weeping, to Agnes and to her parents, and besought them to accept his son : but Agnes made the same answer as before, and the prefect was angered to think that another should be preferred before his son, and he inquired of the neighbours to what great prince Agnes was betrothed? And one said, " Knowest thou not that Agnes has been a Christian from her infancy upwards, and the husband of whom she speaks is no other than Jesus Christ?" When the prefect heard this he rejoiced greatly, for an edict had gone forth against the Christians, and he knew that she was in his power. He sent for her, therefore, and said, " Since thou art so resolved against an earthly husband, thou shalt enter the service of the goddess Vesta." To which Agnes replied with disdain, " Thinkest thou that I, who would not listen to thy son, who yet is a man, and can hear and see, and move and speak, will bow down to vain images, which are but insensible wood and stone, or, which is worse, to the demons who inhabit them?"

'When Sempronius heard these words he fell into a fury; he threatened her with death in the most hideous forms; he loaded her tender limbs with chains; and ordered her to be dragged before the altars of the gods ; but she remained firm. And as neither temptation nor the fear of death could prevail, he thought of other means to vanquish her resistance; he ordered her to be carried by force to a place of infamy, and exposed to the most degrading outrages. The soldiers, who dragged her thither, stripped her of her garments; and when she saw herself thus exposed, she bent down her head in meek shame and prayed ; and immediately her hair, which was already long and abundant, became like a veil, covering her whole person from head to foot ; and those who looked upon her were seized with awe and fear as of something sacred, and dared not lift their eyes. So they shut her up in a chamber, and she prayed that the limbs that had been consecrated to Jesus Christ should not be dishonoured. And suddenly she saw before her a white and shining garment, with which she clothed herself joyfully, praising God, and saying, " I thank thee, O Lord, that I am found worthy to put on the garment of thy elect!"

And the whole place was filled with miraculous light, brighter than the sun at noonday.

'But meantime the young Sempronius thought within himself, "Now is this proud maiden subdued to my will." So he came into the chamber; but the moment he approached her he was struck with blindness, and fell down in convulsions, and was carried forth as one dead. His father and his mother and all his relations ran thither, weeping and lamenting, until Agnes, melted to compassion by their tears, and moved by that spirit of charity which became the espoused of Christ, prayed that he might be restored to health; and her prayer was granted.

'When Sempronius saw this great miracle, he would fain have saved St. Agnes; but the people, instigated by the priests, cried out, "This is a sorceress and a witch, who kills men with a look and restores them to life with a word;—let her die!" And the tumult increased. So the prefect, being afraid, sent one of his deputies to judge the maiden.

'As the people persisted in their clamorous cries against her, and as she openly and boldly professed herself a Christian, the deputy ordered a pile of faggots to be heaped together, and a fire to be kindled, and they threw Agnes into the midst; but when they looked to see her consumed, behold the flames were suddenly extinguished, and she stood unharmed, while the executioners around were slain by the force of the fire, which had had no power over her.

'But the people and the idolatrous priests, instead of seeing in this miracle the hand of God, cried out the more, "She is a sorceress, and must die!" Then Agnes, raising her hands and her eyes to heaven, thanked and blessed the Lord, who had thus openly asserted his power and defended her innocence; but the wicked deputy, incited by the tumult of the people, and fearing for himself, commanded one of the executioners to ascend the pile and end her with the sword: which was done; and she, looking steadfastly up to heaven, yielded up her pure spirit, and fell bathed in her blood.

'Her parents and her relatives took her body and carried it, weeping and singing hymns, to the cemetery outside the city on the Via Nomentana; and there they laid her in a tomb. And day and night the Christians assembled in that place to offer up their devotions.

And it happened that, on a certain day, as her parents with many others were praying by her sepulchre, St. Agnes herself appeared before them, all radiant of aspect; by her side was a lamb, whiter than the driven snow. And she said, " Weep not, dry your tears, and rejoice with exceeding joy ; for me a throne is prepared by the side of Him whom on earth I preferred to all others, and to whom I am united for ever in heaven." And having said these words she vanished. Then the Christian mourners wiped away their tears, and returned to their houses with joy and thanksgiving.'

St. Agnes is the favourite saint of the Roman women : the traditional reverence paid to her memory has been kept alive even to this hour by their local associations, and by the two famous churches at Rome bearing her name, one within and one without the walls.

The first stands on the west side of the Piazza Navona, on the very spot where stood the house of infamy to which she was dragged by the soldiers. The chamber which, for her preservation, was filled with heavenly light, has become, from the change of level all over Rome, as well as the position of the church, a subterranean cell, and is now a chapel of peculiar sanctity, into which you descend by torch-light. The floor retains the old mosaic, and over the altar is a bas-relief, representing St. Agnes, with clasped hands, and covered only by her long tresses, while two ferocious soldiers drive her before them. The upper church, as a piece of architecture, is beautiful, and rich in precious marbles and antique columns. The works of Art are all mediocre, and of the seventeenth century, but the statue over her altar has considerable elegance. Often have I seen the steps of this church, and the church itself, so crowded with kneeling worshippers at matins and vespers that I could not make my way among them ;—principally the women of the lower orders, with their distaffs and market-baskets, who had come there to pray, through the intercession of the patron saint, for the gifts of meekness and chastity —gifts not abounding in those regions.

The other church of St. Agnes—the Sant' Agnese beyond the Porta-Pia—is yet more interesting. According to the old tradition, it was erected by Constantine the Great at the earnest request of his daughter Constantia, only a few years after the death of Agnes, and

to commemorate the spot in which she was laid. This has been controverted, but it remains certain that the church was in 625 an ancient edifice, and at that time restored. Notwithstanding many subsequent renovations, it retains its antique form and most of its antique decorations, and is certainly one of the most remarkable and venerable of the old churches of Rome. So deep below the present level of the soil is the floor of the church, that we have to descend into it by a flight of marble steps. The statue of the saint, of bronze and oriental alabaster, stands over the high altar : beneath it is the sarcophagus, containing her remains—more authentic than such relics usually are. The mosaic in the apsis (A.D. 625—638) represents her standing, crowned, and holding a book in her hand, in the Byzantine manner. Out of the earth spring flowers, and a sword lies at her feet; both in allusion to her martyrdom. On the right is Pope Honorius, holding the church; and on the other side, Pope Symmachus, holding a book.

152 St. Agnes crowned with olive (Martin Schoen)

So ancient is the worship paid to St. Agnes, that, next to the Evangelists and Apostles, there is no saint whose effigy is older. It is found on the ancient glass and earthenware vessels used by the Christians in the early part of the third century, with her name inscribed, which leaves no doubt of her identity. But neither in these images, nor in the mosaic, is the lamb introduced, which in later times has become her inseparable attribute, as the patroness of maidens and maidenly modesty. She bears the palm as martyr,— seldom the book. I have seen her holding a branch of olive together with the palm, and sometimes crowned with olive.

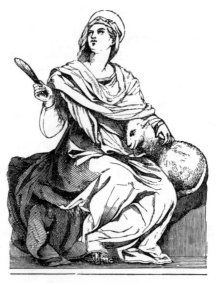

153    St. Agnes   (Andrea del Sarto)

As her effigies are not easily mistaken, and abound in every form
and every school of Art, I shall confine myself to a few celebrated
examples.

1. She is often looking down meekly, as in a beautiful and rare
engraving by Martin Schoen (152).

2. As martyr. She is seated, partly veiled, holding her palm in
the right hand, with the other embracing her lamb, and looking up
with a mild trusting faith; the drapery amber and violet: as in a
picture by Andrea del Sarto in the Duomo at Pisa. It is the head
of his beautiful but worthless wife, more idealised than usual. This
sketch will show the attitude, but it is the colour and expression which
render the picture enchanting (153.)

3. As martyr, she presents her palm to Christ: as in a picture
by Titian in the Louvre.

4. As patroness of maidenhood she presents a nun to the Madonna;
as in a lovely picture by Paul Veronese.[1]

[1] Venice Acad.

5. In the altar-piece by Domenichino at Windsor, she stands lean-ing on a pedestal, in the likeness of a young girl of about twelve or thirteen, magnificently attired, and her long hair confined by a tiara; her hands are joined in supplication, yet she looks up to heaven as one trusting and assured; at her side an angel caresses a lamb; an-other angel descends from above with the palm:—a splendid picture, well remembered by all who have visited the Windsor collection, and universally known by the famous engraving of Strange. I do not admire it, however;—it is not in character; it is too regal, too sump-tuous, too triumphant; and the portrait-like head, and rather heavy figure, deficient altogether in ideal sanctity and elevation. There is a tradition that it is the portrait of the artist's daughter.

Domenichino professed an especial veneration for St. Agnes, and was often called upon to paint her. Besides the single figure at Windsor, he painted for her church at Bologna the famous Martyrdom which is now in the Gallery there. The saint kneels upon the pile of faggots; the fire has just been extinguished by divine interposition; two of the executioners lie prostrate on the ground; a third has seized her hair, and, drawing back her head, plunges the sword into her bosom : there are several spectators, and among them the usual group of the frightened women and children. Above, the heavens open in glory, and Christ delivers to an angel the palm and crown which are to recompense the martyr. This picture, which has always been reckoned amongst the most celebrated productions of the Bologna school as a masterpiece of dramatic arrangement and expression, is to me sovereignly displeasing. In the first place, there is something not only shocking, but positively unnatural, in the stupid, brutal indifference with which the executioner slaughters the young and beautiful saint. It is a murder, and not a martyrdom, which we see before us;—the women who look on ought to fly, or hide their faces, from such a spectacle. To complete the discordant feeling, and in contrast with the cold-blooded horror of the lower part of the picture, we behold a chorus of angels piping and fiddling up in the sky, with the most unsympathising self-complacency.

The Martyrdom of St. Agnes, by Tintoretto, in the S. Maria dell' Orto at Venice, is treated like a theatrical scene; there is a flight of steps, on which are a number of spectators, and on the summit is the

saint, kneeling, attired in virgin white, and prepared to receive the stroke of the executioner.

The same subject by Joanes, at Madrid, 'contains some beautiful Raphaelesque heads.' I know not how the action is represented.

With St. Agnes is sometimes introduced her friend and foster-sister Ermentiana, who was stoned because she reproved the pagans for their barbarity.

Other subjects from the life of St. Agnes must occur rarely. I remember but one: she restores the son of Sempronius to life. The vision of the glorified saint to the Christian mourners appears to me capable of the most beautiful treatment, but I have not met with one example. It is generally as the patron saint of innocence, or as the virgin martyr, that St. Agnes is brought before us.[1]

Richardson describes a picture of a young saint kneeling, and protected from violence by the apparition of an angel, who fills the whole chamber with light. He calls the subject St. Cecilia, but it is evidently St. Agnes. In his time this picture was in the Borghese Palace, and attributed to Correggio. I have no recollection of such a picture.

### ST. AGATHA, VIRGIN AND MARTYR.

*Lat.* Sancta Agatha. *Fr.* Sainte Agathe. *Ital.* Santa Agata. *Ger.* Die Heilige Agatha. Patroness against fire, and all diseases of the breast. Patroness of Malta and of Catania. (Feb. 5, A.D. 251.)

' THERE dwelt in the city of Catania, in Sicily, a certain Christian maiden whose name was Agatha. In those days reigned the emperor Decius, who had strangled his predecessor Philip; and, to make it believed by all that he had put him to death out of great zeal, and for being a Christian, not from motives of ambition, this Decius sent his emissaries throughout the empire to oppress and persecute the Christians, and many were put to death. And to Sicily Decius sent his creature Quintianus, and made him king over the whole island. Not long had Quintianus reigned in Sicily when he heard of the great beauty and perfection of the maiden Agatha. and he sent to have her

[1] We have only two churches in England dedicated in her name.

brought before him; and he tempted her with rich presents, and flatteries, and promises, but she rejected all with disdain. Then Quintianus sent for a courtesan, named Frondisia, who had nine daughters, more wicked and abandoned than herself, and he delivered Agatha into their hands, and he said, "Subdue this damsel to my will, and I will give ye great riches." Then Frondisia took Agatha home to her house, and kept her there for thirty-three days, and tempted her with great promises, and flattered and cajoled her; but seeing this availed not, they persecuted her day and night: and her heart was fixed as a rock in the faith of Jesus Christ, and all their promises and all their threats were as the empty air. At the end of thirty-three days, Frondisia returned to Quintianus and said to him, "Sooner shall that sword at thy side become like liquid lead, and the rocks dissolve and flow like water, than the heart of this damsel be subdued to thy will." Then Quintianus in a fury commanded her to be brought to him, and said, "Who, and what art thou, audacious girl?" And Agatha replied, "I am a free woman, and the servant of Jesus Christ." And he said, "Dost thou call thyself free who art constrained to serve?" And she said, "I am the handmaid of Christ, whom to serve is perfect freedom." Then Quintianus said, "Abjure thy master, and serve our gods, or I will have thee tortured." To which St. Agatha replied, "If thou shouldst throw me to the wild beasts, the power of Christ would render them meek as lambs; if thou shouldst kindle a fire to consume me, the angels would quench it with dews from heaven; if thou shouldst tear me with scourges, the Holy Spirit within me would render thy tortures harmless." Then this accursed tyrant ordered St. Agatha to be bound and beaten with rods; and he commanded two of his slaves to tear her tender bosom cruelly with iron shears; and as her blood flowed forth, she said to him, "O thou tyrant! shamest thou not to treat me so—thou who hast been nourished and fed from the breast of a mother?" And this was her only plaint. Then she was carried from the place of torture into a dark dungeon. And about midnight there came to her a man of a fair and venerable aspect, carrying in his hand a vase of ointment; and before him walked a youth bearing a waxen torch: it was the holy apostle Peter, and the youth was one of the angels of God; but St. Agatha knew it not, and such a glorious light filled the prison, that

the guards were seized with terror, and fled, leaving the door open.
Then came one to St. Agatha and cried, "Arise and fly!" But she
said, "God forbid that I should fly from my crown of martyrdom, and
be the occasion that my keepers should suffer, for my flight, tortures
and death: I will not fly!" Then St. Peter said to her, "I am come
to heal thee, O my daughter!" But she drew her veil more closely
over her wounded bosom, and replied with virgin modesty, "If it be
the will of my Saviour Christ that I should be healed, he will himself
heal me." St. Peter answered, "Fear not, for Christ has sent me to
minister to thee!" So he ministered to her, restoring with celestial
medicines her mutilated bosom, and her body torn with stripes; and
when he had done so, he vanished, and St. Agatha knelt and blessed
the power of Christ, who had visited her with this great mercy.

'The rage and fury of Quintianus not being appeased, he sent again
to have her brought before him, and being astonished to behold her
restored, he said, "Who hath healed thee?" She replied, "He,
whom I confess and adore with my heart and with my lips, hath
sent his apostle and healed me and delivered me!" Then Quintianus
ordered a great fire to be kindled, and they bound the holy maiden
hand and foot and flung her upon it; and in that moment a terrible
earthquake ensued, which made the city quake, and the people ran
armed to the palace, and cried out, "This has fallen upon us because
of the sufferings of this Christian damsel!" and they threatened, that
if Quintianus did not desist from tormenting her they would burn
him in his palace with all his family. So Quintianus ordered her
to be taken from the flames, and again cast into the dungeon,
scorched and in miserable pain; and she prayed that, having thus
far suffered and proved her faith, she might be permitted to see the
glory of God; which prayer was heard, for her pure spirit immediately
departed and ascended to eternal glory. The Christians who dwelt
in Catania came to the prison and carried away her sacred remains,
and embalmed them, and buried her with great devotion in a tomb
of porphyry.

'Now you shall know that nigh to the city of Catania in Sicily
there is a huge mountain, and on the summit a vast gaping chasm,
whence are vomited fire and smoke: the blessed St. Gregory saith that
it is one of the mouths of hell, but the people call it Mongibello (Mount

Etna). In about a year after the martyrdom of St. Agatha, this mountain opened itself, and there flowed forth a stream of fire, consuming all before it; and the inhabitants of the city of Catania, men and women, Christians and Pagans, fled for refuge to the tomb of the martyr Agatha, and taking her silken veil, which lay upon it, they fixed it on the top of a lance, and went forth in long procession to meet the torrent of fire, which had already reached the walls of the city; but it pleased God that by the virtue of this sacred relic the fire was turned aside, and the mountain ceased to bellow, and there was calm. On beholding this great miracle, all the heathen who dwelt in the city were converted to the faith of Christ and received baptism.' [1]

When represented as patron saint, either as a single figure or grouped with other saints, St. Agatha bears in one hand the palm, in the other a dish or salver, on which is the female breast, in allusion to her martyrdom: if she wears the crown, as in some early representations, it is the crown of the bride and martyr of Christ. The shears, the instrument of her cruel martyrdom, are sometimes in her hand, or beside her. She generally wears a long veil in allusion to her legend. The expression should be that of majesty as well as modesty.

Over the high altar of her church at Brescia is a large picture by Calisto da Lodi, representing St. Agatha suspended on a cross. She is dressed in a dark olive-green tunic; the attitude fine and simple; and the expression of complete but dying resignation in the head most lovely; the manner of her suffering indicated by a few spots of blood on her bosom, which, however, is delicately veiled. At the foot of the cross

154 St. Agatha (Intarsiatura. Malta. Fifteenth century)

---

[1] 'Legende delle SS. Vergini.'

stand St. Peter, St. Paul, and two martyr virgins—I think St. Lucia and St. Barbara.

The atrocious subject of her martyrdom has been seldom represented, and is rarely seen exhibited in any church, perhaps because of the effect it is likely to produce on the feelings and fancies of women. In spite of all possible discretion on the part of the painter, and every attempt to soften the circumstances, they remain in the highest degree horrible and revolting. She is usually bound to a pillar (in the early representations always to a cross), undraped to the waist, and on each side a slave or executioner with a pair of shears. The most famous picture of this subject is that of Sebastian del Piombo, painted for the Cardinal of Aragon, and now in the Pitti Palace, on which are lavished wonderful powers of expression and colour—as it is said—for I never could look at it steadily. Vandyck also has treated it with horrible force and truth, and to both these painters one might address the reproach which St. Agatha addressed to her tormentor. In some pictures she is merely bound and preparing for the torture, the bosom bared, and the eyes uplifted with an expression of devout faith and resignation;[1] as in the noble fresco by Parmigiano, and in two other compositions by Campi and by Tiepolo. In the Duomo at Verona, there is an altar in marble dedicated to St. Agatha. At the top she is on a cross, suffering her cruel martyrdom, an executioner with the shears on each side; beneath, she lies in the tomb, with her long veil gracefully thrown over her; the whole treated with singular elegance and good taste, and more endurable in sculpture than in painting.

' St. Peter healing St. Agatha in prison ' is a subject sometimes met with. The scene is a dungeon; St. Agatha lies extended on the ground, her drapery drawn over her bosom. The apostle, a venerable man with a long white beard, bends over her, a vase of ointment in his hand, and beside him a box like a medicine-chest, containing vials, &c.; a youth (or an angel) bears a torch. This is the obvious and usual treatment, slightly varied; and it would be a beautiful subject if the associations were less intensely painful.

---

[1] The fine head by Domenichino, in the collection of Lord Ellesmere, called a St. Agatha, I believe to be Domenichino's favourite patroness, St. Agnes, whose bosom was transfixed by a sword.

Among the remains of Art relative to St. Agatha may be mentioned the subterranean chapel at Malta. According to a tradition of the island, the ground once belonged to her family: it is carved out of the living rock, and the walls covered with frescoes, containing at least twenty-four figures nearly life-size; most of them have peeled off the surface, but those which remain are of extraordinary beauty. The style is that of the early Tuscan school; the date, about the middle of the fifteenth century.

## ST. LUCIA, VIRGIN AND MARTYR.

*Eng.* St. Luce, or Lucy. *Fr.* Sainte Luce, or Lucie. Patroness of the city of Syracuse. Patroness against all diseases of the eyes; and patron saint of the labouring poor.
(Dec. 13, A.D. 303.)

' WHEN the wicked Diocletian, and the yet more wicked Maximian, ascendéd the throne of the empire, they sent as governor to Sicily one of their creatures, a man sold to all evil, named Pascasius. At that time there lived in the city of Syracuse a noble and virtuous damsel, whose name was Lucia; her mother being a widow, named Eutychia. Lucia, who had been early instructed in Christianity, secretly dedicated her maidenhood to Jesus Christ; but her mother did not know it, and, at the age of fourteen, Lucia was betrothed by her relations to a youth of the same city, noble and of great riches; but he was a pagan.

' Now it happened that the mother of Lucia had long suffered from a grievous disorder, and her daughter counselled her to make a pilgrimage to the tomb of the glorious virgin St. Agatha, assuring her that by her intercession, and the power of Christ, she would certainly be restored to health. Accordingly they journeyed together to the city of Catania, and while praying fervently beside the tomb, for the restoration of her mother, Lucia beheld in a vision the martyr St. Agatha, who appeared to her, surrounded by a choir of angels, clad in precious stones, and brighter than the sun, and said, " O my sister-handmaid of Christ! well art thou called Lucia, who art indeed a light and a mirror to the faithful! What dost thou ask of me which shall

not be granted to thine own faith and sanctity ?    Behold! thy mother
is from this hour healed ; and as the city of Catania has been through
me defended, so shall the city of Syracuse be for thy sake favoured and

155  St. Lucia with her lamp.

protected of Heaven.''   When Lucia heard these
words, she awoke from her vision with great joy,
and found her mother healed; and she persuaded
her mother to allow her to remain unmarried,
and moreover entreated that her dowry might be
given to the poor.   Her mother was troubled at
this request; but she answered, '' My child, I am
content; do with all my possessions as thou wilt,
only let me die first, lest during my lifetime I
become a beggar.''   Whereupon Lucia smiled,
and said, '' Of a certainty, O my mother, God
hath little care for that which a man dedicates to
His service only when he can no longer enjoy it
himself.  What doth it profit to leave behind that
which we cannot carry away?''   Then her
mother, being struck with these words, said, '' Do
as thou wilt, my daughter.''   So Lucia sold all
their possessions, and gave the money to the poor
and the sick, and the widows and the orphans.
And when the young man to whom she was
betrothed saw this, he was enraged, and he went
and denounced her to the governor as being a
Christian : so Pascasius ordered her to be brought before him, and
commanded her to sacrifice to his idols ; and when she refused, he
ordered her to be carried to a place of shame, and treated with
indignity, and humbled to his will.  And she said, '' My body is in thy
power ; but know, that there can be neither sin nor shame to which
the mind doth not consent.  If thou shouldst cut off my hand and with
it offer incense to thine idols, God would not impute it to me as sin.
Thou mayest not force my will, for that is beyond thy power.''   Then
Pascasius, in his fury, commanded that they should drag her away ;
but, behold a miracle!—for when these bold and wicked and shameless
men advanced to seize her, she became suddenly, by the power of God,
immovable.   They brought ropes, fastening them to her waist, her

arms, and legs ; and men and oxen pulled with all their might, but in vain ; the more they pulled the more firmly she stood there.    Then Pascasius sent for the magicians and enchanters ; but they also failed, with all their spells and enchantments, to move her from the spot. Then he ordered a great fire to be kindled around her ; but she prayed that the fire might not harm her, and that the enemies of Christ might be confounded.    Pascasius, seeing that she was not destroyed by these means, became more and more furious ; whereupon one of his servants, to do him pleasure, pierced her throat with a sword or poniard.    Thus she died, and the Christians took her body and buried it exactly on the very spot where she had suffered martyrdom.    There a church was erected soon afterwards, and called by her most blessed name.'

There is no mention here, nor in any of the oldest legends, of the loss of her eyes.    The device of some of the early painters, to express her name, Lucia, *light*, by the emblem of an eye or eyes placed near her, seems to have given rise to the invention of this additional incident in her story : a signal instance of that conversion of the image or metaphor into a fact, which I have so often had occasion to notice.

The story in the more modern legend is thus related :—

' In the city wherein the blessed Lucia dwelt, there dwelt also a youth, who, having once beheld her, became enamoured of her beauty, and, by messages and promises and gifts, he ceased not to woo her ; but Lucia, being a Christian and fearing God, resisted all these attacks on her virtue.    Now this youth, in his letters and his tender speeches, was accustomed to protest that it was the brightness of her eyes which inflamed him, and that it was for the sake of those beautiful eyes he pursued her, leaving her no rest, because those eyes left *him* no rest, by day or by night.    Lucia, considering these things, and calling to mind the words of Christ, " If thine eye offend thee, pluck it out, and cast it from thee," and fearing lest her eyes should be the cause of damnation to the young man, and perhaps also to herself, called for a knife and took out her beautiful eyes, and sent them to her lover in a dish, with these words : " Here hast thou what thou hast so much desired ; and for the rest, I beseech thee, leave me now in peace."    Whereat the young man, being utterly as-

156                    St. Lucia (Crivelli)

tonished and full of grief and remorse, not only ceased his pursuit, but became also a convert of Christ, and lived ever afterwards an example of virtue and chastity.

'But God would not suffer that the blessed Lucia, having given this proof of her courage and piety, should remain blind: for one day, as she knelt in prayer, behold! her eyes were restored to her more beautiful than before. And if any one doubts of this great miracle, let him consult the writings of that learned and praiseworthy man,

157      St. Lucia.   Garofalo   (Capitol, Rome)

Filippo Bergomense, and also of that famous Spaniard Don Juan Maldonato, where they will find it all set down as I have related. And this is the reason that St. Lucia is invoked against blindness and all diseases of the eyes, and that in her effigy she is represented bearing two eyes in a dish.'[1]

There is a version of her legend which represents her as having

[1] There are only two churches dedicated to her in England ; at Dumbleby, in Lincolnshire, and Great Upton, in Shropshire.

158    St. Lucia with the poniard   (Angelico da Fiesole.   Siena Acad.)

suffered martyrdom by the loss of her eyes, and this has sometimes been followed by the painters; but it is no authority.

Devotional pictures of St. Lucia bearing her eyes in a dish, or on a salver, are commonly met with.   As her eyes were bored out by an awl, she often carries this instrument in her hand: I have seen her with her two eyes on it as on a skewer; but this is utterly bad taste: neither are the eyes an invariable attribute; much more beautiful, and far superior in significance and feeling, are those figures which represent her as carrying a flaming lamp in her hand (155).   When she stands with her lamp, she appears in the character

given to her by Dante—the type of celestial light or wisdom.[1] She is thus represented in a graceful bas-relief, by Luca della Robbia, over the door of her church at Florence. In an altar-piece within the same church she stands on one side of the Madonna, with her eyes in a dish;—this picture is remarkable and interesting, as being the only undoubted production of Domenico Veneziano, who was assassinated by Andrea del Castagno. F. Angelico represents her with her lamp, beautiful, fair-haired, and in pale-green drapery.

In a picture by Baroccio, St. Lucia presents her palm to the Madonna, while an angel holds her eyes in a cup, and St. Antony is in deep meditation.[2]

She has sometimes a sword or poniard in her neck; or a wound in her neck, from which rays of *light* proceed, in allusion to her name; as in a picture by Carlo Dolce in the Florence Gallery. I have not found in the old masters any characteristic type of expression.

Pictures from her history are not commonly met with. In her martyrdom she is seen with ropes about her waist, her neck, her arms; men and oxen are tugging with all their might in vain: as in the ancient fresco at Padua, where her air and attitude, so expressive of meek confidence, are charming. Or she is bound to a stake, and a soldier is about to pierce her neck with a sword: as in a picture by Massarotti, in her church at Cremona; and in a picture by Pesellino, where the tyrant orders her execution, and the executioner pierces her neck with a poniard.[3] In her apotheosis, she is borne into heaven in a glory of angels, one of whom carries her eyes: as in a picture by Palma in her church at Venice.[4]

---

In looking back to the legends of these famous Virgin-Martyrs, we cannot but feel that they rise up in the fancy with a distinct individuality, which has not always—indeed has but seldom—been attended

---

[1] As in the picture of St. John Chrysostom, described at pp. 327, 328, vol. i.
[2] Louvre, No. 864.　　　　　　　　　　　　[3] Berlin Gal. No. 64.
[4] The German patroness of eyes is St. Ottilia, a princess who was born blind, and became abbess of Hohenberg in the eighth century. She will be found among the monastic saints. In several German catalogues I have seen the St. Lucia of the Italian pictures styled St. Ottilia, who was an abbess, and not a martyr.

to by the best painters : in general, when grouped together, they are too much alike; and in the separate figures, the old painters give us certain abstractions of feminine purity and grace, without much regard to characteristic discrimination.

In St. Cecilia, the Roman Lady and the Muse, we should have majesty and a rapt inspiration; the eyes should listen rather than look.

The expression in St. Agnes should be extreme simplicity and meekness, and the girlhood should not be forgotten : she may look down.    In St. Agatha, the character should be a noble fortitude, with a look, perhaps, of trustful supplication for the power to endure. In St. Lucia should prevail a calm intellectual expression; with eyes as beautiful and refulgent as possible : she is the type—not of learning and knowledge, for this is St. Catherine's department— but of wisdom, ' the wisdom from above, which is pure and gentle.' Thus Dante has introduced her as the messenger from the Virgin to Beatrice—

<div align="center">Lucia, nimica di ciascun crudele,—</div>

the gentleness, and the ' *occhi belli, lucenti,*' not being forgotten.[1]

<div align="center">[1] Inf. c. ii.   Purg. ix.   Par. xxxii.</div>

<div align="center">159</div>

# The Roman Martyrs.

THE following martyrs are to be found most frequently in the Roman churches and works of Art. Many of them are exclusively Roman : they are, in fact, merely local saints. But at Rome local influences fill the mind, as Rome itself once filled the universe.

The effect produced upon the fancy by the remains of early Christian Art, still existing within the walls of Rome, will vary of course with the character, turn of mind, and early associations of those who visit them ; but to none can they be wholly indifferent, and on many they will leave a profound and even melancholy impression. Whether contemplated in connection with religious feeling or religious history, they are full of interest.

For myself, I must say that I know nothing to compare with a pilgrimage among the antique churches scattered over the Esquiline, the Cælian, and the Aventine Hills. They stand apart, each in its solitude, amid gardens, and vineyards, and heaps of nameless ruins , —here a group of cypresses, there a lofty pine or solitary palm ; the tutelary saint, perhaps some *Sant' Achilleo*, or *Santa Bibiana*, whom we never heard of before,—an altar rich in precious marbles—columns of porphyry—the old frescoes dropping from the walls—the ever-lasting colossal mosaics looking down so solemn, so dim, so spectral ; —these grow upon us, until at each succeeding visit they themselves, and the associations with which they are surrounded, become a part of our daily life, and may be said to hallow that daily life when con-sidered in a right spirit. True, what is most sacred, what is most poetical, is often desecrated to the fancy by the intrusion of those prosaic realities which easily strike prosaic minds ; by disgust at the foolish fabrications which those who recite them do not believe, by lying inscriptions, by tawdry pictures, by tasteless and even profane restorations ; by much that saddens, much that offends, much that disappoints ;—but then so much remains !—so much to awaken, to elevate, to touch the heart—so much that will not from the memory, so much that makes a part of our after-life.

The pleasure and the interest that I had in connecting these vener-
able and desolate old churches with the traditions of the early faith,
I would now share with others.   And first, in that hollow at the foot
of the Esquiline, and near to the Santa Maria Maggiore, we come
upon two ancient churches dedicated to two charitable sisters : one
of which is considered as the first building ever consecrated publicly
for Christian worship,—in other words, as the most ancient church
in the known world.

## St. Praxedes and St. Pudentiana.

*Ital.* Santa Prassede e Santa Pudenziana.   *Fr.* Sainte Prassède et Sainte Potentienne.
(July 21, May 19, A.D. 148.)

It is related, that when St. Peter came to Rome he lodged in the
house of a patrician whose name was Pudens, and that, in a short
space of time, this Pudens, with his wife Sabinella, his son Nova-
tus, and his two daughters, Praxedes and Pudentiana, were con-
verted to the faith and baptized : soon afterwards, their parents
and brothers being dead, the sisters were left alone, inheriting
great riches, among which were certain public baths, and several
houses at the foot of the Esquiline.   At this time began the first
great persecution of the Church, in which St. Peter and many
saints perished.   And these two sisters, Praxedes and Pudentiana,
went about aiding and comforting and encouraging their poorer
brethren.   They sought out those who had been tortured and mu-
tilated, received them into their houses, and ministered to them ;
they visited those who were in prison, sending them food and clothing.
Such works of mercy as tenderly-nurtured women shrink from, they
performed fearlessly ; the bodies of the martyred Christians, which
were cast out in numbers without burial, they sought for, and rever-
ently washed and shrouded, and laid in the caves beneath their house ;
and the blood they collected with a sponge, and deposited in a certain
well.   In all these things they were assisted by a certain holy man
named Pastorus, who waited upon them with exceeding devotion.
Thus they passed their lives in works of piety, daily braving, for
the sake of their suffering brethren, the power of the tyrant and the
terrors of the law, yet by some miracle escaping the fate to which

they were ever exposed: at length they died, after distributing all
their remaining goods to the poor, and were buried in the cemetery
of Priscilla.   Pastorus, who survived them, wrote a brief chronicle
of their virtues.   The house of Pudens, already sanctified by the
preaching of Peter and by the good works of the two holy sisters,
was consecrated as a place of Christian worship by Pope Pius I. in
the year 141.

Their churches are among the most interesting relics of ancient
Christian Rome.   That of Santa Prassede is remarkable for the
poetical significance and richness of the mosaics executed by order
of Pope Paschal I. about the year 817, when he restored the then
ancient and ruined church.   The decoration of the apsis nearly
resembles that of the church of St. Cosmo and St. Damian.   The
Saviour, a majestic colossal figure, stands in the midst, one hand
extended, the other holding the Gospel as a roll.   On the right, St.
Peter presenting St. Praxedes; on the left, St. Paul presenting St.
Pudentiana: the two saints are richly draped, and bear crowns of
offering in their hands.   Farther to the left is seen St. Zeno, hold-
ing the book of the Gospel;[1] last on the right is Pope Paschal, the
restorer of the edifice, bearing a church in his hands, and with the
square nimbus over his head, denoting that he still existed at the
time, and had not the dignity of saint.   Palms close the composi-
tion on each side: on one of them sits the Phœnix, emblem of im-
mortality; beneath this, and running round the apsis, are seen
Christ as the Lamb, and the twelve apostles as sheep, in the usual
manner.   In front of the arch over the tribune, we have the Lamb
of God throned, and the glorification of the martyrs as described in
the Revelation.   Lower down, the elders bearing crowns in their
hands; and in front of the arch, over the choir, the same *motif* con-
tinued.   The heavenly Jerusalem is seen above, guarded by angels,
Christ standing in the midst: the blessed company of saints and
martyrs are seen in multitudes, on each side; some bearing crowns
and some palms; all assisting, as it were, as witnesses of the exal-
tation of the two pious and devoted sisters, who had been their
refuge on earth.

[1] This St. Zeno is not the Bishop of Verona, who will be found among the bishops, but
one of the many martyrs who suffered in the time of St. Praxedes, and to whom she and
her sister ministered. —*Catalogus Sanctorum Italiæ*, Julii ix.

In the same church are some bad modern frescoes representing
Pudens and Sabinella, and in the centre is the well which received the
blood of the martyrs.    They show among the relics in the sacristy
the holy sponge of St. Praxedes, in a silver shrine, remarkable for
its execrable taste and bad workmanship.

The church of St. Pudentiana—the more ancient of the two—is
even more curious and interesting, though the mosaic decorations are
less rich.    The mosaic of the apsis represents Christ in the midst,
and on each side St. Praxedes and St. Pudentiana bearing martyr
crowns in their hands, in gold and green drapery, and, as far as I
could understand, presenting each five martyrs in white garments to
the Saviour.    The modern altar-piece, by Pomerancio, exhibits the
two sisters wiping up the blood of the martyrs; one squeezes the
sponge into a cup; the priest assisting represents Pastorus.    Above,
in a glory, is the apotheosis of St. Pudentiana.    In the Gaetani
Chapel, on the left, there is a fine modern mosaic after the cartoon
of Frederic Zucchero, representing again the two sisters wiping up
the blood of the slaughtered saints.    There is here another well,
containing, as it is said, the relics of 3000 martyrs ; and a modern
picture, representing St. Peter baptizing Pudens and his family.

Elsewhere I have not met with any picture of these earliest
Sisters of Charity.    I have seen a print bearing the name of Cor-
reggio, representing a beautiful female saint with flowing hair and
a veil ; a cup in one hand, and in the other a sponge distilling drops
of blood ; underneath is inscribed, ' *Ste. Potentienne.*'    Of St. Prax-
edes I have never met with any separate representation.    There is
an altar dedicated to her in the Cathedral at Milan, which perplexed
me till I recollected that St. Charles Borromeo was cardinal of Santa
Prassede.[1]

On the other side of the Esquiline, and on the road leading from the
Colosseum to the Lateran, surmounting a heap of sand and ruins, we
come to the church of the ' Quattro Coronati,' the Four Crowned
Brothers.    On this spot, some time in the fourth century, were found

[1] See the ' Monastic Legends.'

the bodies of four men who had suffered decapitation, whose names being then unknown, they were merely distinguished as CORONATI, *crowned*, that is, with the crown of martyrdom. There is great obscurity and confusion in the history of these saints, and their companions, the five martyrs, ' I Cinque Martiri,' who are honoured in the same place and on the same day. It is plain that the early painters did not distinguish them, and therefore I shall not attempt to do so.

The legend relates that, in the reign of Diocletian, there lived in Rome four brothers, who were Christians, and who were cunning artificers in wood and stone, excelling in sculpture and architecture. ' In those days,' says Gibbon, ' every art and every trade that was in the least concerned in the framing or adorning of idols, was, in the opinion of the Christians, polluted by the stain of idolatry ; a severe sentence, since it devoted to eternal misery the far greater part of the community employed in the liberal or mechanical professions ; ' while those who refused to profane their art were as certainly condemned to poverty and starvation, if not to martyrdom. And this was the fate of the four crowned brothers. They refused to exercise their known skill in obedience to the emperor, saying, ' We cannot build a temple to false gods, nor shape images of wood or stone to ensnare the souls of others.' Whereupon some of them were scourged, and some were enclosed in iron cages and thrown into the sea, and some were decapitated (Nov. 4, A.D. 400). We are not told how these punishments were awarded, nor how their names and fate were afterwards revealed to a ' *santo huomo :* ' but here stands their church to witness to their conscientious piety and courage, and here it has stood for fourteen centuries. It is held in particular respect by the builders and stonecutters of Rome, who are the proprietors of the principal chapel in it, which is dedicated to St. Sylvester, while the convent attached to the church belongs to a Sisterhood of Charity, who have the care and education of deserted orphans.

These ' Santi Coronati,' and their companions the ' Cinque Martiri,' of the same trade, are found not only in Roman Art, for I have seen them in the old sculpture and stained glass of Germany, and, as I remember, in a curious old picture in Nuremberg. They are easily distinguished when they do occur, for they stand sometimes four, some-

times five, in a row, bearing palms, with crowns upon their heads, and various implements of art, such as the rule, the square, the mallet, the chisel, at their feet.  Scenes from their legend are very uncommon : in those I have seen, the subjects selected have been the same.

1. They refuse to build the idolatrous temple : they are kneeling before the emperor, holding their implements in their hands ; six guards around.  2. They are bound to four pillars, and tortured.  3. They are shut up in an iron cage, and cast into the sea.

These three pictures I found in a predella by Alfani, highly finished, and full of expression.[1]

4. They are lying together in a sarcophagus, with crowns upon their heads.  This subject I found in their church.

The names differ, and therefore I give those usually inscribed either within their glories or over their heads :—Severianus, Carpophorus, Severus (or Secundus), Victorinus, Claudius, Symphorian, Castorius, Simplicius.

On the other side of this solitary lane stands the far more celebrated church of San Clemente, one of the most extraordinary monuments of Christian Rome.  Here, according to an ancient tradition, repose together the reliques of St. Ignatius, the famous bishop of Antioch, and St. Clement, the fellow-labourer of St. Paul.  I shall not here give a description of this singular and interesting church, the favourite study of artists and antiquaries ; it may be found in Plattner, Vasi, Murray, and every German, Italian, and English guide to the antiquities of Rome ; but content myself with telling what they do not tell,—the legend of St. Clement, whose dwelling stood upon this spot.

He was the disciple of St. Peter and St. Paul, and the third Bishop of Rome.  He is also considered as one of the Fathers of the Church, and the same person to whom St. Paul alludes in his Epistle to the Philippians (ch. iv. 3), ' I entreat thee, true yokefellow, help those women which laboured with me in the gospel ; with Clement also, and with other my fellow-labourers, whose names are in the book of life.'

According to the legendary story of St. Clement, he presided over
_____
[1] Perugia Acad.

the church at Rome for many years, converting numbers of people to
the true faith, and amongst others Domitilla, the niece of the Emperor
Domitian, and another noble Roman lady whose name was Theodora.
Through the protection of Domitilla, his wife was secure during the
reign of Domitian.  In the year 100, under Trajan, began the third
general persecution, which was the more afflicting because this emperor
was in other respects famous for his humanity and his justice.

The prefect who governed Rome, during the absence of Trajan on
his expedition against the Dacians, commanded Clement to be brought
before him, and on his refusal to sacrifice to the false gods, he ordered
him to be banished to an island whither many convicts were sent
and obliged to work in the quarries of stone.  There did many
Christians already sigh in chains, and several voluntarily accom-
panied the good bishop, willing to partake of his banishment.
Clement found the unhappy prisoners not only condemned to hard
labour, but suffering cruelly from the want of water, which they had
to bring from a distance of ten miles.  The saint, moved with com-
passion, knelt down and prayed; and, raising his eyes, he suddenly
saw a lamb standing upon the summit of a rising ground, which,
remaining invisible to all beside himself, he knew could be none other
than the Lamb of God; therefore St. Clement took up a pickaxe, and
went before the people to the hill, and, digging there, a clear and
abundant stream gushed forth, to the great consolation of the people.
(Observe the beautiful and significant allegory!)  This miracle only
the more incensed his enemies, and they ordered him to be bound to
an anchor and cast into the sea.  But short was their triumph! for,
at the prayer of the Christian disciples, the sea withdrew for the space
of three miles, and they discovered a little ruined temple which had
been formerly buried by the waters: and, wonderful to relate, within
it was found the body of St. Clement with the anchor round his neck;
and, as it is related by credible witnesses, this miracle did not hap-
pen only once, but every year at the anniversary of his martyrdom
the sea retired during seven days, leaving a dry path for those who
went to honour the relics of the saint in this new species of submarine
tomb.  And this lasted for many years; and many grave authors, who
affirm this miracle, also relate, that a certain woman, accompanied by
her son, being at prayer within the temple, her child fell asleep, and

the sea rising suddenly the mother fled, leaving him behind in her fear, and when she reached the shore she wrung her hands, weeping bitterly, and passed that year in great affliction. The next year, returning to pay her devotions at the shrine, to her joyful surprise she found her son there, sleeping, just as she had left him.

St. Clement, in the devotional pictures, appears habited as pope, sometimes with the tiara, but generally without it; an anchor at his side, or a small anchor suspended round his neck. In the ancient mosaic in his church at Rome (12th century), he is thus represented seated by St. Peter and holding the anchor in his hand. In the frescoes of the little chapel already alluded to, on the wall opposite to the life of St. Catherine, Masaccio or one of his scholars painted a series of the life of St. Clement, now in a most ruined state; we can distinguish the scene of the flood, and St. Clement discovering the fountain of living waters—the waters of religious truth and consolation—to his thirsty and fainting disciples. The other subjects are scarcely to be recognised. [1]

---

Far away from these churches, and in a desolate spot amid vineyards and ruins, between the Santa Croce and the Porte Maggiore, stands the small ancient church of SANTA BIBIANA, dedicated to her about the year 468. She was a young Roman lady, who, with her father Flavianus, her mother Dafrosa, and her sister Demetria, suffered martyrdom in the reign of Julian the Apostate. Persisting in her faith, she was scourged to death, or, according to another authority, first scourged and then pierced with a dagger (Dec. 2, A.D. 362). The column to which she was bound is shown within the church, placed there by Urban VIII. when he restored the ruined edifice in 1622.

The statue of St. Bibiana, in marble, by Bernini, stands upon the altar; a graceful figure, leaning against a pillar, and holding the palm

[1] The church of St. Clement, in the Strand, is dedicated to this saint. The device of the parish is an anchor, which the beadles and other officials bear on their buttons, &c., and which also surmounts the weathercock on the steeple. To choose the anchor—the symbol of stability—for a weathercock, appears strangely absurd till we know the reason. There are in England forty-seven churches dedicated to St. Clement.

in her hand. The nave of the church is painted with a series of large frescoes, which exhibit her story in detail. 1. Bibiana refuses to sacrifice to idols.[1] 2. The death of Demetria, who, according to the legend, fell dead to the earth before she was touched by the executioner. 3. Bibiana bound to a column, and scourged. 4. Her body, being cast forth unburied, is found by a dog. 5. Olympia, a noble Roman matron, founds the church, which is dedicated by Pope Simplicius.

Between these large historical subjects are single devotional figures, of a colossal size, representing Bibiana, Dafrosa, Flavianus, Demetria, and Olympia. Though in a mannered taste, they have much grandeur, and are reckoned by Lanzi among the finest works of the master—Pietro da Cortona.

---

On the brow of the Cælian Hill, and in a most striking situation, looking across to the ruins on the Palatine, stands the church of the two brothers ST. JOHN and ST. PAUL, who were martyred in the same year with Bibiana, and whose church has existed since the year 499. They were officers in the service of Constantia, whom the old legends persist in representing as a most virtuous Christian (though, I believe, she was far otherwise), and were put to death by Julian the Apostate. Their house stood upon this spot, one of the most beautiful sites in ancient Rome.

In devotional pictures these saints are always represented standing together in the Roman military costume, and bearing the sword and the palm.

Their famous church at Venice, the SS. Giovanni e Paolo, can never be forgotten by those who have lingered around its wondrous and precious monuments; but among them we may seek in vain for the Roman tutelary saints—at least I did: and I believe, notwithstanding the magnificence of their church, the Venetians knew nothing about them. The Dominicans, who raised this edifice in the thirteenth century, were emigrants from the convent of St. John and St. Paul, at Rome, and carried their patrons with them.

[1] Eng. by Mercati, 1626. Bartsch, xx. p. 140.

On the southern side of the Cælian Hill stand the San Stefano and the Santa Maria della Navicella; then, as we descend into the valley, in that desolate hollow between the Cælian and the Aventine, and close to the baths of Caracalla, stands the old church of SS. NEREO and ACHILLEO.

These two saints, Nereus and Achilleus, are peculiar to Rome. They were the chamberlains of Flavia Domitilla, grand-niece of the Emperor Domitian, and daughter of Flavius Clemens and the elder Domitilla, both of whom had suffered for their adhesion to Christianity. Flavia Domitilla was betrothed to Aurelian, son of the consul; but her two chamberlains, zealous Christians, prevailed upon her to refuse this union with an idolater; for which cause they were beheaded, and Domitilla was at the same time put to death at Terracina (May 12).

St. Nereus and St. Achilleus are represented standing in secular habits, bearing palms in their hands, on each side of Domitilla, who is richly dressed as princess, and bears her palm;—as in a picture by Rubens, painted when he was in Rome in 1604, and now over the high altar of S. Maria della Vallicella.

The Martyrdom of SS. Nereo and Achilleo in the church of S. Maddalena de' Pazzi at Florence, is a *chef-d'œuvre* of Pocetti.

Not far from this church is another of great antiquity, dedicated to St. CESAREO, who perished at Terracina, because he opposed himself to the worship of Apollo. Though very little is known of him, he was celebrated in the sixth century, both in the East and in the West. At present his name and fame seem to be confined entirely to Rome.

On the other side of the baths of Caracalla, and at the foot of the Aventine, we come upon the little church of SANTA BALBINA. Of its foundation all that we know is that it was an ancient church in the time of Gregory the Great (A.D. 590).

St. Balbina is another saint peculiar to Rome. According to the legend, she was the daughter of the prefect Quirinus, and discovered the chains of St. Peter, which had long been lost (March 31, A.D. 130). She is represented veiled, and holding a chain in her hand, or with fetters near her.

On the summit of the Aventine are several of the most interesting of these old churches. That of St. SABINA was dedicated to a noble Roman matron, who suffered martyrdom in the time of the Emperor Hadrian (Aug. 29, second century). This church, built upon the site of her house, existed in 423. Though spoilt, as usual, by white-washing and restoration, it is singularly elegant. The altar-piece, by Federic Zucchero, represents St. Sabina as dragged up the marble steps of a temple by an executioner with a drawn sword. With her was martyred her Greek slave, Seraphia, who was also a zeal-ous Christian, and, as the legend relates, had converted her mistress. St. Sabina, though a Roman saint, is among those not confined to Rome. I saw at Venice, in the San Zaccaria, a most lovely picture by the Vivarini of Murano, in which she is represented with her palm and crown, richly dressed, and surrounded by worshipping angels; on the right, St. Jerome; and on the left, another saint in a short tunic, fastened with a gold belt, bearing a palm. The exquisite softness of this picture, the lovely colour, and the divine expression in the faces, render it one of the most beautiful productions of the early Venetian school.

Not far from the Church of St. Sabina is that of St. PRISCA.

On this spot, according to the old tradition, stood the house of Aquila and Priscilla, where St. Peter lodged when at Rome, and who are the same mentioned by St. Paul as tent-makers; and here is shown the font from which, according to the same tradition, St. Peter baptized the first Roman converts to Christianity. The altar-piece represents the baptism of St. Prisca, whose remains being after-wards placed in this church, it has since borne her name. According to the legend, she was a Roman virgin of illustrious birth, who at the age of thirteen was exposed in the amphitheatre. A fierce lion was let loose upon her, but her youth and innocence disarmed the fury of the savage beast, which, instead of tearing her in pieces, humbly licked her feet—to the great consolation of the Christians and the confusion of the idolaters. Being led back to prison, she was there beheaded. St. Prisca is not peculiar to Rome; she appears in old prints and pictures, and in French sculpture and stained glass,

bearing her palm, and with a lion at her side: sometimes also an eagle, because it is related that an eagle watched by her body till it was laid in the grave; for thus, says the story, was virgin innocence honoured by the kingly bird as well as by the kingly beast.   St. Prisca was so much venerated in England that her name is preserved in our reformed calendar.

In the valley behind the Esquiline, in that long lonely road between Santa Maria Maggiore and the Lateran, stands the church of *SS. Pietro e Marcellino*, whom we style ST. PETER EXORCISTA and MARCELLINUS.   They are always represented together.   Their legend relates, that in the last persecution under Diocletian they were cast into prison.   Artemius, keeper of the dungeon, had a daughter named Paulina, and she fell sick; and St. Peter offered to restore her to health if her father would believe in the true God.   And the jailer mocked him, saying, ‘If I put thee into the deepest dungeon, and load thee with heavier chains, will thy God then deliver thee?   If he doth, I will believe in him.’   And Peter answered, ‘ Be it so ; not out of regard to thee, for it matters little to our God whether such an one as thou believe in him or not, but that the name of Christ may be glorified, and thyself confounded.’

And in the middle of the night Peter and Marcellinus, in white shining garments, entered the chamber of Artemius as he lay asleep, who, being struck with awe, fell down and worshipped the name of Christ, and he, his wife, his daughter, and three hundred others were baptized.   After this the two holy men were condemned to die for the faith.   And the executioner was ordered to lead them to a forest three miles from Rome, that the Christians might not discover their place of sepulture.   And when he had brought them to a solitary thicket overgrown with brambles and thorns, he declared to them that they were to die, upon which they cheerfully fell to work and cleared away a space fit for the purpose, and dug the grave in which they were to be laid.   Then they were beheaded, and died encouraging each other (June 2).

The fame of SS. Pietro e Marcellino is not confined to Rome.   In the reign of Charlemagne they were venerated as martyrs throughout

Italy and Gaul; and Eginhard, the secretary of Charlemagne, who married his daughter Emma, is said to have held them in particular honour. Every one, I believe, knows the beautiful story of Eginhard and Emma. And the connection of these saints with them as their chosen protectors lends an interest to their solitary deserted church.

They are always represented together, in priestly habits, bearing their palms. In the *Roma Sotterranea* of Bosio, p. 126, there is an ancient fragment found in the catacombs which represents St. Peter Exorcista, St. Marcellinus, and Paulina standing together. In a picture by Gervasio Gatti, over the altar of their church at Cremona, the two saints, habited as priests, baptize Paulina, the daughter of the jailer—the rest of the family and many converts being present.

On the western brow of the Aventine, and not far from the Priorata, there stood, in the year 305 or 306, a little oratory, which a Greek woman of birth and fortune, named Aglae, had reared over the remains of her lover Boniface. According to the story, they had lived together in sin and luxury for many years; but when the last dreadful persecution of the Christians burst forth like a storm, both were seized with a deep compassion for the sufferers, and with compunction for their own sinful and shameful life; and Aglae sent away her lover with much gold and treasure for the purpose of redeeming the Christian martyrs from torture, or at least their precious remains from insult. Boniface did as he was commanded, but in his zeal he exposed himself to death, and expiated his former sins by a glorious martyrdom. His mutilated body being brought home to Aglae, she immediately retired from the world, distributed her goods to the poor, and built a hermitage and an oratory, in which she deposited the remains of Boniface, and spent the rest of her life in prayers, tears, and penitence. Both were subsequently canonised.

But the oratory of Aglae and Boniface was soon afterwards almost forgotten in the superior fame of the church of St. Alexis, whose

story, as given in the Legendario Romano, is one of the most beauti-
ful of the sacred romances of the Middle Ages.[1]

## St. Alexis.

*Lat.* S. Aletius.   *Ital.* Sant' Alessio.   *Fr.* St. Alexis.   *Ger.* Der Heilige Alexius.
Patron saint of pilgrims and beggars.   (July 17, A.D. 400.)

In the days when Innocent I. was pope, and Arcadius and Honorius
reigned over the East and West, there lived a man in Rome whose
name was Euphemian, rich and of senatorial rank; he had a house
and great possessions on the Cælian Hill, but he had no son to inherit
his wealth.   He and his wife, whose name was Aglae, besought the
Lord earnestly to grant them offspring, and their prayer was heard;
for after many years they had a son, and called him Alexis.   And
Alexis from his childhood had devoted himself to the service of
God, and became remarked by all for his humility, his piety, and
his charity.   Although outwardly he went clothed in silk and gold,
as became his rank, yet he wore a hair shirt next his body; and
though he had a smiling and pleasant countenance towards all, yet
in his chamber he wept incessantly, bewailing his own sinful state
and that of the world, and made a secret vow to devote himself
wholly to the service of God.

And when he was of a proper age his father wished him to marry, and
chose out for his wife a maiden of noble birth, beautiful and graceful
and virtuous, one whom it was impossible to look on without being irre-
sistibly attracted.   Alexis, who had never disobeyed his parents from
his infancy upwards, trembled within himself for the vow he had spoken,
and seeing his bride, how fair she was and how virtuous, he trembled
yet the more; but he did not dare to gainsay the words of his father.

[1] Baillet says distinctly, ' Cette histoire de St. Alexis semble être plutôt une exhortation
faite à la manière des paraboles pour exciter au mépris du monde et à l'amour des humilia-
tions, que la relation de quelque histoire véritable.   Il paroît pourtant que l'auteur n'a point
produit du néant le fonds sur lequel il a voulu travailler et que l'Église n'a point cru que
Saint Alexis ne fût qu'une idée de sainteté ou un saint imaginaire, puisqu'elle lui a décerné
un culte public en Orient et en Occident.'—*Baillet, Vies des Saints,* Juillet xvii.

On the appointed day the nuptials were celebrated with great pomp and festivity; but when evening came the bridegroom had disappeared, and they sought him everywhere in vain; and when they questioned the bride, she answered, 'Behold, he came into my chamber and gave me this ring of gold, and this girdle of precious stones, and this veil of purple, and then he bade me farewell, and I know not whither he has gone!' And they were all astonished, and, seeing he returned not, they gave themselves up to grief: his mother spread sackcloth on the earth, and sprinkled it with ashes, and sat down upon it: and his wife took off her jewels and bridal robes, and darkened her windows and put on widow's attire, weeping continually; and Euphemian sent servants and messengers to all parts of the world to seek his son, but he was nowhere to be found.

In the meantime, Alexis, after taking leave of his bride, disguised himself in the habit of a pilgrim, fled from his father's house, and throwing himself into a little boat he reached the mouth of the Tiber; at Ostia he embarked in a vessel bound for Laodicea, and thence he repaired to Edessa, a city of Mesopotamia, and dwelt there in great poverty and humility, spending his days in ministering to the sick and poor, and in devotion to the Madonna, until the people, who beheld his great piety, cried out 'A saint!' Then, fearing for his virtue, he left that place and embarked in a ship bound for Tarsus, in order to pay his devotions to St. Paul. But a great tempest arose, and after many days the ship, instead of reaching the desired port, was driven to the mouth of the Tiber, and entered the port of Ostia.

When Alexis found himself again near his native home, he thought, 'It is better for me to live by the charity of my parents, than to be a burthen to strangers;' and, hoping that he was so much changed that no one would recognise him, he entered the city of Rome. As he approached his father's house, he saw him come forth with a great retinue of servants, and, accosting him humbly, besought a corner of refuge beneath his roof, and to eat of the crumbs which fell from his table; and Euphemian, looking on him, knew not that it was his son; nevertheless he felt his heart moved with unusual pity, and granted his petition, thinking within himself, 'Alas for my son Alexis! perhaps he is now a wanderer and poor, even as

this man!' So he gave Alexis in charge to his servants, commanding that he should have all things needful.

But, as it often happens with rich men who have many servitors and slaves, Euphemian was ill obeyed; for, believing Alexis to be what he appeared, a poor, ragged, way-worn beggar, they gave him no other lodging than a hole under the marble steps which led to his father's door, and all who passed and repassed looked on his misery; and the servants, seeing that he bore all uncomplaining, mocked at him, thinking him an idiot, and pulled his matted beard, and threw dirt on his head; but he endured in silence. A far greater trial was to witness every day the grief of his mother and his wife: for his wife, like another Ruth, refused to go back to the house of her fathers; and often, as he lay in his dark hole under the steps, he heard her weeping in her chamber, and crying, 'O my Alexis! whither art thou gone? why hast thou espoused me only to forsake me?' And, hearing her thus tenderly lamenting and upbraiding his absence, he was sorely tempted; nevertheless, he remained steadfast.

Thus many years passed away, until his emaciated frame sank under his sufferings, and it was revealed to him that he should die. Then he procured from a servant of the house pen and ink, and wrote a full account of all these things, and all that had happened to him in his life, and put the letter in his bosom, expecting death.

It happened about this time, on a certain feast-day, that Pope Innocent was celebrating high mass before the Emperor Honorius and all his court, and suddenly a voice was heard which said, 'Seek the servant of God who is about to depart from this life, and who shall pray for the city of Rome!' So the people fell on their faces, and another voice said, 'Where shall we seek him?' And the first voice answered, 'In the house of Euphemian the patrician. And Euphemian was standing next to the emperor, who said to him, 'What! hast thou such a treasure in thy house, and hast not divulged it? Let us now repair thither immediately.' So Euphemian went before to prepare the way; and as he approached his house, a servant met him, saying, 'The poor beggar whom thou hast sheltered has died within this hour, and we have laid him on the steps before the door.' And Euphemian ran up the steps and uncovered the face of the

beggar, and it seemed to him the face of an angel, such a glory of light proceeded from it; and his heart melted within him, and he fell on his knees; and as the emperor and his court came near, he said, 'This is the servant of God of whom the voice spake just now.' And when the pope saw the letter which was in the dead hand of Alexis, he humbly asked him to deliver it; and the hand relinquished it forthwith, and the chancellor read it aloud before all the assembly.

But now what words shall describe the emotions of his father, when he knew that it was his son who lay before him? and how the mother and the wife, rushing forth distracted, flung themselves on the senseless body, and could with difficulty be separated from it? and how for seven days they watched and wept beside him? and how the people crowded to touch his sacred remains, and many sick and infirm were healed thereby? But all this I pass over: let it suffice that on the spot where stood the house of Euphemian the church of St. Alexis now stands. The marble steps beneath which he died are preserved in the church, in a chapel to the left of the entrance, and beneath them is seen the statue of the saint lying extended on a mat in the mean dress of a poor pilgrim, his staff beside him, and the letter in his hand. The remains of Aglae and the martyr Boniface also rest in this church under the high altar.

Although St. Alexis did not perish by a violent death, yet, through his extreme sufferings, and the spirit of resolute yet humble resignation in which they were met and endured, he is supposed to have merited the honours of martyrdom. I have seen figures of St. Alexis in which, in addition to the pilgrim's habit, ragged and worn, and the beggar's dish, he carries the palm. In the mosaics of Monreale he stands among the glorified martyrs, of colossal size, in a white vest, a blue mantle, the crown on his head, and the cross, through which he triumphed, in his hand.

But in general we find St. Alexis represented in the old pictures and prints as penitent, pilgrim, and beggar; in the churches of the ascetic orders, and in hospitals and houses of refuge for the poor, which are placed under his protection, we find his effigy with the characteristic ragged attire, and expression of pathetic resignation and humility.

1. There is a fine statue of St. Alexis on the façade of the church of the Trinità at Florence.

2. In a picture by Pietro da Cortona at Alton Towers, St. Alexis is dying under the steps of his father's door, holding the cross and a paper pressed to his bosom. The figure is life-size, and very forcible in colour and expression.

3. In a very fine picture by Annibal Caracci, painted for the Mendicanti at Bologna, St. Alexis, as pilgrim and beggar, stands with St. Louis, St. Catherine, St. Clara, and St. John the Baptist: he might be mistaken for St. Roch, but that the last-named saint has always the plague-spot, which distinguishes his effigies from those of St. Alexis.

---

At the foot of the Capitoline Hill, on the left hand as we descend from the Ara Cœli into the Forum, there stood in very ancient times a small chapel dedicated to the memory of ST. MARTINA, a Roman virgin, who was martyred in the persecution under Alexander Severus. The veneration paid to her was of very early date, and the Roman people were accustomed to assemble there on the first day of the year. This observance was, however, confined to the people, and not very general till 1634; an era which connects her in rather an interesting manner with the history of Art. In this year, as they were about to repair her chapel, they discovered, walled into the foundations, a sarcophagus of terra-cotta, in which was the body of a young female, whose severed head reposed in a separate casket. These remains were very naturally supposed to be those of the saint who had so long been honoured on that spot. The discovery was hailed with the utmost exultation, not by the people only, but by those who led the minds and the consciences of the people. The pope himself, Urban VIII., composed hymns in her praise; and Cardinal Francesco Barberini undertook to rebuild her church. Amongst those who shared the general enthusiasm, was the painter Pietro da Cortona, who was at Rome at the time, and who very earnestly dedicated himself and his powers to the glorification of St. Martina. Her church had already been given to the Academy of Painters, and consecrated to St. Luke, their patron saint. It is now

'San Luca e Santa Martina.' Pietro da Cortona erected at his own cost the chapel of St. Martina, and, when he died, endowed it with his whole fortune. He painted for the altar-piece his best picture, in which the saint is represented as triumphing over the idols, while the temple, in which she had been led to sacrifice, is struck by lightning from heaven, and falls in ruins around her.[1] In a votive picture of St. Martina kneeling at the feet of the Virgin and Child, she is represented as very young and lovely ; near her, a horrid instrument of torture, a two-pronged fork with barbed extremities, and the lictor's axe, signify the manner of her death. The picture called 'une Jeune Martyre,' by Guido Cagnacci, in the Orleans Gallery, is a St. Martina.

---

Not far from the church of San Gregorio, and just under the Palatine Hill, we find the church of ST. ANASTASIA, who, notwithstanding her beautiful Greek name, and her fame as one of the great saints of the Greek calender, is represented as a noble Roman lady, who perished during the persecution of Diocletian : the same, I presume, who in Didron's 'Manual of Greek Art' is styled 'Anastasie la Romaine.' Her story is mixed up with that of St. Chrysogonus (Grisogono), who also suffered martyrdom at that time, and is chiefly celebrated for his influence over the mind of Anastasia, and the courage with which he inspired her. She was persecuted by her husband and family for openly professing the Christian faith, exposed to many trials, sorrows, and temptations, and through all these, being sustained by the eloquent exhortations of Chrysogonus, she passed triumphantly, receiving in due time the crown of martyrdom, being condemned to the flames. Chrysogonus was put to death by the sword, and his body thrown into the sea.

According to the best authorities, these two saints did not suffer at Rome, but in Illyria ; yet at Rome we are assured that Anastasia, after her martyrdom, was buried by her friend Apollina in the garden of her house, under the Palatine Hill, and close to the Circus Maximus.

[1] There is a small copy of this once-admired picture in the Dulwich Gallery.

There stood the church dedicated to her in the fourth century, and there it now stands.

It was one of the principal churches in Rome in the time of St. Jerome, who, according to an ancient tradition, celebrated mass at one of the altars, which is still regarded on this account with peculiar veneration. To St. Anastasia is dedicated a beautiful church at Verona; where, however, I looked in vain for any picture representing her. The proper attributes are the palm, the stake, and the faggots.

With regard to St. Chrysogonus, his fine church in the Trastevere, existing since 599, was modernised by Scipio Borghese, cardinal of San Grisogono, in 1623 ; when Guercino painted for the ceiling of the nave his grand picture of the saint carried up to heaven by angels. This picture now decorates the ceiling of the Duke of Sutherland's gallery at Stafford House. I have never seen any other picture of St. Chrysogonus : his proper attributes are the sword and the palm, which in Guercino's picture are borne by angels.

---

Not far from the church of San Grisogono, and on a rising ground, stands the church of *San Pancrazio*, our St. Pancras. In the persecution under Diocletian, this young saint, who was only fourteen years of age, offered himself voluntarily as a martyr, defending boldly before the emperor the cause of the Christians. He was thereupon beheaded by the sword, and his body was honourably buried by the Christian women. His church near the Gate of San Pancrazio, at Rome, has existed since the year 500.

St. Pancras was in the Middle Ages regarded as the protector against false oaths, and the avenger of perjury. It was believed that those who swore by St. Pancras falsely, were immediately and visibly punished ; hence his popularity. We have a church dedicated to him in London, and a large parish bearing his name : French kings anciently confirmed their treaties in the name of St. Pancras. I recollect no effigy of him ; but he ought to be represented as a boy of a very beautiful countenance, richly dressed in the secular habit, and bearing his palm and sword.

---

Except at Rome I have never seen any effigy of ST. SUSANNA; — but I think it probable that such may exist. It appears, however, that those who bore the name of Susanna preferred as their patroness the chaste matron of the Old Testament to the virgin martyr of the Roman legend. It is related that this Susanna was of illustrious birth, the daughter of Gabinius, who was the brother of Pope Caius, and also nearly related to the Emperor Diocletian. She was very fair, but more especially remarkable for her learning and her subtle and penetrating intellect. Diocletian, hearing everywhere of her praises, was desirous to marry her to his adopted son Maximus; but she, who had made a vow of perpetual chastity, refused to listen to these tempting offers. Whereupon the emperor desired his wife, the Empress Serena, to send for her, and to endeavour to overcome her obstinacy. Now the empress, unknown to her husband, was really a Christian; therefore she rather encouraged Susanna in her resistance. Diocletian, being enraged at her firmness, sent an executioner, who put her to death in her own house (Aug. 11, A.D. 290).

She is chiefly honoured at Rome, and would appear to be little known out of that city. Her statue in marble by Fiamingo, over her altar in the church of Santa Maria di Loretto, near the Forum of Trajan, is one of his finest works, and very simple and elegant. She holds the sword and palm as martyr; but I know not any other attribute by which she is distinguished.

---

ST. CHRYSANTHUS (or San Grisante) and ST. DARIA suffered martyrdom together at Rome, about the year 257; or, as others say, under the reign of Numerian, about 284. Their story is very obscure. One legend represents St. Daria as a Vestal virgin, who, on her conversion to Christianity, extinguished the sacred fire, and was consequently buried alive; and it is also related that she was married to St. Chrysanthus, who converted her. I mention them here because they appear in the early mosaics at Ravenna, and have been introduced into the magnificent altar-piece, by Giulio Campi, in the church of St. Sigismond at Cremona. This church was dedicated by

Francesco Sforza, on the occasion of his marriage with Bianca Maria Visconti, the heiress of Milan, which was celebrated on the festival of St. Chrysanthus and St. Daria (October 25).[1]

---

St. Eugenia, anciently one of the most popular and potential saints in the Roman calendar, was the daughter of Philip, proconsul of Egypt in the reign of Commodus. She was brought up at Alexandria in all the wisdom of the Gentiles, was converted to Christianity, and, in learning, eloquence, and courage, seems to have been the prototype of St. Catherine, by whom, however, she has been completely eclipsed. According to the legend, she put on man's attire, and became a monk in Egypt, under the name of the abbot Eugenius; but afterwards, returning to Rome, she suffered martyrdom by the sword, under the Emperor Severus. She rarely appears in works of Art, having lost her popularity before the period of the revival. We find her in the procession of martyrs at Ravenna; and I have seen a picture of her martyrdom in the Bologna Gallery, by Giovanni Sementi, treated with much sentiment.

---

The two saints who follow, though counted among the Roman martyrs, are of general interest. They have many chapels at Rome, but no church dedicated in their name.

### St. Felicitas and her Seven Sons, Martyrs.

*Ital.* Santa Felicità.   *Fr.* Sainte Félicité.   Patroness of male heirs.   (Nov. 23, A.D. 173.)

' In the reign of the Emperor Marcus Aurelius Antoninus, there was a great persecution of the Christians. They were deemed the cause, if not the authors, of all the terrible calamities, the plagues and wars, famines and earthquakes, which at that time desolated the empire, and an inexorable edict condemned them either to sacrifice or to die. In

---

[1] For a further account of this picture, see the ' Legends of the Monastic Orders,' p. 183.

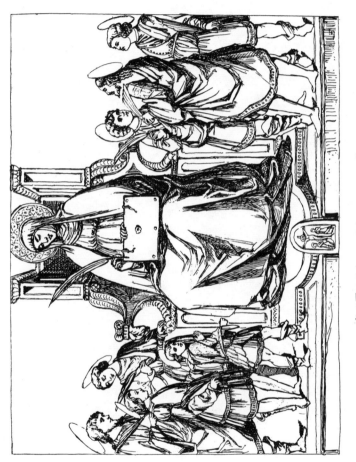

St. Felicita and her seven Sons.

this persecution, Polycarp perished in the East, and Justin in the West.

' At the same time there dwelt in Rome an illustrious matron named Felicitas, a widow having seven sons, whom she brought up in the Christian faith, devoting herself to a life of virtuous retirement, and employing her days in works of piety and charity. Her influence and example, and the virtuous and modest deportment of her sons, caused many to become Christians, so that the enemies of the faith were greatly enraged against her; and as she was exceedingly rich, those who shared in the spoil of the martyrs were eager to accuse her. She was accordingly cited before the tribunal of Publius, the prefect of the city, who, at first with mildness and then with threatening words, endeavoured in vain to induce her to deny Christ, and sacrifice to the false gods. And the prefect said to her, " If thou hast no regard for thyself, at least have compassion on thy sons, and persuade them to yield to the law." But she replied that her sons would know how to choose between everlasting death and everlasting life. Then the prefect called them all one after another before him, and commanded them to abjure Christ on pain of torments and death; but their mother encouraged them to persevere in resistance, saying to them, " My sons, be strong in heart, and look up to heaven, where Christ and all his saints await your coming; and defy this tyrant boldly, for so shall the King of glory reward you greatly." On hearing these words the prefect was enraged, and he commanded the executioners to strike her on the mouth, and put her to silence; but she continued to exhort her sons to die rather than to yield. Then, one after another, they were tortured and put to death before the eyes of their mother: first, the eldest, whose name was Januarius, was scourged with thongs loaded with lead until he died: next to him, Felix and Philip were beaten with clubs; Sylvanus was flung from a rock; and Alexander, Vitalis, and Martial were decapitated. During their sufferings the mother heroically stood by, and ceased not to comfort and encourage them; and when she beheld them extended in death before her, she lifted up her voice and blessed God that she had brought forth seven sons worthy to be saints in paradise. Her hope was to follow them speedily; but the tyrant, through a refinement of cruelty, caused her life to be prolonged for four months in

prison, in order that she might suffer a daily martyrdom of agony, hoping to subdue her spirit through affliction : but she remained firm in the faith, still refusing steadily and meekly to yield, and desiring no other mercy but that of speedily following her martyred children. At length the time of her deliverance arrived, and, being dragged from prison, she was tortured in various ways, and then beheaded ; or, as some say, thrown into a caldron of boiling oil.   This happened on the 23rd day of November, A.D. 173.'

St. Felicitas bears the palm as martyr ; as matron and widow she is hooded or veiled, with ample drapery, as in a beautiful figure by Spinello : [1] she is usually accompanied by her seven sons.   The earliest example is a most curious fragment of fresco, found in the catacombs, and now preserved in the Vatican.   She is standing in the midst of her sons, with arms outspread in prayer, and of colossal proportions compared with the other figures, who are ranged in a line on each side, and their names inscribed above.

In a singular picture, attributed to Neri de' Bicci (A.D. 1476), and now preserved in the sacristy of the church of Santa Felicità at Florence, she is seated on a throne, a majestic colossal figure, holding in one hand the Gospel, which rests on her knee, in the other the palm, while her sons, small in proportion, and treated as accessaries or attributes, are ranged on each side, the youngest standing rather in front.   All have palms and golden glories, and wear rich dresses ; and all but the youngest appear as warriors.   I give an etching from this picture, which has never been engraved.

By Garbieri.   St. Felicitas presents her seven sons at the feet of the Madonna and Child.   In the church of St. Maurice at Mantua.

In the so-called ' Martyrdom of St. Felicitas,' a famous composition by Raphael, a female saint is represented standing in a caldron or bath, her hands clasped in prayer.   Two headless bodies lie on the ground : the prefect is seen on his tribunal surrounded by his lictors, and groups of amazed or sympathising spectators are standing around.   An angel, exquisite for grace and movement, and cleaving the air like a bird, comes down from above with the crown of martyrdom.   There can be no doubt that we have here the death of St. Cecilia, and not the death of St. Felicitas ; that this was the subject

[1] One of the attendant figures in a Coronation of the Virgin, in the Florence Academy.

designed by Raphael probably about the time that he painted the St. Cecilia at Bologna, and that the print was afterwards misnamed.[1]

The seven Jewish brethren, who with their heroic mother are celebrated in the Second Book of Maccabees, are sometimes introduced into ecclesiastical decoration. They have a place among the Greek martyrs, and the representation is so exactly like that of St. Felicitas and her sons, that I know not how to distinguish them further than to observe, that in churches constructed under the influence of Byzantine Art, seven young martyrs grouped together with their mother most probably represent the Jewish brethren (*les sept Machabées*); for St. Felicitas, though so famous in the West, was not accepted in the East.[2]

[1] The composition was painted by one of the pupils of Raphael on the left wall of the chapel of the Villa Magliana, near Rome ; but it is nearly destroyed. The fine engraving of Marc Antonio has, however, preserved the original design in all its beauty.

[2] The confusion which anciently existed between these Jewish and Christian martyrs was such that the name of Felicitas was given to the mother of the Maccabees. The church of Santa Felicità at Florence stands where stood a chapel dedicated to the *Sette Maccabei*, and the hymn in the ancient office of the Church shows that the two mothers were confounded under the same name :—

> Salve ! Sancta Felicitas
> Nobilibus cum filiis,
> Tu florida fecunditas
> Ornata septem filiis,
> Vos lege sub Mosaica
> Vixistis corde simplice,
> Præceptaque Dominica
> Servastis mente supplice !
>
> v. RICHA, *Chiese Fiorentine*, ix.

## St. Veronica.

*Ital.* Santa Veronica.   *Fr.* Sainte Véronique.

The festival of St. Veronica (La Sainte Face de J. C.) is held on Shrove Tuesday.

It is an ancient tradition, that when our Saviour was on his way to Calvary, bearing his cross, he passed by the door of a compassionate woman, who, beholding the drops of agony on his brow, wiped his face with a napkin, or, as others say, with her veil, and the features of Christ remained miraculously impressed upon the linen.   To this image was given the name of Vera Icon, the *true* image, and the cloth itself was styled the *Sudarium* (*Ital.* Il Sudario; *Fr.* Le Saint Suaire).   All the stories relative to the sudarium belong properly to the legendary life of Christ; I shall therefore only observe here, that the name given to the image was insensibly transferred to the woman of whom the legend is related.   The active imagination of the people invented a story for her, according to which she was Veronica or Berenice, the niece of King Herod, being the daughter of his sister Salome, who had been devoted to the pomps and vanities of the world, but, on witnessing the suffering and meekness of the Saviour, was suddenly converted.   The miraculous power of the sacred image impressed upon her napkin being universally recognised, she was sent for by the Emperor Tiberius to cure him of a mortal malady. But the wicked emperor having already breathed his last, she remained at Rome in company with St. Peter and St. Paul until she suffered martyrdom under Nero; or, according to another legend, she came to Europe in the same vessel with Lazarus and Mary Magdalene, and suffered martyrdom either in Provence or Aquitaine.   I think it unnecessary to enter further into these legends, which have been rejected by the Church since the eleventh century.   But the memory of the compassionate woman, and the legend of the miraculous image, continue to be blended in the imaginations of the people.   In the ancient pictures of the procession to Calvary, St. Veronica is seldom omitted.

The devotional figures always represent her as displaying the sacred handkerchief. Sometimes, in allusion to the legend, she is standing between St. Peter and St. Paul, as in a picture by Ugo da Carpi in the sacristy of the Vatican; and in a woodcut by Albert Dürer—very fine and solemn. Sometimes the miraculous image is of colossal proportions; as in a very curious old picture in the Boisserée Gallery. In St. Peter's at Rome, one of the chapels under the dome is dedicated to St. Veronica. An ancient image of our Saviour, painted on linen, and styled the Vera Icon,[1] is regarded by the people as the veritable napkin of St. Veronica, and

160   St. Veronica (Andrea Sacchi)

is exhibited among the relics of the church. In this chapel the mosaic over the altar, after a design by Andrea Sacchi, represents the Saviour sinking under the weight of the cross, and St. Veronica kneeling beside him in white. It is a simple, elegant composition, very matter of fact, and not in the least either mysterious or poetical.

---

I have now done with the Roman Martyrs. Those which follow here are honoured principally in the north of Italy, and their effigies are to be found in the works of Art in Tuscany, Lombardy, and Venice. I have added those few French and Spanish saints who have a *general* interest in connection with Art, either because their celebrity has been widely diffused, or because of the beauty and importance of those productions in which they have been represented.

---

[1] Whence it is supposed that the name of *Veronica* is derived.

# Martyrs of Tuscany, Lombardy, Spain, and France.

The early Martyrs, who figure almost exclusively in pictures of the Tuscan schools, are rather curious as subjects of ancient Art, than either interesting or celebrated.

ST. REPARATA was for six hundred years (from 680 to 1298) the chief patroness of Florence. According to the old Florentine legend she was a virgin of Cesarea in the province of Cappadocia, and bravely suffered a cruel martyrdom in the persecution under Decius, when only twelve years old. She was, after many tortures, beheaded by the sword; and as she fell dead, her pure spirit was seen to issue from her mouth in form of a dove, which winged its way to heaven.

The Duomo at Florence was formerly dedicated to St. Reparata: but about 1298 she appears to have been deposed from her dignity as sole patroness; the city was placed under the immediate tutelage of the Virgin and St. John the Baptist, and the church of St. Reparata was dedicated anew under the title of Santa Maria-del-Fiore.

I have never seen any representation of Santa Reparata except in the old Florentine pictures. In these she is frequently introduced standing alone or near the Madonna, bearing the crown and palm as martyr, and sometimes also a banner, on which is a red cross on a white ground.

In a picture by Angelo Gaddi she wears a green robe, and bears the crown, book, and banner. In another ancient Florentine picture she is in a white robe and red mantle, with the same attributes. In a grand composition of Fra Bartolomeo, representing the Madonna surrounded by many saints, and especially the protectors of Florence, St. Reparata, who is on the left of the Virgin, bears the palm, and leans her hand on the book. She is sometimes represented standing with St. Ansano, the patron of Siena, as in a picture by Simone Memmi.[1] Such pictures, I apprehend, must have been painted when Florence and Siena were at peace. It is difficult to distinguish St. Reparata from St. Ursula, unless

[1] All the above pictures are in the Florence Gallery.

where the latter saint bears her javelin : where there is a doubt, and the picture is undeniably Florentine, the locality and the traditions must be consulted.

Another saint, who is sometimes represented in the old Florentine pictures, is St. Verdiana (A.D. 1222), usually dressed as a Vallombrosian nun, but she did not belong to any order. She is represented with serpents feeding from her basket.

---

Who, that remembers Florence, does not remember well the SAN-MINIATO-IN-MONTE towering on its lofty eminence above the city, and visible along the Lung' Arno from the Ponte alle Grazie to the Ponte alla Carraja ?—and the enchanting views of the valley of the Arno as seen from the marble steps of the ancient church ?—and the old dismantled fortress defended by Michael Angelo against the Medici ?—and the long avenue of cypresses and the declivities robed in vineyards and olive grounds between the gate of San Miniato and the lofty heights above ? But for the old saint himself, he has fared not much better than St. Reparata.

According to the Florentine legend, St. Minias or Miniato was an Armenian prince serving in the Roman army under Decius. Being denounced as a Christian, he was brought before the emperor, who was then encamped upon a hill outside the gates of Florence, and who ordered him to be thrown to the beasts in the Amphitheatre. A panther was let loose upon him, but when he called upon our Lord he was delivered; he then suffered the usual torments, being cast into a boiling caldron, and afterwards suspended to a gallows, stoned, and shot with javelins ; but in his agony an angel descended to comfort him, and clothed him in a garment of light : finally he was beheaded. His martyrdom is placed in the year 254.

There is a town bearing his name half way between Florence and Pisa, celebrated as the birth-place of Francesco Sforza, and the first seat of the Buonaparte family.

Effigies of this saint are confined to Tuscany ; all those I have seen are in his church near Florence, never having visited the cathedral at San-Miniato. He is represented in the attire of a prince with a scarlet robe, a golden crown, one or two javelins in his hand, a lily and a

palm; and is thus exhibited in a very old picture of the Giotto school, with his life in eight small compartments painted around the principal figure.

The Greek mosaic in the choir of his church (11th century), represents him as standing on one side of Christ (the Virgin and St. John on the other); he wears the regal crown and mantle, and holds the Greek cross. An old fresco, engraved in the ' Etruria Pittrice,' represents him with similar attributes.

St. ANSANO appears only in the pictures of the ancient Siena school. He was, until the end of the thirteenth century, the chief patron of the city of Siena; but his popularity has waned before that of the modern patrons, St. Bernardino and St. Catherine.

Ansanus Tranquillinas was the son of a noble Roman. His nurse, Maxima, a Christian woman, caused him to be secretly baptized: he grew up to the age of nineteen in the faith of Christ, and then disclosed his religion, converting and baptizing many; hence he is considered as the apostle of Siena. In the terrible persecution under Diocletian, after many sufferings and many miracles, operated through faith and charity, Ansanus was beheaded on the banks of the river Arbia.[1]

St. Ansano appears in the Siena pictures as a youth richly dressed, bearing the palm. The city with its massive towers is often introduced into the background: sometimes as patron, he carries it in his hand. As one who preached the faith, and baptized, he bears also the standard of the cross.

There is a graceful figure of St. Ansano in a picture by Simone Memmi, in which he holds a palm with a cluster of dates depending from it; the companion figure, called in a catalogue St. Julitta, a saint who had no connection with this part of Italy, I suppose to be St. Reparata.[2] A fine statue of St. Ansano baptizing the Sienese converts is in the Duomo of Siena.

SANTA FINA is scarcely known, I believe, beyond the walls of the little town of San Gemignano. She was not properly a martyr, not having died a violent death; but long and cruel sufferings from disease,

---

[1] Catalogus Sanctorum Italiæ.                    [2] Florence Gal.

endured not only with patience but cheerfulness, during which she worked with her hands as long as it was possible, and ministered to the poor, procured her the honour of canonisation. The people regarded her, while living, with enthusiastic veneration; and it is related, that at the moment of her death all the bells in San Gemignano tolled spontaneously, untouched by human hands;—a poetical figure of speech, expressing the intense and universal grief. She had been warned of her approaching end by a vision of St. Gregory, whom she held in especial honour; and when borne to the place of sepulture, she was seen to raise her emaciated hand and bless her aged nurse, who was thereupon delivered from a grievous malady.

All these incidents were painted in the beautiful little chapel of Santa Fina, in the Cathedral of San Gemignano, by Sebastian Mainardi, with a delicate and pathetic grace, and a truth and tenderness of sentiment, worthy of Angelico himself. There are no tragic horrors, little to strike the eye or seize the attention; but the whole story, as expressed in Art, is the glorification of feminine patience, fortitude, and charity. St. Fina died on the 12th of March 1253.

Effigies of St. Torpè, or Torpet, appear to be peculiar to the locality of Pisa; he was the patron saint of that city, until superseded by San Ranieri. According to the Pisan legend, he was a noble Roman, who served in the guards of the Emperor Nero, was converted by the Apostle Paul, and suffered martyrdom for the faith in the year 70 (May 17). The perpetual intercourse between the ports of Western Italy and those of Provence introduced St. Torpè into France, where he was long known and venerated under the name of St. Tropès. The port of Saint Tropez, east of Marseilles, bears his name, and has a fine old church dedicated to his memory.

Except in the churches of Pisa, I have not met with St. Torpè. In the Duomo there, is a picture representing him as a Roman warrior, and bearing the white banner with a red cross: anywhere else he might be mistaken for a St. George. In the same church is his martyrdom; he is beheaded by an executioner.

The old Pisan chronicle relates, that in a frightful dearth caused by the want of rain, the bed of the Arno being completely dry, the head of St. Torpè was carried in grand procession through the city;

and such was the efficacy of his intercession, that a sudden flood
descending from the mountains not only overflowed the banks of the
river, but swept away part of the pious procession, and with it the
head of the saint.  The people were in despair; but, lo! two angels
appeared to the rescue, dived under the waves, and brought up the
head, which they restored to the hands of the archbishop.  This
picturesque story is also represented in the Duomo at Pisa.

St. Torpè does not appear in the most ancient works of Pisan Art,
not even in the Campo Santo : before the thirteenth century he had
been completely eclipsed by St. Ranieri; but in the seventeenth
century his celebrity revived, and all the pictures I saw of him were
of that period.

St. Ephesus and St. Potitus (Sant' Efeso and San Potito) are
also, I believe, peculiar to Pisa.  The legend relates that St. Ephesus,
an officer in the service of the Emperor Diocletian, was sent to destroy
all the Christians in Sardinia ; but, being warned in a dream not to
persecute the servants of the Lord, he turned his arms against the
Pagans, and with his friend St. Potitus, a native of Cagliari, suffered
martyrdom in the Christian cause.

The Pisans having subdued the island of Sardinia in the eleventh
century, bore the relics of these two Sardinian saints in triumph to
their city, and placed them within the precincts of the Duomo.

The legend of St. Ephesus is among the frescoes of the Campo
Santo, painted by Spinello Aretino.

1. He kneels in the habit of a warrior before the Roman emperor,
and receives his commission to extirpate the Christians.  On the other
side is seen the apparition of our Lord, who commands him to desist
from persecuting the servants of Christ.

2. St. Ephesus, having become a Christian soldier, fights against
the heathen, and receives from St. Michael, an armed angelic warrior
on horseback, the Christian standard (the cross on the red ground,
which is the standard of Pisa); in the next compartment he is seen
combating the Pagans, assisted by St. Michael.  The insular position
of Sardinia, with regard to Pisa, is expressed by water flowing round
it, with fishes, &c.

3. The Martyrdom of St. Ephesus; he is seen in a blue robe

embroidered with stars, kneeling, unharmed, in the midst of a fiery furnace, while the flames issuing from it destroy the soldiers and executioners.

Three other compositions, which represented the martyrdom of St. Potito, and the translation of the relics from Sardinia to Pisa, are now wholly ruined and effaced.

ST. LIBERALE (April 27), venerated in the Friuli, is said to be represented by Giorgione in a beautiful picture now in the Duomo at Castelfranco, and in a picture by Varottari, in S. M. dei Carmine at Venice.[1]

161 St. Julian   (Lorenzo di Credi.   Louvre)

The patron saint of Rimini is ST. JULIAN of Cilicia, one of the Greek martyrs who have been celebrated in Western Art.   Nothing is known or recorded of him but the courage with which he endured a cruel and prolonged martyrdom, of which St. Chrysostom has given a full account.   I imagine that it is this St. Julian of Rimini who is introduced into a splendid picture by Lorenzo Credi, as the pendant of St. Nicholas of Bari, they would naturally be placed together as patron saints of two of the greatest ports on the eastern shore of the Adriatic.   He is also standing with St. Nicholas, and accompanied by St. Barbara and St. Christina kneeling, in a beautiful little ‘ Coronation of the Virgin,’ by the same painter.[2]

---

[1] The figure called St. Liberale (more probably a St. George), by Giorgione, is the same figure (nearly) as the little St. George which belonged to Mr Rogers, and which is now in the National Gallery.                    [2] v. p. 668, note.

In the devotional pictures, St. Julian is represented young and graceful, often with flowing hair; with a melancholy yet benign aspect, richly dressed in the secular habit, bearing his palm, sometimes the standard of victory, and the sword.

His whole history is painted in the church of San Giuliano at Rimini. One of the scenes represents him as thrown into the sea in a sack full of serpents : in another the sarcophagus containing his body is guided over the waves by angels till it arrives on the shores of the territory of Rimini. I have never seen these pictures, which are by Bettino, an early artist of Rimini, and dated 1408 ; but Lord Lindsay praises them highly.[1] In the same church is the Martyrdom of the saint, over the high altar, by Paul Veronese.

There are no less than twelve saints of this name ; but the two most famous are this St. Julian the Martyr, who is represented young, and with the palm and sword ; and St. Julian Hospitator, the patron saint of travellers, who is generally in the dress of a hermit, and accompanied by a stag.

---

The martyrs who appear in the pictures of the Lombard school, though in some instances obscure, and confined to certain localities, are interesting from the beauty and value of the pictures in which they are represented.

I begin with those of Milan.

## St. Gervasius and St. Protasius.

*Ital.* SS. Gervasio e Protasio.   *Fr.* Saint Gervais et Saint Protais.   (June 19, A.D. 69.)

THE *passion* for relics (for I can call it by no other name), which prevailed from the third to the fourteenth century, had been introduced from the imaginative East ; and, as I have already observed, may be

---

[1] *v.* 'Sketches of Christian Art.'

accounted for on the most natural grounds. The remains of those who had perished nobly for an oppressed faith were first buried with reverential tears, and then guarded with reverential care. Periodical feasts were celebrated on their tombs—the love-feasts (*agapæ*) of the ancient Christians : subsequently, their remains were transferred to to places of worship, and deposited under the table or altar from which the sacrament was distributed. Such places of worship were supposed, of course, to derive an especial sanctity, and thence an especial celebrity, from the possession of the relics of martyrs highly and universally honoured. I have not time to trace more in detail the growing influence of such impressions on the popular mind ; but to this particular aspect of religious enthusiasm we owe some of the grandest remains of ancient Art, in architecture, sculpture, and painting.

Already, in the fourth century, no sacred edifice was deemed complete, or could lay claim to the reverence of the people, unless it could boast the possession of some hallowed remains ; and as the offerings of the faithful were multiplied by their devotion, it became too much the interest of the priesthood to lend themselves to these pious impositions ; and even the churchmen of the highest rank for energy and intellect were either seized by the prevalent enthusiasm, or turned it to account for their own interests and purposes.

When St. Ambrose founded a new church at Milan (A.D. 387), the people besought him to consecrate it by some holy relics : these, however, were not easily procured; at that time they had not become articles of barter or merchandise. St. Ambrose was most anxious to gratify his faithful people ; it was also an object of importance to intercept some of the pilgrims, who day by day passed by the city of Milan on their way to the shrines at Rome. The legend goes on to relate, that, ' while possessed with these thoughts, St. Ambrose went to pray in the church of St. Nabor and St. Felix ; and as he knelt a kind of trance, which was not exactly sleep, fell upon him. In a vision he beheld two young men, of incomparable beauty, clothed in white garments; with them were St. Peter and St. Paul : and it was revealed to St. Ambrose that these two young men were martyrs whose bodies lay near the spot where he dwelt. He then convoked his clergy, and commanded that search should be made, and the bodies of two men

were discovered in the spot indicated. They were of gigantic size, their heads were found separated from the bodies, and a quantity of blood was in the tomb; also a record or writing disclosing their names and fate.

They were Gervasius and Protasius—twin brothers, who had suffered for the faith under the Emperor Nero. Having been sent bound to Milan, together with Nazarius and Celsus, they were brought before Count Artesius, who, sharing in the enmity of his master against the Christians, commanded them to sacrifice to his idols. On their refusal, he condemned Gervasius to be beaten to death with scourges loaded with lead; and ordered Protasius to be beheaded. A good man, whose name was Philip, carried home their bodies and buried them honourably in his own garden; and they remained undiscovered until this wonderful revelation to St. Ambrose. On the second day after the discovery of the relics, they were borne in solemn procession to the Basilica. And as they passed along the streets, many of those who were sick or possessed by evil spirits threw themselves in the way, that they might touch the drapery with which the bodies were covered; and immediately they were healed. Among these was a man named Severus, well known to all the city, who had been blind for many years, and was reduced to live upon the alms of the charitable: having obtained permission to touch the bones of these holy martyrs, he was restored to sight; which miracle, being performed before all the multitude who accompanied the procession, admitted of no doubt, and raised the popular enthusiasm to its height. St. Ambrose gave thanks to God for his mercy, and laid the bones of the martyrs beneath the altar, saying, ' Let the victims be borne in triumph to the place where Christ is the sacrifice: he upon the altar, who suffered for all; they beneath the altar, who were redeemed by his suffering!' The Arians, the enemies of Ambrose, did not only mock at this revelation, they even accused him of having bribed Severus and others to play a part in this religious drama; but this authority carried everywhere conviction, and the church was dedicated under the names of the new saints Gervasius and Protasius. After the death of St. Ambrose, who was laid in the same spot, it took his name, and is now ' Sant' Ambrogio Maggiore,' one of the most remarkable churches in Christendom. It does not

appear that St. Gervasius and St. Protasius obtained great popularity either in Italy or Spain ; even at Milan they are less esteemed than several other saints. But it is otherwise in France. Some part of their relics having been carried thither by St. Germain, bishop of Paris, in 560, their story at once seized upon the popular imagination ; under their French names *St. Gervais et St. Protais,* they became the patron saints of five or six cathedrals, and of parish churches innumerable. The best pictures of these saints are to be met with in the French school. In the devotional effigies they usually stand together, Gervasius bearing a scourge with the throngs loaded with lead, as in the legend, and Protasius bearing the sword. Where one only is represented, it is St. Gervasius.

At Venice, in the church of SS. Protasio-e-Gervasio, called by the people, after their peculiar manner of abbreviation, San Trovaso, there is a picture by Lazzarini, of the two saints in glory, carrying palms, not very good.

The fine pictures relating to the history of these saints, executed when the convent of St. Gervais at Paris was at the height of its riches and popularity, are now dispersed : they were the *chefs-d'œuvre* of the French school of the seventeenth century, when distinguished by such artists as Niccoló Poussin, Le Sueur, and Champagne.

1. St. Ambrose sees in a vision Gervasius and Protasius, who are presented to him by St. Paul. 2. St. Ambrose, attended by his clergy, digs for the relics. Two designs by Le Sueur, to be executed in stained glass ; very fine and simple. Engraved in Landon, and in the Musée, but not now in the Louvre.

3. St. Gervasius and Protasius, being brought before the statue of Jupiter, refuse to sacrifice : many figures, life-size, and more dramatic than is usual with Le Sueur ; the heads of the two young saints have a pale, meek, refined grace, most expressive of their vocation as Christians, and in contrast with the coarse forms, furious looks, and violent gestures of the pagan priests and soldiers around them.

Far inferior are the pictures of Champagne, in the Louvre, also large life-size compositions, each about twenty feet in length.

1. Protasius and Gervasius appear to St. Ambrose, who is not asleep, but at prayer. 2. The relics of the saints conveyed in grand

procession to the basilica of St. Ambrose (not to the cathedral, where they never reposed): the martyred brothers lie extended on a bier, the faces seen as if newly dead ; which is a deviation from the legend ; the sick and possessed crowd to kiss the white drapery which lies over them, covered with flowers. Among those who press forward is the blind man Severus; St. Ambrose and his clergy follow, singing hymns ; both pictures are scenic and theatrical, and the heads commonplace. Neither in this picture, nor in any others I have seen, are St. Gervasius and St. Protasius represented as giants, which, in strict adherence to the story, they ought to have been.

---

According to the Ambrosian legend, ST. VITALIS, the famous martyr and patron saint of Ravenna, was the father of SS. Gervasius and Protasius, served in the army of the Emperor Nero, and was one of the converts of St. Peter. Seeing a Christian martyr led to death, whose courage appeared to be sinking, he exhorted him to endure bravely to the end, carried off his body, and buried it honourably ; for which crime, as it was then considered, he was first tortured, and then buried alive. His wife Valeria, and his two sons Gervasius and Protasius, fled to Milan. The church at Ravenna, dedicated to this saint in the reign of the Emperor Justinian, is one of the most remarkable monuments of Byzantine architecture in Italy. It was erected over the spot where he was buried alive, and dedicated by St. Eclesias about the year 547. The Greek mosaics in the vault of the tribune represent the Saviour seated on the Globe of the universe ; on his right hand St. Vitalis offers his crown of martyrdom ; and on the left St. Eclesias presents his church. Round the arch of the choir are the heads of the Twelve Apostles, St. Vitalis, St. Gervasius, and St. Protasius, in medallions. For this church, Baroccio painted the Martyrdom of the patron saint now in the Brera at Milan. It is a crowded composition ; the executioners thrust him down into the pit, and fling earth and stones upon him : and among the spectators are a mother and her two children, one of whom presents a cherry to a magpie. I have seen this incident

praised as expressing the complete innocence and unconsciousness of the child; but it interferes with the tragic solemnity of the scene, and is, to my taste, trivial and disagreeable. The celebrity of San Vitalis extended, with that of St. Gervasius and St. Protasius, all over Europe; there are churches dedicated to him not only in Italy, but in France and Germany.

For the high altar of the church of San Vitale, at Venice, Carpaccio painted his masterpiece,—the saint, habited as a Roman soldier, mounted on a white charger, and bearing the Christian standard of victory.

It was in the church of St. Nabor and St. Felix that Ambrose knelt when he was visited by ' the revelation,' as described above. St. Nabor and St. Felix were two Christians of whom nothing more is related than that they died for the faith in the reign of Diocletian. They were martyred in the city of Milan, buried by a Christian named Philip in his garden, and an oratory was built over their remains, which in the time of St. Ambrose had become the church of SS. Nabor and Felix; it is now San Francesco. The old mosaics in the chapel of San Satiro represent them in secular and classical costume; but in a picture by Sammacchini (a Coronation of the Virgin with several saints), SS. Nabore and Felice stand in front in complete armour.[1]

----

St. Nazarius and St. Celsus (*Ital.* SS. Nazaro-e-Celso) are two Milanese martyrs of great celebrity in Art.

St. Nazarius was the son of a Jew named Africanus, but his mother Perpetua was a Christian, and caused her son to be baptized by St. Peter. Nazarius grew up under his mother's tuition a fervent Christian, and, accompanied by a young disciple named Celsus, he travelled through Cisalpine Gaul, preaching the Gospel and converting many. They came to Genoa, where the people, being obstinate pagans, laid hold of them and flung them into the sea; but the sea refused to drown them; and, after many wanderings, they came to Milan, where Gervasius and Protasius had testified to the

----

[1] Bologna Gal.

truth, and Nazarius comforted and strengthened them.   Some short
time afterwards he and his youthful disciple Celsus suffered together,
being beheaded outside the Porta Romana at Milan.   The beautiful
antique church of San Nazaro Maggiore, at Milan, still stands a
record of their names and fate.

Even more remarkable is that extraordinary monument of Byzantine
Art, the church of SS. Nazaro-e-Celso at Ravenna, better known as
the 'Mausoleum of Galla Placidia,' built and dedicated by that em-
press about the year 447.   Among the antique mosaics with which
the walls are covered I sought in vain for the tutelary saints.

They are always represented together, St. Nazarius old, and St.
Celsus as a youth, and sometimes even as a boy.   They bear the palm
and the sword as martyrs, but are not otherwise distinguished; there
are effigies of them in the church of St. Nazaro at Milan, but probably
not of very great merit, for I confess that I have no recollection of them,
while Titian's altar-piece in their church at Brescia cannot easily be
forgotten.   The central subject is the resurrection of Christ; on the
left wing is the portrait of the provost Averoldi, for whom the picture
was painted, and who is recommended to the Divine favour by St.
Nazarius and St. Celsus.   St. Nazarius is bearded; St. Celsus, as a
youth, stands in front, and both are in armour.   On the right wing
is a beautiful figure of St. Sebastian, drooping and half dead.   The
picture is a votive offering in commemoration of a pestilence.

St. LUPO, Duke of Bergamo, his wife St. ADELAIDE, their daughter
St. GRATA, and St. ALEXANDER, the Martyr, form a group of saints
interesting only at Bergamo.   The two last are patron saints of the
city.

St. Grata, after the death of her husband, was converted to
Christianity, and led a most chaste and holy life; and when Alexander,
one of the soldiers of the Theban legion, was decapitated outside the
gate of Bergamo, she wrapped up the severed head in a napkin, and
buried the sacred remains honourably.   According to the Bergamesque
chronicle, St. Grata converted her father and mother from the super-
stition of the Pagans; and Duke Lupo, by her advice, founded the

Cathedral at Bergamo. After the death of her parents, Grata governed the republic of Bergamo with singular prudence, 'ruling the people more by kindness than by fear, and more by example than by the terrors of the law;'—and everywhere protecting and propagating Christianity. She built three churches, and founded a hospital for the poor and sick, in which she ministered to the sufferers with her own hands; and, after governing the state in great prosperity for several years, she died, and her pure spirit ascended into heaven, there to receive the due reward of her righteousness. (A.D. 300.)

In the pictures of Cariani, Salmeggia, and Lorenzo Lotto, all excellent painters of Bergamo, we find these saints constantly represented. St. Alexander is habited as a Roman warrior, bearing the palm; St. Grata is usually carrying the head of St. Alexander, which is her proper attribute; St. Lupo wears a royal crown, and St. Adelaide a crown and long veil: as in a picture by Salmeggia, now in the Brera at Milan. There is a fine statue of St. Lupo in a tabernacle above the porch of the Cathedral of Bergamo.

In the church of Sant' Alessandro-in-Colonna, at Bergamo, I found two very poetical and dramatic pictures of the martyrdom of St. Alexander. In the first he is decapitated; in the second he is borne to the tomb by two Christian converts: St. Grata follows, carrying the severed head reverently folded in a napkin: as the drops of blood fall to the earth, flowers spring forth, which are gathered by the maidens attending on St. Grata. Here we have, in a novel form, the familiar and poetical allegory which represents flowers, or fountains of pure water, or branches of olive, springing from the blood of the martyr.

St. Adelaide of Bergamo must not be confounded with the German St. Adelaide, wife of the Emperor Otho the Second.

---

St. Julia, a noble virgin, martyred in Corsica about the third century, sometimes appears grouped with the Brescian saints as one of the patronesses of the city. Her relics were brought from Corsica to Brescia, and a beautiful church and convent were dedicated to her.

An altar-piece by Andrea del Sarto, in the Berlin Gallery, repre-

sents the throned Virgin and Child; on her right hand, St. Peter,
St. Benedict, and St. Onofrio; on the left, St. Paul, St. Anthony
with fire in his hand, and St. Catherine; in front, half-length, St.
Celsus in a rich secular costume, and St. Julia, young, beautiful, and
richly dressed, holding her palm. I presume the picture to have
been originally painted for the convent of Santa-Giulia, in Brescia.
St. Julia and St. Afra are sometimes found together in the Brescian
pictures.

St. Panacea. I have only seen this saint in one picture painted
by Gaudenzio Ferrari, in an altar-piece in San Giovanni at Varallo:
she was a poor girl of the Vallais, canonised for her chastity, her
industry, and the perfect patience with which she suffered the injuries
of a cruel stepmother.[1]

The other patron saints of Brescia, San Faustino and San Giovita
(Faustinus et Jovita), and St. Afra, appear in some beautiful pic-
tures of the Brescian school.

At the time that St. Apollonius preached the Gospel at Brescia,
Faustino and Giovita, two brothers, were converted to Christianity,
and led a most holy and exemplary life, preaching to the people,
ministering to the poor, and being zealous in all good works. They
were seized by order of the Emperor Adrian, and thrown into the
Amphitheatre; but as the wild beasts refused to attack them, they
were beheaded outside the gates of Brescia, in the year 119 or 121.

The Brescians honour, as their patroness, St. Afra. With regard
to the identity of this saint, there is some inexplicable confusion,
which leads us to suppose that there were two saints of this name.

The Brescian St. Afra, whose noble church is one of the chief orna-
ments of the city, appears to have been a woman of patrician birth, who
was converted by witnessing the good works of San Faustino, and San
Giovita; she also suffered a cruel martyrdom, together with a certain
Galocerus. These saints appear in the pictures of the best Brescian

[1] This is the local legend. I do not find her in any catalogue of saints.

painters, Moretto, Foppa, Romanino,[1] Gambara, and Cossale; and only in the churches of Brescia, where the group of the Bishop Apollonius with Faustino and Giovita, sometimes with and sometimes without St. Afra, constantly recurs; Apollonius in the episcopal robes, and Faustino and Giovita sometimes habited as deacons.

1. Bassano. In her church at Brescia, St. Afra, and other converts, baptized by St. Apollonius : Faustino and Giovita administer the sacrament. A scene by torchlight, ill composed, but very effective.

2. Paul Veronese. Over her altar, on the left side of the same church, is the martyrdom of St. Afra; she is upon a high scaffold, attired in a rich dress of gold network, and looking up to heaven with a beautiful expression of resigned faith; the headless bodies of Faustino and Giovita lie on the ground (one of the severed heads is the portrait of Paolo himself, and very fine), and St. Apollonius is exhorting and comforting the martyr ; one of the finest works of the painter for colour and dramatic expression.

3. Grazio Cossale. During the siege of Brescia by Niccoló Piccinino (A.D. 1439), Faustino and Giovita are seen defending the city, and hurling back the cannon-balls of the enemy.

The other St. AFRA, whom I will mention here to prevent confusion, is the patroness of Augsburg. ' She was a woman of that city who had for a long time followed the profession of courtesan; and it happened that a certain holy man whose name was Narcissus, flying from the persecution which afflicted the Christians in the reign of Aurelian, took refuge in the house of Afra without knowing that she was abandoned to sin. When she found out that it was a Christian priest, she was overcome with fear and respect, and by a feeling of shame for a profession which it cost her, for the first time, an effort to avow. The good man took the opportunity to exhort her to repentance ; she listened to him weeping, and fell at his feet, entreating to be baptized; he, knowing that Christ had never rejected a repentant sinner, administered to her baptism, and assured her of forgiveness.

' And Afra had three handmaidens, who, like herself, had led a

---

[1] In S. Maria-Caldrera, at Brescia, is the masterpiece of G. Romanino, representing the Bishop Apollonius dispensing the holy sacrament to Faustino, Giovita, Calocero, and Afra who kneel before him.

dissolute life. She brought them to the feet of the Christian priest, and begged that he would instruct them also in the way to salvation. Meantime those who were in pursuit of the priest came to search for him in the dwelling of Afra; but she concealed him, first in her own house, and then in that of her mother Hilaria; and, by her help, he afterwards escaped to his own country, which was Spain.

'But the idolaters seized upon Afra, and accused her of having assisted in the escape of a Christian, and of being a Christian herself. The judge, whose name was Gaius, and who had known her former profession, was astonished at the modesty and dignity with which she replied to his questions, and acknowledged herself to be a follower of Christ. "How!" said he, "do *you*, a woman of evil life, expect to be accepted by the God of the Christians?" To which Afra meekly replied, "It is true I am unworthy to bear the name of Christian; nevertheless, he who did not reject Mary Magdalene, when she washed his feet with her tears, will not reject me." And, continuing constant in the faith, she was condemned to be burned alive; so they tied her to a stake, and heaped round her a pile of vine-branches. Then she lifted up her eyes to heaven, and prayed, saying, "O thou, who didst call, not the righteous, but the erring, to repentance, and who hast promised that even at the eleventh hour thou wouldst receive the sinner who called upon thee, accept of my penitence, and let the torments I am about to suffer be received as an expiation of my sin, that through this temporal fire I may be delivered from the eternal fire which shall consume both body and soul!" Having said these words, her spirit departed, and was carried by the angels into heaven; and a few days afterwards her mother, Hilaria, and her three maidens, Digna, Eunomia, and Eutropia, also perished for the faith with a like constancy.' (August 5, A.D. 307.)

This St. Afra appears only in the German pictures of the Suabian school. Behind the choir of the Cathedral at Augsburg, there is a large altar-piece by Christoph Amberger, in which the painter has represented in the centre the Madonna and Child; on the left wing, the Bishop-patron of Augsburg, St. Ulrich; on the right, the martyrdom of St. Afra. In the predella beneath, five half-length figures;—St. Hilaria in the centre, and on each side St. Eunomia, St. Eutropia, St.

Digna, and the holy man, St. Narcissus. I saw this picture in 1855 It has a peculiar mixture of German and Italian feeling; is correctly drawn, and full of refined sentiment in the expression, particularly in the St. Hilaria. Over the high altar in the same church, the same saints are represented in coloured sculpture, modern, but in an admirable style.

When a bishop is seen in company with the German St. Afra, it is St. Ulrich, bishop of Augsburg in 973; while the companion of the Brescian St. Afra is St. Apollonius, bishop of Brescia in 300.

## ST. CHRISTINA AND ST. JUSTINA.

THESE are two famous Virgin Martyrs who figure in the churches all over the north of Italy, both being patronesses of the Venetian States. There is, however, this difference : that while the fame of St. Justina of Padua is confined to Italy, and her effigy to Italian Art, St. Christina is venerated in France, Sicily, and Bohemia.

## ST. CHRISTINA.

*Ital.* Santa Cristina. *Fr.* Sainte Christine. Patroness of Bolsena, and one of the patronesses of the Venetian States. (July 24, A.D. 295.)

THE legend of this saint is one of those which have been rejected by the Roman Catholic Church. The little town of Tiro, on the borders of Lake Bolsena, which, according to tradition, was her birth-place, has since been swallowed up by the waters of the lake, and no trace of it remains. She is celebrated, however, all over Northern and Central Italy; and is the subject of some beautiful pictures of the Venetian school.

Her legend, as given in the *Perfetto Legendario*, represents her as the daughter of Urbanus, a Roman patrician, and governor of the city.

He was an idolater, but his daughter, who had been early converted
to the faith of Christ, called herself therefore Christina. 'One day, as
she stood at her window, she saw many poor and sick, who begged alms,
and she had nothing to give them.   But suddenly she remembered that
her father had many idols of gold and silver; and, being filled with the
holy zeal of piety and charity, she took these false gods and broke
them in pieces, and divided them amongst the poor.   Strange it was to
see one carrying away the head of Jove, and another the hand of
Venus, and a third the lyre of Apollo, and a fourth the trident of
Neptune.   But, alas! when her father returned, and beheld what had
been done, what words could express his rage and fury!   He ordered
his servants to seize her and to beat her with rods, and throw her into
a dark dungeon; but the angels of heaven visited and comforted her,
and healed her wounds.   Then her father, seeing that torments did not
prevail, ordered them to tie a millstone round her neck, and throw her
into the lake of Bolsena: but the angels still watched over her: they
sustained the stone, so that she did not sink, but floated on the surface
of the lake; and the Lord, who beheld from heaven all that this
glorious virgin suffered for his sake, sent an angel to clothe her in a
white garment, and to conduct her safe to land.   Then her father,
utterly astonished, struck his forehead and exclaimed, "What meaneth
this witchcraft?"   And he ordered that they should light a fiery
furnace and throw her in; but she remained there five days unharmed,
singing the praises of God.   Then he ordered that her head should be
shaved, and that she should be dragged to the temple of Apollo to
sacrifice; but no sooner had she looked upon the idol, than it fell down
before her.   When her father saw this, his terror was so great that he
gave up the ghost.

'But the patrician Julian, who succeeded him as governor, was not
less barbarous, for, hearing that Christina in her prison sang per-
petually the praises of God, he ordered her tongue to be cut out, but
—oh miracle! she only sang more sweetly than ever, and uttered her
thanksgivings aloud, to the wonder of all who heard her.   Then he
shut her up in a dungeon with serpents and venomous reptiles; but
they became in her presence harmless as doves.   So, being well-nigh in
despair, this perverse pagan caused her to be bound to a post, and
ordered his soldiers to shoot her with arrows till she died.   Thus she at

length received the hardly-earned crown of martyrdom; and the angels, full of joy and wonder at such invincible fortitude, bore her pure spirit into heaven.'

In the island of Bisentina, in the lake of Bolsena, is a small church dedicated to her, and painted, it is said, by the Caracci; but few, I believe, have visited it. The superb Cathedral of Bolsena is also consecrated in her name.

In devotional pictures, the proper attribute of St. Christina is the millstone. She has also the arrow or arrows in her hand, and bears, of course, the crown and palm as martyr. When she bears the arrow only, it is not easy to distinguish her from St. Ursula; but in early Italian Art, a female saint bearing the arrow, and not distinguished by any of the royal attributes, is certainly St. Christina. Pictures of her are common in all the cities of Northern and Central Italy, but more especially at Bolsena, Venice, and Treviso. We find her frequently grouped with the other patrons of this part of Italy; for example, with St. Barbara of Ferrara, with St. Catherine of Venice, with St. Justina of Padua, &c.

I shall give a few examples.

1. St. Christina, as patron saint, stands, crowned and bearing her palm, between SS. Peter and Paul. In a beautiful picture by D. Mazza.[1]

2. Johan Schoreel. She stands as martyr, one hand on a millstone, the other bearing a palm; her dress is that of a lady in the time of Henry VIII. I give a sketch from this picture, to show the portrait-like manner in which the saints were often treated in the old German school (162).

3. Vincenzio Catena. St. Christina kneeling on the surface of Lake Bolsena: angels sustain the millstone, which is fastened round her neck by a long rope; in the skies above, our Saviour appears with his banner, as victor over sin and death, and gives to an angel a white shining garment in which to clothe the martyr. This is a variation from the commonplace angel with the crown and palm; and the whole picture is as pure and charming in sentiment as it is sweet and harmonious in colour.[2]

[1] Venice, Abbazia.    [2] Venice, S. Maria-Mater-Domini.

162        St. Christina.  (Johan Schoreel.   Munich Gal.)

4. Lorenzo di Credi.  St. Christina kneeling and holding the
arrow, grouped with St. Nicholas of Bari, St. Julian of Rimini, and
St. Barbara of Ferrara.   Above is the Coronation of the Virgin.[1]

St. Christina is sometimes represented with a sword in her bosom,
as in an altar-piece by Bissolo at Treviso, and another by Palina: it
is then difficult to distinguish her from St. Justina.[2]   In an ancient

---

[1] It was in the collection of Mr Rogers.   When I first remember this picture it used to
hang in his bedroom out of sight of visitors, and I used often to go up to look at it.   'No
one else,' he said, 'cared about it.'   Of late years it was brought down, covered with plate
glass, and hung in his drawing-room—admired by all.

[2] Perhaps, in these and similar instances, the figures are miscalled, and do really repre-
sent St Justina.

picture by Jacopo Avanzi, in the Bologna Gallery, she is bound to a tree, and two executioners shoot her with arrows, in presence of the prefect Julian.

Paul Veronese painted the whole history of St. Christina in a series of ten pictures, which existed formerly in the church of Sant' Antonio in the island of Torcello at Venice. I saw six of these in the Academy at Venice; the others apparently are dispersed or lost. 1. St. Christina is baptized. 2. She refuses to adore the statue of Apollo. 3. She breaks the gold and silver idols, and gives them to the poor. 4. She is scourged. 5. She is comforted by angels, who bring to her fruits and flowers in her dungeon. 6. She is in a boat on Lake Bolsena; two men prepare to throw her overboard with a millstone round her neck, while her father is seen giving his orders from the shore.

## ST. JUSTINA OF PADUA, VIRGIN AND MARTYR.

*Lat.* Justina Patavina Urbis Protectrix. *Ital.* Santa Giustina di Padova.
*Fr.* Sainte Justine de Padoue. Patron saint of Padua and of Venice. (October 7, A.D. 303.)

THIS saint, famous in the Paduan and Venetian territories, was, according to the legend, a virgin of royal birth, who dwelt in the city of Padua. King Vitalicino, her father, having been baptized by St. Prodocimo (Prosdocimus), a disciple of the Apostle Peter, brought up his daughter in the true faith. After the death of her father, Justina being accused before the Emperor Maximian as a Christian, he commanded that she should be slain by the sword; and she, opening her arms to receive the stroke of the executioner, was pierced through the bosom, and fell dead.

In the year 453, Opilio, a citizen of Padua, founded in her honour the magnificent church which bears her name: and as early as the sixth century we find her almost as celebrated in the West as her namesake, the illustrious virgin and martyr of Antioch, was in the East. Her church at Padua, having fallen into ruin, was sumptuously restored by the Benedictine Order in the beginning of the

sixteenth century. The collections made for this purpose through-
out the north of Italy awakened the enthusiasm of the neighbouring
states, and it is from this time that we find Justina represented
in the pictures of the Paduan and Venetian schools, and most fre-
quently in the pictures of Paul Veronese. In the single figures she
is richly dressed, wearing the crown and bearing her palm, as princess
and as martyr, and in general with the sword transfixing her bosom,
which is her proper attribute. She is thus represented in a beautiful
figure by Vittore Carpaccio;[1] and in the fresco by Luini in San
Maurizio, at Milan, where she is called by some mistake St. Ursula.
In the Venetian altar-pieces St. Justina is often placed on one side
of the Madonna, accompanied either by St. Mark or St. Catherine.
As patroness of Venice, we find her interceding in heaven for the
Venetians, as in a picture in the Arsenal at Venice : in another, we
have St. Justina and St. Mark presenting Venice (under the form of
a beautiful woman, crowned and sumptuously attired) to the Virgin ;
the naval battle of Carolari is seen below : a grand, scenic, votive
picture, painted for the State by Paul Veronese.[2]

In the magnificent church of Santa Giustina at Padua, the altar-
piece by Paul Veronese represents the scene of her martyrdom : amid
a crowd of people, the executioner plunges a sword into her bosom ;
Christ, with the Virgin, St. John, and a numerous company of saints
and angels, receive her into glory above. This, to my taste, is a
heavy, crowded picture ; the fine engraving by Agostino Caracci has
given it more celebrity than it deserves. In the same church, in
the centre of the choir, stands a chest or shrine, on which is sculp-
tured the history of the life of Santa Giustina in five compartments.
1. She is baptized by St. Prodocimo. 2. The baptism of her parents.
3. She is seized by the emissaries of Maximian, and dragged out
of her chariot. 4. She is martyred by the sword. 5. She is borne
to the grave by St. Prodocimo and others.

In some Venetian pictures the attribute of the unicorn, which
belongs properly to St. Justina of Antioch, has been given to St.
Justina of Padua ; and when this is the case it is not easy to
determine whether the mistake arose from ignorance or design. In

1 Milan, Brera.                    2 Venice, Ducal Pal.

Domenichino's picture of St. Justina caressing a unicorn in a forest, it is, I imagine, St. Justina of Antioch who is represented.[1]  In Moretto's splendid picture of the Duke Alfonso I. at the feet of St. Justina,[2] I should suppose that the artist had the patroness of Padua and Venice, and not the martyr of Antioch, in his mind ;—or perhaps confounded the two.  Neither must it be forgotten that a beautiful female attended by a unicorn is sometimes merely allegorical, representing Chastity ; but when the palm and sword are added, it is undoubtedly a St. Justina ; and if the picture be by a Venetian artist ; if the figures be in the Venetian costume ; if Venice be seen in the distance ; or St. Mark introduced,—then it is probably St. Justina of Padua : otherwise, when a female saint appears alone, or in a company of martyrs, attended by a unicorn, it is St. Justina of Antioch.

St. Justina figures on the Venetian coins struck by the Doges Leonardo Donato and Pasquale Cicogna.

---

The last of these Italian martyrs who appears worthy of record, as a subject of painting, is one of very recent celebrity, and, perhaps, the most apocryphal saint in the whole calendar,—which is saying much.

## ST. FILOMENA.

*Lat.* Sancta Philumena.  *Fr.* Sainte Philomène.  (Aug. 10, 303.)

In the year 1802, while some excavations were going forward in the catacomb of Priscilla at Rome, a sepulchre was discovered containing the skeleton of a young female ; on the exterior were rudely painted some of the symbols constantly recurring in these chambers of the dead : an anchor, an olive branch (emblems of Hope and Peace), a

---

[1] Or the allegory of Chastity.          [2] Vienna Gal. *t.* p. 577.

scourge, two arrows, and a javelin : above them the following inscription, of which the beginning and end were destroyed :—

———LUMENA PAX TE CUM FI———

The remains, reasonably supposed to be those of one of the early martyrs for the faith, were sealed up and deposited in the treasury of relics in the Lateran ; here they remained for some years unthought of.   On the return of Pius VII. from France, a Neapolitan prelate was sent to congratulate him.   One of the priests in his train, who wished to create a sensation in his district, where the long residence of the French had probably caused some decay of piety, begged for a few relics to carry home, and these recently discovered remains were bestowed on him; the inscription was translated, somewhat freely, to signify *Santa Philumena, rest in peace.  Amen.*  Another priest, whose name is suppressed *because of his great humility*, was favoured by a vision in the broad noon-day, in which he beheld the glorious virgin Filomena, who was pleased to reveal to him that she had suffered death for preferring the Christian faith and her vow of chastity to the addresses of the emperor, who wished to make her his wife.   This vision leaving much of her history obscure, a certain young artist, whose name is also suppressed, perhaps because of his great humility, was informed in a vision that the emperor alluded to was Diocletian, and at the same time the torments and persecutions suffered by the Christian virgin Filomena, as well as her wonderful constancy, were also revealed to him.   There were some difficulties in the way of the Emperor Diocletian, which *incline* the writer of the *historical* account to incline to the opinion that the young artist in his vision *may* have made a mistake, and that the emperor may have been not Diocletian but Maximian.   The facts, however, now admitted of no doubt : the relics were carried by the priest Francesco da Lucia to Naples ; they were enclosed in a case of wood resembling in form the human body ; this figure was habited in a petticoat of white satin, and over it a crimson tunic after the Greek fashion ; the face was painted to represent nature, a garland of flowers was placed on the head, and in the hands a lily and a javelin with the point reversed to express her purity and her martyrdom ; then she was laid

in a half-sitting posture in a sarcophagus, of which the sides were glass; and, after lying for some time in state in the chapel of the Torres family in the church of Sant' Angiolo, she was carried in grand procession to Mugnano, a little town about twenty miles from Naples, amid the acclamations of the people, working many and surprising miracles by the way.

Such is the legend of St. Filomena, and such the authority on which she has become within the last twenty years one of the most popular saints in Italy. Jewels to the value of many thousand crowns have been offered at her shrine, and solemnly placed round the neck of her image or suspended to her girdle. I found her effigy in the Venetian churches, and in those of Bologna and Lombardy. Her worship has extended to enlightened Tuscany. At Pisa the church of San Francesco contains a chapel dedicated lately to Santa Filomena; over the altar is a picture by Sabatelli representing the saint as a beautiful nymph-like figure floating down from heaven, attended by two angels bearing the lily, palm, and javelin, and beneath in the foreground the sick and maimed who are healed by her intercession; round the chapel are suspended hundreds of votive offerings, displaying the power and the popularity of the saint. There is also a graceful German print after Führich, representing her in the same attitude in which the image lies in the shrine. I did not expect to encounter St. Filomena at Paris; but, to my surprise, I found a chapel dedicated to her in the church of St. Gervais; a statue of her with the flowers, the dart, the scourge, and the anchor under her feet; and two pictures, one surrounded, after the antique fashion, with scenes from her life. In the church of Saint-Merry, at Paris, there is a chapel recently dedicated to ' Sainte Philomène;' the walls covered with a series of frescoes from her legend, painted by Amaury Duval;—a very fair imitation of the old Italian style.

I have heard that St. Filomena is patronised by the Jesuits; even so, it is difficult to account for the extension and popularity of her story in this nineteenth century.

St. Omobuono, the protector of Cremona, and patron saint of tailors, was neither a martyr, nor a monk, nor even a hermit; but as effigies of him are confined entirely to pictures of the Cremonese and Venetian schools, I shall place him here to make my chapter of these local Italian saints complete. He is regarded all over the north of Italy as the patron and example of good citizens, and is the subject of some beautiful pictures.

According to the legend, Omobuono was a merchant of Cremona, who had received from his father but little school learning, yet, from the moment he entered on the management of his own affairs, a wisdom more than human seemed to inspire every action of his life; diligent and thrifty, his stores increased daily, and, with his possessions, his almost boundless charity; nor did his charity consist merely in giving his money in alms, nor in founding hospitals, but in the devotion of his whole heart towards relieving the sorrows as well as the necessities of the poor, and in exhorting and converting to repentance those who had been led into evil courses: neither did this good saint think it necessary to lead a life of celibacy; he was married to a prudent and virtuous wife, who was sometimes uneasy lest her husband's excessive bounty to the poor should bring her children to beggary; but it was far otherwise: Omobuono increased daily in riches and prosperity, so that the people of the city believed that his stores were miraculously multiplied. It is related of him, that being on a journey with his family, and meeting some poor pilgrims who were ready to faint by the wayside with hunger and thirst, he gave them freely all the bread and wine he had provided for his own necessities, and going afterwards to fill his empty wine-flasks from a running stream, the water when poured out proved to be most excellent wine, and his wallet was found full of wheaten bread, supplied by the angels in lieu of that which he had given away.

As the life of Omobuono had been in all respects most blessed, so was his death; for one morning, being at his early devotions in the church of St. Egidio, and kneeling before a crucifix, just as the choir were singing the '*Gloria in excelsis*,' he stretched out his arms in the form of a cross, and in this attitude expired. He was canonised by Pope Innocent III. on the earnest petition of his fellow-citizens.

Figures of this amiable citizen-saint occur in the pictures of Giulio

Campi, Malosso, Andrea Mainardi, Borroni, and other painters of Cremona. He is generally habited in a loose tunic trimmed with fur, and cap also trimmed with fur, and is in the act of distributing food and alms to the poor; sometimes wine-flasks stand near him, in allusion to the famous miracle in his legend. In a fine enthroned Madonna by Bartolomeo Montagna, Omobuono stands in an attitude of compassionate thoughtfulness, with a poor beggar at his feet.[1] In the church of St. Egidio-ed-Omobuono at Cremona, I found a series of pictures from his life. 1. He fills his empty flasks at the stream, and finds them full of wine. 2. The bread which he distributes to the poor is miraculously multiplied in his hands. 3. He clothes the ragged and naked poor. 4. He expires before the crucifix, sustained by angels. In the cupola of the same church he is seen carried into Paradise by a troop of rejoicing spirits. These were painted by Borroni in 1684.

---

I have met with very few among the French and Spanish martyrs who have attained to any general importance as subjects of Art. The most interesting of the Spanish saints are those of the monastic orders, and they will be found in their proper place among the monastic legends. St. Vincent, whose fame has become universal, is the most distinguished of the Spanish early martyrs.[2] There are some others almost peculiar to Spanish Art, who, from the beauty of the representations by Murillo and Zurbaran, are interesting to a lover and hunter of pictures; but as very few, even of the best, of these are known through engravings, and as my own acquaintance with Spanish Art is limited, I shall confine myself to those most popular.

[1] Berlin Gal. See also 'Legends of the Madonna,' p. 99.     [2] v. p. 549.

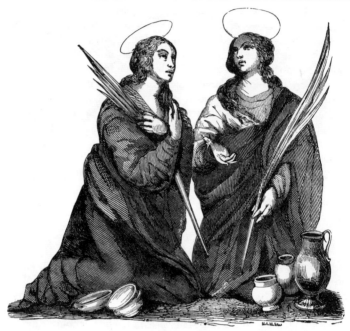

163          St. Justa and St. Rufina  (Murillo)

## St. Justa and St. Rufina, Patronesses of Seville.

### (July 19, A.D. 304.)

These were two Christian sisters dwelling in that city.  They were
the daughters of a potter, and made a living by selling earthenware;
and contenting themselves with the bare necessaries of life, they gave
all the rest to the poor.  Certain women who lived near them, and
who were worshippers of the goddess Venus, came to their shop to
buy vessels for their idolatrous sacrifice.  The two sisters answered
that they had no vessels for such a purpose; that their ware should
be used for the service of God, and not in the worship of stocks and

stones. Upon this the pagan women broke all the earthenware in their shop. Justa and Rufina retaliated by falling upon the image of Venus, which they broke to pieces and flung into the kennel. The populace immediately collected before their door, seized them, and carried them before the prefect. On being accused of sacrilege, they boldly avowed themselves to be Christians; and being condemned to the torture, Justa expired on the rack, and Rufina was strangled. This came to pass in the year 304.

The two sisters are represented as Spanish girls, bearing the palm as martyrs, and holding in their hands earthenware pots. Pictures of them are entirely confined to the Seville school. They are generally represented with the Giralda (which is supposed to be under their especial care and patronage) between them. According to Mr Ford,[1] their great miracle was the preservation of this beautiful and far-famed tower in a thunder-storm, in 1504. When Espartero bombarded Seville in 1843, the people still believed that the Giralda was encompassed by invisible angels led by Rufina and Justa, who turned aside every bomb.

Murillo has frequently painted them. The Duke of Sutherland has two beautiful half-length figures of these two saints, holding each their palms and *alcarrazas* (earthenware pots). In the Spanish gallery of the Louvre, there are several representations of them by Zurbaran and others. Zurbaran represents them richly dressed; but Murillo has generally painted them as *muchachas*, Spanish girls of the lower class.

There was a magnificent sketch by Murillo in the Aguado Gallery, representing the Virgin in glory; and, kneeling in adoration before her, St. Rufina and St. Justa with their *alcarrazas* at their feet, accompanied by St. Francis and St. John the Baptist: painted, I presume, for the Capuchins of Seville (163).

St. Eulalia of Merida (Dec. 10) was a Spanish martyr, whose story is related in one of the hymns of Prudentius. He tells us that at the time the terrible edict of Diocletian was published, Eulalia, who was only twelve years old, escaped from her mother's house, and confronted the tyrant prefect, who was sitting in judgment on the

[1] *v.* 'Handbook of Spain,' p. 249.

Christians, and reproached him with his cruelty and impiety. The governor, astonished at her audacity, commanded her to be seized, and placed on one side of her the instruments of torture prepared for the disobedient, and on the other the salt and frankincense which they were about to offer to their idol. Eulalia immediately flung down the idol, and trampled the offering under her feet, and spit in the face of the judge,— an action which, as Butler observes, ' could only be excused by her extreme youth.' She was immediately put to death in the midst of tortures; and at the moment she expired a white dove issued from her mouth (the usual allegory of the soul or spirit), and winged its way towards heaven.

She is renowned in Spain, and I believe only to be met with in the Spanish churches and works of Art. Mr Ford, in his ' Handbook,' warns ' ignorant infidels ' against confounding this St. Eulalia with another St. Eulalia of Barcelona, whose story is so similar that the difficulty would consist, it should seem, in proving any distinction between them. It is true there are two different bodies, one lying at Merida and the other at Barcelona; but this might have been arranged by a miracle. One of these two saints must have been early and widely celebrated, for we find a St. Eulalia in the grand procession of Virgin Martyrs at Ravenna.[1]

St. LEOCADIA (April 26), the renowned patroness of TOLEDO, was a native of that city, and in the persecution of Diocletian she was seized by the cruel governor and thrown into a deep dark dungeon. After being kept there for some time in daily expectation of death, she heard in her prison of the martyrdom of her friend St. Eulalia, and earnestly prayed to be united with her by a glorious death. Her prayer was granted ; for she expired in prison, and her relics have ever since been preserved in that city, where three of the grandest churches in Spain, dedicated to her honour, show the reverence in which she was held. But, according to another legend, she was cast down from the rocks by an order of Dacian. A chapel was built on the spot where she fell, and there, as it is related, angels appeared and removed the stone from her sepulchre, when she arose clad in a mantilla, and revealed to St. Ildefonso, who had written a treatise

[1] v. p. 525.

in honour of the Virgin, the approbation with which his work was regarded in heaven. Before she had time to disappear, St. Ildefonso cut off a part of her veil, which was preserved amongst the treasures of the Church.

St. Leocadia is represented only in Spanish works of Art. At Toledo, in the magnificent church dedicated to her, there is a series of pictures from her life by F. Ricci; and in the hospital of Santa Cruz, is a picture which represents her rising from the tomb to speak to St. Ildefonso. There is a statue of this saint over the gate of Toledo (Puerta del Cambron), executed by Berruguete, which Mr Ford describes as ' Florentine in style, tender and beautiful in form, and sweet, gentle, and serious in expression.'

### St. Crispin and St. Crispianus.

*Ital.* San Crispino e San Crispiano. *Fr.* SS. Crespin et Crespinien.
Patron saints of Soissons.
(October 25, A.D 287, according to Baillet; and according to the Roman legend, A.D. 300.)

THE two holy brothers, Crispin and Crispianus, departed from Rome with St. Denis to preach the Gospel in France; and, not willing to be a burthen upon others, they, after the example of St Paul, laboured with their hands, being by trade shoemakers, ' which is a very honest and peaceable calling.' And these good saints made shoes for the poor without fee or reward (for which the angels supplied them with leather), until, denounced as Christians, they suffered martyrdom at Soissons, being, after many tortures, beheaded by the sword.

The devotional figures, which are common in old French prints, represent these saints standing together, holding the palm in one hand, and in the other the awl or the shoemaker's knife. They are very often met with in the old stained glass, working at their trade, or making shoes for the poor,—the usual subjects in the shoe-makers' guilds all over France and Germany. Italian pictures of these saints are rare. There is, however, one by Guido, which represents the throned Madonna and St. Crispin presenting to her

his brother St. Crispianus, while angels from above scatter flowers on the group.[1]    Looking over the old French prints of St. Crespin and St. Crespinien, which are in general either grotesque or commonplace, I met with one not easily to be forgotten; it represents these two famous saints proceeding on their mission to preach the Gospel in France : they are careering over the sea in a bark drawn by sea-horses and attended by tritons, and are attired in the full court-dress of the time of Louis XV., with laced coats, cocked hats, and rapiers.

These French saints were very popular in England as protectors of the guild of shoemakers ; and are retained, not without reason, in our reformed calendar, the day on which they are celebrated being famous in English history and English poetry.    The readers of Shakespeare will remember it as the anniversary of the battle of Agincourt :—

> And Crispin Crispian shall ne'er go by,
> From this day to the ending of the world,
> But we in it shall be remembered.

It appears to have been celebrated as a holyday all over England ; to which Westmoreland alludes :—

> Oh that we now had here
> But one ten thousand of those men in England
> Who do no work to-day !

---

1 Dresden Gal.

104          Cherubim (Perugino)

*Coins of Italian cities bearing effigies of Saints*

# The Early Bishops.

THE early Bishops of the Church—those who lived in the first five or six centuries, and did not belong to any of the regular monastic orders—form, in their relation to Art, a very interesting and picturesque group of saints. Their importance, general or local, in the propagation of Christianity, renders them indispensable in ecclesiastical decoration; and whether they stand alone, or in a *sacra conversazione*, as the pastors and founders of their respective churches, blessing from their tabernacle above the porch, or shining from the storied window, or presenting the votary at the altar, or interceding for their flock at the feet of the Virgin and Child, their mild majestic air, venerable beards, and splendid sacerdotal robes, render them extremely effective and ornamental as subjects of Art: to the educated eye and reflecting mind, they have, however, a far deeper value and interest.

In general, we find that the first Christian missionary who preached the Gospel in any city or locality, and gathered a Christian community around him, was regarded as the founder and first bishop of that Church; subsequently, he came to be venerated by the inhabitants as their celestial protector and intercessor, as continuing in heaven that care and superintendence he had exercised on earth. Though removed from his place among them, he was still their bishop, they were still his flock: his effigy stood conspicuously in their churches, and still extended the hand in benediction over them.

In the days of the free republics of Italy, their coinage bore, instead of the head of a potentate or tyrant, that of their tutelary saint; in most cases, the bishop who had been the first to bring to them the glad tidings of salvation, or who had shed his blood, either in testimony to his faith or in defence of his flock. Thus, on the coins of Arezzo, we find the effigy of St. Donatus; on those of Bologna, St. Petronius; on those of Ferrara, St. Maurelius; on those of Naples,

St. Januarius.   In the fourteenth century, all the coinage of Italy
was solemnly placed under the protection of the guardian saints.   On
the coins of Milan we have on one side St. Ambrose, on the reverse
St. Gervasius and St. Protasius: on those of Florence, St. John the
Baptist, and St. Cosmo and St. Damian.   Perhaps it was some
association with the sanctity of the image impressed on it which
made the counterfeiting of money a sort of sacrilege, and induced
Dante to place a coiner in one of the lowest circles of hell.[1]

The representations of these primitive bishops have an especial
interest and propriety, I might almost say a sanctity, when contem-
plated within the walls of the church consecrated to their honour in
a spirit of grateful veneration.   We may conceive this sort of interest
by imagining how we should feel, if, within the walls of Westminster
Abbey, we were shown the figure, however idealised, of him who first
brought the tidings of the Gospel to this island.   Is there any one
who could turn away from it with indifference or inattention?—who
would not feel it to be more in harmony with the place than General
Monk or Sir Cloudesley Shovel?

It is not, however, the less true that with some of these mediæval
bishops the impression of the sacred and the venerable is somewhat
spoiled by the legendary attributes which accompany them.   It is
not pleasant to see a bishop walking without his head, like St. Denis,
or flourishing a scourge, like St. Ambrose ; but even such representa-
tions, however grotesque they may appear, strike us in quite another
point of view when we consider the meaning of these attributes and
their relation to history, to the character of the individual, and the
manners and morals of the age in which he lived.

In former times the Christianity of the city or district was, like
a patent of nobility, the more honourable for its antiquity.   A
community traced back its Christianity as a noble traced back
his genealogy, as far as it was possible.   The object was to prove
that one of the apostles, or at least some immediate delegate or
disciple of Peter or Paul, had been the first to gather them within
the pale of salvation.   Each, too, jealous for the dignity of the
local patron, multiplied and boasted of his miracles ; and if St.
Petronius performed a wonder at Bologna, it was immediately

[1] Inferno, c. xxx.

emulated by St. Gaudenzio at Rimini, or St. Maurelius at Ferrara. Hence the uncertainty which has been studiously thrown round the origin of the early churches; and hence the amount of legendary inventions with which the people surrounded the memory of their founders, till the simplicity and credibility of the old tradition were wholly lost. Hence, too, the perpetual repetition of the same extravagant stories, only varying the names of the actors; so that, when these venerable personages appear in Art, it becomes, from the moment they are removed from the locality for which they were painted, very difficult—often impossible—to discriminate them aright, they are so much alike in appearance and habiliments, and the same stories and attributes are so constantly repeated.

A bishop is immediately recognised by his dress; and here the grand distinction is between the Greek and the Latin bishops. The primitive Greek bishops wear the *alba* or surplice, always white, and over that the white *planeta* or *chasuble* embroidered with purple crosses. Their crosier, where they have one, is a staff surmounted by a cross, and they wear no mitre. The later artists frequently commit the error of giving to the Greek bishops the Latin mitre, and to the Latin bishops the Greek crosier. The etching of the Greek Fathers will give a correct idea of the Greek episcopal costume. St. Chrysostom, in the centre, wears the dalmatica only; the others wear the planeta, which was a mantle made of a wide circular piece of cloth with an aperture in the middle for the head to pass through, and no sleeves, so that, when the arms were raised, it was necessarily gathered up in graceful folds on each side.

In Western Art the vestments given to the bishops, merely as distinctive of the episcopal rank, were not those proper to the age in which they lived, but those of the time in which the picture was painted. The difference, however, was only in the cut of the garb, the garb itself was the same. They wear, first, the white tunic (alba) fastened round the waist with a girdle, and which has a wide lace border falling to the feet, and seen beneath the upper vestments. Over this is thrown, in the manner of a scarf, the *stole*, a long narrow piece of cloth richly embroidered with crosses; the two ends, fringed, are crossed upon the breast and hang down on each side, and often appear

below the *chasuble* (or *planeta*), which is the proper eucharistic robe. The planeta was at first, as I have described it above, only a circular piece of cloth with an aperture in the middle, but for the sake of convenience it was cut shorter and shorter on each side, till it hung only before and behind, the back part being embroidered with a large cross. The pallium, the insignia of dignity worn over the planeta only by archbishops and patriarchs, resembles the stole : it is a white woollen band about three fingers in breadth passed round the shoulders, and from which depend three short bands embroidered with crosses ; two hang behind, and one towards the right shoulder hangs in front. Over the whole is thrown the cope or *pluviale* (literally, rain-cloak), because first adopted merely as a covering from the weather, in the processions from one church to another. Subsequently it became a part of the episcopal costume, falling over the whole person, generally of purple or scarlet, most richly embroidered, open in the front, and fastened across the breast with a jewelled clasp. The gloves, with the ruby on the back of the hand, figuring the wounds of Christ, and the official ring on the forefinger of the right hand, are sometimes, but not always, introduced ; the mitre almost always ; the *infulæ*, two bands or lappets, depending from the mitre behind, distinguish the bishop from the abbot. The staff, in the form of a shepherd's crook (*baculus pastoralis*), completes the episcopal habit and attributes. What is properly the *crosier*, the staff surmounted by a cross, is borne by archbishops.

At the head of the early bishops we place the Hierarchs of Rome, first styled POPES about the year 500. Few are of general interest in their pontifical character, considered, I mean, as subjects of Art. St. Gregory, for instance, does not figure as pope but as a doctor of the Church ; nor St. Clement as pope, but as martyr : of both I have already spoken at length. St. Sixtus figures in the pictures of St. Laurence ; and St. Urban in those of St. Cecilia. St. Cornelius, pope in 250,[1] and St. Cyprian, bishop of Carthage, are generally found in the same picture, because they were friends, contemporaries, and, as martyrs, commemorated on the same day.

---

[1] A saint, wearing the triple tiara and holding a horn (*cornu*), is St. Cornelius, but he is very rarely met with. St. Cornelius as *pope*, holding a horn in his hand. H. v. der Goes. As patron, with four female votaries. Altar small : Academy, Vienna.

St. Leo, surnamed the Great, when Rome was threatened by Attila, preserved it by his bold and eloquent intercession. ' The apparition,' says Gibbon, ' of the two apostles, St. Peter and St. Paul, who menaced the barbarian with instant death if he rejected the prayer of their successor, is one of the noblest legends of ecclesiastical tradition. The safety of Rome might deserve the interposition of celestial beings; and some indulgence is due to a fable which has been represented by the pencil of a Raphael and the chisel of Algardi.'

Raphael's fresco, styled ' the Attila,' is in the Vatican : it is rather historically than religiously treated; it is, in fact, an historical picture. The marble altar-piece of Algardi is placed in St. Peter's, over the chapel of St. Leo. The King of the Huns, terrified by the apparition of the two apostles in the air, turns his back and flies. We have here a picture in marble, with all the faults of taste and style which prevailed at that time, but the workmanship is excellent; it is, perhaps, the largest bas-relief in existence, excepting the rock sculpture of the Indians and Egyptians—at least fifteen feet in height.

There is an effigy in mosaic and a grand fresco representing St. Mark (the only pope who bore this name, and who lived in 340), in the church of San Marco at Rome.

The popes, as bishops of Rome, are distinguished by the triple tiara, and the crosier surmounted by a double cross. The tiara, I believe, was first adopted by Boniface VIII., and supposed to signify the triple crown of our Saviour,—the crown of glory, the crown of mercy, and the crown of martyrdom; but others have interpreted it to signify the triple dominion asserted by the Roman pontiff, as God's vicegerent over heaven, earth, and hell.

Cardinal priests did not exist before the eighth century, and among the early prelates only St. Jerome wears, by usage and courtesy, the cardinal attributes. The earliest cardinal saint, properly so styled, was St. Bonaventura the Franciscan, whose curious legend will be found among those of the Monastic Orders.

Next after the popes and cardinals follow the Greek bishops; at the head of these we place the Greek doctors, and immediately after them the universal bishop patron St. Nicholas, who, in Western Art,

is always attired in the vestments proper to the Latin Church. Next to him the Greek bishops most universally honoured in their effigies are St. Ignatius, St. Blaise, and St. Erasmus.

At the head of the Latin bishops we place St. Ambrose and St. Augustine, who generally appear in their higher character of Fathers of the Church.

The other Latin bishops who figure in Art fall naturally into two groups,—those who were martyrs, and who take the first rank by virtue of their palm; and those who were confessors.

The obscure pastors of the early Italian churches are in a manner consecrated anew by the exceeding beauty and value of those works of Art in which they figure. I shall, therefore, particularise a few of the most interesting among them.

I begin my chapter of Bishops with the story of St. Sylvester, patriarch of Rome, giving him the precedence as such; the title of POPE was not in use for two centuries at least after his time.

## St. Sylvester, Pope.

*Ital*. San Silvestro. *Fr*. Saint Silvestre. (December 31, A.D. 335.)

' Sylvester was born at Rome of virtuous parents; and at the time when Constantine was still in the darkness of idolatry, and persecuted the Christians, Sylvester, who had been elected Bishop of Rome, fled from the persecution, and dwelt for some time in a cavern, near the summit of Monte Calvo. While he lay there concealed, the emperor was attacked by a horrible leprosy: and having called to him the priests of his false gods, they advised that he should bathe himself in a bath of children's blood, and three thousand children were collected for this purpose. And as he proceeded in his chariot to the place where the bath was to be prepared, the mothers of these children threw themselves in his way with dishevelled hair, weeping, and crying aloud for mercy. Then Constantine was moved to tears, and he ordered his

chariot to stop, and he said to his nobles and to his attendants who were around him, " Far better is it that I should die than cause the death of these innocents ! " And then he commanded that the children should be restored to their mothers with great gifts, in recompense of what they had suffered ; so they went away full of joy and gratitude, and the emperor returned to his palace.

' On that same night, as he lay asleep, St. Peter and St. Paul appeared at his bedside; and they stretched their hands over him and said, " Because thou hast feared to spill the innocent blood, Jesus Christ has sent us to bring thee good counsel. Send to Sylvester, who lies hidden among the mountains, and he shall show thee the pool, in which, having washed three times, thou shalt be clean of thy leprosy ; and henceforth thou shalt adore the God of the Christians, and thou shalt cease to persecute and to oppress them." Then Constantine, awaking from this vision, sent his soldiers in search of Sylvester. And when they took him, he supposed that it was to lead him to death ; nevertheless he went cheerfully; and when he appeared before the emperor, Constantine arose and saluted him, and said, " I would know of thee who are those two gods who appeared to me in the visions of the night? " And Sylvester replied, " They were not gods, but the apostles of the Lord Jesus Christ." Then Constantine desired that he would show him the effigies of these two apostles ; and Sylvester sent for two pictures of St. Peter and St. Paul, which were in the possession of certain pious Christians. Constantine, having beheld them, saw that they were the same who had appeared to him in his dream. Then Sylvester baptized him, and he came out of the font cured of his malady.[1] And, the first day after his baptism, he ordered that Jesus Christ should be adored throughout Rome as the only true God ; on the second day, that those who blasphemed against Him should be put to death ; on the third day, that whoever should insult a Christian should have the half of his goods confiscated ; on the fourth day he

[1] Constantine was not baptized till a few days before his death, and then by Eusebius. I hope it is not necessary to remind the reader of the wide difference between the Constantine of history and the St. Constantine of the legends. The donation of Constantine to the Bishops of Rome was for ages considered a genuine grant, but is now universally regarded as spurious.

decreed that thenceforth the Bishop of Rome should be the chief over all the bishops of Christendom—as the Emperor of Rome was the first among the sovereigns of the earth ; on the fifth day he granted the privilege of sanctuary to all the Christian churches ; on the sixth day he decreed that no one should build a church without the authority of the bishop; on the seventh day, that the tithes of all the Roman domains should be granted to the Church.  On the eighth day, after confessing his sins and receiving forgiveness, he took a spade and dug with his own hands the foundation of a new basilica; and he carried upon his shoulders twelve hods full of the earth that he had dug out.  Then he laid the first stone of the great basilica of St. John the Baptist, since called the Lateran.

'Now when the Empress Helena, the mother of Constantine, heard these things, she reproached him, and told him it would have been better for him to have followed the God of the Jews than the God of the Christians (for Helena at this time inclined to Judaism). And Constantine wrote to her that she should bring with her the wisest of the Jewish Rabbis, and that they should hold an argument with Sylvester.  So she repaired to Rome, bringing with her one hundred and forty of the doctors most learned in the law ; and the emperor appointed a day on which to listen to them.  He named as arbitrators two famous Greek philosophers, Crato and Zeno ; and it was wisely decreed beforehand, that only one should speak at a time, and all the others should keep silence till he had finished.  And Sylvester, being inspired by the Holy Ghost, clearly convicted these men out of the Scriptures, and put them to silence.  Then the most learned among the doctors, who was also a magician, defied Sylvester to a trial of the power of his God, and said to him with scorn, " Dost thou know the name of the Omnipotent, that name which no creature can hear and live ?  I know it; let them bring me a wild bull, the fiercest that can be found, and when I have uttered that name in his ear he will fall dead."  Then they brought in a fierce bull, which it required a hundred men to restrain.  And when Zambri the magician had whispered that terrible name in his ear, he rolled his eyes and fell dead to the ground.  Then the Jews cried out aloud, and threw themselves with fury upon Sylvester ; the two philosophers were struck dumb, and even Constantine was staggered.  But Sylvester

said calmly, " The name which he has pronounced cannot be that of God, but of Satan ; for Christ, who is our Redeemer, does not strike dead the living, but restores life to the dead; the power to kill belongs equally to men and to wild beasts : lions, tigers, serpents, can destroy life. Let Zambri restore with a word the creature he has slain ; as it is written, ' I will kill, I will make alive.' " Therefore the judges desired Zambri to restore the bull to life, but he could not do it. Then Sylvester made the sign of the cross, and commanded the bull to rise and go in peace. And the bull rose up, as tame and as gentle as if he had been in the yoke from the hour of his birth. Then the Jews and the doctors, and all others present, being confounded by this miracle, believed and were baptized.'

The story which follows is rather a parable than a legend :—
' Some time after the baptism of the emperor, the priests of the idols came to him and said, " Most Sacred Emperor, since you have embraced the faith of Christ, the great dragon which dwelleth in the moat hath destroyed every day more than three hundred men by his envenomed breath." The emperor consulted Sylvester, who replied, " Have faith only, and I will subdue this beast." Having said this, he went down into the moat, to which there was a descent of 142 steps, and having exorcised the dragon in the name of Him who was born of a virgin, crucified, buried, and raised from the dead, he closed and bound up the mouth of the dragon with a thread, twisting it round three times, and sealing it with the sign of the cross ; and thus he delivered the people from a double death,—the death of idolatry and the death of sin. (Here the obvious allegory requires no explanation ; it is merely another form of the ancient myth of the dragon overcome and cast out.)
' Also it is related of Sylvester, that he gave a refuge in his house to a Christian whose name was Timotheus, and who afterwards suffered martyrdom for having preached the faith of Christ. The governor, Tarquinian, being persuaded that Timotheus had left great riches, called upon Sylvester to deliver them up, threatening him with death and divers tortures. And Sylvester said, " Thou fool! this night shall thy soul be required of thee, and shall be delivered up to torments." And so it came to pass ; for when Tarquinian was

at dinner, a fish-bone stuck in his throat, choked him, and he gave up the ghost.

'After this, Sylvester was present at the great council which was held at Nicea, a city of Bithynia, in which Arius was condemned, and many ordinances did Sylvester make for the good of the Church. When he had governed for twenty-three years and ten months, he died, and was buried in the cemetery of Priscilla at Rome.'

The single figures of Sylvester represent him in the pontifical robes, and wearing, sometimes, a plain mitre; sometimes the triple tiara, with the book and the crosier as bishop. I have seen a small full-length figure, in which he carries in his hand, merely as his attribute, a small dragon, and around its mouth are the three twisted threads.[1] He has a bull crouching at his feet, which is his proper attribute, and generally accompanies his Gothic effigies, whether in sculpture or stained glass, in such examples, it is necessary to observe that his episcopal attire alone distinguishes him from St. Luke, who also has the ox. Sometimes he holds in his hands the portraits of St. Peter and St. Paul, or points to them. There is a full-length figure of a pope holding the pictures, *en buste*, of the two apostles, called the portrait of Urban V.; but if it be really a portrait, and represent this pope (which I doubt much), it is in the character of St. Sylvester.[2]

165         St. Constantine.

Constantine is represented in the dress of a Roman emperor, or a Roman warrior; in one hand the *labarum*, or standard of the cross,

---

[1] The picture is at present in the collection of Mr Bromley of Wootten.    [2] Bologna Gal.

which is sometimes a banner, and sometimes a lance surmounted by the monogram of Christ, as in this figure, from the antique statue in the portico of the Lateran.

As the legend of Sylvester and Constantine, half romantic, half allegorical, is one of the most curious and important in very early Art, I shall give one or two examples which may render others intelligible and interesting.

1. In the Bardi chapel in the Santa Croce at Florence, Giottino painted, in three compartments, the dispute with the Jews; the legend of the resuscitation of the bull; and the dragon bound and silenced for ever by the power of the cross. These frescoes, which cover the right hand wall, though much ruined, are still quite intelligible; and the compositions, for spirit and dramatic power, surprising, considering the period at which they were painted.

2. The whole story of Constantine and Sylvester, in a series of very antique frescoes, as old perhaps as the eleventh century, at the upper end of the chapel of San Silvestro in the church of the ' Quattro Incoronati.' 1. Constantine, in his chariot, is encountered by the bereaved and weeping mothers, to whom he restores their children. 2. He sees in a vision St. Peter and St. Paul. 3. He sends messengers to summon Sylvester. 4. The messengers arrive at Sylvester's cell on the Monte Calvo; he looks out of the grated window. 5. He shows to the emperor the effigies of St. Peter and St. Paul. 6. The baptism of Constantine. 7. He is crowned by St. Sylvester. The three compartments which follow are in a most ruined state, but we can just discern the miracle of the wild bull. The whole series is engraved in D'Agincourt's work.

3. The legend of St. Sylvester in three compartments, in a beautiful predella by Angelico da Fiesole.[1]

4. The story of St. Sylvester and Timotheus is most elaborately painted in thirty-one different subjects on one of the windows of the Cathedral of Chartres.

5. Constantine and Pope Sylvester are seated on a throne together. The bishops and the Empress Helena seated in a circle; several

---

[1] Doria Gal., Rome.

executioners are burning the heretical books, and the Holy Ghost descends in a glory from above. I believe this ancient picture represents the first council of Nice.[1]

6. Constantine bestows, by a deed of gift, the city and territory of Rome on Pope Sylvester and his successors. (A.D. 325.) One of the grand frescoes in the Vatican. The scene represents the interior of the old church of St. Peter; to the left St. Sylvester, in the pontifical habit and seated on a throne, receives from the kneeling emperor the gift of the city of Rome, which is here represented by a symbolical figure in gold; the head of Sylvester is the portrait of Clement VII., the reigning pontiff. Among the numerous personages who surround the pope and the emperor as attendants are several distinguished characters of that time; for instance, Count Castiglione, the friend of Raphael, and Giulio Romano, to whom the design as well as the execution of the fresco is ascribed by Passavant.[2]

In the same hall are eight grand ideal figures of the most celebrated of the early popes, attended by allegorical figures representing the virtues for which each pontiff was remarkable, or expressive of some leading point in his life and character.

1. St. Peter, in the pontifical habit, attended by the Church and Eternity. 2. Clement I. (the martyr), attended by Moderation and Gentleness. The beautiful figure of Gentleness, with the lamb at her feet, has been engraved by Strange, and might be mistaken for a St. Agnes. 3. Alexander I. (or Sylvester), attended by Faith and Religion. 4. Urban I., the friend of St. Cecilia, attended by Justice and Charity. 5. Damasus I. (A.D. 366–384) attended by Foresight and Peace. 6. Leo I. (A.D. 440–462) attended by Purity and Truth. 7. Felix III. attended by Strength. 8. Gregory VII. (the famous Hildebrand, A.D. 1073–1085), attended by a single female figure holding a thunderbolt in one hand, in the other the Gospel; according to Passavant, signifying Spiritual Might.

Much might be said of this series of Popes and their attendant virtues; and, indeed, the whole of this Hall of Constantine suggests a thousand thoughts, which I must leave the reader *to think out for*

---

[1] Ciampini, vol. ii. p. 183.          [2] ' Rafael,' vol. ii. p. 373.

himself. I will only repeat, that the papal saints, with the exception of St. Sylvester and St. Gregory, are not of *general* interest in the history of Art.

## St. Ignatius Theophorus, Bishop and Martyr.

*Ital.* Sant' Ignazio. *Fr.* Saint Ignace. *Ger.* Der Heilige Ignaz. (Feb. 1, A.D. 107.)

' Ignatius and Polycarp were disciples together of St. John the Evangelist, and linked together in friendship, as they were associated in good works. It is a tradition that St. Ignatius had seen the face of the Lord; that he was the same whom, as a child, the Saviour had taken in his arms, and set in the midst of the disciples, saying, " Of such are the kingdom of heaven." It is also related of him that he grew up in such innocence of heart and purity of life, that to him it was granted to hear the angels sing; hence, when he afterwards became Bishop of Antioch, he introduced into the service of his church the practice of singing the praises of God in responses, as he had heard the choirs of angels answering each other.

' And it happened in those days that the Emperor Trajan went to fight against the Scythians and Dacians, and obtained a great victory over them. And he commanded that thanksgivings and sacrifice to the false gods should be offered up in all the provinces of his vast empire. Only the Christians refused to obey.

' When Trajan came to Antioch he ordered Ignatius to be brought before him, and reproached him for seducing the people from the worship of their gods, promising him infinite rewards if he would sacrifice in the temple; but Ignatius replied, " O Cæsar, wert thou to offer me all the treasures of thy empire, yet would I not cease to adore the only true and living God!" And Trajan said, " What! talkest thou of a living God? Thy God is dead upon the cross. Our gods reign upon Olympus." And Ignatius said, " Your gods were vicious mortals, and have died as such: your Jove is buried in Candia; your Esculapius was shot with an arrow; your Venus lies in the island of Paphos; and your Hercules burned himself in a great fire because he could not endure pain. These be your gods, O

Emperor!"[1]　When Trajan heard this, he caused his mouth to be stopped, and commanded him to be led forth to a dungeon; and at first he resolved to put him at once to death, but afterwards he reserved him for the amphitheatre.

'When Ignatius heard his sentence, he rejoiced greatly; he assisted his guards in fastening the chains on his limbs, and set forth on his journey; and being come to Smyrna, he met Polycarp and other of his friends, to whom he recommended the care of his Church. And all wept, and Polycarp said, "Would to God that I too might be found worthy to suffer for this cause!" To which Ignatius replied, "Doubt not, brother, that thy time will come; but for the present the Church has need of thee." So they embraced, weeping, and his friends kissed his hands, his garments, his chains, and bid him farewell, rejoicing in his courage and fervour. Then Ignatius and his guards embarked in a vessel and sailed for Rome; and being come there, the prefect on a certain feast-day ordered him to be brought forth and placed in the midst of the amphitheatre. And Ignatius, standing in the midst, lifted up his voice and cried, "Men and Romans, know ye that it is not for any crime that I am placed here, but for the glory of that God whom I worship. I am as the wheat of his field, and must be ground by the teeth of the lions that I may become bread worthy of being served up to him." Such were the words of this holy and courageous man as they have been truly recorded; and no sooner were they uttered than two furious lions were let loose upon him, and they tore him to pieces and devoured him, so that nothing was left of him but a few bones.' (But according to another version of the story he fell down dead before the lions reached him, and his body remained untouched.)

A few days after his death his remains were collected by his disciples and carried to Antioch; and, according to tradition, some relics were brought to Rome, about the year 540, and deposited in the ancient church of San Clemente.

The story and the fate of Ignatius are so well attested, and so sublimely affecting, that it has always been to me a cause of surprise as well as regret to find so few representations of him. I do not remember

---

[1] This reply of Ignatius does not seem consistent with the notions of the early Christians respecting the false gods. I give it, however, from the '*Perfetto Legendario*.'

166     The Martyrdom of St. Ignatius  (From a Greek MS. of the 9th century)

any figure of him in a devotional picture ; but he ought to be repre-
sented in the dress of a Greek bishop, with a lion or two lions at
his side.

His martyrdom is a more frequent subject.  The woodcut is from a
curious miniature in the Greek Menology, executed for the Emperor
Basil in the 9th century.  The original is on a gold ground, the
colours still most vivid.  At Seville there is a picture of St. Ignatius
exposed in the amphitheatre, by P. Roelas ; and I have seen one at
Vienna by Creutzfelder.  None of these are worthy of the subject ;
but in truth it is one which we could more easily endure to see ill
than well expressed.  The horror with which we regard it is increased
by the recollection that St. Ignatius only represents one of many
hundreds who perished in the same manner for the atrocious
pleasure of a sanguinary populace.

On the side walls of the church of San Clemente are some large
and very bad frescoes, or rather distemper paintings, representing
scenes from the life of St. Ignatius.  They appear to be of the time

of Clement XI., that is, about 1700. I am informed that the modern frescoes in the church of St. Ignatius at Mayence are extremely fine; but cannot speak of them from my own knowledge.

There are several dramas on the story of St. Ignatius. A tragedy entitled ' The Martyrdom of St. Ignatius,' written in 1740, was acted at Hull in 1781, and the part of Ignatius performed by Stephen Kemble: I do not know with what success, but it was pronounced more pious than poetical.

St. Polycarp, bishop of Smyrna, was condemned many years afterwards to the same cruel death; but the games being over, he was burned alive, in the reign of Marcus Aurelius. Of this celebrated martyr and father of the Church I have never seen any effigy. Some of the scenes of his life—for instance, the parting with Ignatius, or his condemnation by the people—would furnish fine picturesque subjects, and the authenticity of his story renders the neglect of it the more extraordinary.

## St. Blaise, Bishop of Sebaste.

*Ital.* San Biagio. *Fr.* Saint Blaise. *Ger.* Der Heilige Blasius.
Patron saint of woolcombers, of all who suffer from diseases of the throat, and of wild animals.
Patron of Ragusa. (Feb. 3, A.D. 289.)

The legend of St. Blaise, a popular saint in England and France, is of Greek origin. He was bishop over the Christian Church at Sebaste in Cappadocia, and governed his flock for many years with great vigilance, till the persecution under Diocletian obliged him to fly, and he took refuge in a mountain cave at some distance from the city. This mountain was the haunt of wild beasts, bears, lions, and tigers; but these animals were so completely subdued by the gentleness and piety of the good old man, that, far from doing him any harm, they came every morning to ask his blessing; if they found him kneeling at his devotions, they waited duteously till he had finished, and having received the accustomed benediction they retired. Now in the city of Sebaste, and in the whole province, so many Christians were put to death, that there began to be a scarcity of wild beasts for the amphitheatres; and

Agricolaus, the governor, sent his hunters into the mountain to collect as many lions, tigers, and bears as possible; and it happened that these hunters, arriving one day before the mouth of the cave in which St. Blaise had taken refuge, found him seated in front of it, and surrounded by a variety of animals of different species;—the lion and the lamb, the hind and the leopard, seemed to have put off their nature, and were standing amicably together, as though there had been everlasting peace between them; and some he blessed with holy words, knowing that God careth for all things that he has made; and to others that were sick or wounded he ministered gently, and others he reprehended because of their rapacity and gluttony. And when the hunters beheld this, they were like men in a dream, they stood astonished, thinking they had found some enchanter; and they seized him and carried him before the governor, and, as they went, the good bishop returned thanks to God, and rejoiced greatly, that, at length, he had been found worthy to die for the cause of Christ. On the journey, they met a poor woman whose only child had swallowed a fish-bone, which had stuck in his throat, and he was on the point of being choked; and seeing the bishop, the mother fell at his feet, saying, ' O servant of Christ, have mercy upon me!' and he, being moved with compassion, laid his hand upon the throat of the child and prayed, and the child was healed, and he restored him to his mother: and going a little farther, they found another poor woman whose only worldly riches had consisted in a pig, which the wolf had carried off; and he who had obtained power over all the savage beasts, told her to be of good cheer, for her pig should be restored to her; and the wolf, at his command, brought it back unharmed.

When, at length, he appeared before the tribunal, the cruel governor ordered him to be scourged, and cast into a dungeon without food; but the poor woman, whose pig he had saved, having meanwhile providentially killed her pig, brought him a part of it cooked, with some bread and fruit, so that he did not perish; and he blessed this woman, with whom all things prospered from that time forth. Then he was brought a second time before the governor, and he, far more savage than the beasts of the forest, ordered St. Blaise first to be tortured by

having his flesh torn with iron combs, such as they use to card wool ; and finding that his constancy was not to be subdued by this or any other torments, he commanded his head to be struck off, which was done.    Thus, the good bishop received the crown of martyrdom; and seven pious women wiped up his blood.

Pictures of St. Blaise are not frequent.    In single figures and devotional pictures he is represented as an old man with a white beard, attired as a bishop with the planeta and mitre, holding in one hand a crosier, in the other an iron comb, such as is used by the woolcombers, the instrument of his torture ; this is his peculiar attribute.    He is thus represented on the coins of Ragusa.

A picture by Monsignori (of Verona), engraved in Rossini's History of Painting, represents him stripped ready for the torture, his hands tied above his head ; on one side stands an angel holding the iron comb, on the other an angel holding the crosier and mitre.

St. Blaise sitting at the mouth of his cave, and surrounded by a variety of animals, with his hand raised in the act of benediction, is a subject frequent in the ancient miniatures and stained glass.

In 'The Martyrdom of San Biagio,' by Carlo Maratti (in the Carignano, at Genoa), he has, with great good taste, avoided the dreadful and disgusting as far as possible.    The executioners are in the act of raising the aged saint by means of a pulley, to suspend him to a gallows; others are standing by with the iron combs prepared to torture him; while he, with an expression of pious resignation, raises his eyes to heaven, and seems to pray for fortitude to endure the impending torment.    In allusion to the 'pious women' mentioned in the legend, one or two women are generally introduced into the martyrdom of St. Blaise.

This saint keeps his place in the English reformed calendar, and as patron and protector of woolcombers and woolstaplers is especially popular in Yorkshire, where he is regarded as the inventor of woolcombing, and still commemorated in the town of Bradford by a festival held every seven years, wherein Prince Jason and the Princess Medea, Bishop Blaise and his chaplain, all walk together in grand procession.[1]

---

[1] He has three churches dedicated to his honour in England.

St. Cyprian, bishop of Carthage, who perished in the persecution under Valerian, and whose martyrdom is one of the most authentic and interesting in the history of the Christian Church, is so rarely met with as a subject of Art, that I can recollect but one example, in a picture by Paul Veronese, in the Brera at Milan, where St. Augustine sits enthroned, and before him stands St. Cyprian with the palm and mitre at his feet, and on the other side his friend St. Cornelius, pope in 251.

## St. Erasmus.

*Ital.* Sant' Elmo or Erasmo. *Sp.* St. Ermo or Eramo. *Fr.* Saint Elme.
(June 3, A.D. 296.)

This saint was one of the bishops of the early Church, and was martyred in the persecution of the Christians under Diocletian and Maximian at Formia, now Mola di Gaeta, between Rome and Naples. As his firmness withstood all ordinary tortures, for him a new and horrible death was prepared; he was cut open, and his entrails wound off on a sort of wheel such as they use to wind off skeins of wool or silk. Such an implement is placed in his hand, and is his peculiar attribute. He is represented as an aged man attired as a bishop.

His supposed martyrdom—for the affrighted imagination is obliged to take refuge in doubt or incredulity—is the only subject from his life which I have met with in a picture, and fortunately it is very rare. It was painted by Niccolò Poussin—though how his tender and refined mind could be brought to study all the details of a subject so abominable, is difficult to conceive;—it was commanded by the pope, Urban VIII., and is perpetuated in a mosaic which is over the altar of St. Erasmo in St. Peter's. It is said to be in point of *expression* one of Poussin's best works; and that the head of the saint, agonised at once and full of heavenly faith and resignation, is a masterpiece. I never could look at the picture long enough or steadily enough to certify to the truth of this eulogium, and I should rather subscribe to the just remarks of Sir Edmund Head: after observing that the French artists in general do not seem to feel 'the

limits which separate the horrible from the pathetic,' he adds, ' the subject is no excuse for the painter.    Such subjects, as has been well observed, should be treated by the selection of a moment before the horror is complete ; ' as in Parmigiano's St. Agatha.

St. Erasmus, under the name of Sant' Elmo, is famous on the shores of the Mediterranean, in Calabria, Sicily, and Spain, where the mariners invoke him against storms and tempests : he is sometimes represented with a taper in his hand or on his head.    Every one who has visited Naples will remember the celebrated monastery and fortress placed under his protection.

## St. Apollinaris of Ravenna.

*Ital.* Sant' Apollinare.   *Fr.* Saint Apollinaire.   (July 23, A.D. 79.)

In the last year of the reign of the Emperor Vespasian, Apollinaris, first bishop of Ravenna, was martyred outside the gate of that city.

It is related of him that he accompanied the apostle Peter from Antioch, and was for some time his companion and assistant at Rome; but, after a while, St. Peter sent him to preach the Gospel on the eastern coast of Italy, having first laid his hands on him and communicated to him those gifts of the Holy Spirit which were vouchsafed to the apostles.

Apollinaris, therefore, came to the city of Ravenna, where he preached the faith of Christ with so much success that he collected around him a large congregation, and performed miracles, silencing, wherever he came, the voice of the false oracles, and overcoming the demons; but the heathens, being filled with rage, threw him into prison, whence escaping by the favour of his jailor, he fled from the city by the gate which leads to Rimini.    His enemies pursued him, and, having overtaken him about three miles from the gate, they fell upon him and beat him, and pierced him with many wounds, so that when his disciples found him soon afterwards he died in their arms, and his spirit fled to heaven.

On the spot where he suffered, about 534 years afterwards, was built and dedicated to his honour the magnificent basilica of St. Apollinaris-in-Classe.    It is still seen standing in the midst of a solitary marshy

plain near Ravenna, surrounded with rice-grounds and on the verge of that vast melancholy pine-forest made famous in the works of Boccaccio, Dante, and Byron. The full-length figure in mosaic, in the apsis of this antique church, exhibits the oldest of the few representations I have met with of this saint, whose celebrity and worship are chiefly confined to Ravenna. He is in the habit of a Greek bishop, that is, in white, the pallium embroidered with black crosses, no mitre, and with grey hair and beard. He stands, with hands outspread, preaching to his congregation of converts, who are represented by several sheep—the common symbol. Another of the wonderful old churches of this city, also dedicated to the saint, stands within the walls: it was built by Theodoric, as the chief place of worship for the Arians, and close to his palace. The interior is covered with mosaics in the Greek style. Among them is the grand procession of martyrs, already described.[1]

## St. Donato of Arezzo.

*Lat.* S. Donatus. *Fr.* Saint Donat. (August 7.)

In the time of the Emperor Julian the Apostate, was martyred St. Donatus, bishop of Arezzo. He was of illustrious birth, and was brought up with Julian, both being educated in the Christian faith; but when Julian became emperor, and apostatised from the truth, he persecuted the Christians, and put many of them to death, and among them was the father of Donatus; therefore Donatus fled from Rome, and took refuge in Arezzo. He had for his companion the monk Hilarion, a man of most holy life, and together they performed many miracles, healing the sick and curing those who were possessed by evil spirits. There was a certain man who was the taxgatherer of the province, who, having occasion to go on a journey, left all the money in his possession due to the imperial treasury in the care

[1] *v.* p. 525. At Remagan, on the Rhine, a very beautiful church has lately been dedicated to St. Apollinaris; the whole of the interior is painted in fresco by the most celebrated painters of the modern German school.

of his wife Euphrosina. It was a large sum, and she, fearing to be robbed, dug a hole in a corner of her house and buried it. Having done this, she died suddenly without having revealed the spot in which she had hidden the money. When her husband returned he was in great trouble, fearing to be put to death as a defaulter, and he had recourse to St. Donatus. The holy man, having compassion on him, went with him to the sepulchre of his wife; and having first prayed earnestly, he called out with a loud voice, 'Euphrosina, make known to us where thou hast hidden the treasure;' and she from the tomb answered him, which was a great wonder, and witnessed by many people. And after these things, being made bishop of Arezzo, it happened that on a certain day, as he was celebrating the communion, the sacramental cup, which was of glass, was broken by some rude pagans who thought to insult the Christians; but, at the prayer of the holy bishop, the fragments reunited in his hand, and it became as before, and spilt no drop. This miracle, which is related by St. Gregory in his Dialogues, was the cause that many were converted, and so enraged the heathens that the Roman prefect ordered Hilarion to be scourged to death, and St. Donatus, after being tortured, was decapitated. The bodies of both lie buried under the high altar of the Cathedral of Arezzo.

The shrine of San Donato, executed for the people of Arezzo by Giovanni Pisano, A.D. 1286, stands upon the altar, which is isolated in the choir, and is covered on all sides with bas-reliefs, representing the life and miracles of the saint. It is very celebrated as a monument of Italian Middle-Age Art, but appeared to me extremely unequal: some of the figures full of grace and feeling;—others rude, clumsy, and disproportioned. Parts of it are engraved in Cicognari's work.

Several pictures from the life of St. Donato are also in the cathedral, among which his martyrdom is the best. His effigy appears on the ancient coins of Arezzo.

---

St. Zenobio of Florence is extremely interesting as connected with the beautiful ecclesiastical edifices of Florence, and with some of the finest and most important works of the early Florentine school, both in painting and sculpture.

St. Zenobio was born in the last year of the reign of Constantine, of a noble family. His father's name was Lucian, his mother's name was Sophia. They brought him up in all the wisdom and learning of the Gentiles, but he was converted secretly by his teachers, and afterwards converted his parents. He became himself distinguished by his pious and modest deportment, and by his eloquence as a preacher of the faith. He afterwards resided with Pope Damasus I. as deacon and secretary, and being sent to appease the religious dissensions in his native city, was unanimously elected bishop by the Catholics and Arians. He continued to lead a life of poverty and self-denial, honoured by the good, respected by the wicked, converting numbers to Christianity, not less by his example than his teaching; and died at length in the reign of Honorius (May 25, A.D. 417.)

In the picture of St. Zenobio suspended against one of the pillars opposite to the principal entrance of the Duomo at Florence, he is represented enthroned, in his episcopal robes, and with his hand raised in the act of benediction. He has no particular attribute, but occasionally in the old Florentine prints some legend from his life is represented in the background, and this serves to fix the identity: a tree bursting into leaf is, I think, the attribute usually adopted. Sometimes it is a mother kneeling by her dead child; but this, being applicable to several other saints, is deceptive.

'It is related that when they were bearing the remains of St. Zenobio through the city in order to deposit them under the high altar of the cathedral, the people crowded round the bearers and pressed upon the bier in order to kiss the hands or touch the garments of their beloved old bishop. In passing through the Piazza del Duomo, the body of the saint was thrown against the trunk of a withered elm standing near the spot where the baptistery now stands, and suddenly the tree, which had for years been dead and dried up, burst into fresh leaves.' [1]

This story is the subject of an admirable picture by Ridolfo Ghirlandajo, in which there are heads worthy of Raphael for beauty and intense expression. [2]

'St. Zenobio made a journey to a city among the Apennines, in

[1] Ezek. xvii. 24; Job xiv. 7.        [2] Florence Gal.

167                    St. Zenobio revives the dead child  (Masaccio)

order to consecrate a Christian church.   On this occasion his friend
St. Ambrose sent messengers to him with gifts of precious relics.
But it happened that the chief of the messengers, in passing through
a gorge in the mountains, fell, with his mule, down a steep preci-
pice, and was crushed to death.   His companions, in great grief and
consternation, brought his mutilated body and laid it down at the
feet of St. Zenobio; and at the prayer of the good bishop the man
revived, and rose up, and pursued his journey homewards with
prayer and thanksgiving.

'A French lady of noble lineage, who was performing a pilgrimage
to Rome, stopped at Florence on the way, in order to see the good
bishop Zenobio, of whom she had heard so much, and, having
received his blessing, she proceeded on to Rome, leaving in his care
her little son.   The day before her return to Florence, the child
died.   She was overwhelmed with grief, and took the child and laid
him down at the feet of St. Zenobio, who, by the efficacy of his
prayers, restored the child to life, and gave him back to the arms of
his mother.'

This popular legend appears in several of the most beautiful works
of the early Florentine school :—

1. In a picture by Masaccio. Here the resuscitation of the child is represented in the artless manner usual with the early artists. The dead child lies on the ground, and the living child stands beside the lifeless effigy of himself (167).

2. In the picture by Rodolfo Ghirlandajo, the dead child lies on the earth, crowned with flowers, as if prepared for the grave : the mother kneels with dishevelled hair, and the bishop and his attendants stand near. The scene of this miracle was the Borgo degli Albizzi, well known to those who have visited Florence.

'A little child, having strayed from his mother in the streets of Florence, was run over and trampled upon by a car drawn by two unruly oxen, but restored to life by the prayers of the holy bishop Zenobio.' This story also frequently occurs in the Florentine works of Art.

3. On the bronze sarcophagus executed by Lorenzo Ghiberti to contain the remains of St. Zenobio, are three beautiful groups in bas-relief. 1. The Restoration of the Son of the French Lady. 2. The Resuscitation of the Messenger of St. Ambrose. 3. The Story of the Child trampled by the Oxen.[1]

---

St. Regulus is interesting only at Lucca ; his statue, and the bas-relief beneath representing his martyrdom, in the Duomo there, rank among the finest works of one of the finest of the Middle-Age sculptors, Matteo Civitale di Lucca. This St. Regulus was an African bishop, who, in the disputes between the Catholics and Arians, fled from his diocese in Africa, and took refuge in Tuscany, where for some time he lived in holy solitude ; but on the invasion of Italy by Totila, king of the Goths, he suffered martyrdom, being beheaded by some barbarian soldiers on refusing to appear before their king. The legend relates, that he took his head in his hands and walked with it to the distance of two stadia, and there sat down, when, two of his disciples coming up, he delivered to them his head, which they with great awe and reverence buried on the spot. I do not remem-

---

[1] 'The Miracles and Death of St. Zenobio,' by Sandro Botticelli, was in the collection of Herr v. Quandt, at Dresden, and engraved by J. Thäter.

ber that this incident is introduced in Civitale's bas-relief, nor do I recollect in genuine Italian Art any bishop represented without his head, even where the legend justifies it.

---

ST. FREDIANO (Frigdianus), the other patron of Lucca, was an Irish saint, who migrated to Lucca, and became bishop of that city in the sixth century (A.D. 560). It is related that in a terrible inundation which threatened to destroy Lucca he turned the course of the river Serchio, tracing the direction in which it was to flow by drawing a harrow along the ground, and the river obediently followed the steps of the holy man. Thus we find poetically shadowed forth those costly embankments through which the course of the Serchio was changed, and its terrible annual inundations rendered less destructive. In the extraordinary old church of San Frediano at Lucca (dating from the seventh century), Francia painted the whole history of the saint.

---

ST. ZENO, bishop of Verona in the fourth century, has the title of martyr, but on uncertain grounds. He was celebrated for his charity and Christian virtues, and for the manner in which he kept together his flock in times of great tribulation. According to one version of his legend, he was martyred by Julian the Apostate (April 12, A.D. 380.)

He is honoured chiefly at Verona, where his very ancient church is one of the most interesting monuments of Art in all Italy. In this church is a statue of him held in great veneration by the people. It is of wood, painted to imitate life. He is seated in his pastoral chair, and holds a long fishing-rod (or reed) in his hand, with a fish hanging to the line. The complexion is very dark, and the expression not only good-humoured, but jovial. The dark colour is probably given to indicate his African birth. According to the legend at Verona, he was very fond of fishing in the Adige; but I imagine that the fish is here the ancient Christian symbol which represented conversion and the rite of baptism.

The ' *Coppa di San Zenone*,' preserved in this church, is a large vase

of porphyry, in which the saint used to baptize his converts. According to the Veronese legend, it was brought by a demon from Palestine, by command of the bishop, and in a single night.

In the early pictures of the Veronese school, those for instance by Liberale and Morando, a saint in the habit of a bishop, and with a fish suspended from his crozier, may be presumed to represent St. Zeno.[1]

It is related that King Pepin held this saint in such estimation, that he desired to be buried in the same grave with him.

168    St. Zeno of Verona   (Morando)

ST. GEMINIANUS was bishop of Modena about the year 450; pictures of the legends related of him appear only in the churches of that city. He was sent for to Constantinople to dispossess the daughter of the emperor, who suffered grievously from a demon;[2] he also by his intercession saved the city of Modena, when threatened by Attila, king of the Huns; and lastly (after his death), preserved the cathedral from being destroyed in a great inundation.

He figures on the coins of Modena, and also in some celebrated pictures, as patron and protector of the city.

1. Correggio, in his famous picture, 'the Madonna di San Giorgio,' painted for the Dominicans at Modena, and now at Dresden, has represented San Geminiano taking from an angel the model of a

---

[1] In a picture by Girolamo da' Libri (Berlin Gal., 30), St. Zeno appears without the mitre.

[2] I presume the Princess Honoria, whose story is so graphically related by Gibbon in his thirty-fifth chapter.

church, and about to present it to the Infant Redeemer, whose hands
are eagerly stretched out as if to save it.   This, I believe, alludes,
very poetically, either to the dedication or the preservation of the
cathedral.   On the other side are St. Peter Martyr the Dominican,
St. John the Baptist, and the admirable figure of St. George.

2. Paul Veronese.   St. Geminiano, bishop of Modena, and St.
Severus, bishop of Ravenna, are seen reading the Gospel out of the
same book; this alludes to the legend that St. Severus, while reading
the epistle in the service at Ravenna, suddenly fell asleep, and beheld
in a vision the death and obsequies of St. Geminianus.   (At Venice,
but I now forget in what church.)

3. Guercino.   St. Geminiano, in his episcopal habit and wearing
the mitre, receives from an angel the city of Modena (represented
as a small model of the city), which he is about to present to the
Saviour.   This alludes, poetically, to the preservation of the city
from Attila.[1]

---

SANT' ERCOLANO (Herculanus) was bishop of Perugia about the
year 546.   At this time took place the invasion of the Goths under
Totila.   During the long siege of Perugia, the good bishop assisted
and encouraged his people; and when the city was at length taken,
Totila ordered him to be beheaded on the ramparts.   His body was
thrown into the ditch, where being afterwards found with a little
child lying dead beside him, they were both buried in the same grave.
His effigy is on the coinage of Perugia.

Of ST. COSTANZO (Costantius), bishop of Perugia in the third or
fourth century, nothing is known but that he was martyred in the
reign of Marcus Aurelius.   He is venerated in this part of Italy, and
the territory between Perugia and Foligno is called the *Strada di
Costanza.*

These two saints are interesting at Perugia, as they occur in some
beautiful pictures of that school, particularly in those of Perugino:
for instance, in one of his finest works, the altar-piece now in the
Vatican, called the '*Madonna con quattro Santi,*' which was one of
the pictures carried off from Perugia to France in 1797.

[1] Louvre, No. 55.

St. Petronius, bishop and patron saint of Bologna, was a Roman of illustrious birth, and an early convert to Christianity. He distinguished himself by banishing the Arians from Bologna, which appears to have been his chief merit; he died October 4, A.D. 430, and is not entitled to the honours of a martyr.

Pictures of this saint are confined to Bologna. Every traveller in Italy will remember his beautiful church in that city. The most ancient representation of him is the full-length effigy, carved in wood, and painted, which stands within his church, on the left-hand side. He wears the episcopal robes, mitre, and crosier, with a thick black beard, a characteristic not usually followed by the Bologna painters, who exhibit him either with no beard at all or with very little. In the devotional pictures he holds in his hand the city of Bologna, distinguished by the tall central tower (the *Torre Asinelli*), and the leaning tower near it.

169    St. Petronius   (Lorenzo Costa)

As he is the subject of many celebrated pictures, I shall give a few examples.

He is enthroned as patron and bishop, between St. Francis d'Assisi and St. Thomas Aquinas the Dominican; by Lorenzo Costa.[1]

St. Petronius, seated, holds the city in his hand, opposite to him St. John the Evangelist reading his gospel; by Francesco Cossa.

In a beautiful figure by Lorenzo Costa, he stands on the right of the Virgin, holding the city; St. Thecla is on the left (169, 141).

'The Descent of the Holy Ghost;'—the Virgin as well as the apostles being present, and St. Gregory and St. Petronius standing by

[1] Bologna Gal.

as witnesses of this stupendous scene.   This appears an unaccountable combination, till we learn that the picture was painted for the brotherhood of the Santo Spirito.

But the most celebrated picture in which St. Petronius appears is the masterpiece of Guido, the Pietà in the Bologna Gallery.

Another picture, one of Guido's finest works, was dedicated on the cessation of a terrible plague in 1630.   St. Petronius is represented as interceding for his city at the feet of the Madonna and Child in glory.

ST. PROCULUS is another bishop of Bologna, who appears in the Bolognese pictures ; he was martyred by Totila, King of the Goths ; about 445.   He must not be confounded with St. Proculus the *soldier*, also a Bolognese saint.[1]

ST. MERCURIALE, first bishop of Forli in the second century, appears as patron saint in some fine pictures in the churches at Forli.   He has the common attribute of the dragon, as having vanquished sin and idolatry in that part of Italy, as in a picture by Cigoli.

SAN ROMULO (Romulus), first bishop and apostle of Fiesole. According to the legend he was a noble Roman, one of the converts of St. Peter, who sent him to preach the Gospel to the people of Fiesole, then one of the greatest of the Etruscan cities.   Romulus, accused of being a Christian, and taken before the prætor, was condemned to death ; he was first bound hand and foot and thrown into a dungeon, where he remained four days, and then, after many torments, despatched with a dagger.   He suffered under Nero (July 23).

The old Cathedral of Fiesole is dedicated to him.   The fine altarpiece by Allori represents St. Romulus baptizing the converts.   He is found also in the sculptures of Mino da Fiesole and Andrea Feracci ; by the latter is the fine basso-relievo in his church representing his martyrdom.   I have also found St. Romulo in the churches of Florence ; he wears the episcopal habit, and carries the palm.

SAN MAURELIO (Maurelius), first bishop and patron of Ferrara and

[1] See the ' Warrior Saints,' farther on.

Imola : he was beheaded. This saint appears on the coinage of Ferrara. The Martyrdom of San Maurelio, painted by Guercino for the abbot of San Giorgio, is now in the public gallery of Ferrara.

SAN CASCIANO (St. Cassian), patron of Imola, was a schoolmaster of that city, and being denounced as a Christian, the judge gave him up to the fury of his scholars, whom the severity of his discipline had inspired with the deepest hatred ; the boys revenged themselves by putting him to a slow and cruel death, piercing him with the iron styles used in writing : his story is told by Prudentius, and is represented, as I have been informed, in the Cathedral at Imola.

ST. GAUDENZIO (Gaudentius), bishop and patron of Rimini, was scourged, and then stoned, by the Arian party, which at that time had the upper hand in Italy. (October 14; A.D. 359.) His effigy is on the early coinage of Rimini.

Another St. Gaudentius was bishop of Novaro, and appears as patron of that city.

ST. SIRO (Syrus), first bishop of Pavia in the fourth century, governed the church there for fifty-six years : whether he was martyred is uncertain. His effigy is on the early coins of Pavia, and a beautiful statue of him is in the cathedral.

ST. ABBONDIO, fourth bishop of Como, was a native of Thessalonica, contemporary with Leo I. He is the apostle and patron of that part of Italy, and figures in the Cathedral at Como.

ST. HILARY, though properly a French saint (he was bishop of Poitiers in the fourth century), is considered as one of the lights of the early Italian Church, and distinguished himself in Lombardy by opposing the Arians ; hence he is reverenced through the north of Italy under the name of Sant' Ilario. As one of the patrons of Parma, where some of his relics are said to repose, he is the subject of one of Coreggio's splendid frescoes in the cathedral there. He has a church at Cremona, where I remember a very fine picture by Giulio

Campi, representing the grand old bishop seated on a raised throne reading the Gospel, which lies open on his knees, while St. Catherine and St. Apollonia stand on each side.[1] It recalls the best manner of Parmigiano in style and colour, and is about the same date (1537).

St. JANUARIUS (*Ital.* San Gennaro; *Fr.* Saint Janvier) is the great patron of Naples and protector of the city against the eruptions of Mount Vesuvius; as such he figures in the pictures of the Neapolitan school, and in pictures painted for the churches of Naples.

The legend relates that he was bishop of Benevento; and, in the tenth persecution, he came with six of his companions to Naples, to encourage and comfort the Christians: they were seized and carried to Puzzuoli, and there exposed to the wild beasts in the amphitheatre; but the beasts refused to touch them. Then St. Januarius was thrown into a burning fiery furnace, and came out of it unharmed; finally he was beheaded (Sept. 19, A.D. 303).

In the devotional figures he is represented in the robes and mitre of a bishop, holding his palm, with Mount Vesuvius in the background.

The miraculous preservation of the city of Naples when menaced by torrents of lava, is a frequent subject in the churches there.

Domenichino, when at Naples, painted his large fresco of St. Januarius appearing to the Neapolitans during the eruption of 1631. And by Spagnoletto I have seen the martyrdom of St. Januarius: he is thrown into a furnace. Except at Naples I have never met with any pictures relating to this saint.

---

[1] This St. Hilary, patron of Parma, who died January 13, 363, must not be confounded with another St. Hilary, bishop of Arles in the fifth century, and not in any way associated with Italy or Italian Art. Hilary of Poitiers left behind him writings which have been quoted with admiration by Erasmus, Locke, and Gibbon. The latter observes, in his sneering way, that Hilary 'had *unwarily* deviated into the style of a Christian philosopher.' ('Decline and Fall,' chap. **xxi.**) Correggio has given him a countenance full of pensive benignity.

# French Bishops.

## St. Denis of France; St. Dionysius the Areopagite.

*Lat.* Sanctus Dionysius. *Ital.* San Dionisio or Dionigi. *Fr.* Saint Denis.
Patron saint of France. (October 9.)

THE legend which confounds Dionysius the Areopagite with St. Denis of France (bishop of Paris in the third century) will not bear any critical remark or investigation; but as it is that which presents itself everywhere in Art, I give it here as it was popularly received.

' Dionysius was an Athenian philosopher, who, for his great wisdom in heavenly things, was named Theosophus, and, being a judge of the Areopagus, was also called the Areopagite. He travelled into Egypt to study astrology under the priests of that country. Being at Heliopolis with his companion, the philosopher Apollophanes, and studying together the courses of the stars, they beheld the heavens darkened, and there was darkness over the heaven and earth for three hours; and Dionysius was much troubled in spirit, not knowing what this might signify. He knew not then, though he afterwards learned, that this was the darkness which fell upon the earth in the same hour that the Redeemer died for our sins,— the darkness which preceded the dawning of the true light. And on these things did Dionysius meditate continually. Some time after his return to Athens, St. Paul arrived there, and preached to the people: and he preached to them THE UNKNOWN GOD. Dionysius listened with wonder, and afterwards he sought Paul, and asked him concerning this unknown God. Then Paul explained all the mysteries of the Christian religion, and Dionysius believed, and was baptized in the faith. The apostle ordained him priest, and he became the first bishop of Athens.

' Among the writings attributed to this great saint are certain letters, in which he tells us that he travelled to Jerusalem to pay a visit to the holy Virgin, and that he was struck with admiration and

wonder to behold the glory which shone around her, and dazzled by
the glorious company of angels which continually attend upon her.
Also the same Dionysius tells us that he was present at her death
and burial, and he has recorded the names of the apostles who were
also present on that occasion.

'Afterwards he returned to Athens, and thence travelled into Italy
and France, and having joined Paul at Rome, he attended him to
his martyrdom. After that he was sent by Pope Clement, the suc-
cessor of Peter, to preach the Gospel in the kingdom of France.
And Clement gave him for his companions, to aid him in his labours,
a priest, whose name was Rusticus, and a deacon, who was called
Eleutherius.

'St. Denis (for so the French afterwards called him) arrived at
Paris, the capital of that country, an exceedingly great and rich city,
full of inhabitants, and well provided with all the good things of this
earth; the skies were bright, and the lands fertile: "it seemed to
Dionysius another Athens." So he resolved to fix his residence there,
and to teach these people, who were learned, and happy, and rich in
all things but those which concerned their salvation, the way of truth
and righteousness. Therefore Dionysius preached to them the Gospel,
and converted many. Moreover, he sent missionaries to all the pro-
vinces of France, and even into Germany.

'Now you can easily believe that these things were particularly dis-
pleasing to Satan, that enemy of the human race. He stirred up many
of the nobles and others against the good bishop, and certain of their
emissaries accused him to the Emperor Trajan; but others say it was
the Emperor Domitian, and that this wicked emperor despatched the
proconsul Fescennius from Rome to Paris with orders to seize St.
Denis, and throw him into prison, together with his companions,
Rusticus and Eleutherius. The prefect ordered them to be brought
before him, and, finding that they persisted in denying and contemning
his gods, he commanded that they should be dragged forth to death;
and being come to the place of execution, Dionysius knelt down, and
raising his hands and his eyes to heaven, he commended himself to God,
and Rusticus and Eleutherius responded with a loud amen. Then the
venerable and holy prelate Dionysius said to the executioner, 'Do thine
office;' and he, being diligent, in a few minutes struck off all their

heads, and left them there, as was usual, to be devoured by the wild beasts. But the Lord did not forget his servants, nor was it his will that their holy remains should be dishonoured; therefore he permitted a most stupendous miracle, namely, that the body of Dionysius rose up on its feet, and, taking up the head in his hands, walked the space of two miles, to a place called the Mount of Martyrs (since called Mont Martre), the angels singing hymns by the way. Many were converted by this great miracle, particularly Lactia, the wife of Lubrius, who, having declared herself a Christian, was also beheaded.'

The bodies of St. Denis, of St. Eleutherius, and St. Rusticus were buried afterwards on this spot, and the first person who raised a church to their honour was St. Geneviève, assisted by the people of Paris. In the reign of King Dagobert the holy relics were removed to the Abbey of St. Denis. The saint became the patron saint of the French monarchy, his name the war-cry of the French armies. The famous oriflamme—the standard of France—was the banner consecrated upon his tomb. About the year 754, Pope Stephen II., who had been educated in the monastery of St. Denis, transplanted his native saint to Rome, and from this period the name of St. Denis has been known and venerated through all Europe. In the time of Louis le Débonnaire (A.D. 814), certain writings, said to be those of Dionysius the Areopagite, were brought to France, and then it became a point of honour among the French legendary writers to prove *their* St. Denis of Paris identical with the famous convert and disciple of St. Paul; in which they have so far succeeded, that in sacred Art it has become difficult to consider them as distinct persons.

The popular effigies of St. Denis, those which are usually met with in the French and German prints, in the Gothic sculpture and stained glass of the French churches, represent him in his episcopal robes, carrying his head in his hand; sometimes, while he wears his own mitred head, he carries also a head in his hand,—which I have heard sneered at, as adding the practical blunder of the two heads to the original absurdity of the story : but the fact is, that in both instances the original signification is the same ; the attribute of the severed head expresses merely martyrdom by decapitation, and that

ᵗhe martyr brings his head an offering to the Church of Christ.    Such figures appear to have suggested the legends of several headless saints promulgated to gratify the popular taste for marvels and miracles.

Devotional figures of St. Denis are not common in the Italian schools, and in these I recollect no instance in which he is without his head.

There is a very fine picture by Ghirlandajo,[1] in which San Dionigi and St. Thomas Aquinas stand on each side of the Virgin : the former, a most majestic and venerable figure, stands in his episcopal robes, richly and elaborately embroidered, holding his crosier; St. Thomas, in his Dominican habit as a doctor of theology, holding his book : they are here significantly and intentionally associated as two great lights of the Church who have both treated especially of the heavenly mysteries and the angelic hierarchies.    St. Clement, who was the spiritual father of St. Denis, and St. Dominic, who stood in the same relation to St. Thomas, are kneeling as secondary personages.    The picture was of course painted for the Dominicans.

The Sicilians have oddly enough mixed up the saint Dionysius with the tyrant Dionysius, and claim him as a saint of their own. There is a picture over the high altar of his church at Messina, in which he is seated in his episcopal throne, as the superior saint, and surrounded in the usual manner by other saints standing.

Subjects from the life of St. Denis are very common as a series, in the sculpture and stained glass of the French cathedrals, and in the modern restorations of the Cathedral of St. Denis : one of the finest is the grand window in the Cathedral at Chartres.    The separate pictures and prints from his legendary story are principally confined to the French school.

1. St. Denis at Heliopolis, seated on the summit of a tower or observatory : he is contemplating, *through a telescope,* the crucifixion of our Saviour, which is seen in the far distance.  This subject I saw once in an old French print; underneath, in Latin, the verse from Isaiah (xxiv. 23), *Confundetur sol,* &c.  'Then the moon shall be confounded and the sun ashamed, when the Lord of Hosts shall reign on Mount Sion.'

2. St. Denis converted by St. Paul is a frequent subject in old

[1] Florence Acad.

French prints.  In Raphael's cartoon of ' Paul preaching at Athens,'
the figure of the man in front, who, as Sir Joshua says, ' appears to
be thinking all over,' is probably Dionysius.

3. Le Sueur.  St. Denis at Rome takes leave of Pope Clement,
and receives his blessing before he departs on his mission to Paris.[1]

4. Joseph-Marie Vien.  St. Denis preaching to the Parisians.[2]

5. The martyrdom of St. Denis.  He is seen walking with his head
in his hand, and sustained on each side by angels,—' *en pareil cas,*'
as the witty Frenchwoman observed, ' *ce n'est que le premier pas qui
coûte;*' nevertheless, it must be conceded that the sustaining angels
greatly diminished the incredibility of the story.

6. St. Denis, St. Maurice, and St. Martin rescue the soul of King
Dagobert from demons : represented within the Gothic recess over
the tomb of King Dagobert: on which he lies in effigy, full length.
The story is told in three compartments, one above the other.  1.
The anchorite John is seen asleep, and St. Denis reveals to him in
a vision that the soul of King Dagobert is tormented and in danger ;
to the right is seen Dagobert, standing in a little boat; demons
seize him forcibly, and one of them takes off his crown.  2. St.
Martin, St. Maurice, and St. Denis come to the rescue of Dagobert :
they are attended by two angels, one of whom swings a censer, and
the other holds a vase of holy water ; St. Martin and St. Denis seize
upon the soul of Dagobert, while St. Maurice, sword in hand, attacks
the demons.  3. The three saints, attended by angels, hold a sheet
extended, on which stands the soul of Dagobert in the attitude of
prayer.  The Divine hand appears in a glory above, as if about to
lift him into heaven.  The whole is executed with extraordinary
spirit, but I should be doubtful as to the date assigned by Le Noir
(A.D. 632–645); or rather, I have no doubt that it is a mistake :
the style is that of the fourteenth century.

A very remarkable monument appertaining to St. Denis is a
manuscript memoir of his life (according to the legend must be
understood), which exists in the Royal Library at Paris, and which
cannot be of later date than the year 1322.  The miniatures in this
beautiful manuscript I did not count, but they must have exceeded,

---

[1] Methuen Coll.                              [2] Paris, St. Roch.

I think, a hundred and fifty, drawn with a pen, and slightly tinted; the figures Gothic in taste and feeling, yet with a certain delicacy in the character, and a lengthiness in the forms, such as we see in the best Gothic sculpture of that period. I can only mention here a few of the subjects, which from their beauty and peculiarity struck me most.

1. The Athenians raise to *The Unknown God* an altar, on which Dionysius is in the act of writing the inscription DEO IGNOTO. 2. Paul preaching to the Athenian philosophers; in the background the altar, to which he points. 3. Paul converts Dionysius and Damaris. 4. Paul consecrates Dionysius first bishop of Athens. 5. Dionysius writing his famous treatise on the celestial hierarchy. The nine choirs of angels are hovering over him, surmounted by the Trinity. 6. He carries his head (two angels sustaining him on either side) and presents it to the Christian woman, here called Catulla: she receives it in a napkin. 7. The spirits of the three martyrs (in the usual form of naked infants) are carried into heaven by angels.

The compositions throughout are superior in spirited and dramatic expression, but inferior in purity and grace, to the contemporary Italian school—that of Giotto.

There are several other saints who are represented in Gothic Art in the same manner as St. Denis, that is, in the act of carrying their own heads. In every instance the original meaning of the attribute must be borne in mind.

St. Cheron, bishop of Chartres, was a contemporary and disciple of St. Denis. Being on his way from Chartres to Paris, to visit St. Denis, he was attacked by robbers, who struck off his head; whereupon the saint, taking his head up in his hands, continued his journey. His whole history is represented on one of the magnificent windows of the Cathedral of Chartres.

St. Clair, carrying his head, I saw on one of the fine windows of St. Maclou at Rouen: he was martyred between Rouen and Pontoise in the third century.

St. Nicaise (*Lat.* Nicasius), bishop of Rheims, famous for his success

in preaching the Gospel, was besieged in Rheims by the Vandals, A.D. 400, and he went forth attended by his clergy to meet the enemy, singing hymns: one of the barbarian soldiers struck off the upper half of his head; nevertheless, the saint continued singing his stave until, after a few steps, he fell dead. A picture by Jan Schoreel represents St. Nicasius in his episcopal robes, without the upper part of his head, which, with the mitre on it, he carries in his hand.[1]

'St. Valérie, or Sainte Valère, without her head, which she carries in her hands, approaches the altar and presents her head to St. Martial.' I saw this strange subject in a large mosaic in the *Studio de' Mosaici*, at Rome: it was executed for St. Peter's, but some misgiving happily prevented it from being placed there. These two saints, patrons of Aquitaine, lived in the third century. The legend sets forth that Martial was first bishop of Limoges; that among his early converts was a beautiful virgin, whose name was Valérie; she refusing to listen to the addresses of the Duke de Guyenne, 'il entra en une telle rage qu'il luy fit trancher la teste, couronnant sa virginité d'un martyre bien signalé, car à la veuë d'un chacun elle prit sa teste, et la porta jusques au pied de l'Autel où S. Marcial disoit la messe; le bourreau, la suivant pas-à-pas, mourut dans l'Église, après avoir clairement protesté qu'il voyoit les anges à l'entour de son corps.' I have been thus particular in giving this old French legend because the story of St. Martial and St. Valérie appears so frequently in the chased and enamel work for which Limoges was famous from the twelfth to the sixteenth century. St. Martial did not suffer martyrdom. I have seen him standing in his bishop's robes, and St. Valérie holding her palm with a streak or mark round her neck, in some ivory carved work which served as the cover of a book; the whole story is represented on one of the windows of the Cathedral of Limoges.

St. Romain, who was bishop of Rouen in the time of Clovis I., is generally considered as the apostle of Normandy. He overthrew the heathen temples, and preached Christianity among the Gauls of that district. The Seine, having overflowed its banks, nearly destroyed

[1] Munich Gal.

the city of Rouen: St. Romain commanded the waters to retire to their channel, but from the mud and slime left by the receding flood was born a monstrous dragon, called in the French legend *la Gargouille,* which spread terror along the shores. St. Romain went forth against the venomous beast, and by the aid of a wicked murderer, vanquished and bound the monster. Hence, down to the time of the Revolution, it was a privilege of the chapter of Rouen to deliver and pardon a criminal condemned to death. The whole history of St. Romain is painted on the windows of the Cathedral of Rouen, and is commonly met with in the Norman churches, and the dragon-legend of the *Gargouille* is merely the usual allegory so often referred to— the conquest of Christianity over Paganism. St. Romain died Oct. 23, 639, and was succeeded by Saint Ouen.

St. Trophime of Arles (whose church is one of the most magnificent in all France, and one of the few which escaped destruction in the time of the first Revolution) was the disciple of St. Paul.[1] I mention him here because the sculpture of the Cathedral of Arles is celebrated in the history of sacred Art.

### St. Martin of Tours.

*Lat.* Sanctus Martinus. *Ital.* San Martino.
Patron of Tours, of Lucca, &c., and of penitent drunkards. (November 11, A.D. 397.)

THIS illustrious saint, second to St. Nicholas only because confined to Western Christendom, is one of those whom the Middle Ages most delighted to honour. There can be no doubt of the extraordinary character of the man, nor of the extraordinary influence he exercised at the time in which he lived, nor is there any saint of whom so many stories and legends have been promulgated on such high ecclesiastical authority, and so universally believed; still, though so generally venerated throughout Christendom, he has never been so great a

[1] Acts xx. 4 ; xxi. 29.

favourite in Italy and Germany as in France, the scene of his life and miracles; we find him, consequently, less popular as a subject of Art than many saints who may be considered as comparatively obscure.

St. Martin was born in the reign of Constantine the Great, at Saberia, a city of Pannonia.[1] He was the son of a Roman soldier, a tribune in the army, and his parents were heathens; but for himself, even when a child, he was touched by the truth of the Christian religion, and received as a catechumen at the age of fifteen; but before he could be baptized he was enrolled in the cavalry and sent to join the army in Gaul. Notwithstanding his extreme youth and the licence of his profession, St. Martin was a striking example that the gentler virtues of the Christian were not incompatible with the duties of a valiant soldier; and from his humility, his mildness of temper, his sobriety, chastity, and, above all, his boundless charity, he excited at once the admiration and the love of his comrades. The legion in which he served was quartered at Amiens in the year 332, and the winter of that year was of such exceeding severity that men died in the streets from excessive cold. It happened one day that St. Martin, on going out of the gate of the city, was met by a poor naked beggar, shivering with cold; and he felt compassion for him, and having nothing but his cloak and his arms, he, with his sword, divided his cloak in twain, and gave one half of it to the beggar, covering himself as well as he might with the other half. And that same night, being asleep, he beheld in a dream the Lord Jesus, who stood before him, having on his shoulders the half of the cloak which he had bestowed on the beggar; and Jesus said to the angels who were around him, ' Know ye who hath thus arrayed me? My servant Martin, though yet unbaptized, hath done this! ' And St. Martin, after this vision, hastened to receive baptism, being then in his twenty-third year.

He remained in the army until he was forty, and then, wishing to devote himself wholly to a religious life, he requested to be dismissed: but the emperor (Julian the Apostate, according to the legend) reproached him scornfully, saying, that he desired to be dismissed because he wished to shun an impending fight; but St. Martin

[1] *Now* Stain in Hungary.

replied boldly, 'Place me naked, and without defence, in front of the battle: then shalt thou see that, armed with the Cross alone, I shall not fear to encounter the legions of the enemy.' The emperor took him at his word, and commanded a guard to be placed over him for the night; but early the next morning the barbarians sent to offer terms of capitulation; and thus to the faith of St. Martin the victory was granted, though not exactly as he or his enemies might have anticipated.

After leaving the army, he led for many years a retired and religious life, and at length, in 371, he was elected bishop of Tours. One day, when preparing to celebrate mass in the cathedral, he beheld a wretched naked beggar, and desired his attendant deacon to clothe the man; the deacon showing no haste to comply, St. Martin took off his sacerdotal habit and threw it himself around the beggar; and that day, while officiating at mass, a globe of fire was seen above his head, and when he elevated the Host, his arms being exposed by the shortness of the sleeves, they were miraculously covered with chains of gold and silver suspended there by angels, to the great astonishment and admiration of the spectators. At another time, the son of a poor widow having died, St. Martin, through his prayers, restored him to his disconsolate mother. He also healed a favourite slave of the proconsul who was possessed by an evil spirit; and many other wonderful things did this holy man perform, to the great wonder and edification of those who witnessed them. The devil, who was particularly envious of his virtues, detested above all his exceeding charity, because it was the most inimical to his own power, and one day reproached him mockingly that he so soon received into favour the fallen and the repentant; and St. Martin answered him sorrowfully, saying, 'Oh! most miserable that thou art! if thou also couldst cease to persecute and seduce wretched men, if thou also couldst repent, thou also shouldst find mercy and forgiveness through Jesus Christ!' What peculiarly distinguished St. Martin was his sweet, serious, unfailing serenity; no one had ever seen him angry, or sad, or gay; there was nothing in his heart but piety to God and pity for men. He was particularly distinguished by the determined manner in which he rooted paganism out of the land. Neither the difficulty of the enterprise, nor the fury of the Gentiles, nor his own

danger, nor the superb magnificence of the idolatrous temples, had any power to daunt or to restrain him. Everywhere he set fire to the temples of the false gods, threw down their altars, broke their images. The complete uprooting of heathenism in that part of Gaul is attributed to this pious and indefatigable bishop. The demons against whom he waged this determined war made a thousand attempts to terrify and to delude him, sometimes appearing to him as Jupiter, sometimes as Mercury, and sometimes as Venus or Minerva; but he overcame them all.

In order to avoid the great concourse of people who crowded around him, he withdrew to a solitude about two miles from the city, and built himself a cell between the rocks and the Loire. This was the origin of the celebrated monastery of Marmoutier, one of the greatest and richest in the north of Christendom.

While St. Martin was inexorable in breaking down the altars of the heathens, he appears to have opposed himself to some of the superstitions of the people. In the neighbourhood of Tours there was a little chapel in which the people worshipped a supposed martyr. The saint, believing their worship misplaced, went and stood upon the sepulchre, and prayed that the Lord would reveal to him who was buried there. Suddenly he beheld a dark spectral form, of horrible aspect, standing near ; and he said, ' Who art thou ? ' and the shade replied that he was a robber, who had been executed there for his crimes, and was now suffering the torments of hell.

Then St. Martin destroyed the chapel, and the people resorted to it no more.

Among the innumerable stories related of St. Martin, there is one which ought to be noted here as an admirable subject for a picture, though I am not aware that it has ever been painted. On some occasion the emperor invited him to a banquet, and, wishing to show the saint particular honour, he handed the wine-cup to him before he drank, expecting, according to the usual custom, that St. Martin would touch it with his lips, and then present it respectfully to his imperial host; but, equally to the astonishment and admiration of the guests, St. Martin turned round and presented the brimming goblet to a poor priest who stood behind him; thus showing that he

accounted the least of the servants of God before the greatest of the
rulers of the earth.    From this incident, St. Martin has been chosen
as the patron saint of drinking, and of all jovial meetings.

Also the empress, whose name was Helena, and who was the
daughter of a wealthy lord of Caernarvonshire, entertained him with
great honour.    It was somewhat against his will, as he avoided all
converse with women, but she clung to his feet, and would not be
separated from him, washing them with her tears.    She prepared for
him a supper, she alone, allowing no other service ; she cooked the
viands herself, she arranged his seat, offered the water for his hands,
and while he sat at meat she stood immovable before him, according
to the custom of menials.    She poured out the wine, and presented
it to him herself, and, when the repast was over, she collected the
crumbs that had fallen from his table, preferring them to the
banquet of the emperor.    This story also would be a most picturesque
subject.

After governing his diocese in great honour for nearly thirty years,
and having destroyed many temples and cut down many groves
dedicated to the false gods, the blessed St. Martin died, and many
heard the songs of the angels as they bore his soul to Paradise.

From the hour that he was laid in the tomb he became an object
for the worship of the people.    The church dedicated to him in Rome
(San Martino-in-Monte) existed within a hundred years after his
death ; and when St. Augustine of Canterbury first arrived in Eng-
land, he found here a chapel which had been dedicated to St. Martin
in the middle of the fifth century, and in this chapel he baptized his
first converts.

In the single devotional figures St. Martin is always represented
in his sacerdotal, never in his military character.    When it is
necessary to distinguish him from other bishops, he has a naked
beggar at his feet, looking up with adoration.    In the old French
ecclesiastical sculpture and stained glass, he has frequently a goose
at his side.    This attribute alludes, I believe, to the season at which
his festival was celebrated, the season when geese are killed and
eaten, called with us Martinmas-tide, which used to be solemnised in
France, like the last day of carnival, as a period of licensed excess.[1]

[1] We have in England about 160 churches dedicated to St. Martin.

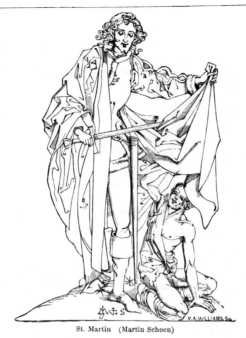

170                St. Martin   (Martin Schoen)

The famous subject called ' La Charité de Saint Martin,' or, in English, ' St. Martin dividing his cloak,' is sometimes devotionally, sometimes historically treated.

It is a devotional subject when the act of charity is expressed so simply, and with so few accessories, that it is to be understood not so much as the representation of an action, but rather as a general symbol of this particular form of charity : ' I was naked, and ye clothed me.'   I will cite, as an instance of this religious sentiment in the treatment, a picture by Carotto, which I remember over one of the altars, in the church of St. Anastasia at Verona.   The saint, in military attire, but bare-headed, and with a pensive, pitying air, bends down towards the poor beggar, who has, in his extremity, already wrapped one end of the mantle around his naked shivering body—while St. Martin prepares to yield it to him by dividing it with his sword.   There is nothing here of the heroic self-complacency

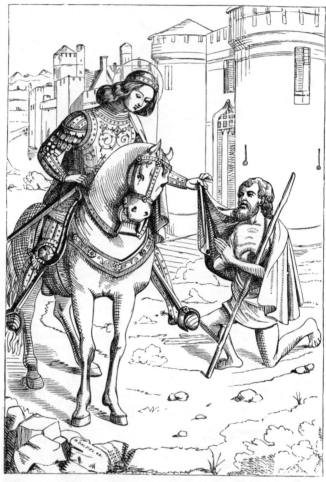

171            St. Martin divides his cloak   (French Miniature, 1500)

of the saint in Vandyck's picture; but the expression is so calm, so
simple—the benign humility of the air and countenance is in such
affecting contrast with the prancing steed and panoply of war, that

it is impossible not to feel that the painter must have been penetrated by the beauty and significance of the story, as well as by the character of the saint.

The famous picture by Vandyck at Windsor is a striking instance of the historical treatment in style and conception. Here St. Martin a fine martial figure wearing a cap and feather, brilliant with youth and grace, and a sort of condescending good-nature, advances on his white charger, and turning, with his drawn sword, is in act to divide his rich scarlet cloak with a coarse squalid beggar, while a gipsy-looking woman, with black hair streaming to the winds, holds up her child to receive the benediction of the saint. It is said that Vandyck has here represented himself mounted on the white charger which Rubens had presented to him; certainly the whole picture glows with life, animated expression, and dramatic power; but it is wholly deficient in that deep religious feeling which strikes us in the altar-piece of Carotto, and leaves an impression on the memory not trivial nor transitory :—

> Whence grace, through which the heart may understand,
> And vows, that bind the will, in silence made !

The other incidents in the life of St. Martin are less peculiar and attractive, and are not often met with separately. The miracle of the globe of fire, called ' La Messe de Saint Martin,' was painted by Le Sueur for the abbey of Marmoutier. It is a composition of fifteen figures. St. Martin stands before the altar ; he is characteristically represented as of low stature and feeble frame, but with a most divinely expressive face ; the astonishment in the countenances of those around, particularly of a priest and a kneeling woman, is admirably portrayed, without interfering with the saintly calm of the scene and place.[1]

' St. Martin raising the dead Child,' by Lazzaro Baldi, is in the Vienna Gallery. ' The slave of the Proconsul healed ' is the subject of a coarse but animated composition by Jordaens: St. Martin is in full episcopal robes—the possessed man writhing at his feet—the lord of the slave, attended by his falconer, is seen behind watching the performance of the miracle.[2]

[1] Louvre.  École française.  [2] Brussels Gal.

On a certain occasion St. Martin appeared before the Emperor
Valentinian, who, at the approach of the holy man, did not show due
respect by rising to receive him; whereupon the chair on which he sat
took fire under him, and forced him to rise.    This rather grotesque
incident I have seen represented, I think, at Assisi.

A series of subjects from the life of St. Martin often occurs in the
French stained glass of the thirteenth and fourteenth century.    We
find it at Bourges, at Chartres, at Angers, and others of the old
French cathedrals.    In the San Francesco at Assisi there is a chapel
dedicated to him covered with beautiful frescoes from his life—many
of them, unhappily, in a most ruined state.    In the first, he appears
as a youth before the Roman emperor, and is enrolled as a soldier in
the Roman cavalry; in the second, he divides his cloak with the
beggar; in the third, he is asleep on his bed, and Christ appears to
him in a vision, attended by four angels; in the fourth, he is ordained
by St. Hilary.    The rest I could not well make out, but the figures
and heads have great expression and elegance.    These frescoes are
attributed to Simone Memmi.

## St. Eloy.

*Lat.* Sanctus Eligius.    *Eng.* St. Loo.    *Ital.* Sant' Alò or Lò, Sant' Eligio.
Patron of Bologna, of Noyon; of goldsmiths, locksmiths, blacksmiths, and all workers in
metal; also of farriers and horses.    (Dec. 1, A.D. 659.)

St. Eloy was born of obscure parents in the little village of Chatelas.
He was first sent to school at Limoges, and afterwards bound apprentice
to a goldsmith of that city.    His progress in the art of design, and in
chasing and working in gold, was so rapid, that he soon excelled his
master.    He then went to Paris, where his talents as a worker in metal
introduced him to the notice of Bobbo, treasurer to Clotaire II.    About
this time it happened that King Clotaire desired to have a throne
overlaid with gold and set with precious stones,[1] but he knew not to

[1] Or a saddle.  See Maitland's 'Dark Ages,' p. 81, for the story of St. Eloy refusing to
take oaths.

whom to entrust the execution of a work which required not merely skill, but probity. The treasurer introduced Eloy to the king, who weighed out to him a quantity of gold sufficient for the work; but Eloy constructed, with the precious materials entrusted to him, not one throne, but two thrones; and with such wonderful skill that the king was filled with admiration for the perfection of the work, yet more for the probity of the workman, and thenceforth employed him in state affairs. In a word, he seems to have been much in the same circumstances as those of George Heriot at the court of our King James. The successor of King Clotaire, Dagobert, also held him in the highest esteem, and appointed him Master of the Mint. It appears that Eloy cut the dies for the money coined in these two reigns; thirteen pieces are known which bear his name inscribed. After the death of Dagobert, Eloy was so much distinguished by the holiness and purity of his life that he was thought a fit successor to the Bishop of Noyon, and he was consecrated at Rouen in the third year of Clovis II.

After he had attained to this high dignity, Eloy was not less distinguished than before for his humanity, his simplicity, and his laborious life. Out of a vast number of sermons and homilies composed for his flock, many remain to this day; and as he was remarkable for his eloquence and his power over the minds of the people, he was sent to preach the Gospel to the idolaters of Belgium, and it is even said that he was the first to carry the Gospel to Sweden and Denmark.

In the midst of all these labours and hardships, and journeyings to and fro, he still found time for his original and beloved vocation; but, instead of devoting his labour to the formation of objects of vanity and luxury, he employed himself upon the shrines of the saints and the holy vessels of the church. Thus he decorated with wonderful skill the tombs of St. Martin and St. Denis; and executed moreover the shrines of St. Germain, St. Quentin, St. Geneviève, and many others. Also he decorated with precious utensils the church of St. Columba; but soon afterwards, some robbers having carried off these riches, the inhabitants ran in haste to implore the assistance of St. Eloy. He immediately went to the church, and kneeling down in the oratory of the patron saint, he thus addressed her in a loud voice, ' Hearken, Columba, to my

words.  Our Redeemer commands that forthwith thou restore to me the jewels of gold which have been taken from this church, for otherwise I will close up the entrance thereof with thorns, so that henceforth thou shalt be no more honoured or served within these walls.'  Of course the saint delayed not, but caused the thief to restore the jewels.

Like all holy men of that time, St. Eloy was much beset by the persecutions of the arch-enemy.  On one occasion, when the pious artist was troubled by him in the midst of his work, he took his tongs out of the fire and seized the demon by the nose.  The same story is told of our Saxon saint Dunstan.  On another occasion a horse was brought to him to be shod which was possessed by a demon, and kicked and plunged so violently that all the bystanders fled in dismay ; but St. Eloy, no whit discomfited by these inventions of Satan, cut off the leg of the horse, placed it on his anvil, fastened on the shoe leisurely, and then, by making the sign of the cross, replaced the leg, to the great astonishment and edification of the faithful.[1]

172     St. Eloy  (Statue;
Or-San-Michele at Florence)

In single figures and devotional pictures, St. Eloy is sometimes represented in the short tunic and secular dress of an artisan, but more generally in the robes of a bishop, with a book or a crosier in one hand, and a hammer or tongs in the other ; or the hammer, an anvil, a pair of bellows, or other implements of smith's work, lie at his feet. There is a very famous picture of him in the *Strada dei Orefici* at Genoa, painted by the Genoese, Pelegrino Piola, in which he is represented as

---

[1] This legend is represented in bas-relief on the pedestal of his statue, in one of the niches of the exterior of Or-San-Michele at Florence.  It was executed in marble by Nanni di Banco, of the school of Donatello, and dedicated by the guild of Blacksmiths about 1420.

the patron saint of the craft; Napoleon gave orders that it should be sent to Paris, but was so firmly resisted by the company of goldsmiths, that he allowed it to remain. In an ancient statue in the cathedral at Senars, St. Eloy in the habit of a smith, wearing a small cap, a leathern apron tied round his neck, and with a hammer in his hand, stands beside his anvil, on which lies a horse's leg. He is here the patron saint of blacksmiths. As one of the patrons of Bologna, he is frequently represented in the Bologna pictures. There is a picture by Innocenzio da Imola, in which St. Eloy (or Alò) figures as pendant to St. Petronius : the legend of the demoniac horse is seen in the background.[1]

The scenes from his life are not unfrequent.

1. St. Eloy, employed in chasing a cup, is seated in front, an assistant behind. (In an old print.[2])

2. St. Eloy forging a piece of work in presence of King Dagobert; his assistant blows the bellows. (In an old print.)

3. In an altar-piece by Botticelli, St. Eloy stands as bishop. In the predella underneath he is seen at his forge, and on his anvil the horse's leg : Satan, in female attire, stands near him.[3]

4. St. Eloy seizes the demon by the nose (who is here in the form of an ' *impudica femina*'), and shoes the possessed horse : by Cavedone, —a fine picture, notwithstanding the grotesqueness of the subject.[4]

5. St. Eloy, in his workshop, presents a beautiful shrine to King Dagobert; painted for the company of goldsmiths by Empoli. The painter has given to King Dagobert and his goldsmith the costumes of Francis I. and Benvenuto Cellini.[5]

6. St. Eloy had once a heaven-sent dream. He dreamed that he saw the sun eclipsed in the beginning of his course, and the moon and three bright stars reigned in the heavens. The moon was eclipsed in her turn, and the three stars approached the meridian—but lo ! one of them was hidden from sight; soon afterwards a second disappeared, but the third shone out with increasing splendour. This dream foreshadowed the fate of the royal family. Clovis II. died young; his queen, Bathilde, after reigning for ten years as regent, followed him; two sons died successively ; the third, Thiery, reigned in prosperity.

---

[1] Berlin Gal., No. 280.  [2] Bartsch, vol. ix. p. 146.  [3] Fl. Acad.
[4] Bologna, Mendicanti.  [5] Fl. Acad.

This vision I have found in an old French print; St. Eloy is in bed, an angel draws the curtain, and points to the skies, where the sun is seen eclipsed.[1]

---

St. LAMBERT, bishop of Maestricht, and St. HUBERT, bishop of Liége, are important personages in the Flemish and German works of Art.

St. LAMBERT, who lived in the distracted time of the later Merovingian kings, was distinguished by his efforts to keep his Christian community together, and to alleviate as far as possible the horrible tyrannies, lawless oppression, and miseries of that dark period. He had, however, dared to remonstrate with Pepin d' Heristal (then *Maire du Palais*, under, or rather *over*, the weak Childeric) on his attachment to his beautiful mistress Alpaïde, the grandmother of Charlemagne. A relation of Alpaïde, revenged the interference of the bishop after the manner of that barbarous time; surprised him in his dwelling near Maestricht, and slew him, as he knelt, unresisting, with his arms extended in the form of a cross, to receive the stroke of death. He is thence honoured as a martyr, and is represented in the episcopal dress, bearing the palm, with a lance or javelin at his feet.

It is related of St. Lambert, that, when he was only an acolyte, he brought burning coals in the folds of his surplice to rekindle the incense before the altar,—a poetical allegory to express the fervour of his piety. I saw this story in a picture in the church of St. Bavon at Ghent. A good picture of the Martyrdom of St. Lambert by Carlo Saraceni is in the S. Maria dell' Anima, Rome. St. Lambert keeps his place in the English reformed calendar. (Sept. 17, A.D. 709.)

St. HUBERT, a far more celebrated saint, has, on the contrary, been banished from our English calendar. He was a nobleman of Aquitaine, who lived for some years in the court of Pepin d'Heristal,—a court, as we have seen, not remarkable for severe morality. Here

---

[1] 'The church of Durraston in Dorsetshire is named in his honour, and his legend is sculptured over the doorway.' (*Calendar of the Anglican Church.*)

Hubert abandoned himself to all worldly and sinful pleasures, but more especially to the chase, which he sometimes pursued on the days set apart by Holy Church for fasting and for prayer.

One day in the Holy Week, when all good Christians were at their devotions, as he was hunting in the forest of Ardennes, he encountered a milk-white stag bearing the crucifix between his horns. Filled with awe and astonishment, he immediately renounced all the sinful pursuits and vanities to which he had been addicted. At first he turned hermit in that very forest of Ardennes which had been the scene of his former wickedness; afterwards, placing himself under the tutelage of St. Lambert, he was ordained priest, and for twenty years distinguished himself by a life of the most edifying piety; finally he became Bishop of Liége; and died Nov. 3, 727.

The forest of Ardennes, which we can never bring before the fancy but as a scene of romance, was at this period the haunt of robbers, and the inhabitants of the neighbourhood were still heathens and idolaters. St. Hubert appears to have been one of those ecclesiastics who, in the darkest of the dark ages, carried not only religious discipline but social civilisation into the depths of the forests; and whose effigies were anciently represented, sometimes with wild animals, as wolves and bears, around them, showing that they had extirpated savage beasts and savage life, as in the pictures and statues of St. Magnus; sometimes with the stag bearing the crucifix, which among the antique symbols either expressed piety or religious aspiration in a general sense, or the conversion of some reckless lover of the chase, who, like the Wild Huntsman of the German ballad, had pursued his sport in defiance of the sacred ordinances and the claims of humanity. In this latter sense it was anciently applied, till, *realised* in the fancy of the people, the instructive allegory became an actual miracle or a wondrous legend; as in this story of St. Hubert, and that of St. Eustace, who is often confounded with him.

According to his own desire, St. Hubert was buried first in the church of St. Peter at Liége. Thirteen years after his death his body was disinterred in presence of Carloman, king of the Franks, and found entire; even the episcopal robes in which he had been

interred were without spot or stain ; and his tomb became famous
for the miracles and cures performed there.   About a century after
his death, at the request of the Benedictine monks of Ardennes, his

body was removed from Liége and
deposited in their abbey church, and
St. Hubert became thenceforth St.
Hubert of Ardennes.   The emperor,
Louis le Débonnaire, then at Aix-
la-Chapelle, assisted at the trans-
lation of the relics, and the day was
long kept as a festival throughout
this part of Flanders.

I believe this translation of the
body of St. Hubert from Liége to
Ardennes, and his reinterment in
the abbey church, to be the subject
of an old Flemish picture now in
the possession of Sir Charles East-
lake.   It was formerly styled the
burial of St. Thomas à Becket,—I
know not on what grounds, for here
we find none of the attributes of a
martyr, nor any of the miraculous
picturesque circumstances attending
the burial of St. Thomas à Becket.
On the altar, behind the principal
group, stands a shrine, on which is

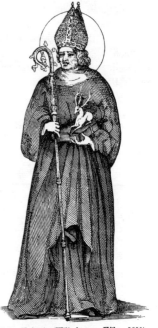

173 St. Hubert  (Wilhelm von Köln, 1830)

a little figure of St. Hubert with his hunting-horn, just as I have
seen him represented in the old French and Flemish carvings.   The
royal personage assisting is probably intended for Louis le Débon-
naire.   This picture, which is of wonderful beauty, finished in every
part, and the heads like miniature portraits in character and delicacy
of execution, is attributed to Justus of Ghent (a scholar of Hubert
van Eyck), and was probably painted about 1474.

To St. Hubert, as patron saint of the chase, chapels were often
erected within the precincts of the forest, where the huntsman might
pay his devotions to his favourite saint before he began his favourite

sport. As he was also the patron saint of dogs, we often find them introduced into pictures of him : bread blessed at his shrine was considered as a holy charm against the hydrophobia.

In the devotional figures so frequent in the old French and Flemish churches, St. Hubert is represented in his episcopal habit, with a book in one hand and a hunting-horn in the other ; or the stag, with the crucifix between its horns, stands at his side ; or, more rarely, he holds the breviary horizontally in his hands, and on it stands the miraculous stag (173). Where St. Hubert, as bishop, bears the hunting-horn, I believe he must be considered as the patron saint of the military order of St. Hubert, instituted in 1444 by Gerard, duke of Guelders ; the knights bear as their insignia a golden cor de chasse. It is necessary to distinguish carefully between the *hunting-horn* and the *drinking-horn* ; a bishop with a drinking-horn in his hand represents St. Cornelius, and the attribute of the horn is merely in allusion to his name ; he was Bishop of Rome in the third century.[1]

The vision of the miraculous stag is styled ' The Conversion of St. Hubert ; ' and here it becomes necessary, but sometimes difficult, to distinguish him from St. Eustace. We must bear in mind that St. Hubert seldom (as far as I know, never) appears in Italian Art, while St. Eustace seldom appears in Northern Europe ; St. Hubert wears the dress of a hunter, St. Eustace that of a Roman soldier. He will be found among the Warrior Saints.

The sketch (174), from a beautiful miniature in the ' Heures d'Anne de Bretagne,' will give an idea of the manner in which the conversion of St. Hubert is generally represented. The angel who flies towards him, bearing the stole in his hand, is intended to show that he exchanged the life of a hunter for that of an ecclesiastic. In the French legend it is related that when ' Monseigneur Saint Hubert ' was consecrated bishop, an angel brought down from heaven the stole with which he was invested.

The most celebrated example, however, is the rare and exquisite print of Albert Dürer, so well known to collectors. St. Hubert is

---

[1] The horn was used in ancient times to hold the consecrated oil; it was then called the Horn of Sacrament, and in the pictures of St. Cornelius may have a religious significance.

174        The Conversion of St. Hubert   (French Miniature, 1500)

kneeling, in the hunting costume of the fifteenth century, with his
horn and couteau de chasse suspended at his side, and wearing the

furred cap and the knightly spurs; his horse is near him, and his panting dogs in the foreground. On a wooded eminence stands the visionary hart, with the crucifix between his horns. This celebrated composition, having no title, has sometimes been styled St. Eustace; but I believe that in the French and German works of Art the subject may be understood to refer to the legend of St. Hubert the Hunter; in Italian pictures, it is generally St. Eustatius.[1]

In our National Gallery are two pictures from the story of St. Hubert. 1. His Conversion by the Miraculous Stag. 2. The Angel Descending with the Stole.[2]

---

Among the early Spanish bishops, ST. LEANDER and ST. ISIDORE, two brothers who were successively bishops of Seville, and became the patrons of the city, are found represented in the pictures of the Seville school. Both these saints were chiefly distinguished as the determined opponents of Arianism in Spain. St. Leander is styled the 'Apostle of the Goths;' St. Isidore, the 'Egregius Doctor of Spain.'

In the dissensions between the Catholics and the Arians, Hermengildus, son of King Leovigild, relinquished the Arian faith, and was put to death by his father: he has been regarded as one of the famous martyrs of Spain. The arms of the city of Seville exhibit St. Ferdinand, King of Castile and Leon, on a throne with St. Leandro on one side, and St. Isidore on the other. And, in the pictures of Roelas and Herrera, we often find the princely martyr, St. Hermengildo, attended by the two bishops; or sometimes St. Justa and St. Rufina, St. Leander and St. Isidore, the four patrons of Seville, are in the same picture.

Among the *chefs-d'œuvre* of Murillo are counted the San Leandro

---

[1] The Life of St. Hubert, in a series of eight bas-reliefs, has been lately executed by Wilhelm Geefs, a Belgian sculptor of great reputation, for the shrine in the church of St. Hubert in Ardennes. They are designed with much poetic feeling in the picturesque style of the early *Renaissance*. There are fine casts in the Crystal Palace (No. 109, French Court); and for a full description, see the 'Handbook to the Modern Sculpture,' p. 41.

[2] These are attributed to the Meister von Werden (252). In another picture by the same old German (250), St. Hubert is attired as bishop, with the stag on his book.

and the San Isidoro, each enthroned, robed in white, and wearing their mitres,—noble and characteristic heads, now in the Cathedral at Seville. The masterpiece of Roelas is the fine picture of the death of St. Isidore (*el Transito de San Isidoro*), where he is expiring on the steps of the altar, after dividing his substance among the poor; and the masterpiece of Herrera is the apotheosis of St. Hermengild, where, after his martyrdom, the Gothic prince is seen carried into glory, arrayed in a cuirass of blue steel and a red mantle, and holding a cross. St. Isidore stands on the left, St. Leander on the right; and the son of Hermengild, a beautiful fair-haired boy, is gazing rapturously upwards, as his sainted father mounts to heaven.[1]

The other Spanish bishops who are most remarkable as subjects of Art—for example, St. Ildefonso, St. Thomas of Villanova, &c.—belonged to the regular Monastic Orders.[2]

---

[1] For a further account of these pictures, see Mr Stirling's 'Annals of the Artists in Spain.' He thus describes the death of St. Isidore : 'Clad in pontifical robes, and a dark mantle, the prelate kneels in the foreground expiring in the arms of a group of venerable priests, whose snowy hair and beards are finely relieved by the youthful bloom of two beautiful children of the choir, who kneel beside them ; the background is filled up with the far-receding aisle of the church, some altars, and a multitude of sorrowing people. At the top of the picture, in a blaze of light, are seen our Lord and the Virgin enthroned on clouds.' He adds : 'For majesty of design, depth of feeling, richness of colour, and the various beauty of the heads, and for the perfect mastery which the painter has displayed in the use of his materials, this altar-piece (in the church of St. Isidore at Seville) may be ranked amongst the greatest productions of the pencil;' and he compares it with Domenichino's 'Communion of St. Jerome' in the Vatican. Juan de las Roelas was one of the earliest and greatest painters of the Spanish school. I cannot but remember that a most admirable and interesting picture by Roelas was sold in the Soult collection for less than one half of the sum which the former (not the present) managers of the National Gallery thought fit to give for a coarse, bedaubed, fifth-rate Titian. For the story of Hermengild, see Gibbon, c. xxxvii.

[2] See 'Legends of the Monastic Orders.'

# The Hermit Saints.

## St. Paul, St. Anthony, and the Hermits of Syria and Egypt in the Third and Fourth Centuries.

Amongst the most interesting, most picturesque, most imaginative productions of the early ages of Art, are the representations of the Hermits of the Desert. Every one who has looked at pictures recognises at once the image of their chief and leader, St. Anthony the abbot, with his long white beard, his crutch, his bell, and his pig; but we must look back to the contemporary state of society, and to a most curious and most interesting period of Church history, to comprehend the large circle of suggestive association which such effigies, however rude in themselves, may excite in the thinking mind.

Towards the end of the third century, the Roman Empire, though it still held together, was fast crumbling to dissolution. It was in a state analogous to that of the decrepit human frame when we say it is breaking up; the vital functions go on for a time, but weak and intermitting;—neither potions nor physicians can do more than postpone the evil hour.

The throes of the perishing Colossus were, however, fearful. A glance at the countries which composed the vast heterogeneous mass of the Roman Empire will show us rottenness and corruption at the centre, and utter disorganisation towards the extremities. In the distant governments there was no security for life or for property: wars, famines, tyrannies, had desolated the provinces. The religious persecutions which had broken out in the days of the last heathen emperors, and the dissensions caused by that very religion which preached peace, added to the horrors of the time.

In this state of things, the promises of the Millennium had seized on the imaginations of the Christians. Many of them believed that the end of the world was near, that there was no help for man in his fellow-man, nor profit in the labour of his hands;—no good anywhere, no hope, no rest, no peace, but in heaven.

In the persecution under the Emperor Decius, PAUL of Thebes, a Christian youth of noble family, terrified less by the tortures which were threatened, than by the allurements which were tried, to induce him to deny his faith, fled to the desert to the east of the Nile; and, wandering there alone, he found a cavern, near to which was a date-tree and a fountain of clear water; and he chose this for his dwelling-place, eating of the fruit of the date-tree, drinking from the stream which bathed its roots, and, when the raiment which he wore had fallen to rags, clothing his wasted frame in a sort of mat formed of the palm-leaves woven together.

Thus he lived for the space of ninety-eight years, far from the haunts of men, and having, in all that time, only casual communication, and at long intervals, with his kind. But it was the Divine will that his long penance, and his wondrous virtues, as they were then deemed, should be made known for the edification of men, through the medium of another saint even more renowned, the blessed St. Anthony. As Paul is regarded as the founder of the anchorites or solitary hermits, so Anthony is regarded as the founder of the Cenobites, or hermits living in communities: in other words, the founder of Monachism. Under his immediate disciple, Pachomius, the first cloister was erected in an island surrounded by the Nile. Hilarion, a native of Gaza, in Palestine, who had been sent by his parents to study philosophy at Alexandria, was also converted by St. Anthony, and became the founder of the first monastery in Syria: Basil, his disciple, founded the first in Asia Minor. Jerome, who had visited Anthony in his desert, carried the fashion into Italy and Gaul; and thus, Monachism, which originated in the hermit-life in Egypt, spread, in a short time, over the whole of Eastern and Western Christendom.

The hermits were at first bound by no very strict rules. They took no vows; and many wandered about in companies, mingling with the people; like certain modern fanatics, they held in scorn all human learning, and founded their notions of orthodoxy on some obscure feeling of what was, or was not, true piety. Thus, while they turned away the exercise of human intellect and reason from all objects of utility, from all elevating, all strengthening purposes, their traditional

M & S

A. J. _Scott_.

*St. Anthony*
*lifted into the air and tormented by Demons.*

theology shut out all improvement, all research ; and their ignorant
enthusiasm, if it sometimes assisted, often endangered, the progress
of religion.   To them the laws of the state presented no barriers ;
they did not acknowledge the authority of the civil magistrates ;
they united to their religious fanaticism a cynical indifference
to the social duties and the proprieties of life.   Such was the state
of Monachism in its commencement, from the middle of the fourth
century down to the great monastic reformation, and the institution
of the first regular order of monks by Benedict, in the middle of the
fifth century.   In reading the stories which are related of these
solitaries, it is sometimes with feelings of disgust, sometimes with
pity, sometimes not without a sense of amusement, at their childish
absurdities.   But, in the midst of all this, we are not seldom charmed
by instances of sincerity and self-denial, and by pictures of simplicity
and tranquillity of life, intermingled with beautiful and poetical
parables, which, when reproduced in the old works of Art, strongly
interest the imagination.

## St. Anthony and St. Paul, Hermits.

*Ital.* Sant' Antonio Abbate, or l'Eremita.   *Fr.* St. Antoine l'Abbé.   *Ger.* Der Heilige Anton,
or Antonius.   (Jan. 17, A.D. 357.)

' ANTHONY was born at Alexandria in Egypt; his parents died when
he was only eighteen, and left him with a noble name, great riches,
and an only sister, whom he loved tenderly ; but from his childhood
he had been of a melancholy, contemplative disposition ; and now that
he was left master of himself, with power and wealth, he was troubled
by the fear of the temptations of the world, and by the burthen of the
responsibilities which his possessions imposed upon him.

' One day, as he entered into a church to pray, he heard these
words : " Every one that hath forsaken houses, or brethren, or sisters,
or father, or mother, or wife, or children, or lands, for my name's
sake, shall receive a hundred-fold, and shall inherit everlasting life." [1]

[1] Matt. xix. 29 ; Acts iv. 32.

And he left the house of God sad and disturbed; and while he was yet meditating on their import, on another day he entered into another church, and at the moment he entered the priest was reading these words : " If thou wilt be perfect, go and sell all thou hast, and give to the poor, and thou shalt have treasure in heaven." [1] Anthony received this repeated admonition as a warning voice from heaven; and he went forthwith, and dividing his hereditary possessions with his sister, he sold his own share, distributing the money to the poor ; and then, with no other raiment than what he wore at the time, and with his staff in his hand, he departed from the city, and joined a company of hermits, who had already fled from the persecutions of the heathen and the corruptions of the time, and who lived in community, but in separate cells.

'Here he dwelt for some time in great sanctity and rigid self-denial; and observing the lives of the hermits around him, he thought to attain perfection by imitating from each the virtue for which he was most distinguished,—the chastity of one, the humility of another, the silent devotion of a third. He would pray with him who prayed, fasted with him who mortified his body, and mingled contrite tears with him who wept. Thus he united in himself all their various merits, and became even in his youth an object of admiration and wonder and reverence to all.

' But the sight of such amazing virtue and sanctity was naturally displeasing to the enemy of mankind, who had sagacity enough to foresee that the example of this admirable saint would lessen his own power in the world, and deprive him of many votaries ; therefore he singled him out as an object of especial persecution, and gave him over to his demons to be tormented in every possible way. They began by whispering to him, in the silence of his cell, of all that he had sacrificed for this weary life of perpetual rigour and self-denial; they brought to mind his noble birth, his riches, and all that riches could obtain,—delicate food, rich clothing, social delights. They pictured to him the fatigue of virtue, the fragility of his own frame, the brevity of human life; and they sang to him in sweetest accents, " While thou livest, enjoy the good things which have been provided for thee." The saint endeavoured to drown these promptings of the devil in the voice of prayer ;—he prayed till

[1] Matt. xix. 21.

the drops stood on his brow, and at length the demon ceased to whisper to him, but only to have recourse to stronger weapons; for, seeing that wicked suggestions availed not, Satan raised up in his sight the sensible images of forbidden things. He clothed his demons in human forms; they spread before Anthony a table covered with delicious viands; they hovered round him in the shape of beautiful women, who, with the softest blandishments, allured him to sin. The saint strove against this temptation with all his might, and prayed, and conquered. But, in his anguish, he resolved to flee yet farther from men and from the world; and, leaving the company of the hermits, travelled far, far away into the burning desert, and took up his abode in a cave, whither, as he hoped, Satan would not follow to molest him. He fasted more rigorously than ever; ate but once a day, or once in two or three days; slept on the bare earth, and refused to look upon any living creature. But not for this did the cruel demon relax in his persecution. As he had already tried in vain the allurements of appetite and pleasure, so now he thought to subdue the saint by the influence of pain. Spirits in hideous forms pressed round him in crowds, scourged him, tore him with their talons, chased him from his cell; and one of the hermits he had left behind, who was wont to carry him food, found him lying on the sands senseless, apparently dead. Then he flung down the food he had brought, and taking the miserable sufferer in his arms, he carried him to one of the cells, where, after a long time, he was restored to his senses and recollection.

‘ But no sooner had Anthony opened his eyes, and beheld around him his sympathising brethren, than he closed them again, and desired to be taken back to his cave; which was done, and they laid him on the ground and left him;[1] and Anthony cried out and defied the demon, saying, “Ha! thou arch-tempter! didst thou think I had fled? lo, here I am again, I, Anthony! I challenge all thy malice! I spit on thee! I have strength to combat still!” When he had said these words, the cavern shook, and Satan, rendered furious by his discomfiture, called up his fiends, and said, “Let us now affright him with all the terrors that can overwhelm the soul of man.” Then

[1] See, in the Berlin Gallery (1198), a strange grotesque picture by Jerome Bosch; but in the catalogue the monks are styled demons.

hideous sounds were heard; lions, tigers, wolves, dragons, serpents, scorpions, all shapes of horror, "worse than fancy ever feigned, or fear conceived," came roaring, howling, hissing, shrieking in his ears; scaring him, stunning him;—but, in the midst of these abominable and appalling shapes and sounds, suddenly there shone from heaven a great light, which fell upon Anthony, and all these terrors vanished at once, and he arose unhurt and strong to endure. And he said, looking up, " O Lord Jesus Christ! where wert thou in those moments of anguish?" And Christ replied, in a mild and tender voice, " Anthony, I was here beside thee, and rejoiced to see thee contend and overcome. Be of good heart; for I will make thy name famous through all the world."

' So he was comforted; but he resolved to go yet farther from all human intercourse, all human aid; and he took his staff and wandered forth; and as he traversed the desert he saw heaps of gold and vases of silver lying in his path; but he knew full well they were the delusions of Satan; he would not look upon them, but turned his eyes away, and lo! they dissolved into air.

' And Anthony was thirty-five years of age when he shut himself up in the cavern, in which he dwelt for twenty years. During all that time he never saw nor was seen of any: and when at last he reappeared, it was plainly perceived that miraculous comfort and aid had been granted to him; for he was not wasted by the fasts he had endured, nor was he pale of cheer, though he had scarcely seen the sun in all that time; nor was he changed, except that his hair was white, and his beard of venerable length. On the contrary, he was of a mild and serene aspect, and he spoke kindly words to all; and consoled the afflicted; and healed those who were sick; and expelled demons (who, we are told, after their signal defeat, held him in such awe and terror, that his very name was sufficient to make them flee); reconciled those who were at feud; and preached to all men the love of God, and abstinence, and purity of life: and multitudes were so convinced by his example and his eloquence, that they retired to the desert, and became his disciples, living in caves hollowed out of the sandy hills, and in the ancient tombs; and at one time there were more than five thousand hermits assembled round him, and he performed many wonders and many miracles in the desert.

' One night, as Anthony sat in his cell, he heard a knocking at the door, and, going to see who it was there, he beheld a man of a terrible aspect, and of gigantic stature; and he said, " Who art thou?" The stranger answered, " I am Satan, and I come to ask thee how it is that thou and all thy disciples, whenever ye stray into sin, or any evil befall ye, lay the blame and the shame on me, and load me with curses?" And Anthony said, " Have we not cause? Dost thou not go about seeking whom thou mayest devour, and tempt us and torment us? And art thou not the occasion of fall to many?" And the demon replied, " It is false! I do none of these things of which men accuse me; it is their own fault; they allure each other to sin; they torment and oppress each other: they are tempted of their own evil propensities; they go about seeking occasion to sin; and then they weakly lay the cause at my door: for, since God came upon earth, and was made man to redeem man, my power is at an end. Lo! I have no arms, I have no dwelling-place, and, wanting everything, can perform nothing. Let men complain of themselves, not of me; not I, but they alone are guilty." To which the saint, marvelling at so much sense and truth from the lips of the devil, replied, " Although thou art called the father of lies, in this thou hast spoken the truth; and even for this, blessed be the name of Christ!" And when Satan heard the holy name of the Redeemer, he vanished into air with a loud cry: and Anthony, looking out, saw nothing but the desert, and the darkness of the night.

' On another occasion, as the hermits around him were communing together, there arose a question as to which of all the virtues was most necessary to perfection. One said, chastity; another, humility; a third, justice. St. Anthony remained silent until all had given their opinion, and then he spoke. " Ye have all said well, but none of you have said aright: the virtue most necessary to perfection is prudence; for the most virtuous actions of men, unless governed and directed by prudence, are neither pleasing to God, nor serviceable to others, nor profitable to ourselves."

' These are some of the parables and wise sayings with which the blessed St. Anthony instructed his disciples.

' And when he had reached the great age of ninety years, and had lived in the desert seventy-five years, his heart was lifted up by the

thought that no one had lived so long in solitude and self-denial as he had done. But there came to him a vision in the deep midnight, and a voice said to him, "There is one holier than thou art, for Paul the hermit has served God in solitude and penance for ninety years." And when Anthony awoke, he resolved to go and seek Paul, and took his staff and set forth. As he journeyed across the desert, he met a creature half man and half horse, which by the poets is called a centaur, and he asked him the way to the cave of Paul, which the centaur, who could not speak intelligible words, indicated by pointing with his hand; and farther on, coming to a deep narrow valley, he met a satyr; and the satyr bowed down before him, and said, "I am one of those creatures who haunt the woods and fields, and who are worshipped by the blind Gentiles as gods. But we are mortals, as thou knowest, and I come to beseech thee that thou wouldst pray for me and my people, to thy God, who is my God, and the God of all." And when Anthony heard these words, the tears ran down his venerable face, and trickled down his long white beard, and he stretched out his arms towards Thebes; and he said, "Such be your gods, O ye pagans! Woe unto you when such as these confess the name of Christ, whom ye, blind and perverse generation, deny!"[1]

'So Anthony continued his journey all that day and the next; and on the third day, early in the morning, he came to a cavern overhung with wild and savage rocks, with a palm-tree, and a fountain flowing near, and there he found the hermit Paul, who had dwelt in this solitude for ninety years.

'It was not without difficulty, and yielding to his prayers and tears, that Paul at length admitted him. Then these two venerable men, after gazing for a while upon each other, embraced with tears of joy, and sat down by the fountain, which, as I have said, flowed by the mouth of the cave; and Paul asked of Anthony concerning the world, and if there yet existed idolaters; and many other things; and they held long communion together. While they talked, forgetting the

---

[1] St. Jerome, in telling this story, adds, that though this apparition of the satyr may appear to some to be incredible, yet all the world knows that one of these monsters was brought to the Emperor Constantine, at Alexandria, and that afterwards the body was preserved for the edification of those who were curious in such matters.

flight of time and the wants of nature, there came a raven, which
alighted on the tree, and then, after a little space, flew away, and
returned carrying in his beak a small loaf, and let it fall between them;
then Paul, lifting up his eyes, blessed the goodness of God, and said,
" For sixty years, every day, hath this raven brought me half a loaf;
but because thou art come, my brother, lo ! the portion is doubled,
and we are fed as Elijah was fed in the wilderness." Then there
arose between these two holy men a contention, out of their great
modesty and humility, which of the two should break the bread ; at
last they both took hold of the loaf and broke it between them.　Then
they ate, and drank of the water of the fountain, and returned thanks.
Then Paul said to Anthony, " My brother ! God hath sent thee here
that thou mightest receive my last breath and bury me.　Go, return
to thy dwelling ; bring here the cloak which was given to thee by that
holy bishop, Athanasius, wrap me in it, and lay me in the earth."
Greatly did Anthony wonder to hear these words, for the gift of the
cloak, which Athanasius had bestowed on him some years before,
was unknown to all ; but he could only weep, and he kissed the aged
Paul, and left him and returned to his monastery.　And thinking
only of Paul, for no other thought could enter his mind, he took
down the cloak, and went forth again, and hastened on his way, fear-
ing lest Paul should have breathed his last breath ere he could arrive
at the cave.　When he was at the distance of about three hours'
journey from the cavern, he heard of a sudden the most ravishing
music, and, looking up, he beheld the spirit of Paul, bright as a star,
and white as the driven snow, carried up to heaven by the prophets
and apostles, and a company of angels, who were singing hymns of
triumph as they bore him through the air, until all had disappeared.
Then Anthony fell upon his face and scattered dust on his head, and
wept bitterly, saying, " Alas ! Paul, alas ! my brother, why hast thou
left me ? why have I known thee so late, to lose thee so early ? " And
when he had thus lamented, he rose in haste, and, with all the speed
of which his aged limbs were capable, he ran to the cave of Paul,
and when he reached it he found Paul dead in the attitude of prayer.
Then he took him in his arms, and pressed him, and wept abundant
tears, and recited over the cold remains the last offices of the dead; and
when he had done this, he thought how he might bury him, for he had

no strength to dig a grave, and it was three days' journey from the convent; and he thought, "What shall I do? would it might please God that I might lie down and die at thy side, O my brother!" And as he said these words, behold, two lions came walking towards him over the sandy desert; and when they saw the body of Paul, and Anthony weeping beside it, they, by their roaring, expressed their sympathy after their manner, and they began to dig in the sand with their paws, and in a short time they had dug a grave. When Anthony saw this, he was amazed, and blessed them, saying, " O Lord, without whose divine providence no leaf can stir upon the tree, no little bird fall to the ground, bless these creatures according to their nature, who have thus honoured the dead!"—and the lions departed.

' Then Anthony took the dead body, and, having wrapped it in the cloak of Athanasius, laid it reverently in the grave.

' When these things were accomplished, he returned to his convent and related all to his disciples, and not only they believed, but the whole Catholic Church; so that, without any further testimony, Paul has been canonised, and has since been universally honoured as a saint.

' After this, Anthony lived fourteen years; and when he was in his hundred-and-fifth year, he showed to his disciples that he must shortly die. And they were filled with the profoundest grief, and fell at his feet, and kissed them, and bathed them with tears, saying, " Alas! what shall we do on earth without thee, O Anthony! our father, instructor, and friend?" But he comforted them; and withdrawing to a solitary place, with a few of his monks, he exacted from them a solemn promise, that they would reveal to no man the spot in which he was buried: then, as they prayed around him, he gently drew his last breath, being full of days and good works; and the angels received his spirit, and carried it up to heaven, to taste of bliss eternal. Amen!'

The devotional figures of Paul the Hermit represent him as a man in extreme old age; meagre, half naked, his only clothing a mat of palmleaves, having his legs and arms bare, his beard and hair white and of great length. He is generally seated on a rock, in deep meditation.

There ought to be a palm-tree near him, and a fountain at his feet; but these are not always attended to. He is not often introduced in the Madonna pictures, or grouped with other saints; but is often a solitary figure in a landscape. Sometimes a raven is introduced, bringing him food; and then it is necessary to observe the peculiar dress of interwoven leaves, and the meagre, superannuated look, to distinguish the pictures of Paul (*Primo Eremita*) from those of Elijah in the wilderness;—the haggard, wasted, self-abased penitent, from the majestic prophet.

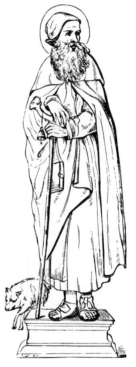

The most important, and I must add the most disagreeable representation I have seen of St. Paul the Hermit, is a figure, by Spagnoletto, life-size, seated, undraped except by a girdle of palm-leaves, with a skull at his side: in the background St. Anthony is seen crossing the desert; and in the air is seen the raven who brought them bread.[1]

Devotional figures of St. Anthony occur more frequently, and are easily recognised. He has several distinctive attributes, each significant of some trait in his life or character, or of the sanctity and spiritual privileges popularly ascribed to him.

1. He wears the monk's habit and cowl, as founder of monachism; it is usually black or brown. In the Greek pictures, and in the schools of art particularly influenced by Greek traditions, the figures of Anthony, besides the monkish garb, bear the letter T on the left shoulder, or on the cope; it is always blue. In Revelation xiv. 1, the elect, who are redeemed from the earth, bear the name of God the Father written on their foreheads: the first letter of the Greek word *Theos*, God, is T, and

175    St Anthony
(Carotto. Leuchtenberg Gal.)

[1] Turin Gal.

Anthony and his monks are represented bearing the T.—'For these are they which follow the Lamb whithersoever he goeth. These were redeemed from among men, and in their mouth was found no guile, for they are without fault before the throne of God.' In a specimen of painted glass (from *St. Denis*) a man in a turban or crown marks another with the T on the forehead; three others stand bareheaded, and over the whole in Gothic letters is inscribed, 'Signum Tau.'

2. The crutch given to St. Anthony marks his age and feebleness.

3. The bell, which he carries in his hand, or suspended to his crutch, or to a cross near him, has reference to his power to exorcise evil spirits. According to Durandus, the devil cannot endure the sound of a consecrated bell. 'It is said that the wicked spirits that be in the region of the air fear much when they hear the bells ringen: and this is the cause why the bells be ringen when it thundereth; to the end that the foul fiends and wicked spirits should be abashed, and flee, and cease from moving of the tempest.' When the passing bell tolled in the house of death, it was conceived to answer a double purpose; it advertised all good Christians to pray for the departing soul, and it scared away the demons who were hovering around, either with the hope of seizing the liberated spirit as their prey, or at least to molest and impede it in its flight to heaven. With great propriety, therefore, is the bell placed near St. Anthony, who had so great occasion for it in his own person, and was besides renowned for the aid he gave to others in the same predicament.

4. For the same reason, and as an instrument of exorcism, the asperges—the rod for sprinkling holy water—is put into the hand of St. Anthony; but it is not peculiar to him, for we find it an attribute of St. Benedict, St. Martha, and other saints famous for their contests with the devil.

5. I have read somewhere that the hog is given to St. Anthony because he had been a swineherd, and cured the diseases of swine. This is quite a mistake. The hog was the representative of the demon of sensuality and gluttony, which Anthony is supposed to have vanquished by the exercises of piety and by Divine aid. The ancient custom of placing in all his effigies a black pig at his feet, or under his feet, gave rise to the superstition, that this unclean animal was especially

dedicated to him, and under his protection. The monks of the Order of St. Anthony kept herds of consecrated pigs, which were allowed to feed at the public charge, and which it was a profanation to steal or kill : hence the proverb about the fatness of a ' Tantony pig.'

6. Flames of fire are often placed near St. Anthony and under his feet, or a city or a house is burning in the background, signifying his spiritual aid as patron saint against fire in all shapes, in the next world as well as in this.[1]

With one or more of these attributes St. Anthony is seen alone, or in the Madonna pictures grouped with other saints. I shall give a few instances only, for in such representations he is not easily mistaken.

1. In an ancient Greek panel-picture of the 12th century,[2] St. Anthony is seen half-length, in the habit of a Greek monk, and wearing a sort of coif on his head ; with the right hand he gives the benediction in the Greek form ; in the left he bears a scroll with a Greek inscription, signifying that he knows all the arts of Satan, and has weapons to oppose them.

2. Col' Antonio del Fiore. St. Anthony, seated in a monk's habit, with a bald head and very long white beard, holds in one hand a book, the other is raised in the act of benediction; two angels, kneeling before him, hymn his praise with harp and dulcimer, and two cherubim are seen above.[3]

3. St. Anthony, seated, with flames under his feet. A beautiful miniature, in the ' Heures d'Anne de Bretagne.'[4]

4. In a print by Albert Dürer, St. Anthony is seated on the ground, reading intently, his face hidden in his cowl; by his side stands a cross, to which is suspended a bell; in the background the citadel of Nuremberg, which I suppose to be a caprice of the artist. This print is celebrated for the beauty of the execution, as well as for its fine solemn feeling.

St. Anthony reading or meditating in his cell, with the skull and

---

[1] Thus, in the beautiful Madonna by Bonvicino in the Museum at Frankfort, she is attended on one side by St. Anthony, the protector against fire, and on the other by St. Sebastian, the protector against pestilence.

[2] Eng. D'Agincourt, Pl. 86.  [3] Naples, A.D. 1371.  [4] MS. Paris, Bib. Imp.

crucifix (the general symbols of penitence) beside him, is a common subject; and where there is no attribute peculiarly significant, he might be confounded with St. Jerome: this, however, is seldom the case, and in general there is a distinct character attended to. There ought, in fact, to be a marked difference between the simple-minded portly old hermit Anthony in his long robes, and the acute theological doctor doing penance for his learning—emaciated, eager, and half naked. As Anthony despised all learning, the book which is often put into his hand is less appropriate to him than the other attributes. It must, however, be borne in mind, that a book is given to all the early fathers who left writings behind them: and St. Anthony is the author of seven theological epistles still extant.

With regard to the historical representations, the subject called the ' Temptation of St. Anthony ' is by far the most common.

In the earlier pictures it is very simply treated: St. Anthony is praying in his cell, and the fiend, in shape like a beautiful woman, stands behind him; the saint appears fearful to turn his head. In the later schools, and particularly the Dutch schools, the artists have tasked their fancy to the utmost to reproduce all the foul and terrible shapes, all the ghastly and obscene vagaries, which solitude could have engendered in a diseased and excited brain. Such is the celebrated engraving of Martin Schoen, in which St. Anthony is lifted up into the air by demons of the most horrible and grotesque forms; such are the pictures of Teniers, who had such a predilection for this subject, that he painted it twelve times with every variety of uncreated abominations. Such are the poetical demoniac scenes of Breughel; such is the famous print by Callot.[1] In a picture by Salvator Rosa, a single gigantic demon bestrides the prostrate saint like a horrid nightmare. In a picture by Ribera, the demon, in female shape, has seized on the bell, and rings it in his ears to interrupt his prayers. The description in the legend has been closely followed in the picture by Annibal Caracci, now in our National Gallery.

I recollect a picture in which St. Anthony is tempted by three beautiful women, who have much the air of opera-dancers, long and thin, in scanty draperies; one pulls his beard, another twitches his

---

[1] Of which the original picture is at Malahide Castle, near Dublin.

robe, a third gazes up in his face; the miserable saint, seated on the ground, with a look of intense suffering, and his hands clenched in prayer, seems to have set himself to endure: mocking demons fill the air behind.

The locality of the temptation of St. Anthony ought to be the interior of an Egyptian sepulchre or temple. The legend relates that he took refuge in a *ruin;* and the painters, unfamiliar with those grand and solemn and gigantic remains which would have given a strange sublimity to the fearful scene, sometimes make the ruin an old brick house or Gothic chapel.

Other subjects from the life of St. Anthony occur less frequently. By L. Caracci, we have St. Anthony instructing the hermits.[1]

The death of St. Anthony, surrounded by his monks, is a frequent subject. Sometimes angels are seen carrying his soul into heaven; in a picture by Rubens, the pig is seen looking out from under the bed of the dying saint,—a grotesque accessory, which might well have been omitted.

The legend of the meeting between St. Paul and St. Anthony has been very popular in Art, and a favourite subject in convents. It is capable of the most beautiful and picturesque treatment. I shall give a few celebrated examples.

1. Pinturicchio. Paul and Anthony divide the loaf which is brought by a raven; three evil spirits, in the form of beautiful women, stand behind St. Anthony, and two disciples behind St. Paul.[2]

2. Lucas v. Leyden. St. Paul and St. Anthony (who wears his large cowl drawn over his head) are seated in the wilderness; the raven, after depositing the loaf, flutters along the ground in front: a very quaint and curious little picture, full of character.[3]

3. Velasquez. St. Anthony visits Paul the hermit; he appears before the door of the cavern, and craves admittance.[4]

There are in the Berlin Gallery four small pictures (1085 and (1086), forming the predella of an altar-piece, and representing the story of St. Paul and St. Anthony.

---

[1] Brera, Milan, No. 39.  [2] Vatican.  [3] Lichtenstein Gal., Vienna  [4] Madrid Gal.

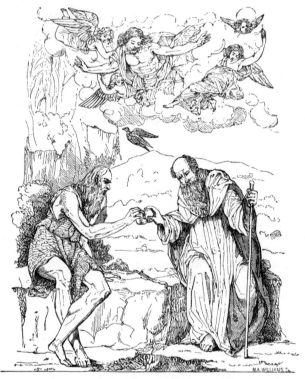

176　　　　　Paul and Anthony　(Brusasorci. 1530. Brera Gal.)

In general, however, there are only the two figures in a solitary landscape, which is much more striking; as in the illustration,[1] and also in a fine picture by Guido:[2] the two lions, or the centaur, are sometimes introduced into the background.

4. B. Passari.  The death of Paul the hermit; angels are kneeling by, and two lions dig his grave.

5. St. Anthony coming to visit Paul, finds him dead, lying on a mat,

[1] In the original picture by Brusasorci, the satyr and the centaur are seen far off and diminutive in the background.　　　　　[2] Berlin Gal.

with a skull, a book, and a rosary near him.  In the background the two lions are digging a grave in the sand.  A large engraving, signed ' Biscaino.'[1]

I have said enough of these celebrated saints to render the subjects in which they figure intelligible and interesting.  The other hermits of the desert who appear in Art are much less popular ; and as they are generally found grouped together, I shall so treat them.

St. Onuphrius (Onofrio, Honofrio, Onuphre), a monk of Thebes, retired to the desert far from the sight of men, and dwelt there in a cave for sixty years, and during all that time he never beheld one human being, nor uttered one word of his mother tongue except in prayer.  He was unclothed, except by some leaves twisted round his body, and his beard and hair had become like the face of a wild beast. In this state he was discovered by a holy man whose name was Paphnutius, who, seeing him crawling along the ground, knew not, at first, what like thing it might be, and was afraid; but when he found it was indeed a man, he was filled with amazement and admiration at so much sanctity, and threw himself at his feet.  Then the hermit showed him what trials he had endured in his solitude, what pains of hunger and of thirst, what parching heat and pinching cold, what direful temptations, and how God had sent his angel to comfort him and to feed him.  Then he prayed that Paphnutius would remain to bury him, as his end was now approaching; and having blessed his visitor, he died.  So Paphnutius took off his own cloak, and having torn it in two pieces, he wrapped the body of the holy hermit in one half of it, and laid him in a hole of the rock, and covered him with stones ; and it was revealed that he should not remain there, but depart and make known to all the world the merits of this glorious saint and hermit.

The name and fame of this saint came to us from the East: and he is interesting because many convents in which the rule of solitude and exclusion was rigorously enforced were placed under his protec-

[1] Bartsch, xxi. 200.  There is a good impression in the British Museum.

tion.   Every one who has been at Rome will remember the beautiful
Franciscan monastery of Sant' Onofrio in the Trastevere, where Tasso
breathed his last, and in which he lies buried.

St. Onofrio is represented as a meagre old man, with long hair and
beard, grey and matted; a leafy branch twisted round his loins, a
stick in his hand.   The artist generally endeavours to make him look
as haggard and unhuman as possible, and I have seen him in some
early prints and pictures very much like an old ouran-outang,—I
must write the word, for nothing else could express the unseemliness
of the effigy.   I have seen him standing, covered with his long hair,
a crown, a sceptre, and gold and silver money lying on the ground at
his feet, to express his contempt for earthly glory and riches; as in
a Spanish picture once in the Louvre.

---

St. Job (San Giobbe), a saint who figures only in the Venetian
pictures with the attributes of St. Onofrio, and who has a church at
Venice, was, I believe, the patriarch of the Old Testament.[1]

St. Moses (San Moisè), who is also confined to Venetian Art, was
a converted robber, who turned hermit.

---

St. Ephrem of Edessa was a hermit of Syria, who, on account of
some homilies and epistles of great authority, takes rank as one of the
Fathers of the Greek Church.   He is memorable in Art as the subject
of a most ancient and curious Greek picture.   It represents the ' Ob-
sequies of St. Ephrem ;' in front he lies dead, wept by many hermits ;
and in the background are seen the caves of the anchorites, some
reading, some doing penance, others in conversation.   In the centre
of the picture is seen the famous anchorite, Simeon Stylites, who

---

[1] The intercourse of Venice with the East introduced the prophet Job as a saint into the
north of Italy.   St. Job was a favourite patron of hospitals, and particularly of lepers.   It
is in this character we find him in the Venetian pictures ; for example, in a beautiful group
by Bellini, now in the Academy at Venice.

passed thirty years on the top of a pillar, exposed to all the vicissitudes of the seasons : he brought this kind of penance into fashion, for we find it frequently imitated. The picture of the ' Obsequies of St. Ephrem' is engraved in D'Agincourt's work, and in Pistolesi's ' Vaticano,' and should be considered (by those who have these works at hand) with reference to the illustration of the hermit-life, as I have endeavoured to describe it.

But the most interesting of all these representations is the great fresco in the Campo Santo at Pisa; and a repetition, with some variations, in a small picture in the Florentine Gallery ; both by Pietro Laurati, containing, in a variety of groups, the occupations of the hermits, with distinct scenes and incidents from the lives of the most celebrated among them. In the annexed etching, I have given a sketch from this composition. We have—1. The visit of Anthony to the hermit Paul. 2. The death of Paul, and the lions digging his grave. 3, 4. The temptation of Anthony, first haunted, tormented, and flagellated by demons ; 5. then comforted by a vision of our Saviour, as in the legend. 6. In one place he is beating the demon out of his cave with his crutch ; in another, carving wooden spoons. 7. Farther to the right is St. Hilarion, riding on his ass ; 8. and by the sign of the cross vanquishing a great dragon which ravaged Dalmatia, and commanding the beast to leap into the fire and be consumed and destroyed for ever : his companion is seen fleeing in terror. 9. On the left, St Mary of Egypt receives the sacrament from Zosimus. 10. Demons, in the disguise of monks or of women, are seen tempting the hermits; 11. to the right is the story of St. Paphnutius and St. Onofrio: 12. and when Paphnutius, forgetful of the last commands of Onofrio, defers his return to the monastery, the cell in which he had taken refuge, and the date-tree, are overthrown by an earthquake. 13. In the lower part of the picture, to the left, we have the story of Paphnutius, who, being tempted by a beautiful woman, thrusts his hands into the fire ; the temptress, on this, falls down dead ; but, at the prayer of the saint, is recalled to life and repentance, and is seen kneeling as a hermitess in the dress of a nun. 14. The other groups express the usual occupations of the hermits : 15. the hermit Arsenius, who, before he turned hermit, had been the tutor of the emperors Arcadius and

Honorius, is weaving baskets of palm-leaves ; 16. another is cutting wooden spoons ; another fishing.

In the centre of the picture is a hermit looking down upon a skull, which he is touching with his staff: this figure represents St. Macarius of Alexandria, one of the most famous of these anchorites, and of whom many stories were current in the Middle Ages. The figure with the skull alludes to one of the most popular and significant of these religious apologues :—

‘ One day, as Macarius wandered amongst those ancient Egyptian tombs wherein he had made himself a dwelling-place, he found the skull of a mummy, and, turning it over with his crutch, he inquired to whom it belonged ; and it replied, “ To a Pagan.” And Macarius, looking into the empty eyes, said, “ Where, then, is thy soul ?” And the head replied, “ In hell.” Macarius asked, “ How deep ?” And the head replied, “ The depth is greater than the distance from heaven to earth.” Then Macarius asked, “ Are there any deeper than thou art ?” The skull replied, “ Yes, the Jews are deeper still.” And Macarius asked, “ Are there any deeper than the Jews ?” To which the head replied, “ Yes, in sooth ! for the Christians whom Jesus Christ hath redeemed, and who show in their actions that they despise his doctrine, are deeper still.” ’

17. The monk, or rather the woman in the disguise of a monk, seated in the lower part of the picture, with a child in her arms, represents the story of St. Marina:—

‘ A certain man, who had turned hermit, left behind him, in the city, his little daughter Marina ; and, after a while, he greatly longed to see his child ; but fearing that if it were known that he had a daughter, she would not be permitted to come to him, he disguised her in boy’s attire, and she came and dwelt with her father, under the name of Brother Marinus ; and she grew up, and became an example of piety, wisdom, and humility to all the monks of the convent : and her father commanded her strictly, that she should discover herself to no human being.

‘ And Marinus, for so she was called, was often sent by the abbot, with a waggon and oxen, to a man who lived upon the shores of the Red Sea, in order to bring back things necessary for the convent. And it happened that the daughter of this man fell into sin, and, when

her father threatened her, she, being instigated by Satan, accused
Marina of being the father of her child; and as Marina, in her great
humility, answered not a word, the abbot, in his indignation and wrath,
ordered her to be scourged, and thrust out of the gate; and the wicked
mother came and put the child into her arms, saying, "There, as you
are its father, take care of it." But Marina endured all in silence; she
took the child, she brought it up tenderly outside the gate of the
convent, begging for it, and living on the alms which were thrown to
her with grudging and contumely, as to a shameless sinner : and thus
she lived in bitter but undeserved penance for many years; nor was the
secret discovered till after her death; and then great was the mourning
and lamentation, because of the unmerited sufferings of this pure and
lowly-minded virgin, who, through obedience and humility had endured
to the end !'[1]

St. Marina is usually represented with the face of a young and
beautiful woman, but the dress of a monk, and often with a child in her
arms or at her feet. The legend is popular at Venice, where there was
formerly a church dedicated to her.

---

I have said enough of these hermits of Egypt and Syria to lend an
interest to the pictures in which they are represented. And there is
one circumstance gravely suggestive to those who look beyond the
technicalities and historical associations to the moral significance of
Art. There are few of these pictures of the early hermits in which we
do not find some obscene fiendish horror, or Satan himself in person,
figuring as an indispensable, or at least important, accessory. There
is no need to set down all this to pure invention or imposture. That
ignorance of the natural laws which govern our being and a miserable
credulity should impute to infernal agency what was the inevitable
result of diseased, repressed, and misdirected feeling, is a common case
in the annals of religious fanaticism.[2] The sanctity, so called, which

[1] The same legend is related of St. Theodora. (Bartsch, xx. p. 158.)
[2] The contests of Balfour of Burley with the demon, which Walter Scott has not invented,
only recorded, and Luther's battle with the visible arch-fiend in the castle of Wartburg,
differ but little from the stories related of the poor haunted hermits of the Egyptian desert
in the fourth century.

in the absence of social temptations of every kind peopled the desert with more ' devils than vast hell could hold,' has its parallel even in our own days.   For myself, I have sometimes looked at the most grotesque of these representations of Anthony and his compeers with more disposition to sorrow than to laughter, for no doubt the worst abominations to which the pencil could give form did not equal the *reality*—if I may so use the word.   It may be interesting to add, that the cells of St. Anthony and St. Paul still remain, with the monasteries appended, which are inhabited by Coptic monks; they are about 167 miles east of Cairo, in the valley called Wadee el Arraba, and the cell of St. Paul is about 14 miles to the south-east of the cell of St. Anthony.

Leaving, however, these hermits of the East, let us turn to some of the anchorites of the West, who did not belong to the regular monastic orders, and who, as subjects of Art, are also very suggestive and interesting; the most important are St. Ranieri of Pisa, St. Julian Hospitator, St. Leonard of Aquitaine, St. Giles, and St. Geneviève of Paris.

## St. Ranieri.

*Ital.* San Ranieri.   *Fr.* Saint Régnier.   (July 17, A.D. 1161.)

SAN RANIERI is the patron saint and protector of Pisa, and, except in the edifices of Pisa, and in pictures of the Pisan school, I do not remember to have met with any representation of him.   His legend, though confined to the city and its precincts, has become interesting from the importance attached to the old frescoes in the Campo Santo at Pisa, in which the whole history of his life was painted by Simone Memmi and Antonio Veneziano.   These are of the highest importance in the history of early Art.

Ranieri was born in the city of Pisa, of the noble family of the Scaccieri, about the year 1100; and being a young man in the bondage of vanity, and addicted to the pleasures of this world, he was on a certain day singing and playing on the lyre in company with several beautiful

damsels.   While he sang and played a holy man passed that way, who turned and looked upon him with pity.   And Ranieri, struck with sudden compunction and shame, threw down his lyre and followed the man of God, bewailing his sins and his dissolute life, till he was blind with weeping.   He embarked for the Holy Land, and at Jerusalem he took off his own vestments, and received from the hands of the priests the *schiavina* or slave-shirt, a scanty tunic of coarse wool with short sleeves, which he wore ever after, in token of humility; and for twenty years he dwelt a hermit in the deserts of Palestine, performing many penances and pilgrimages, and being favoured with many miraculous visions.

On one occasion, when the abstinence to which he had vowed himself was sorely felt, he beheld in his sleep a rich vase of silver and gold wrought with precious stones; but it was full of pitch and oil and sulphur.   These being kindled with fire, the vase was burning to destruction—none could quench the flames.   And there was put into his hands a little ewer full of water, two or three drops of which extinguished the flames.   And he understood that the vase signified his human frame, that the pitch and sulphur burning within it were the appetites and passions, that the water was the water of temperance.   Thenceforward Ranieri lived wholly on coarse bread and water. He had, moreover, a particular reverence for water, and most of his miracles were performed by means of water, whence he was called in his own city San Ranieri dell' Acqua.   In a Roman Catholic country, St. Ranieri would now be the patron of temperance societies.   This, however, did not prevent him from punishing a fraudulent host of Messina, who mixed water with the wine he sold his customers, and to whom the saint revealed the arch-enemy seated on one of his casks, in the shape of a huge cat with bat-like wings, to the great horror of the said host, and to the wonder and edification of all believers.   Returning to his own city of Pisa, after many years, he edified the people by the extreme sanctity of his life; and after performing many miracles, healing the sick, restoring the blind to sight, and expelling demons, so that the most obstinate were converted, he died, and was by angels carried into heaven.

His body was reverently laid in a tomb within the walls of the Duomo, where pictures representing various scenes from his life are

hung near the altar dedicated to him, but none of great merit, nor older than the seventeenth century.

Being, however, a saint of merely local interest, it is unnecessary to say more of San Ranieri. The legend as I have given it above is sufficient to render the engravings from the Campo Santo intelligible and interesting. The three upper compartments contain—

1. The conversion of St. Ranieri.
2. St. Ranieri embarks for the Holy Land.
3. He puts on the dress of a hermit.
4. He has many visions and temptations in his hermit life.
5. St. Ranieri returns to Pisa.
6. The detection of the fraudulent innkeeper.
7. The death and obsequies of the saint.
8. The miracles of Ranieri after his death.

As there is a very accurate account of these celebrated old frescoes in Murray's 'Handbook,' and every guide to Pisa, I do not dwell upon them further.

## St. Julian Hospitator.

*Ital.* San Giuliano Ospitale.    *Fr.* Saint Julien l'Hospitalier.
Patron saint of travellers ; of ferrymen and boatmen ; also of travelling minstrels who wander from door to door.  (January 9, A.D. 313.)

HERE we have again one of the most celebrated and popular of the religious romances of the Middle Ages. In those days, when the privileged orders of illiterate hunters and iron warriors trampled and tortured at their will man and beast, it is edifying to find in these old legends the human sympathies appealed to, not merely in behalf of the woman and the serf, the feeble, the sick, and the poor; but even in favour of the dumb creatures ; and that divine Christian precept everywhere inculcated—

> Never to blend our pleasure or our pride
> With suffering of the meanest thing that feels.

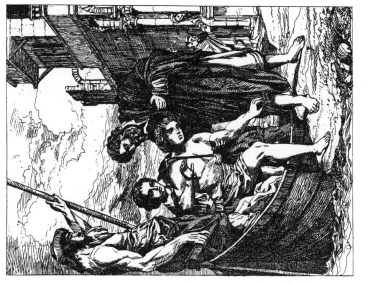

The Hospitality of S! Julian

A. J. Fait

S! Leonard with the fetters

Count Julian was a nobleman, who lived in his castle in great state and prosperity; he spent his days in hunting, and his nights in feasting. One day, as he was hunting in the forest, he started a deer, and pursued it over hill and dale. Suddenly the miserable and affrighted creature turned round and opened his mouth and said, ' Thou, who pursuest me to the death, shalt cause the death of thy father and thy mother!' And when Julian heard these words, he stood still; remorse and fear came over him, and, as the only means of averting this fatal prophecy, he resolved to flee from his home. So he turned his horse's head and travelled into a far distant country.

Now it happened that the king of that country was a munificent and a gracious prince, who received Julian with all honour and entertained him in his service. Julian distinguished himself greatly, both at the court and in war, so that the king knighted him, and gave him to wife a rich and beautiful widow, with whom he lived for some years in great happiness, and had well nigh forgotten the terrible prophecy.

In the meantime the father and the mother of Julian lamented the loss of their only son, and they sent messengers everywhere into all the surrounding provinces in search of him; and, hearing no tidings, they put on the habits of pilgrims, and went themselves in search of their lost son.

And it happened that one night, when Julian was absent at the court, they arrived at his castle, and knocked at the gate; and, Basilissa, the wife of Julian, who was a good and a pious woman, received them hospitably ; but when she learned who they were, she was filled with exceeding joy, waited upon them at supper as became a dutiful daughter, and yielded them her own bed in which to repose after their journey ; and the next morning, at early matins, she went to the neighbouring church to thank God for this great mercy. In the meantime Julian returned, and straightway entered his own chamber, and seeing by the imperfect light two people in bed, and one of them a bearded man, he was seized with jealous fury, and drawing his sword slew them both on the spot. Then rushing out of the house he met his wife, who was returning from the church, and he asked her, staring wide in astonishment, ' Who then are in

my bed?' And she replied, 'Thy father, and thy mother, who have been seeking thee for long years over all the world, and I have laid them in our bed.' And when he heard these words, Julian remained as one stupefied and half dead. And then he wept bitterly and wrung his hands, and said, 'Alas! by what evil fortune is this, that what I sought to avoid has come to pass? Farewell, my sweet sister! I can never again lie by thy side, until I have been pardoned by Christ Jesus for this great sin!' And she answered him, 'Nay, my brother, can I allow thee to depart, and without me? Thy grief is my grief, and whither thou goest I will go.' So they departed together, and travelled till they came to the bank of a great river, which was often swollen by torrents from the mountains, so that many in endeavouring to pass it perished miserably. And there did Julian found a cell of penance for himself, and near to it an hospital for the poor; and by day and night, in summer and winter, he ferried the travellers across this torrent without fee or reward.

One night in the depth of winter, when the flood had broken its icy bounds, and was raging horribly, he heard, in the pauses of the storm, a mournful voice, which called to him across the stream. And he arose immediately, and found on the opposite bank a youth who was a leper, and who appeared to be dying from fatigue and cold. He brought him over the river, and carried him in his arms, and laid him in his own bed, notwithstanding that he was a leper; and he and his wife watched by him till the morning. When it dawned, the leper rose up in the bed, and his face was transformed, and appeared to them as that of an angel of light, and he said, 'Julian, the Lord hath sent me to thee, for thy penitence is accepted, and thy rest is near at hand,' and then vanished from their sight. Then Julian and his wife fell upon their faces and thanked God for all his mercies; and shortly afterwards, being full of years and good works, they slept with the Lord.

The single figures of St. Julian represent him in rich secular attire, as a cavalier or courtier, young, with a mild and melancholy expression: often he has a hunting-horn in his hand, and a stag is behind him or at his feet. To distinguish him from St. Hubert, who has the same attributes, there is generally a river and a boat in the back-

ground; but it must also be observed, that in pictures of St. Julian the stag ought not to have the crucifix between his horns, as in the pictures of St. Hubert.

The beautiful subject called ' The Hospitality of St. Julian' represents him ferrying travellers over the stream, while his wife stands at the door of their house, holding a light. The picture by Allori, in the Palazzo Pitti, is a *chef-d'œuvre* as regards both painting and expression. The bark with the leprous youth has just touched the shore, a man stands at the helm, and Julian, with an expression of benign solicitude, receives the fainting pilgrim in his arms. In the background, his wife, with a light in her hand, appears to be welcoming some poor travellers. Here St. Julian is arrayed as a hermit and penitent, with a loose gown and a venerable beard. The principal figures are rather above life-size.

' The angel guest throws off his disguise, and ascends in a glory of light; Julian and his wife fall prostrate.' I saw this subject in a picture in the Brussels Gallery.

St. Julian slays his father and mother. Ant. della Corna, Cremonese, 1478.[1]

The legend of St. Julian Hospitator is often found as a series of subjects in ecclesiastical decoration, and in the old stained glass. It is beautifully told in a series of subjects on one of the windows of the Cathedral of Rouen, presented by the company of boatmen (bateliers-pêcheurs) of that city, in the fourteenth century.

## St. Leonard.

*Ital,* San Leonardo. *Fr.* St. Léonard, or Lionart.
Patron saint of all prisoners, captives, and slaves. (November 6, A.D. 559.)

Here we have another beneficent saint. Nothing is more touching in these old Christian legends than the variety of forms in which Charity is deified.

St. Leonard was of France. His father held a high office in the palace of King Theodobert, and Leonard himself being well educated, modest, and of a cheerful and gracious presence,

Lanzi, iv. 100.

the king honoured him and greatly delighted in his company.
He had been early converted and baptized by St. Benignus, and,
without giving up his duties as a courtier, fulfilled those of a
devout and charitable Christian.   He particularly delighted in
visiting the prisons, and ministering to the prisoners—the Howard
of his day ; and those for whom he interceded the king pardoned.
He also devoted great part of his substance to the liberation of
captives from slavery.   The cares and pleasures of a court becoming
daily more distasteful to him, he withdrew secretly to a desert place
near Limoges, and turned hermit, and spent several years in penance
and in prayer.

And it happened, that the king going to the chase in company
with the queen and all his court, she, being suddenly seized with the
pangs of child-birth, was in great peril and agony, and like to die ;
and the king and his attendants stood around her in utter affliction
and perplexity.   When St. Leonard, who dwelt in that vicinity,
heard of this grief, he prayed to the Lord, and, at his prayer, the
queen was relieved and happily delivered.   The king then presented
to St. Leonard a portion of that forest land, and he cleared the
ground, and gathered round him a religious community ; and, after
many years spent in works of piety and charity, he died there in the
year 559.

St. Leonard is invoked by all those who languish in captivity,
whether they be prisoners or slaves ; it was also a custom for those
who had been delivered from captivity to hang up their fetters in the
churches or chapels dedicated to him : hence he is usually represented
with fetters in his hand, his proper attribute.   He is claimed by the
Benedictines as a member of their Order, and either wears the white
or the black tunic fastened round the waist with a girdle ; and
sometimes he has a crosier, as abbot of the religious community he
founded ; but sometimes also he wears the dress of a deacon,
because, from his great humility, he would never accept of any
higher ecclesiastical dignity.

The ancient basso-relievo over the entrance of the *Scuola della Carità*
at Venice exhibits the effigy of St. Leonard standing full length with
fetters in his hand, a liberated slave kneeling on each side.   This *Scuola*
was a confraternity founded for the liberation of prisoners and slaves ;

and it is interesting to find that in Venice, where, from the commercial pursuits of the people, and their perpetual wars with the Turks, imprisonment for debt at home, and slavery abroad, became not rarely the destiny of their most distinguished men, St. Leonard was particularly honoured. Among the mosaics in St. Mark's, high up in the transept, to the right of the choir, I found his whole story in a series of subjects. 1. He is baptized by St. Benignus. 2. He raises water miraculously for the thirsty poor. (The common allegory to signify Christian instruction.) 3. He delivers the captives, who bring their fetters, and cast them at his feet. 4. He saves the life of the queen, who is represented in a dying state, under a sort of tent, and surrounded by her weeping attendants. 5. He founds his monastery. I am unable to fix the date of this mosaic, which is not mentioned in any of the Venetian guide-books that I have met with, but it appears to be of the sixteenth century. The groups have much dramatic expression.

177  St. Leonard  (Old fresco)

Among the bas-reliefs on the exterior of St. Mark's, the figure of St. Leonardo occurs more than once. There is a curious old effigy of him near the northern entrance.

' St. Leonard, kneeling, presents fetters to the Virgin and Child; St. Joseph behind:' in a fine composition by Razzi.[1]

' St. Leonard, standing in a long white tunic, holds in one hand a book and a crosier as superior of his monastery; in the other, the fetters as usual:' in a curious old *pietà*, attributed to Buonfigli of Perugia.[2]

' St. Leonard in the white habit, and holding the fetters, stands with St. Peter, Mary Magdalene, and Martha;' painted by Correggio for the *Oratorio della Misericordia* at Correggio.[3]

' St. Leonard, in the habit of a deacon, stands on one side of St.

---

[1] Siena, Pal. Comunale.                     [2] Perugia.

[3] A large picture in the collection of Lord Ashburton.

Lawrence, throned; on the other side, St. Stephen:' in a picture by Perugino.[1]

I found the whole story of St. Leonard in the beautiful illuminations of the far-famed Bedford missal,[2] where he is called *St. Lionart.* The group of the fainting queen, and the king sustaining her in his arms, is particularly graceful. Here the king is named Clovis, and the bishop who baptizes St. Leonard is St. Remy. In other respects the legend, as I have given it above, is closely followed.[3]

## St. Giles.

*Lat.* Sanctus Egidius. *Ital.* Sant' Egidio. *Fr.* Saint Gilles or Gil. (Sept. 1, A.D. 725.)

This renowned saint is one of those whose celebrity bears no proportion whatever to his real importance. I shall give his legend in a few words. He was an Athenian of royal blood, and appears to have been a saint by nature; for one day on going into the church, he found a poor sick man extended upon the pavement; St. Giles thereupon took off his mantle and spread it over him, when the man was immediately healed. This and other miracles having attracted the veneration of the people, St. Giles fled from his country, and turned hermit; he wandered from one solitude to another until he came to a retired wilderness, near the mouth of the Rhone, about twelve miles to the south of Nismes. Here he dwelt in a cave, by the side of a clear spring, living upon the herbs and fruits of the forest, and upon the milk of a hind, which had taken up its abode with him. Now it came to pass that the King of France (or, according to another legend, Wamba, king of the Goths) was hunting in the neighbourhood, and the hind, pursued by the dogs and wounded by an arrow, fled to the cavern of the saint, and took refuge in his arms; the hunters, following on its track, were surprised to find a venerable old man, kneeling in prayer, and the wounded hind crouching

---

[1] Fl. San Lorenzo.                    [2] Paris, Bibliothèque Impériale.

[3] St. Leonard, perhaps for the same reasons as at Venice, has been much honoured in England. He keeps his place in the English calendar, and we have about 150 churches dedicated to him.

at his side. Thereupon the king and his followers, perceiving that it was a holy man, prostrated themselves before him, and entreated forgiveness.

The saint, resisting all the attempts of the king to withdraw him from his solitude, died in his cave, about the year 541. But the place becoming sanctified by the extreme veneration which the people bore to his memory, there arose on the spot a magnificent monastery, and around it a populous city bearing his name and giving the same title to the Counts of Lower Languedoc, who were styled Comtes de Saint-Gilles.

The Abbey of Saint-Gilles was one of the greatest of the Benedictine communities, and the abbots were powerful temporal as well as spiritual lords. Of the two splendid churches which existed here, one has been utterly destroyed; the other remains one of the most remarkable monuments of the Middle Ages now existing in France. It was built in the eleventh century; the portico is considered as the most perfect type of the Byzantine style on this side of the Alps, and the whole of the exterior of the church is described as one mass of bas-reliefs. In the interior, among other curiosities of antique Art, must be mentioned an extraordinary winding staircase of stone, the construction of which is considered a miracle of skill.[1]

St. Giles has been especially venerated in England and Scotland. In 1117, Matilda, wife of Henry I., founded an hospital for lepers outside the city of London, which she dedicated to St. Giles, and which has since given its name to an extensive parish. The parish church of Edinburgh existed under the invocation of St. Giles, as early as 1359.[2] And still, in spite of the Reformation, this popular saint is retained in our calendar. He was the patron saint of the woodland, of lepers, beggars, cripples; and of those struck by some sudden misery, and driven into solitude like the wounded hart or hind.

He is generally represented as an aged man in the dress of a Bene-

---

[1] This staircase, called in the country 'La vis de Saint-Gilles,' was formerly 'le but des pélerinages de tous les compagnons-tailleurs de pierre.'—*Voyages au Midi de la France.*

[2] There are 146 churches in England dedicated to St. Giles. They are frequently near the outskirts of a city or town; St Giles, Cripplegate, St. Giles-in-the-Fields, St. Giles, Camberwell, were all on the outside of London as it existed when these churches were erected, and there are other examples at Oxford, Cambridge, &c. (See Parker's 'Anglican Calendar.')

178　　　St. Giles　(Lucas van Leyden)

dictine monk, a long black tunic with loose sleeves; and a hind pierced by an arrow is either in his arms or at his feet,

Ane Hynde set up beside Sanct Geill.

Sometimes the arrow is in his own bosom, and the hind is fawning on him.[1]　Sometimes the habit is white in pictures which date subsequently to the period when the Abbey of St. Giles became the property of the Reformed Benedictines, who had adopted the white habit.

Representations of St. Giles are seldom met with in Italy, but very frequently in early French and German Art.[2]

[1] In our National Gallery, No. 250, there is a figure of St. Giles, wearing the black Benedictine habit, and with the hind fawning upon him.

[2] It is necessary to distinguish between St. Giles the Hermit and St. Giles the Franciscan. It is the latter who is represented standing in a transport of religious ecstasy, before Pope Gregory IX. The picture, which was painted by Murillo for the Franciscan convent at Seville, is now, I believe, in England.

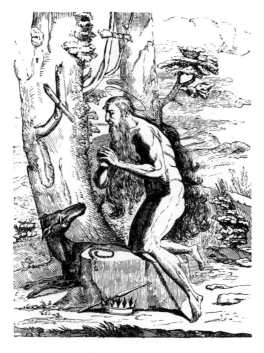

179          St. Procopius.

The story of St. Procopius is very like that of St. Giles. He
was a Bohemian king, who resigned his crown, and, retiring to a
solitude, became a hermit. He lived unknown for many years, till
a certain Prince Ulrich pursuing a hind through the forest, the
creature took refuge in the arms of St. Procopius, and thus he was
discovered. St. Procopius and the other Bohemian saints became
popular as subjects of Art when the Emperor Rodolph II. distin-
guished himself as a patron of the Fine Arts, and drew many painters
from Italy to Prague. To this period may be referred the etching
by L. Caracci of which I give a sketch, and which has sometimes,
from the similarity of the attribute, been called St. Giles.

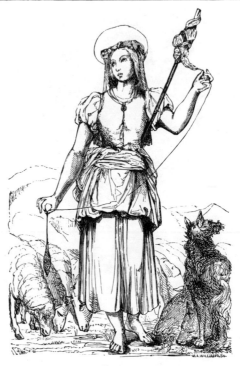

180          St. Geneviève of Paris (Guérin).

## St. Geneviève of Paris.

*Eng. Ger. Ital.* Saint Genoveva.   (Jan. 3, A.D. 509.)

The popularity of St. Geneviève, as a subject of artistic representation, is almost wholly confined to Paris and the French school of Art. I have met with only two instances of the treatment of her story by Italian painters; yet among the female enthusiasts of the Middle Ages she is one of the most important and the most interesting.

She was a peasant girl, born at Nanterre, a little village two leagues and a half from Paris, in the year 421, and in her childhood was employed by a neighbouring farmer to keep his sheep.   When

she was about seven years old, St. Germain, bishop of Auxerre, passing through Paris on his way to England, spent one night at Nanterre; the inhabitants crowded around him to obtain his benediction; and among them came the parents of *la pucelette Geneviève*, already distinguished in the village by her graceful piety and humility. St. Germain had no sooner cast his eyes upon her, than he became aware, through divine inspiration, of her predestined glory. He called her to him, questioned her, and when she expressed, with childish fervour, a strong desire to become the handmaid of Christ, he hung round her neck a small copper coin marked with the sign of the cross, and consecrated her to the service of God. Thenceforth did Geneviève regard herself as separated from the world and dedicated to Heaven.

Even while yet a child, many wondrous things are related of her. On a certain occasion, her mother, being transported by anger (though otherwise a good woman), gave her pious daughter a box on the ear; but in the same moment she was struck blind: and so she remained deprived of the sun's light for twenty-one months, until restored by the prayers of St. Geneviève, who, having drawn water from the well and made over it the sign of the cross, bathed her mother's eyes with it, and she saw clearly as before. And Geneviève at the age of fifteen renewed her vow of perpetual chastity; remaining, however, still subject to her parents, till both were dead. She then betook herself to the city of Paris, where she dwelt with an aged kinswoman; and where her extraordinary gifts of piety and humility, and, above all, her devoted and active benevolence, rendered her an object of popular veneration. At the same time there were not wanting those who treated her as a hypocrite and a visionary, and much did the holy maiden suffer from the slanders and contumelies of the evil-disposed. She had to undergo not merely the persecutions of men, but of demons; often, during her nightly vigils, the tapers lighted for the service of God were maliciously blown out by the enemy of mankind; but Geneviève, not dismayed, rekindled them by her faith and her prayers. God never left her in darkness when she prayed for light. When beset by the fiend she held up one of the tapers thus miraculously rekindled, and he fled. On another occasion, when she went with a company of pious women to pray at the shrine of St. Denis,

on the road a storm arose which blew out their tapers ; but Geneviève holding hers aloft, it was immediately rekindled by her prayers, or, as some aver, by an angel who descended expressly from Heaven for that purpose.

After being for many years maltreated and condemned by one party of her fellow-citizens, as much as she was revered and trusted by the other, Heaven was pleased to grant a signal and public proof of the efficacy of her piety, and to silence for ever the voice of the envious and unbelieving.

A certain barbarian king, called in the story Attila, king of the Huns, threatened to lay siege to the city of Paris.  The inhabitants prepared to fly, but Geneviève, leaving her solitude, addressed the multitude, and entreated them not to forsake their homes, nor allow them to be profaned by a ferocious pagan, assuring them that Heaven would interfere for their deliverance.  The people, being overcome by her enthusiastic eloquence, hesitated; and while they remained irresolute, the news was brought that the barbarians, without any visible reason, had changed the order of their march, and had withdrawn from the vicinity of the capital.  The people fell prostrate at her feet; and from this time she became, in a manner, the mother of the whole city.  In all maladies and afflictions her prayers were required; and many miracles of healing and consolation proved the efficacy of her intercession.

When Childeric invested Paris, the people suffered greatly from sickness and famine.  Geneviève was not only indefatigable in her benevolent ministry, but she also, laying aside the habit of the religious recluse, took the command of the boats which were sent up the Seine to Troyes for succour, stilled by her prayers a furious tempest which threatened to overwhelm them, and brought them back safely, laden with provisions.  When the city was taken by Childeric, he treated Geneviève with extreme respect: his son Clovis, even before his conversion to Christianity, regarded her with great veneration; and it is related that he frequently liberated prisoners, and pardoned malefactors, through her intercession.  Moreover, it was through the influence of St. Geneviève over the mind of this prince and his wife Clotilde that Paganism was banished from Paris, and that the first Christian church was erected on the summit of that eminence which has

since been consecrated to St Geneviève and known by her name. She died at the age of eighty-nine, and was buried by the side of King Clovis and Queen Clotilde.

In the year 550, St. Eloy executed a magnificent shrine, in which her remains were enclosed. This shrine, doubly interesting and curious, if not sacred, was during the Revolution broken up, and the relics of the patroness and preserver of Paris burned publicly in the *Place de Grève*.

Among the miracles imputed to St. Geneviève, was the cessation of a horrible plague, called the *mal ardent*, which desolated Paris in the reign of Louis le Gros ; and on the spot where stood the house of St. Geneviève, a small church, known as *Ste. Geneviève des Ardents*, existed so late as 1747, when it was pulled down, and a Foundling Hospital built on the site. The present superb church of St. Geneviève was the Pantheon of the Revolution; the painting of the dome, which is in the worst possible taste, represents St. Geneviève in glory, receiving the homage of Clovis, Charlemagne, St. Louis, and Louis XVIII. *Au reste*, the classic cold magnificence of the whole structure is as little in harmony with the character of the peasant patroness, as the church of the Madeleine with that of the Syrian penitent and castaway.

181 St. Geneviève (Gothic sculpture, Paris)

The most ancient effigies of St. Gene-viève as patroness of Paris, represent her veiled, holding in one hand a lighted taper, in the other, a breviary ; beneath her feet, or at her side, crouches the demon holding a pair of bellows. In this instance,

the obvious allegory, of the light of faith or holiness extinguished by the power of sin, and rekindled by prayer, seems to have given rise to the legend. She is thus represented in a graceful statue under the porch of St. Germain l'Auxerrois ; and in general wherever she figures among the female saints in the decorative architecture of the old French churches. The illustration (181) is from a figure at the entrance of the church of St. Nicholas at Paris, and sketched on the spot. But all the more modern representations exhibit her as the pious *bergerette* of Nanterre, seated or standing in a landscape, with her sheep around her, generally with her distaff and spindle, but sometimes with a book—though it is nowhere asserted, that the poor shepherdess possessed the then rare accomplishment of reading her mother tongue. Sometimes she has a basket of provisions on her arm, and holds a loaf of bread, in allusion to the miraculous deliverance of Paris.

Such is the conception in the pictures of Lebrun, Philippe de Champagne, Bourdon, Vanloo, Gros, and all the French painters. In the picture of Vanloo, St. Geneviève is reading at the foot of a tree; a few sheep and goats are browsing near ; her spindle and sabots are lying beside her; the hair and dress reminding us irresistibly of a French grisette seized with a sudden fit of piety. A charming little picture by Watteau exhibits St. Geneviève keeping sheep, and reading a volume of the Scriptures which lies open on her knee. This picture has all the painter's sweet harmonious colouring and mannered grace; and St. Geneviève here reminds us of one of the learned shepherdesses in Sir Philip Sydney's ' Arcadia.'[1]

Lebrun. St. Geneviève kneels, holding her taper ; at her feet, the keys of Paris, distaff, sheep, and book; in the distance the city of Paris, and the barbarians dispersed by a storm.

In the church of *St. Etienne-du-Mont* is a chapel dedicated to her, in which they preserve a tomb of solid stonework said to be the same in which her remains were originally deposited. When I visited this church in 1847, I found the tomb surrounded by worshippers, and stuck over with at least fifty lighted tapers, the offerings of the poor ; while votive pictures in honour of the saint covered the walls.

---

[1] Paris, St. Médard.

In the church of St. Germain is a chapel dedicated to her, and painted with modern frescoes from her life. 1. She receives, as a child, the blessing of St. Germain. 2. She harangues the Parisians, and promises them aid from heaven.

In the church of St. Gervais, over the altar of her chapel, she is represented as restoring sight to her mother.

In no picture or statue that I have seen is St. Geneviève, the patroness of Paris, worthily placed before us. The heroine who twice saved the capital of France by her courage and constancy, if not by her prayers, who ought to be placed in companionship with Joan of Arc, is ill expressed by the mawkish, feeble, or theatrical effigies which figure in the Parisian churches; and we have reason to regret that the same hand which gave us Joan of Arc, as the woman and the warrior, did not leave us also a St. Geneviève commanding the storm to cease, or pleading the cause of humanity against the barbarian Clovis.

The legend of St Geneviève (or Genoveva) of Brabant must not be confounded with that of St. Geneviève of Paris. St. Geneviève of Brabant was the wife of a certain Count Siegfried, who, misled by the representations of his treacherous steward, a sort of Iago, ordered his innocent wife to be put to death. The assassins spared her, and only exposed her in the forest, where she brought forth a child, which was tended and nursed by a white doe. After some years had passed in the savage wilderness, her husband while hunting came upon her retreat; the conscience-stricken steward confessed her innocence and his own misdeeds; was duly put to death, and Geneviève restored to happiness. This romantic legend, which has afforded an inexhaustible subject for poetry, painting, and the drama, hardly belongs to the domain of religious art; but there are beautiful pictures from her history by Riepenhausen, Führich, and others of the modern German school. A well-known print by

Albert Dürer, sometimes entitled ' St. Geneviève of Brabant,'
represents a legend much more ancient and altogether different.[1]

---

Another famous rustic saint is ST. ISIDORE the ploughman (in
Spanish, San Isidro el Labrador; and in Italian, Sant' Isidoro Agri-
cola), the patron of the city of Madrid, and of those who cultivate
the soil.   According to the Spanish legend, he was the son of a poor
husbandman, and could neither read nor write.   He hired himself as
labourer to a rich farmer, whose name was Juan de Vargas.   His
master was a hard man, and he grudged his poor servant even the
time spent in his prayers and in works of charity.   On a certain day,
Juan went into the field intending to reprimand his labourer for loss
of time and neglect of his work.   Being come to the field, he beheld
with great amazement Isidro kneeling at his devotions, while two
angels were engaged guiding his plough.   Thereupon, being struck
with awe and shame, he turned back to his house and thenceforth
dealt less hardly with his pious servant.

Also it is related, that, his master being on a certain day athirst in
his field, Isidro, taking up the goad wherewith he guided his oxen,
struck the hard rock, and immediately there gushed forth a fountain
of the purest water.   And when his little son fell into a well, Isidro,
by his prayers, miraculously restored him to life.

St. Isidro is still reverenced by the peasantry round Madrid, where
his festival (May 15th) is kept with great devotion and hilarity.   He
is represented only in the Spanish pictures, wearing the dress of a
labourer, and sometimes with a spade in his hand: an angel plough-
ing in the background is his proper attribute.

---

[1] See Vol. 1, p. 329.   The story of 'The Penance of St. John Chrysostom.'

A saint who is often confounded with St. Geneviève of Paris is St. GUDULA, patroness of the city of Brussels. She was a virgin of noble lineage, her father, Count Wittiger, and her mother, St. Amalaberga, who was a niece of Pepin d'Heristal, consecrated her early to the service of Christ, and she was educated by her godmother, St. Gertrude of Nivelle.[1] Nothing particular is recorded of St. Gudula beyond the singular holiness of her life and the usual miracles,—except the legend of her miraculous lantern. She was accustomed to rise in the middle of the night, in order to perform her devotions in the church of Morselle, at a great distance. She guided her steps with a lantern, which Satan, in his envy of so much piety and virtue, frequently extinguished, hoping thereby to lead her astray; but whenever he blew out the light, the prayer of the saint rekindled it.

In the devotional figures, St. Gudula bears a lantern, and near it hovers a malicious demon, who is trying to blow it out. There is a beautiful votive picture of this saint by Jan Schoreel,[2] in which she is thus represented, and there are various effigies of her in the splendid Cathedral of Brussels, which bears her name. Where she carries a lamp or lantern she may be mistaken for St. Lucia.[3] Her death is placed about 712.

[1] See 'Legends of the Monastic Orders.'     [2] Munich Gal.
[3] The picture by Previtale in the Berlin Gal., called St. Gudula, is, I think, a St. Lucia.

182

## The Warrior Saints of Christendom.

THE legendary histories commemorate many hundred military saints and martyrs, of whom the far greater number are obscure, known only by name, or of merely local interest, but about twenty might be selected, as illustrious and popular throughout Christendom, and representing in Art the combined sanctity and chivalry of the Middle Ages. They form a most interesting and picturesque group of saints, not only through the fine effect produced by their compact martial figures, lucid armour, and glittering weapons, when associated with the pacific ecclesiastical saints and melancholy monks; but from the charming and often pathetic contrast which the fancy suggests, between the prowess of the warrior and the humility of the Christian.

As an interesting example of the manner in which the military and the ecclesiastical saints were not unfrequently combined, as representing the Church Militant and the Church Spiritual, we may observe the two pictures (evidently part of one altar-piece) recently placed in our National Gallery (Nos. 254 and 255). In the first St. George, with the red cross on his shield, stands between the two Fathers of the Church, St. Gregory and St. Augustine; in the second St. Maurice, with the cross on his breast, stands between the Fathers St. Ambrose and St. Jerome.[1]

---

[1] In the catalogue of the National Gallery, the two military saints in these pictures by the 'Meister von Liesborn' are styled *St. Exuperius* and *St. Hilary,* on the authority of Herr Krüger of Minden, from whom they were purchased. St. Exuperius (one of the companions of St. Maurice) was honoured in Brabant; and of St. Hilary (or St. Hilier) martyr, a French saint, nothing whatever is known but his name, and that he perished by the hands of the pagan barbarians about the year 406. Neither of these saints was anywhere of sufficient consequence to represent the Church Militant, in companionship, almost on an equality, with the Church Spiritual: this distinction would belong naturally to St. George and St. Maurice, the two great military patron saints of the Western Church, and, as such, worthy of being grouped with the four great Doctors of the Western Church. If, however, there existed in the abbey of Liesborn, for which these pictures were painted, any relics of these obscure saints, it is just possible they might be thus honoured: in any case the significance of the grouping is the same.

We distinguish between the Greek and the Latin warriors.

In the Byzantine mosaics and pictures, we find St. George, St. Theodore, St. Demetrius, and St. Mercurius. The costume is always strictly classical: they wear the breastplate and chlamys, are armed with the short sword and lance, are bareheaded, and in general beardless. Of St. George I have spoken at length;[1] in the Greek pictures he appears as the patron of Constantinople, and generally in companionship with St. Demetrius, the patron of Salonica (who figures in the procession of martyrs at Ravenna). Next to Demetrius we generally find St. Mercurius; these two saints are peculiar to Greek Art, and the legend of Mercurius is extremely wild and striking. Julian the Apostate, who figures in these sacred romances not merely as a tyrant and persecutor, but as a terrible and potent necromancer who had sold himself to the devil, had put his officer Mercurius to death, because of his adhesion to the Christian faith. The story then relates that when Julian led his army against the Persians, and on the eve of the battle in which he perished, St. Basil the Great was favoured by a miraculous vision. He beheld a woman of resplendent beauty seated on a throne, and around her a great multitude of angels; and she commanded one of them, saying, 'Go forthwith, and awaken Mercurius, who sleepeth in the sepulchre, that he may slay Julian the Apostate, that proud blasphemer against me and against my Son!' And when Basil awoke, he went to the tomb in which Mercurius had been laid not long before, with his armour and weapons by his side, and, to his great astonishment, he found neither the body nor the weapons. But on returning to the place the next day, and again looking into the tomb, he found there the body of Mercurius lying as before; but the lance was stained with blood; 'for on the day of battle, when the wicked emperor was at the head of his army, an unknown warrior, bareheaded, and of a pale and ghastly countenance, was seen mounted on a white charger, which he spurred forward, and, brandishing his lance, he pierced Julian through the body, and then vanished as suddenly as he had appeared.[2] And Julian being carried to his tent, he took a handful of the blood which flowed from his wound, and flung it into the air, exclaiming with his last breath, 'Thou hast conquered, Galilean!

[1] See p. 398.　　[2] Julian was killed by a javelin flung by an unknown hand.—*Gibbon.*

thou hast conquered!' Then the demons received his parting spirit.
But Mercurius, having performed the behest of the blessed Virgin,
re-entered his tomb, and laid himself down to sleep till the Day of
Judgment.'

I found this romantic and picturesque legend among the Greek
miniatures already so often alluded to,[1] where the resurrection of the
martyr, his apparition on the field of battle, and the death of Julian,
who is falling from his horse, are represented with great spirit.[2]

St. THEODORE held a high rank in the armies of the Emperor
Licinius; being converted to Christianity, in his zeal he set fire to
the temple of Cybele, and was beheaded or burned alive (Nov. 9.
A.D. 300). His legend was early brought from the East by the Vene-
tians, and he was the patron saint of Venice before he was super-
seded by St. Mark. He is represented in armour, with a dragon
under his feet; which dragon, in the famous old statue on the column
in front of the Piazzetta at Venice, is distinctly a sort of crocodile,
and very like the huge fossil reptiles in the British Museum.

In a very curious old Greek picture of the fourteenth century, two
St. Theodores are seen on horseback, armed with lances, with glories
round their heads, and careering at full speed.[3] By the description
we find that one represents St. Theodore of Heraclea, and the other
St. Theodore Tyro or the younger; the latter is, I believe, the patron
of Venice, and the same whom we find in the early Venetian
pictures, young and beautiful, with long dark hair, armed, not as a
Roman soldier, but as a Christian knight, bearing his sword and
palm, and generally in companionship with St. George.[4]

I found his whole story on one of the magnificent windows at
Chartres, where he is represented firing the temple of Cybele.

To which of these two St. Theodores is dedicated the very ancient
church of San Teodoro at Rome, I am unable to decide; the figure
of the saint is there represented in mosaic over the altar, in company
with St. Peter and St. Paul.

[1] Ninth century.  Paris Bib., Gr. MSS. 510.

[2] v. Waagen's 'Kunstwerke und Kunstler in Paris,' p. 315.  It appears, from his de
scription of these miniatures, that he was not acquainted with the Greek legend.

[3] D'Agincourt, pl. 90.

[4] Mosaic, Sacristy of St. Mark's.  In the Crystal Palace at Sydenham are two casts from
ancient bas-reliefs at Venice, representing St. Theodore and St. George, both mounted,
and both combating the dragon.

The six colossal warrior saints, who stand in the Cathedral of Monreale (*Palermo*) over the arch which separates the choir from the nave, as if guarding the sanctuary, are the four Greek soldiers, St. George, St. Demetrius, St. Mercurius, and St. Theodore : and the two Roman warriors, St. John and St. Paul.

Among the saints who were imported from the Levant by Venice in her palmy days, we find St. Menna, a Greek warrior, who was martyred in Phrygia, by order of Galerius Maximian (Nov. 11, A.D. 301). I have met with but one effigy of this saint :—a noble figure by Paul Veronese, standing in a niche, in complete armour, bareheaded, and leaning on his sword.

---

In Western Art, the warrior saints, who have been accepted by the Latin Church, are sometimes represented in the classical military costume; more frequently in the mail shirt or plate armour of the fifteenth century, with the spurs, the lance, the banner, and other accoutrements of a Christian knight. But sometimes also they wear the court dress of a cavalier of the fifteenth century, or of the time the picture was painted; a vest or short tunic, furred or embroidered; hose of some vivid colour, crimson or violet; a mantle, and a cap and feather; the sword either girded on, or held in the hand, as in the figure of St. Sebastian, and that of St. Proculus.[1]

St. George, that universal type of Christian chivalry, stands at the head of the Latin as well as of the Greek warriors. Next to him, in Italian Art, the Roman St. Sebastian takes the place of the Greek St. Demetrius. But in French and German Art, the warrior who is usually found as a pendant to St. George is St. Maurice. In the Coronation of the Virgin, in Prince Wallerstein's collection,[2] one of the most interesting and important pictures ever brought to England, five great warrior saints of the West are grouped together in the lower part of the composition; they are all in armour, with embroidered tunics, and all crowned with laurel, ' meed of mighty conquerors ;

[1] On one of the old windows in the Cathedral of Cologne we have the Nativity of our Lord attended by four warriors,—St. George, St. Maurice, St. Adrian, and St. Gereon.

[2] Now at Kensington Palace.

and these were mighty conquerors in the spiritual as well as the earthly sense. St. George, conspicuous in front, wears a white tunic, with the red cross on the clasp of his baldrick; St. Maurice has the large cross of the Order of Savoy embroidered in front of his crimson vest; St. Adrian wears a black velvet tunic over his chain armour, and a collar composed of the letters 𝕬.𝕯.𝕽.𝕴.𝕬.𝕹.𝖀.𝕾 worked in gold. The saint with the nine balls on the sleeve of his dress, I suppose to be St. Quirinus; the fifth saint, not otherwise distinguished than by his armour and his laurel wreath, I suppose to be either the Italian St. Sebastian, or the German St. Florian, probably the latter. Like all the other figures in this wonderful picture, each head is finished like the most exquisite miniature, and has the look of a portrait from nature.

## St. Maurice.

*Lat.* Sanctus Mauritius.　*Ital.* San Maurizio.

Patron saint of foot-soldiers; patron of Savoy; one of the patrons of Austria, and of the city of Mantua.　(Sept. 22, A.D. 286.)

THE legend of St Maurice and the Theban legion is of great antiquity, and has been so universally received as authentic, as to assume almost the importance and credibility of an historical fact: as early as the fourth century the veneration paid to the Theban martyrs had extended through Switzerland, France, Germany, and the north of Italy. The story is thus related:—

Among the legions which composed the Roman army, in the time of Diocletian and Maximin, was one styled the 'Theban Legion,' because levied originally in the Thebaïd. The number of soldiers composing this corps was 6666, and all were Christians, as remarkable for their valour and discipline as for their piety and fidelity. This legion had obtained the title of *Felix;* it was commanded by an excellent Christian officer, a man of illustrious birth, whose name was Maurice, or Mauritius.

About the year 286, Maximin summoned the Theban legion from the East to reinforce the army with which he was about to march into Gaul. The passage of the Alps being effected, some companies of the Theban Legion were despatched to the Rhine; the rest of the army halted on the banks of the Lake of Geneva, where Maximin ordered a great sacrifice to the gods, accompanied by the games and ceremonies

usual on such occasions. But Maurice and his Christian soldiers withdrew from these idolatrous rites, and, retiring to a distance of about three leagues, they pitched their camp at a place called Aganum (now Saint-Maurice). Maximin insisted on obedience to his commands, at the same time making it known that the service for which he required their aid was to extirpate the Christians, whose destruction he had sworn.

The Theban legion with one voice refused either to join in the idolatrous sacrifice or to be led against their fellow-Christians; and the emperor ordered the soldiers to be decimated. Those upon whom the lot fell, rejoiced as though they had been elected to a great honour; and their companions, who seemed less to fear than to emulate their fate, repeated their protest, and were a second time decimated. Their officers encouraged them to perish rather than yield; and when summoned for the third time, Maurice, in the name of his soldiers, a third time refused compliance. ' O Cæsar!' (it was thus he addressed the emperor) ' we are thy soldiers, but we are also the soldiers of Jesus Christ. From thee we receive our pay, but from Him we have received eternal life. To thee we owe service, to Him obedience. We are ready to follow thee against the barbarians, but we are also ready to suffer death, rather than renounce our faith, or fight against our brethren.' Thus he spoke, with the mild courage becoming the Christian warrior; but the cruel tyrant, unmoved by such generous heroism, ordered that the rest of the army should hem round the devoted legion, and that a general massacre should take place, leaving not one alive; and he was obeyed: if he expected resistance, he found it not, neither in the victims nor the executioners. The Christian soldiers flung away their arms, and, in emulation of their Divine Master, resigned themselves as ' sheep to the slaughter.' Some were trampled down by the cavalry; some hung on trees and shot with arrows; some were killed with the sword; Maurice and others of the officers knelt down, and in this attitude their heads were struck off: thus they all perished.

Other companies of the Theban legion, under the command of Gereon, reached the city of Cologne on the Rhine, where the prefect Varus, by order of the emperor, required them either to forsake their faith or suffer death; Gereon, with fifty (or, as others tell, 318) of his companions, were accordingly put to death in one day, and their

bodies were thrown into a pit. And, besides these, many other soldiers of the Theban legion suffered martyrdom for the sake of Christ, so that their names form a long list. St. Maurice and St. Gereon are the most honoured in Germany. Piedmont, Savoy, and the neighbourhood of Cologne abound in saints of the Theban legion.[1]

St. Maurice is usually represented in complete armour; he bears the palm in one hand, and a standard in the other. In Italian works of Art, he is habited as a Roman soldier, and bears the large red cross, the badge of the Sardinian Order of St. Maurice, on his breast. In old German pictures he is often represented as a Moor, either in allusion to his name or his African origin.[2]

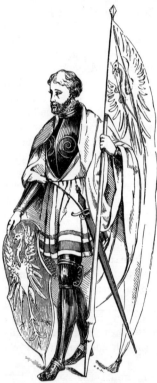

In San-Maurizio at Milan, over the altar, we have on the left St. Maurice, kneeling, and beheaded, and his companions standing round ; on the right, St. Maurice standing on a pedestal, while St. Sigismond presents to him the model of the church ;—fine frescoes by Luini.

In a small full-length figure by Hemskirk, he wears a suit of black armour, with a crimson mantle, and bears on his shield and banner the Austrian eagle : he is here one of the patrons of Austria. He stands on the left of the Madonna in Mantegna's famous Madonna della Vittoria in the Louvre. He is here one of the patrons of Mantua.

Other saints of the Theban legion, venerated through the north of Italy, are St. Secundus (Asti), St. Alexander[3]

183  St. Maurice  (Hemskirk)

(Bergamo), St. Theonestus (Vercelli), St. Antoninus (Piacenza).

---

[1] There are five churches in England dedicated in honour of St. Maurice.
[2] There is such a picture in the Munich Gal., No. 69.
[3] There is a splendid church at Milan dedicated to this military Sant' Alessandro.  Over

In the account-book of Guercino, published by Calvi and Malvasia, we find an entry of 400 ducats received for a picture, ordered by Madame Royale of Savoy, ' of the Virgin in glory ; and below, three Warrior Saints, wearing on their breast the cross of the Order of St. Maurice, who were SS. Aventore, Auditore, and Ottavio,' three of the companions of St. Maurice, mentioned in the legend.[1]

The Martyrdom of the Theban legion is not a common subject, but there are some remarkable examples. In the Pitti Palace there is a picture by Pontormo, with numerous small figures, exquisitely painted ; but the conception is displeasing ; a great number of the martyrs are crucified, and the figures are undraped. Another picture of the same subject, by the same painter, in the Florence Gallery, is equally unpleasing and inappropriate in treatment ; the Christian soldiers are seen contending with their adversaries, which is contrary to the spirit and the tenor of the legend as handed down to us. In the Munich Gallery, upon two wings of an altar-piece by Peter de Marés, we have, on one side, St. Maurice and his companions refusing to sacrifice to idols ; and on the other, St. Maurice beheaded, while the Emperor Maximin looks on, mounted on a white horse : both pieces are very curious and expressive, and, though grotesque in the accessories, infinitely more true in feeling than the classical and elaborate pictures by Pontormo.[2]

the high altar is the martyrdom of the saint, and St. Grata receiving the severed head, which is offered in a napkin.

[1] Turin, in the church of the ' Gesuiti,' which is dedicated to them.

[2] There is a celebrated woodcut by Albert Dürer, which represents a multitude of martyrs suffering every variety of death ; some are crucified, some are flung from rocks. At first view, this might be mistaken for the martyrdom of the Theban legion ; but it is a different story, and represents the massacre of the Christians by Sapor, king of Persia, popularly known as the ' Legend of the Ten Thousand Martyrs.'

There is another wild legend of ten thousand martyrs, all crucified together by order of the Emperor Adrian, ' on a certain great mountain called Mount Ararat.' (See the *Legenda Aurea.*) It is this legend which I suppose to be represented by Carpaccio in a picture now in the Academy at Venice, and which is known to collectors by the large wood-engraving in eight sheets : it is very fine as a study ; the martyrs are tied to the stems of vast trees in grand attitudes, and there are nearly three hundred figures in all (see Vasari, *Vita di Scarpaccia*) ; and the same subject I believe to be represented in the two pictures by Pontormo, called the Theban Martyrs. Between 1500 and 1520 this extravagant legend appears to have been popular.

St. Gereon also wears the armour, and carries the standard and the palm ; sometimes he has the Emperor Maximin under his foot, to express the spiritual triumph of faith over tyranny.   The celebrity of St. Gereon appears to be confined to that part of Germany which was the scene of his martyrdom : at Cologne there is a church dedicated to him ; and he is frequently met with in the sculpture and stained glass of the old German churches.

1. In the famous old altar-piece by Master Stephen of Cologne, now in the Cathedral, he is standing on one side in a suit of gilt armour and a blue mantle, attended by his companion-martyrs (his pendant on the other side is St. Ursula with *her* companions).

2. In a fine old Crucifixion by Bartholomew de Bruyn, St. Gereon is standing in armour, with his banner and shield, and a votary kneeling before him (here his pendant is St. Stephen).[1]

3. ' St. Gereon and his Companions ; ' in the Moritzkapelle at Nuremberg (here his pendant is St. Maurice with *his* companions). I remember no Italian picture in which St. Gereon is represented.

4. In a Crucifixion by Israel v. Meckenem, St. Ursula stands on one side presenting a group of young maidens, and St. Gereon on the other.   (He is called in the catalogue St. Hippolytus ;—a mistake).[2]

## St. Longinus.

*Ital.* San Longino.   *Fr.* Saint Longin.   Sainct Longis.   Patron saint of Mantua.
(March 15, A.D. 45.)

St. Longinus is the name given in the legends to the centurion who pierced the side of our Saviour, and who, on seeing the wonders and omens which accompanied his death, exclaimed, 'Truly this man was the Son of God!'[3]   Thus he became involuntarily the first of the Gentiles who acknowledged the divine mission of Christ.   It is related that, shortly after he had uttered these words, he placed his hands, stained with the blood of our Lord, before his eyes; and immediately a great imperfection and weakness in his sight (*i.e.*, spiritual blindness),

---

[1] Munich Gal.   [2] Munich Cabinet, 11, 27.   [3] Matt. xxvii. 54 ; Mark xv. 39 ; John xix. 34.

which had afflicted him for many years, was healed; and he turned away repentant, and sought the apostles, by whom he was baptized and received into the Church of Christ. Afterwards he retired to Cæsarea, and dwelt there for twenty-eight years, converting numbers to the Christian faith; but at the end of that time he was seized by order of the governor, and ordered to sacrifice to the false gods. Longinus not only refused, but being impatient to receive the crown of martyrdom, he assured the governor, who was blind, that he would recover his sight only after putting him to death. Accordingly, the governor commanded that he should be beheaded, and immediately his sight was restored; and he also became a Christian; but Longinus was received into eternal glory, being 'the first fruits of the Gentiles.'

This wild legend, which is of great antiquity, was early repudiated by the Church; it remained, however, popular among the people; and it is necessary to keep it in mind, in order to understand the significance given to the figure of the centurion in most of the ancient pictures of the Crucifixion. Sometimes he is gazing up at the Saviour with an expression of adoration; sometimes his hands are clasped in devotion; sometimes he is seen wringing his hands, as one in an agony of grief and repentance; and I have seen an old carving in which he covers his eyes with his hands, in allusion to the legend. In the Crucifixion by Michele da Verona, he is on horseback, and looks up, his hands clasped, and holding his cap, which he has reverently removed.[1]

In the Crucifixion by Simone Memmi, in the chapel *de' Spagnuoli* at Florence, Longinus is conspicuous in a rich suit of black and gold armour, looking up with fervent devotion.

When introduced into pictures or sculpture, either as a single figure, or grouped with other saints, St. Longinus wears the habit of a Roman soldier, and carries a lance or spear in his hand. He is thus represented in the colossal marble statue which stands under the dome of St. Peter's at Rome. The reason of his being placed there, is the tradition, that the spear wherewith he pierced the side of our Saviour is preserved to this day among the treasures of the Church.

[1] Milan, Brera.

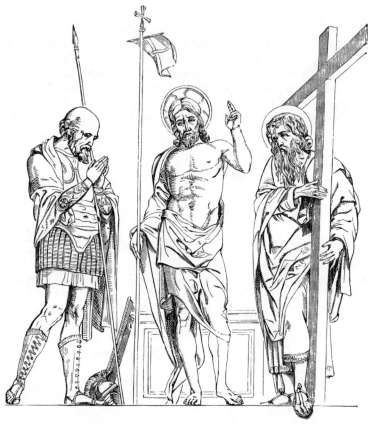

184        Our Saviour between St. Longinus and St. Andrew   (Andrea Mantegna)

Some relics, said to be those of St. Longinus, were brought to
Mantua in the eleventh century, and he has since been reverenced
as one of the patron saints of that city.

For the chapel dedicated to him in the church of Sant' Andrea, at
Mantua, Giulio Romano painted a famous Nativity, in which the saint
is standing on one side, holding a pix or reliquary, containing a portion
of the blood of our Saviour, which, according to the tradition, had been

preserved by St. Longinus, and brought to Mantua from the Holy Land. This picture, once in possession of our Charles I., is now in the Louvre. For the altar-piece of the same chapel, Andrea Mantegna painted the Saviour as risen from the tomb, with St. Andrew on one side, and St. Longinus on the other (184). In the Madonna della Vittoria, painted by Mantegna for Federigo Gonzago, St. Longinus stands behind, on the left of the Virgin, in a Roman helmet, and distinguished by his tall lance.[1]

## St. Victor.

*Ital.* San Vittore. (July 21, A.D. 303.)

THERE are two St. Victors who figure in works of Art.

St. Victor of Marseilles was a Roman soldier serving in the armies of Diocletian ; being denounced as a Christian in the tenth great persecution, neither tortures nor bribes could induce him to forsake his faith. In the midst of the torments to which he was condemned, a small altar was brought to him, on which to offer incense to Jupiter, and thus save himself from death ; but in the fervour of his zeal he overthrew it with his foot, and broke the idol. He was then crushed with a millstone, and finally beheaded with three of his companions, whom he had converted. At the moment of his death, angels were heard singing in chorus, ' Vicisti, Victor beate, vicisti ! ''

The reverence paid to this saint is principally confined to France. He is generally represented in the dress of a Roman soldier, with a millstone near him. I have seen him on one of the windows of Strasburg Cathedral in a full suit of chain armour, with shield and spurs, like a knight of romance.

St. Victor of Milan was also a Roman soldier, and suffered in the same persecution. He was a native of Mauritania, but quartered at that time in the city of Milan. He was denounced as a Christian,

[1] Louvre.

and, after suffering severe torments, he was beheaded by order of
the Emperor Maximian (May 8).

This saint is greatly honoured throughout Lombardy, and is the
favourite military saint in the north of Italy.   He is often introduced
into the pictures of the Milan and Brescian schools; and is sometimes
represented as a Moor ('*San Vittore-il-Moro*'), wearing the habit of
a Roman soldier.   In his church at Milan (which, at the time I
visited it, was crowded with soldiers) there is a fine picture on the
left of the high altar, by Enea Salmeggia, representing St. Victor as
*victorious* (in allusion to his name), mounted on a white horse, which
is bounding forward.   In his church at Cremona, there is a splendid
Madonna picture by Andrea Campi, in which St. Victor is the
principal saint, standing *victorious*, with his foot on a broken altar.
According to some authorities, this St. Victor was thrown into a
flaming oven; and is therefore represented with an oven near him,
from which the flames are issuing; but I have never yet met with an
instance of this attribute.

## ST. EUSTACE.

*Lat.* Sanctus Eustatius.   *Ital.* Sant' Eustachio.   *Fr.* Saint Eustache.   (Sept. 20, A.D. 118.)

'St. EUSTACE was a Roman soldier, and captain of the guards to
the Emperor Trajan.   His name before his conversion was Placidus,
and he had a beautiful wife and two sons, and lived with great
magnificence, practising all the heathen virtues, particularly those
of loyalty to his sovereign and charity to the poor.   He was also a
great lover of the chase, spending much of his time in that noble
diversion.

'One day, while hunting in the forest, he saw before him a white
stag of marvellous beauty, and he pursued it eagerly, and the stag fled
before him, and ascended a high rock.   Then Placidus, looking up,
beheld, between the horns of the stag, a cross of radiant light, and on
it the image of the crucified Redeemer; and being astonished and
dazzled by this vision, he fell on his knees, and a voice, which seemed
to come from the crucifix, cried to him, and said, "Placidus! why dost
thou pursue me?  I am Christ, whom thou hast hitherto served without

knowing me. Dost thou now believe?" And Placidus fell with his face to the earth, and said, "Lord, I believe!" And the voice answered, saying, "Thou shalt suffer many tribulations for my sake, and shalt be tried by many temptations; but be strong and of good courage, and I will not forsake thee." To which Placidus replied, "Lord, I am content. Do thou give me patience to suffer!" And when he looked up again the wondrous vision had departed. Then he arose and returned to his house, and the next day he and his wife and his two sons were baptized, and he took the name of Eustace. But it happened as it was foretold to him; for all his possessions were spoiled by robbers, and pirates took away his beautiful and loving wife; and, being reduced to poverty, and in deep affliction, he wandered forth with his two children, and, coming to a river swollen with torrents, he considered how he might cross it. He took one of his children in his arms, and swam across, and having safely laid the child on the opposite bank, he returned for the other: but, just as he had reached the middle of the stream, a wolf came up and seized on the child he had left, and ran off with it into the forest; and when he turned to his other child, behold, a lion was in the act of carrying it off! And the wretched father tore his hair, and burst into lamentations, till remembering that he had accepted of sorrow and trial, and that he was to have patience in the hour of tribulation, he dried his tears and prayed for resignation: and, coming to a village, he abode there for fifteen years, living by the labour of his hands. At the end of that time, the Emperor Adrian being then on the throne, and requiring the services of Placidus, sent out soldiers to seek him through all the kingdoms of the earth. At length they found him, and he was restored to all his former honours, and again led on his troops to victory; and the emperor loaded him with favours and riches; but his heart was sad for the loss of his wife and children. Meanwhile, his sons had been rescued from the jaws of the wild beasts, and his wife had escaped from the pirates; and, after many years, they met and recognised each other, and were reunited; and Eustace said in his heart, "Surely all my tribulation is at an end!" But it was not so; for the Emperor Adrian commanded a great sacrifice and thanksgiving to his false gods, in consequence of a victory he had gained over the Barbarians. St. Eustace and his

family refused to offer incense, remaining steadfast in the Christian

185   St. Eustace   (Domenichino)

faith.   Whereupon the emperor ordered that they should be shut up in a brazen bull, and a fire kindled under it; and thus they perished together.'

There is nothing in this legendary romance to recommend it, but it has been popular from the earliest times, and is constantly met with in Art.

In the devotional pictures, St. Eustace is represented either as a Roman soldier, or armed as a knight ; near him the miraculous stag.   In a picture by N. Soggi (a rare master, who lived and worked about 1512) he stands armed with a kind of mace or battle-axe, and his two sons, as boys with palms and glories, stand behind him.[1]

The ' Conversion of St. Eustace ' is only distinguished from the legend of St. Hubert by the classical or warrior costume.   The martyrdom of St. Eustace and his family in the brazen bull, I have frequently met with; and a series of subjects from this legend is often found in the stained glass and sculpture of the old French cathedrals.[2]

St. Quirinus was another Roman soldier, serving under the Emperor Aurelian.   As he did not hesitate both to profess and preach openly the Christian faith, he suffered martyrdom by being dragged to death by horses ;  his tongue was first thrown to a hawk.   He is represented in armour, with a horse and a hawk near him, bearing a shield

[1] Florence, Pitti Pal.

[2] St. Eustace has been banished from the English Calendar; there are, however, three churches in England dedicated in his name.

with nine balls, and the palm as martyr. Of this military saint I have met with only one representation, in an old German picture; where he stands in complete armour, bearing the standard, on which are nine balls.[1]

---

ST. FLORIAN, one of the eight tutelar saints of Austria, was another Roman soldier, who, professing Christianity, was martyred in the reign of Galerius. He was a native of Enns, in Lower Austria, and worked many miracles : among others he is said to have extinguished a conflagration by throwing a pitcher-full of water over the flames. A stone was tied round his neck, and he was flung into the river Enns. (May 4.)

St. Florian is rarely met with in Italian Art, but he occurs frequently in the old German prints and pictures; and in Austria and Bohemia we encounter him in almost every town and village, standing, in a sort of half-military half-ecclesiastical costume, at the corner of a street or in an open space, generally marking the spot on which some destructive fire occurred or was arrested. I have often found his statue on a pump or fountain. He is also painted on the outside of houses, in armour, and in the act of throwing water from a bucket or pitcher on a house in flames. The magnificent monastery of St. Florian, which is also a famous seminary, commemorates the scene and the legend of his life and martyrdom. ' St. Florian in a deacon's dress, his right hand on a millstone, his martyrdom in the background,' is described in a picture by Murillo.[2] The costume is, I think, a mistake.

---

The legend of St. Hippolytus (*Sant' Ippolito Romano*), the friend of St. Laurence, I have already given at length, and shall only add, that in the fine Coronation of the Virgin in the Wallerstein collec-

---

[1] A St. Quirinus bishop of Sissek in Croatia, and martyr (June 4, A.D. 309), is one of the eight tutelar saints of Austria ; he was thrown into a river with a millstone round his neck ; he figures in Albert Dürer's fine print of the patrons of the Emperor Maximilian.
[2] Petersburg, Hermitage.

tion he stands behind St. Laurence, in armour, and with the head of
a Moor or Negro: for this peculiarity I find no authority; there seems
to have been some confusion in the painter's mind between the Moorish
saints, St. Maurice and St. Victor, and St. Hippolytus the Roman.

When we find St. Hippolytus in
the Brescian pictures, it is because
the inhabitants of Brescia claim to
possess his relics.   They insist that
the body of the saint reposes, with
that of St. Julia, in the convent of
Santa Giulia in Brescia.   There was
a fine figure of St. Hippolytus,
accompanied by St. Catherine (St.
Julia?), by Moretto di Brescia, in
the collection of Mr W. Coning-
ham, and probably painted for this
convent.

ST. PROCULUS, military protector
of Bologna, is often found in the
pictures of that school of Art, and
sometimes also in the north of Italy.
This is the only saint, as far as I can
recollect, of whom an act of violence
and resistance is recorded.   When the
tenth persecution broke out, a cruel
officer named Marinus was sent to
Bologna to enforce the imperial edict;
and Proculus, more of a Roman than
a Christian, being moved with indig-
nation and pity because of the suffer-
ings of the martyrs, entered the house

186      San Proculo   (Francia)

of Marinus, and put him to death with an axe [1]: this axe is usually
placed in his hand.   In some effigies he carries a head in both hands;

---

[1] In Guido's picture, dedicated after the plague at Bologna, St. Proculus appears as a fine
martial figure, with an angel holding the axe.   ('Legends of the Madonna,' p. 108.)

whether his own, or that of Marinus, does not seem clear.    In the
Bolognese pictures, San Proculo *Vescovo* and San Proculo *Soldato*
are sometimes found together as joint patrons.

In a beautiful altar-piece by Don Lorenzo Monaco, St. Proculus
is represented as a young saint, leaning on a sword, the belt of which
he holds in one hand.    The name is inscribed underneath.[1]

The Martyrdom of St. Proculus, by Palma Vecchio, is at Venice,
in the church of St. Zaccaria.

---

St. Quintin, the son of Zeno, held a high command in the Roman
army, and being converted to the Christian faith, he threw away his
arms and preached to the people of Gaul, particularly at Amiens and
in the country of Belgium ; but being denounced before the prefect
Rictius Varus, he suffered a cruel martyrdom.    He is represented in
armour, and his proper attribute is an iron spit on which he was im-
paled; but this is often omitted: he is famous in the old French
and Flemish ecclesiastical decorations, but so rare in Italian Art
that I can remember no example.

---

The last of these military saints who may be considered of suffi-
cient importance to require a detailed notice, is St. Adrian, illus-
trious throughout all Christendom, both in the East and in the West;
but less popular as a subject of Art than might have been expected
from the antiquity of his worship, and the picturesque as well as
pathetic circumstances of the legend.

' Adrian, the son of Probus, was a noble Roman ; he served in the
guards of the Emperor Galerius Maximian, at the time when the
tenth persecution against the servants of our Lord first broke out in
the city of Nicomedia in Bithynia (A.D. 290).    Adrian was then not
more than twenty-eight years old, and he was married to a wife
exceedingly fair and virtuous, whose name was Natalia, and she was
secretly a Christian.

' When the imperial edict was first promulgated, it had been torn
down by the brave St. George, which so incensed the wicked emperors,
that in one day thirty-four Christians were condemned to the torture;

[1] Academy, Florence.

and it fell to the lot of Adrian to superintend the execution; and as he stood by, wondering at the constancy with which these men suffered for the cause of Christ, his heart was suddenly touched, and he threw away his arms, and sat down in the midst of the condemned, and said aloud, "Consider me also as one of ye, for I too will be a Christian!" Then he was carried to prison with the rest.

'But when his wife, Natalia, heard these things, she was transported with joy; and came to the prison, and fell upon her husband's neck and kissed his chains, and encouraged him to suffer for the truth.

'And shortly afterwards, Adrian, being condemned to die, on the night before he was to suffer prevailed upon the jailer by large bribes, and by giving sureties for his return, to permit him to visit his wife.

'And Natalia was spinning in her chamber when the news was brought that her husband had fled from prison; and when she heard it she tore her garments, and threw herself upon the earth and lamented, and exclaimed aloud, "Alas! miserable that I am! I have not deserved to be the wife of a martyr! Now will men point at me, and say, 'Behold the wife of the coward and apostate, who, for fear of death, hath denied his God.'"

'Now Adrian, standing outside the door, heard these words; and he lifted up his voice, and said, "O thou noble and strong-hearted woman! I bless God that I am not unworthy of thee! Open the door, that I may bid thee farewell before I die." So she arose joyfully, and opened the door to him, and took him in her arms and embraced him, and they returned to the prison together.

'The next day Adrian was dragged before the tribunal; and after being cruelly scourged and tortured, he was carried back to his dungeon; but the tyrants, hearing of the devotion of his wife and other Christian women, who ministered to the prisoners, ordered that no woman should be allowed to enter the dungeon. Thereupon Natalia cut off all her beautiful hair, and put on the dress of a man; and thus she gained access to the presence of her husband, whom she found lying on the earth, torn and bleeding. And she took him in her arms, saying tenderly, "O light of mine eyes, and husband of mine heart! blessed art thou, who art called to suffer for Christ's sake!" And Adrian was comforted, and prepared himself to endure bravely to the end.

'And the next day, the tyrants ordered that Adrian should have his limbs struck off on a blacksmith's anvil, and afterwards be beheaded, and so it was done to him; and Natalia held him and sustained him in his sufferings, and before the last blow was struck he expired in her arms.

'Then Natalia kissed him upon the brow, and, stooping, took up one of the severed hands, and put it in her bosom; and, returning to her house, she folded up the hand in a kerchief of fine linen, with spices and perfumes, and placed it at the head of her bed; but the bodies of Adrian and his companions were carried by the Christians to Byzantium, which was afterwards Constantinople.

'And it happened after these things, that the emperor threatened to marry Natalia, by force, to one of the tribunes of the army. Therefore she fled, and embarked on board a vessel, and sailed for Argyropolis, a port near Byzantium; and the remainder of her life did she pass in widowhood, near the tomb of her husband. And often, in the silence of the night, when sleep came upon her eyes, heavy with weeping, did Adrian, clothed in the glory of beatitude, visit her dreams, and invite her to follow him. Nor long did she remain behind him; for it pleased God to release her pure and noble spirit from its earthly bondage; and Adrian, accompanied by a troop of rejoicing angels, descended from heaven to meet her; and they entered into the joy of the Lord, with the prophets and with the saints and those whose names are written in the book of life; and they dwell in the light of His presence, reunited for ever and ever.

'The Greek Church counts St. Natalia among the most distinguished female martyrs, with honours equal to those of her husband; for, not less precious was her death in the sight of God, than if she had perished by the sword of the persecutors, seeing that she had endured a more terrible martyrdom than any that the ingenuity of man could inflict; therefore they place the palm in her hand, and the crown upon her head, as one victorious over worse than death.'

St. Adrian and St. Natalia are commemorated on the 8th of September, and the story in its main points is one of the most ancient and authentic in the calendar. St. Adrian was for ages the chief military saint of the north of Europe, next to St. George; and was, in Flanders and Germany and the north of France, what Sebastian was in Italy—the patron of soldiers, and the protector against the

plague.  He is also the patron of the Flemish brewers.  According to an ancient tradition, his relics have reposed since the 9th century in the convent of St. Adrian at Grammont, in Flanders.  His sword, long preserved as a most precious relic at Walbeck, in Saxony, was taken from its shrine by the Emperor Henry II. (St. Henry), and girded on by that pious emperor when preparing for his expedition against the Turks and Hungarians.

St. Adrian is represented armed, with an anvil in his hands or at his feet; the anvil is his proper attribute; sometimes a sword or an axe is lying beside it, and sometimes he has a lion at his feet.

1. In a picture by Hemling, now belonging to Mr Harcourt Vernon, St. Adrian is thus represented, armed as a Roman soldier, with a magnificent helmet and cuirass, and carrying the anvil in his arms.

2. St. Adrian, in a short tunic richly embroidered, but without helmet or cuirass, holds his sword, the point of which rests on the anvil; in the left hand he holds the banner of victory.[1]

3. St. Adrian, crowned with laurel and in complete armour, holds the sword and anvil; a lion, here the emblem of fortitude, crouches at his feet.  A beautiful miniature in the breviary of Marie de Médicis.[2]

4. St. Adrian, with the lion at his feet (engraved in Carter's 'Specimens of Ancient English Painting and Sculpture').

It is necessary to observe these effigies with attention, for I have seen figures of St. Adrian in which the anvil in his hand is so small as to look like a casket; others, in which the anvil placed at his feet is like a block or a large stone.

SS. Adrian and Natalia are represented by Domenichino in the chapel of St. Nilo at Grotta Ferrata, because this chapel had been originally dedicated to these Greek saints.

I regret that I can cite no other separate figure of St. Natalia, nor any series of subjects from this beautiful legend.  No doubt many examples might be found in the old Flemish churches.[3]

---

[1] Italian print.                                    [2] Oxf., Bodleian.

[3] In the collection of Mr M'Lellan, of Glasgow, I saw a small picture representing St. Adrian in complete armour, with a helmet and floating plumes; the anvil, on which he was mutilated, at his feet, and a crouching lion near him.  In the collection of the late Mr Dennistoun, at Edinburgh, I saw (in November 1854) a small and very beautiful picture—by Hemling, I think—which represented St. Nathalie, bearing the severed hands of her husband.

According to the Greek and German authorities, St. Natalia bears the lion as her proper attribute: if it be so, the lion is not here expressive of martyrdom, but is given to her as the received emblem of magnanimity and invincible fortitude. She is the type of womanly love and constancy exalted by religious enthusiasm; and though the circumstances of her heroic devotion have been deemed exaggerated, we may find in the pages of sober and authentic history warrant for belief. Every one, in reading the legend of St. Natalia, will be reminded of the story of Gertrude de Wart, who, when her husband was broken on the wheel, stood by, and never left the scaffold. during the three days and three nights of his protracted torture :—

> For, mightier far
> Than strength of nerve or sinew, or the sway
> Of magic, potent over sun and star,
> Is Love, though oft to agony distrest,
> And though his favourite seat be feeble woman's breast.

187

# INDEXES.

I. NAMES OF ARTISTS (EMBRACING PAINTERS, SCULPTORS, AND
ENGRAVERS).

II. GALLERIES, CHURCHES, MUSEUMS, AND OTHER DEPOSITORIES
OF ART.

III. GENERAL INDEX.

# I.

## INDEX TO NAMES OF ARTISTS

### (EMBRACING PAINTERS, SCULPTORS, AND ENGRAVERS.)

# II.

## INDEX TO GALLERIES, CHURCHES, MUSEUMS, AND OTHER DEPOSITORIES OF ART.

# III.

## GENERAL INDEX.